Neoclassicism David Irwin

ART&IDEAS

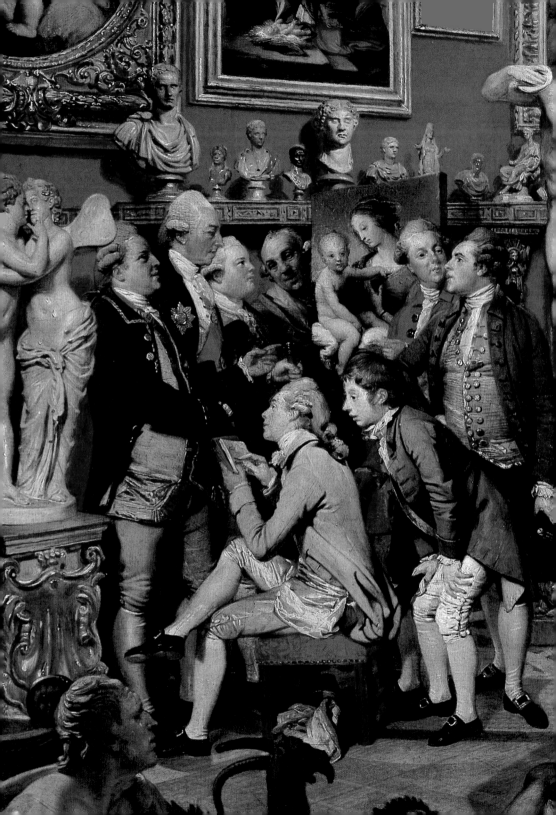

Neoclassicism

Opposite
**Johann
Zoffany**,
*The Tribuna
of the Uffizi*
(detail),
1772–7.
Oil on canvas;
123·5×154·9 cm,
48¾ ×61 in.
Royal Collection,
Buckingham
Palace

Napoleon's favourite style in art was Neoclassical. Monuments erected to commemorate Nelson's achievements were Neoclassical. They and their contemporaries lived through a period of ferment, political as well as cultural. Their lives, in terms of the visual arts, were dominated by one style: Neoclassicism. Houses, churches, museums, banks and shops were frequently designed in the new style. It was the form of building and decoration that emigrants took with them to the developing colonies. Teapots, buckles and lamp-posts were among the daily reminders of the wide-ranging influence of the classical past of Greece and Rome on contemporary taste. Today we take for granted a much more diffuse situation, with no single style predominating. The period between about 1750 and 1830, however, was more clear-cut. Neoclassicism held sway for roughly eighty years, with medieval and exotic alternative styles either scarcely gaining a hold or being absorbed into the classical idiom. Neoclassicism was a very pervasive style. Originating in France and Italy, it spread in all directions, as far as St Petersburg, Edinburgh, Philadelphia and Sydney, and penetrated all levels of society. Only after 1830 was its leading position seriously undermined.

This book embraces all manifestations of the Neoclassical style, looking not only at the movement's unusually broad territorial scope, but also at its versatility in every branch of art. In its comprehensiveness the book aims to provide an insight into the richness and variety of one of the most fertile and dynamic styles in the history of art that affected the lives of so many people. That is the first reason why Neoclassicism is important. There is also a second. While being deeply conscious of the past, the period also saw the laying of foundations for the later development of modern art, from the 1880s onwards. Leading Neoclassicists questioned some of the basic fundamentals of art which had been accepted

from the Renaissance onwards. Gauguin, Matisse and other modern masters were to inherit and explore further ideas that had originated about 1800. Like the two-faced classical god Janus, Neoclassicism looked both behind and ahead.

Since the fall of the Roman Empire, a strand of the classical past has been continuously alive, sometimes hardly perceptible, but on occasions more obviously discernible in the form of classical revivals. The civilization of ancient Greece and Rome was viewed as a state of perfection, a Golden Age. Different generations took it as a model, to be emulated in contemporary thought, literature and art. The Renaissance of the fifteenth and sixteenth centuries was the most famous of these revivals. It had been preceded by two earlier ones, but the more important of these, in the twelfth century, had not been as wide in either intellectual or territorial scope as the later Renaissance.

The classical tradition as embodied in the Renaissance of the fifteenth and sixteenth centuries lived on uninterrupted through succeeding centuries. Classicism remained of fundamental importance to the development of European art right through the period from Raphael to the advent of Neoclassicism in the mid-eighteenth century. That movement learnt a great deal not only from Raphael and his contemporaries, but also from their succes-sors in the seventeenth century. Although often called the Age of the Baroque, the art of the seventeenth century was not wholly swept up in the extravaganza of that style. Concurrent with the Baroque, indeed interwoven with it, was a seventeenth-century classicism, embodied in the work of such painters as Poussin and Claude, as well as like-minded architects and sculptors. This form of classicism was well known to the Neoclassical generation, who derived much inspiration from it, especially in the early development of the style.

In the eighteenth century itself, classicism was still alive through-out Europe in the first fifty years. However, it was also the period of the Rococo style, against which the Neoclassical generation reacted vehemently, dismissing the art of Boucher and his

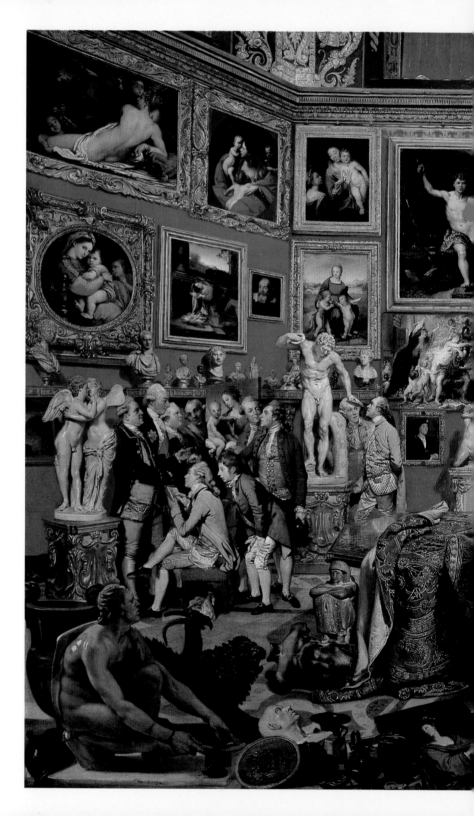

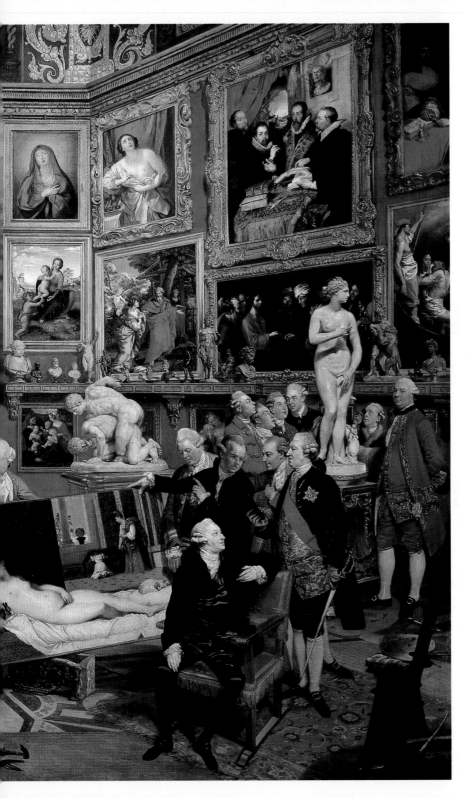

1
Johann
Zoffany,
The Tribuna
of the Uffizi,
1772–7.
Oil on canvas;
123·5 × 154·9 cm,
48³⁄₄ × 61 in.
Royal Collection,
Buckingham
Palace

contemporaries as frivolous, or worse. The rejection of Rococo –
for varying reasons in different countries – helped to galvanize a
strong resurgence of classicism.

This new classicism, to be subsequently labelled 'Neoclassicism',
was stimulated by a vastly increased first-hand knowledge of
classical antiquity. The second half of the eighteenth century knew
far more about ancient Roman, and subsequently ancient Greek,
art than any previous century since the fall of those civilizations.
Herculaneum and Pompeii were excavated for the first time,
and important sites on the Greek mainland and islands were
measured and published, also for the first time. This explosion of
knowledge about classical art and society went hand in hand with
influential theoretical and historical writings and contributed as
strongly as the ancient artefacts themselves to a change in taste.

The Neoclassical style is therefore characterized by a strong
classical influence, derived not only directly from the antique
past, but also from the filtering of that tradition through the
Renaissance and the seventeenth century. This did not mean,
however, that the Neoclassical style was exclusively antique,
in either form or content. Other styles made minor contributions,
such as medieval and Egyptian, together with elements from
cultures further east. Content, as far as painters and sculptors
were concerned, although often determined by classical history
and mythology, also embraced a wide range of other sources
for subject matter. Even contemporary subject matter, however,
could be treated in the Neoclassical style. Out of all this material
evolved an art that suited many tastes and requirements. It could
be intellectually exacting or charmingly decorative. It could be
manipulated for political propaganda or commercial gain. It was,
above all, very versatile.

The noun 'Neoclassicism' was first used in its present-day meaning
only a hundred years ago, and is therefore not contemporary
with the movement itself, unlike the use of the word 'Romantic'.
Reviewing the current annual exhibition at the Royal Academy in
London, a leading newspaper critic in 1893 said of one artist's

history piece entitled *The Sleep of the Gods* that 'a man must be a scholar before he can make neoclassicism even tolerable in art'. This derogatory comment on a minor Victorian painting was an unspectacular adoption of the word 'neoclassicism'. The term had already been in use in art criticism, from 1881 onwards, but only to describe the style of Poussin. But in describing his art with such adjectives as 'noble', 'solemn' and 'austere', a vocabulary was beginning to emerge that would be applied subsequently to the art of the period from 1750 to 1830. From the 1920s onwards, 'Neoclassicism' acquired its now generally accepted sense. Rather confusingly, however, literary historians apply the same term to English writings in the first half of the eighteenth century, while musicologists apply it to certain composers of the nineteenth and twentieth centuries (including Stravinsky).

During the writing of this book, the controversy raged about the possible export from Britain of an important marble group of the *Three Graces* by the great Italian Neoclassicist Antonio Canova, bought by a landed aristocrat in the early nineteenth century for his country house, and recently sold by a descendant. During the fund-raising campaign, one newspaper columnist noted: 'Poor old *Three Graces*! As a popular work of art it has everything going against it. It is Neoclassical – a style which has been revised in esteem but never taken to heart.' The journalist was the latest in a long line of commentators in the twentieth century who have shown little sympathy for the style. Kandinsky dismissed Neoclassicism as 'a still-born child'; the potter Bernard Leach dismissed the Neoclassical products of Wedgwood as 'unnatural, useless and false'; while Kenneth Clark labelled the style 'frigid'. In the 1990s Neoclassicism has indeed been revised in esteem; but 'never taken to heart'? An Empress of Russia, a President of the newly formed United States of America, an English industrial- ist – these would be among the countless objectors from the Neoclassical period itself to the use of 'never'. The style appealed to both mind and heart then, and as one of the most important movements in the history of art can do so today.

The story of Neoclassicism can be viewed in three phases. The first, the period from about 1750 to 1790, was the age of the Grand Tour, which formed a vital part of the education of many artists, writers and aristocrats, and which provides the background to the development of a taste for classical styles born of first-hand experience of Italian and, later, Greek sites. Architects who espoused Neoclassicism at this time include such great names of the century as Soufflot, Ledoux and Boullée in France, Adam in Britain and Piranesi in Italy, while history painting formed a major part of the output of artists ranging from early pioneers like Benjamin West to the most famous of all Neoclassical painters, Jacques-Louis David. The response of the Neoclassical generation to landscape embraced a new kind of 'picturesque' or natural style of garden design, incorporating Neoclassical buildings and sculptural ornaments, as well as the idealized classical landscapes created on canvas by such artists as Turner. In the decorative arts, Neoclassicism flourished in the ceramic products of such firms as Wedgwood and Sèvres, as well as other items such as wallpapers and textiles.

The period from 1790 to 1830 saw the Neoclassical style change in character, becoming more austere, increasingly influenced by ancient Greece rather than Rome. Neoclassical themes informed the use of art as patriotic propaganda at the time of the French Revolution and Napoleonic period, and continued to be explored in the paintings, sculptures and buildings of the post-1790 period. Prominent among the architects are Soane in Britain and Schinkel in Germany, where he created a modern Berlin. Neoclassicism became an influential style in the newly independent United States, together with the British colonies in India and Australia, and featured prominently in early industrial design.

The final phase is from 1830 to the present day. Although no longer dominant, Neoclassicism nevertheless continued to exert an influence, as can be seen from works as disparate as sculptures shown at the Crystal Palace in 1851 and buildings erected by Hitler during the Third Reich. Neoclassicism is still with us today.

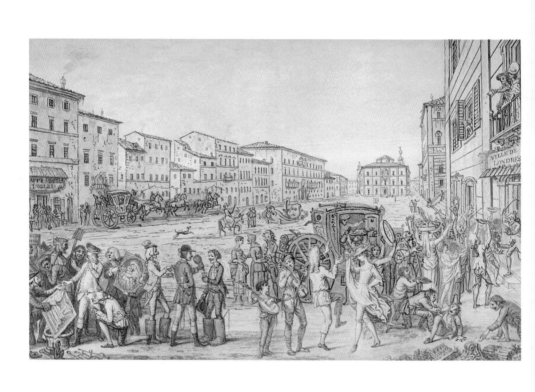

Wearing his new, red silk suit acquired in Lyons on his journey south, a young British architect travelled in his own green and gold coach, hoping to make an impression as he passed through Italy. Like many other eighteenth-century artists he was making a journey that he felt was obligatory. It was both a real journey and a journey of ideas. As he travelled to Italy he looked at many works of art, as tourists still do. However, at a deeper level, those same works were shaping contemporary taste and ideas about art. Classical archaeology, in particular, was changing perceptions of the past.

2
David Allan,
The Arrival of a Young Traveller and his Suite during the Carnival in Rome, c.1775.
Pen and brown wash;
40×54 cm,
15¾×21¼ in.
Royal Collection, Windsor Castle

The young man was the 26-year-old Robert Adam (1728–92), who knew how to project an image of himself that would inspire confidence in potential clients. Not all artists splashed out on fancy suits and coaches, but they did have other things in common while on their travels in Italy. They hoped to invest in their future success by gaining knowledge and skills, combined with a modest amount of social life that might lead to commissions. The aristocracy and gentry, on the other hand, treated their tour as a continuation of their education, combined with a whirl of social activity, and possibly a shopping spree for their art collections. Adam was one of the many thousands of the rich and the educated from all over Europe who travelled south to Italy during the eighteenth century: a journey which became known as the Grand Tour (2). British travellers were predominant, and have left numerous autobiographical accounts of Italy; fewer came from France and Germany, and smaller numbers still from such countries as Russia, Denmark and the newly independent United States. In terms of the number of artists on the move, however, the French and Germans do not seem to have been outnumbered by the British.

There were two main routes to Italy for those travelling from

Britain: from Paris through Switzerland (via Mont Cenis) to Turin, Milan, Florence, and then south; or via Lyons to Nice, and then by boat first to Genoa then Livorno (Leghorn) or occasionally further north to Lerici. Whichever route was chosen, however, travelling was tedious and expensive. Letters and journals are full of accounts of inns with poor accommodation and food, of carriages that were uncomfortable and got stuck in ruts or snow, and of sea-crossings delayed for days or even weeks by bad weather. Tourists also found some of the scenery on the way depressing or, worse still, alarming – some travelled through the Alps with their coach blinds drawn down.

Whatever the rigours, however, the goal of Italy made the journey worthwhile. 'There is certainly no place in the world where a man may travel with greater pleasure and advantage than in Italy', run the opening words of a guidebook by Joseph Addison (1672–1719), the famous essayist and critic contributing to the *Tatler* and the *Spectator*. First published in 1705 and frequently reprinted throughout the century, Addison's *Remarks on Several Parts of Italy* found its way into the luggage of many British travellers. Its compact, pocket-sized format contained a wealth of basic facts combined with an erudite commentary, interspersed with numerous classical quotations. The era of the modern guidebook had arrived, with publishers across Europe supplying a rapidly expanding demand from both travellers and armchair readers.

On his first page, Addison summarized Italy's varied attractions. The landscape was 'more astonishing than anywhere else in Europe'. It was the 'great school' of music and painting. It contained 'all the noblest productions of statuary and architecture, both ancient and modern', and it 'abounds with cabinets of curiosities, and vast collections of all kinds of classical antiquities'. For those interested in politics, 'no other country in the world has such a variety of governments' (Italy was not united until late in the nineteenth century). And for those concerned with history, 'there is scarce any part of the nation that is not famous, nor so

much as a mountain or river, that has not been the scene of some extraordinary action.' Italy could provide something to suit all tastes. In days long before tourist boards and travel agents' brochures, Addison did a good job in promoting Italy's longstanding attractions. By the mid-eighteenth century, Italy already had a booming tourist industry.

The 'advantage' of Italy – which Addison's readers would have taken for granted – meant the furthering of one's education, the acquisition of intellectual and cultural knowledge that was an integral part of the upbringing of the aristocracy, gentry, writers and artists. Travelling to Italy was not just for fun, although there was plenty of enjoyable social life available on arrival. According to some commentators on education, this Grand Tour should begin around the age of twenty. By then the traveller would have acquired a sound basis in classical history and literature – the foundation of European education in the eighteenth century. Many travellers were of course older, but all shared this classical background, and their imaginations were well prepared long before they set foot on Italian soil.

Most of the towns *en route* to Rome merited only brief stays to see the sites. Florence, however, attracted visitors for longer periods because of its greater artistic riches. These were greatly enhanced by the Duke of Tuscany's removal of his antique sculptures from the Villa Medici in Rome in 1770 to the Uffizi Gallery in Florence. The city then became the only one in Italy that could compete with Rome and Naples for classical statuary.

In the Uffizi Gallery, one of the greatest art collections in Europe, the focal point was the Tribuna. Specially built to display some of the most famous works in the collection, its crimson velvet walls were thickly hung with Old Master paintings. They provided a dazzling, if bewildering, backdrop for a group of major antique sculptures. In the best eighteenth-century visual record of the Tribuna (see 1), a large group of British tourists – or 'flock of travelling boys' as one contemporary waspishly described them – is shown examining and copying works in the room. Although the

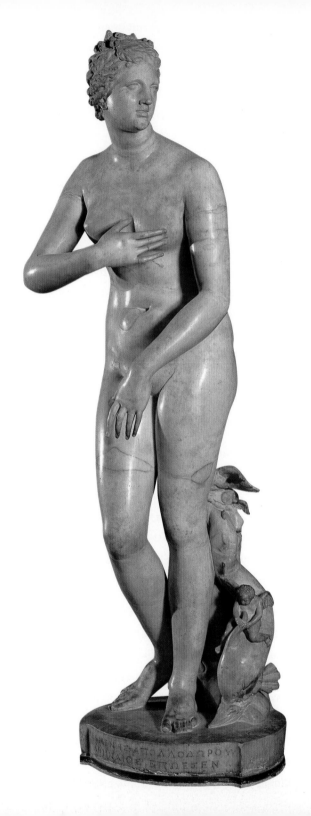

artist has introduced some items not actually on display in the Tribuna at the time, he conveys the mixture of genuine appreciation and social bustle which characterized such gallery outings. The sculptures shown in the painting were frequently drawn and copied, especially the *Cupid and Psyche* (not actually in the room at the time) and, above all, the *Medici Venus* (3). For the eighteenth century, she represented the ultimate in female beauty in the ancient world. The painter and writer Jonathan Richardson (1665–1745), in his 1722 guidebook to Continental travels, recorded gazing at her for ten hours. Later, for Byron, she 'fills / The air around with beauty; we inhale / The ambrosial aspect.' Many antique and other variants of the *Medici Venus* existed, including one bought by a tourist for a vast sum while in Italy, and exported to his country house in England (see 37). She was also available as a small-scale figurine, both cast in bronze and manufactured throughout Europe by the ceramic industry.

3
*Medici Venus
(Venus de'
Medici),*
1st century BC.
Marble;
h.153 cm,
60 in.
Galleria degli
Uffizi, Florence

Like any tourists, travellers on the Grand Tour looked at things famous or noteworthy. But the eighteenth-century traveller had a mental list of artistic preferences, influenced by the prevailing ideas in artistic theory. Classical remains had priority. From modern times, works of art of the sixteenth and seventeenth centuries took precedence over earlier periods, which covered the wide expanse from the medieval period through to the early Renaissance of the fifteenth century. Works in these periods were apt to be dismissed as 'Gothic', which in the eighteenth century meant crude and disagreeable. This hierarchy of taste had been largely determined by writers and academies during the seventeenth century in Italy and France, and was firmly in position when the Neoclassical period began. Only at the turn of the eighteenth and nineteenth centuries were there signs of any amendments (see Chapter 7). Within the accepted canon there was an ascending order of merit, represented in its crudest form in some books as a chart listing artists' names, and in one example even awarding marks out of 20, under the headings of composition, design, colour and expression. Raphael comes top with a score of 17, 18, 12 and 18 respectively; Caravaggio, however, makes only

4
**Giovanni
Paolo Panini**,
*The Roman
Forum*,
1735.
Oil on canvas;
58·1×134·6 cm,
22⁷₈×53 in.
Detroit Institute
of Arts

6, 8, 16 and an astonishing 0, and Dürer 8, 10, 10, 8. Such charts almost reduce to the level of caricature a vast body of rarified discussion, but they nonetheless summarize a standard of taste that had become an accepted part of the eighteenth century's assessment of modern art.

Although Florence had much to offer tourists, Rome and Naples remained the ultimate destinations. Only the most intrepid proceeded further south by sailing on to Sicily. The Bay of Naples offered Vesuvius and the antiquities of Herculaneum and Pompeii, but in terms of ancient, and also modern, art Rome far excelled its southern rival. The French writer François-René de Chateaubriand

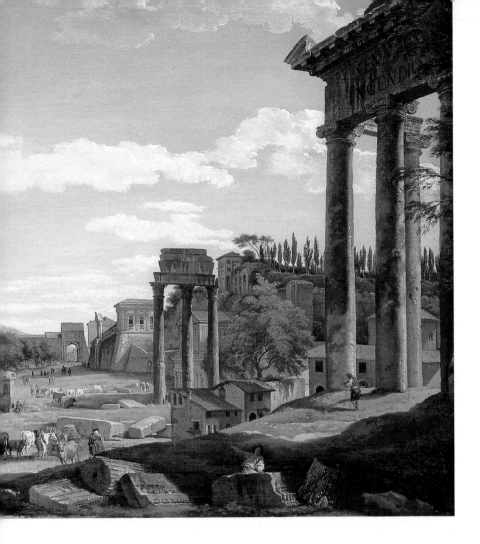

**(1768–1848) expressed succinctly, when on his Grand Tour in
1803–4, what so many other writers on Rome had noted about the
dominant presence there of the historical past:**

The man who occupies himself solely in the study of antiquities and the
fine arts, or he who has no other ties in life, should live at Rome. The very
stone that he treads on will speak to him; the dust blown by the wind
around him will be decomposed particles of some great human being.

**As another traveller noted, making the same point somewhat
differently: 'It is impossible to feel ennuie at Rome, though
not a place of gaiety.' For that component of one's tour,**

Naples was more dynamic and catered more for present-day tastes. These comments come from Lady Anna Miller, who was to take a leading part in the social and literary life of Bath on her return home in the later 1770s. For her, while Rome was admittedly 'the most agreeable retreat in the world for all those who love the fine arts, and have a real pleasure in the study of antiquity', the city 'yet rather inclines one to melancholy than cheerfulness'.

Once in Rome, some commentators recommended a stay of at least a year, and many tourists stayed longer. The Grand Tour was a leisurely pursuit that was not to be hurried. In order to take full advantage of what the city had to offer, the tourist was recommended to take a regular course with an antiquarian or guide. On average it would last about six weeks, occupying three hours a day, and consisted of instructed visits to all the worthwhile palaces, villas, churches and ancient sites (4) in and around Rome. Tourists were then advised to spend the succeeding months in revisiting the most interesting sites 'again and again' to 'reflect on them at more leisure', because otherwise 'those [objects] you see on one day [are] so apt to be effaced by, or confounded with, those you behold on another, that you must carry away a very faint and indistinct recollection of any.' This practical advice was offered in

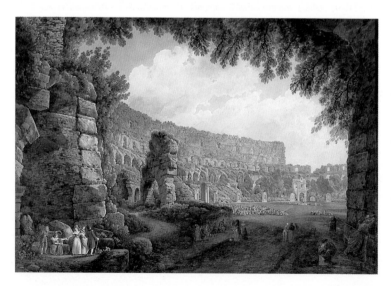

5
Abraham Louis Ducros,
The Interior of the Colosseum,
c.1786.
Watercolour and gouache;
76×112 cm,
30×44 ¹⁄₈ in.
Hoare Collection,
Stourhead

his *Society and Manners in Italy* (1781) by John Moore. He had first-hand experience as a tutor, having accompanied the young Duke of Hamilton on his Grand Tour in the previous decade (30). The study of the art and antiquities of Rome, indeed of other cities too, was not a matter to be undertaken lightly.

The study of the past may have been taken seriously, but this did not mean that ancient Rome had been carefully preserved as a series of tidy archaeological sites. Far from it. Ruins and marble fragments were put to new, up-to-date uses. The French painter Elisabeth-Louise Vigée-Lebrun (1755–1842) often visited the Colosseum at sunset, enjoying the play of light on the arcading and the beauty of the interior 'now filled with greenery, flowering shrubs and wild ivy', where small chapels had been erected for monks to follow the Stations of the Cross (5). Elsewhere in the city, washerwomen used ancient Roman baths for their laundry, ancient marble basins were used as outdoor pulpits, sarcophagi made excellent water troughs, while cattle and sheep grazed in the Forum and sheltered under triumphal arches. Many artists recorded this living use of the past in drawings and paintings, a lively counterpart to the works of art displayed indoors. But even here, in galleries and museums, the contents were treated in a more relaxed way than would be tolerated today. Marble statues were frequently subjected to detailed measuring. Pictures that had been hung at the top of the fashionable many-tiered rows could be viewed from ladders or even scaffolding. A picnic lunch followed by siesta was even possible in the Sistine Chapel itself, provided the custodian was handsomely tipped. And when it came to souvenir hunting on archaeological sites, eighteenth-century tourists were no better behaved than today's. The German writer Johann Wolfgang von Goethe (1749–1832) records walking through some ruins in Rome, partially covered by fields of artichokes, where he and his companion 'could not resist the temptation to fill our pockets with tablets of granite, porphyry, and marble which lay around in thousands, still bearing witness to the splendour of the walls which they once covered'.

Although visitors to Rome referred to it as a serious, sombre city, the picture could be exaggerated. There was always a great deal of music both ecclesiastical and secular. And like other cities it had a big annual festival, which lasted six weeks, culminating in a week when everyone wore masks. At this time of year there were also plenty of theatrical performances – normally forbidden. Even without the festival, though, there was always the colourful local life, in and around Rome, all faithfully recorded by the hordes of visiting artists (7).

The Vatican was at the heart of any tourist's site-seeing in Rome, with the great church of St Peter's, the Sistine Chapel and the many frescoed suites of rooms (some by Raphael), as well as the

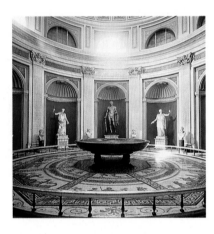

6
Michelangelo Simonetti, Rotonda in the Museo Pio-Clementino, Vatican, Rome, 1776–80

7
Dietrich Wilhelm Lindau, *Saltarello in a Roman Inn*, 1827. Oil on canvas; 50·3×71·9 cm, 19⁷⁸×28³⁸ in. Thorvaldsens Museum, Copenhagen

8
John Flaxman, *Death of Orpheus*, c.1791. Pen and ink and wash; 24·4×65·8 cm, 92¹² ×25⁷⁸ in. Whitworth Art Gallery, Manchester

large collection of antique sculptures. The number of marbles grew rapidly during the eighteenth century, partly through purchases and partly through new excavations. This expansion necessitated the creation of new museums, firstly on the Capitol on the other side of the city, and later, from 1770 onwards, in the Vatican itself (6). Here rooms were altered and refurbished to create the still-surviving Museo Pio-Clementino, named after the two popes responsible for this initiative, Clement XIV and Pius VI. The Vatican collections, like other private collections in Rome, were well displayed, often in specially designed rooms and outdoor court-yards. They provided the richest concentration of classical antiqui-ties in Europe, which visiting artists assiduously drew, taking home

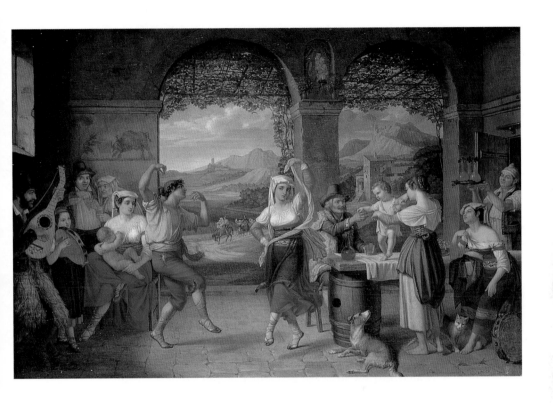

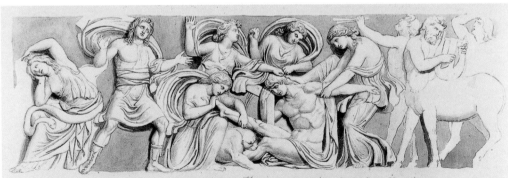

records for possible subsequent re-use (8, 9). The one drawback of some of these displays, however, resulted from the vagaries of daylight, with dark shadows cast in corners and niches, so that some sculptures could not be seen to best advantage. Even a group as famous as the *Laocoön*, displayed in its own niche in a Vatican courtyard, received no direct daylight. For this reason torchlight visits to collections of sculpture were a popular form of evening entertainment, supplementing the frequent daytime visits. Torchlight made a close study of the *Laocoön* and other sculptures feasible, bringing out the finer qualities of the carving and usefully focusing attention on one work at a time, by preventing the gaze from being distracted by a whole roomful of antiquities.

The climax of a visit to the Vatican galleries was an encounter with two of the most famous sculptures in Europe: the *Apollo Belvedere* and the *Laocoön* (10, 11). Tourists would already know these sculptures from engravings and plaster casts, while guidebooks extolled them as the 'finest' anywhere. The marbles themselves, however, exceeded expectations, especially in the period when the folding doors, which briefly covered the niche housing the *Apollo*, were dramatically thrown open. 'I started

back with surprise', noted Lady Miller; 'Never did I see any sculpture come so near the life.' Both statues seemed to Viscount Palmerston to 'breath a spirit one could scarcely believe marble could convey'.

Both the *Apollo* and the *Laocoön* had been eulogized since their installation as part of the Vatican collections during the Renaissance. There was nothing new in the fact that the age of Neoclassicism continued to admire them. The novelty lay in the way they were described and the stress laid on particular characteristics. The second half of the eighteenth century looked at these two marbles and classical art as a whole, but especially sculpture, under the influence of the widely read publications of the German antiquarian scholar Johann Joachim Winckelmann (1717–68).

In 1755 Winckelmann (12) published his first book on ancient art – before he had even arrived in Rome and seen the originals about which he was writing. *Reflections on the Imitation of the Painting and Sculpture of the Greeks (Gedanken über die Nachahmung der griechischen Werke in der Mahlerei und Bildhauer-Kunst)* contained ideas that he was to elaborate in later books after he

9
Hubert Robert,
An Artist Drawing in the Capitoline Museum,
1762.
Crayon on paper;
33·5 × 45 cm,
13¼ × 17¾ in.
Musée des Beaux-Arts,
Valence

10
Apollo Belvedere,
original
*c.*320 BC.
Roman copy of Greek original.
Marble;
h.224 cm,
88in.
Vatican Museums

11
Laocoön,
*c.*150 BC.
Marble;
h.184 cm,
72½ in.
Vatican Museums

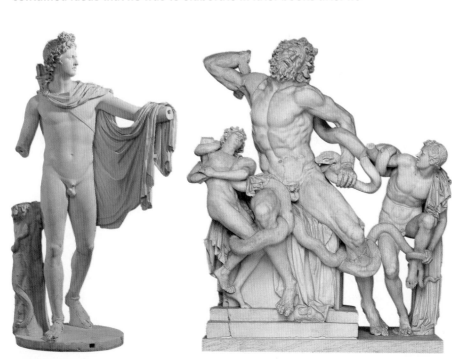

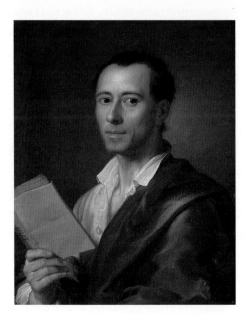

had settled in Rome, and its first sentence is like a clarion call: 'Good taste, which is gaining ever wider currency throughout the world, first began to develop under the skies of Greece.' He arrived in Rome later the same year, and in due course was appointed librarian to Cardinal Alessandro Albani (1692–1779), one of the foremost collectors of classical antiquities in Italy. An even more important appointment followed, as Prefect of Papal Antiquities. Influential connections combined with dedicated scholarship put Winckelmann in a unique position in the circle of scholars and connoisseurs concerned with classical antiquities in mid-eighteenth-century Rome, and within a decade of his arrival he became its leading classical scholar (and thus effectively the principal scholar in his field in Europe).

Apart from his youthful *Reflections,* his most significant work was the *History of Ancient Art* (*Geschichte der Kunst des Alterthums*), published in 1764. With it he became the first writer on the subject to sort out a proper chronological development, intended to show 'the origin, progress, change and downfall of art'. Earlier writers had not concerned themselves overmuch with chronology, employing instead the vague word 'ancient' and

using 'Greek' to cover Roman art as well. The assortment of images of Venus shown in an engraving (13) from one of the main early eighteenth-century antiquarian publications, is typical of this unhistorical approach. Winckelmann therefore laid the foundations of modern archaeological studies.

Parallel with this new accuracy in archaeological studies went a comparable development in the visual recording of ancient sites. Early eighteenth-century views of them were conceived as attractive pictures, inaccurate in their detailing, sometimes even rearranging monuments to produce a more marketable commodity. The Italian painter Giovanni Paolo Panini (1691/2–1765) was particularly adept at this kind of manipulation but could also give reasonably accurate impressions of Roman monuments, as in his view of the Forum (4). Both kinds of picture by him were immensely popular with travellers on the Grand Tour. But even this painting of the Forum lacks the precision of later views of it and other sites. Once information was more clearly delineated, it could have a stronger impact on collectors and artists alike, allowing archaeological evidence to be absorbed more easily into the mainstream of thought and art.

12
Anton
Raphael
Mengs,
Winckelmann Holding a Copy of the Iliad,
*c.*1758.
Oil on canvas;
63·5×49·3 cm,
25×19⅜ in.
Metropolitan
Museum of Art,
New York

13
Bernard de
Montfaucon,
Plate 103 from
Antiquités expliquées,
volume I,
showing several statues and gems of Venus,
1719.
Engraving;
31·2×17·3 cm,
12⅜×6⅞ in

Winckelmann's discussions of the *Apollo Belvedere* and the *Laocoön* exemplify his approach to classical art. His description of the *Apollo* goes much further than those of earlier eighteenth-century writers, who were content to describe it as 'exquisitely great and awful [full of awe], as well as beautiful', in the words of Jonathan Richardson's guidebook. Winckelmann's long discussion of the *Apollo* in his *History* contains two ideas that are central to the eighteenth-century view of ancient art. The first is the concept of an ideal art that is more perfect than nature, and the second is the beauty of the male nude. His discussion is also a subjective and sometimes passionate response to the statue, a new tone in European art criticism, anticipating the outpourings associated later with Romanticism.

Winckelmann stated categorically that of 'all the works of antiquity which have escaped destruction, the statue of the *Apollo Belvedere* is the highest ideal of art. The artist has constructed this work entirely on the ideal.' Winckelmann had discussed this concept earlier in his *History*, having already put the point neatly in his *Reflections*. There he had written of 'something superior to nature' that was to be found in Greek art, namely 'ideal beauties, brain-born images'. This was not to deny that the ancients copied from nature, they most certainly did. But artists went beyond a 'just resemblance', aiming at 'a more beauteous and more perfect nature'. Copying from just one head or body led to the naturalistic art associated with seventeenth-century Holland, showing every-day people and scenes, which Winckelmann despised. Instead, the Greek artist combined elements from a variety of observations to create a general beauty, an ideal image. Here Winckelmann was reiterating an academic position that had been current from the Renaissance onwards, and which derived ultimately from classical texts. While not originating the concept of ideal art, however, Winckelmann helped to give it a new lease of life in books that were to be widely read.

Returning to his description of the *Apollo Belvedere*, we find Winckelmann becoming increasingly rhapsodic. The idealized

beauty of the god 'clothes with the charms of youth the graceful manliness of ripened years, and plays with softness and tenderness about the proud shape of his limbs ... Neither blood-vessels nor sinews heat and stir his body, but a heavenly essence, diffusing itself like a gentle stream, which seems to fill the whole contour of the figure.' He continues with a fulsome account of each part of the body, expressing a languorous enjoyment of each detail. 'The soft hair', for example, 'plays about the divine head as if agitated by a gentle breeze, like the slender waving tendrils of the noble vine.' He concludes by confessing that 'in the presence of this miracle of art I forget all else.'

Winckelmann has much to say about the beauty of the youthful male nude, linking it with the beneficence of the Greek climate. The beauty of their bodies, he argued, was far in excess of those of modern Europeans. In the past 'a mild and clear sky influenced the childhood development of the Greeks', and this when combined with all their physical exercises in the gymnasium and in games, shaped 'their noble form'. It was these exercises that gave the bodies of the Greeks that 'great and manly contour which the Greek masters imparted to their statues, with no vague outlines or superfluous accretions.' The gymnasia were the schools of art, because there the Greeks – artists and philosophers among them – could watch completely naked youths at their exercises, in a range of postures far more varied and genuine than could ever be reproduced by a model hired to pose in a modern academy. Such beauty, readily available in nature, formed the basis from which evolved the idealized images in the Vatican of the *Apollo Belvedere*, and of another famous male nude there, that of *Antinous* (14), the youthful lover of Emperor Hadrian. With these two works 'all that nature, mind and art have been able to accomplish stands here before us.'

Aesthetic pleasure and scholarly erudition expressed by Winckelmann and his contemporaries in their response to ancient sculpture are only part of the significance of Greek and Roman art for the eighteenth century. Winckelmann had made a

passing reference to the use of nude models in modern academies or art schools, and just as the study of the nude had been of fundamental importance for the Greek and Roman artist, so it was again with the 'rebirth' of classical art at the time of the Renaissance. By the Neoclassical period, the study of the nude by a student, firstly using plaster casts of classical statuary and then graduating to the live model, was accepted without question as the basis of a European artist's training.

Nude models were available to students in academies and in the studios of artists who instructed pupils or assistants (16). Once established, artists could afford the expense of hiring their own. One of the attractions of Rome for many visiting artists were the regular facilities for drawing from the nude, principally available in two well-run academies (15). At all stages of an artist's career constant reference to the nude was regarded as of vital importance, especially in understanding properly the articulation of the human body. The nude was studied both in its own right, and also as one of the stages in the course of preparing a particular painting or sculpture. Studies for a composition often entailed posing the model as hero, saint or politician, perhaps drawing an entire scene consisting of many figures in this way. Only after such preparations would the artist then have recourse to clothing. Nudes in the form of plaster casts in academies and studios often included some form of *Apollo*; in the case of the

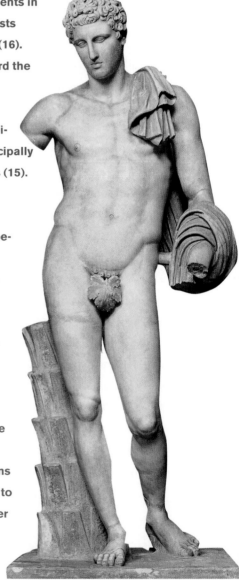

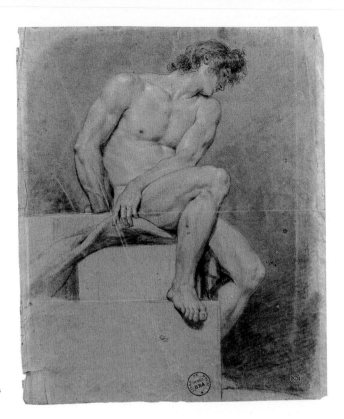

studio in figure 16 there is a copy of an Apollo in the Uffizi (visible
on the right), together with an *Antinous* in the background, and the
head of the priest from the group of the *Laocoön*.

The *Laocoön* in the Belvedere of the Vatican was as famous
as the *Apollo* there, but is a very different sculpture altogether.
Let us return to that collection, and to Winckelmann's commen-
taries on this particular work. The group portrays Laocoön,
a Trojan prince and priest, together with his two sons, who were
killed on the beach by serpents that had risen from the sea.
He had been trying to persuade the Trojans not to pull the fateful
wooden horse within the walls of Troy, at which point divine
intervention punished him. Laocoön's death, and that of his sons,
is an episode full of horror, combining an unjust death with a
painful means of exacting it. As a subject it is 'disagreeable',
to use the poet Shelley's adjective when describing the scene.
The human anguish is very explicit in the lines of Virgil's *Aeneid*,

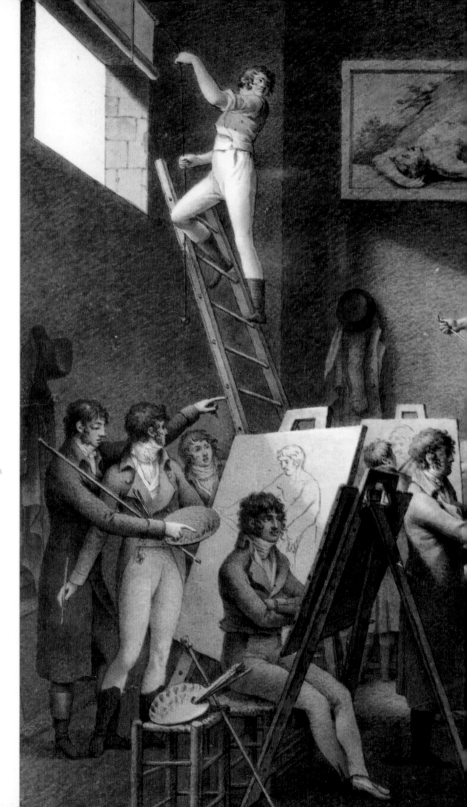

16
Jean-Henri
Cless,
*Artists Drawing
a Model in
David's Studio
in the Louvre*,
1804.
Pen and ink;
46·2 × 58·5 cm,
18¼ × 23 in.
Musée
Carnavalet, Paris

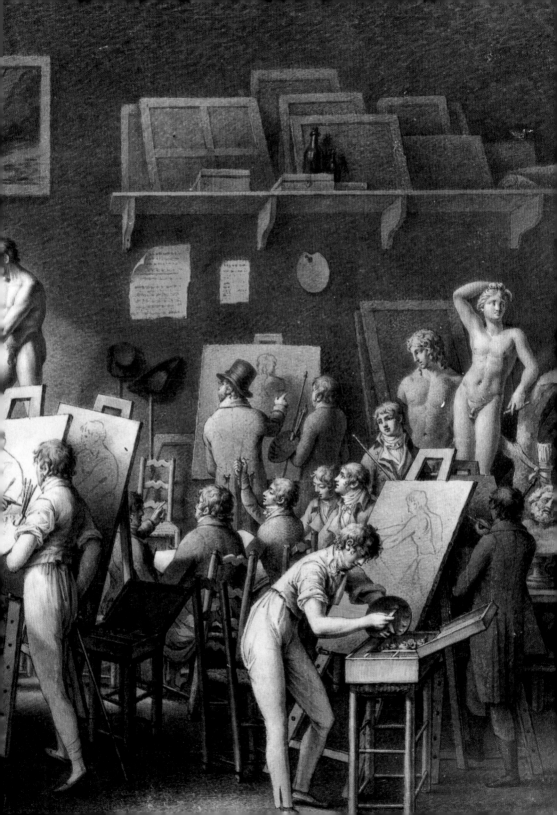

the main source for the story, where Laocoön 'lifts to the stars his horrifying shrieks'. However, the sculptors of the marble group adopted a different approach, which Winckelmann preferred, avoiding exaggeration in both posture and expression. As he explained in his *History*:

Laocoön is an image of the most intense suffering. It manifests itself in his muscles, sinews and veins. The poison introduced into the blood by the deadly bite of the serpents, has caused the utmost excitement in the circulation; every part of the body seems as if straining with agony. By this means the artist brought into action all the natural motive powers, and at the same time displayed the wonders of his science and skill … in the representation of this intense suffering is seen the determined spirit of a great man who struggles with necessity and strives to suppress all audible manifestations of pain.

The reasons lying behind that suppression had already been examined by Winckelmann in his *Reflections*. In a frequently quoted passage, he argued, in the context of the *Laocoön*, that 'the most eminent characteristic of Greek works is a noble simplicity and sedate grandeur in gesture and expression. As the bottom of the sea lies peaceful beneath a foaming surface, a great soul lies sedate beneath the strife of passions in Greek figures.' That soul, for Winckelmann, shone not only in the face of Laocoön 'with full lustre amidst the most violent sufferings', but also throughout the entire body. 'He pierces not heaven, like the Laocoön of Virgil; his mouth is rather opened to discharge an anxious overloaded groan; the struggling body and the supporting mind exert themselves with equal strength.' He continued: 'The more tranquillity reigns in a body, the fitter it is to draw the true character of the soul … Wound up to the highest pitch of passion, she may force herself upon the duller eye; but the true sphere of the action is simplicity and calmness.'

'Noble simplicity' and 'sedate grandeur' were at the heart of Winckelmann's interpretation of ancient art, an interpretation shared both by other writers and by observers in the second half of the eighteenth century, and by practising artists. These two

characteristics were central to Neoclassical art, most notably in painting, drawing and sculpture.

Perceptions of art were being changed not only by the theoretical and historical writings of such men as Winckelmann, but also by new archaeological finds, especially in the Bay of Naples. Discoveries from the excavations at Herculaneum and Pompeii made a journey south from Rome an essential part of the Grand Tour. As one tourist wrote ecstatically after a stay in Naples:

What a variety of attractions! A climate where heaven's breath smells sweet and wooingly; the most beautiful interchange of sea and land; wine, fruits, provisions, in their highest excellence; a vigorous and luxuriant nature, unparalleled in its productions and processses; all the wonders of volcanic power spent or in action; antiquities different from all antiquities on earth; a coast which was once the fairyland of poets, and the favourite retreat of great men.

Naples could satisfy whatever the inclinations and tastes of a tourist. As the third largest city in Europe in the eighteenth century, only exceeded by London and Paris, Naples was well endowed with all the necessary facilities. The commodious accommodation available is nicely portrayed in a genre scene in which a British aristocrat entertains friends, invited to hear the young Mozart perform (17). The city coped with all requirements; souvenirs, including volcanic fragments, could be bought, and guides hired to take tourists around the city, as well as up the arduous climb to the crater of Vesuvius. Just to wander round the streets, observing the colourful local lifestyle, provided much entertainment for any tourist or artist (18).

With luck one's accommodation in Naples embraced a view of Vesuvius, so that, as one traveller noted, 'I never go to bed without watching and bidding it adieu from my window.' The volcano has been dormant since 1944, so we are nowadays denied the excitement aroused whenever Vesuvius was active. If showing signs of erupting in the eighteenth century, which it often did, hundreds of tourists would leave Rome and flock to Naples to watch the spec-

tacle. Tourists, painters and scientists were all enthralled by Vesuvius (20), none more so in the eighteenth century than Sir William Hamilton (1730–1803), the British diplomatic representative at the Neapolitan court (19). A well-known collector of antiquities (22) and a major figure in the life of the city, Hamilton was also a scientist. He was particularly interested in geology, publishing between 1776 and 1779 an important study devoted mainly to Vesuvius, entitled *Campi Phlegraei. Observations on*

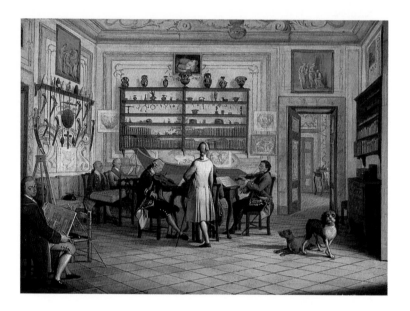

the Volcanoes of the Two Sicilies (the Latin name is that given, to this day, to the area west of Vesuvius). Beautifully illustrated with hand-coloured plates, these volumes provided a detailed, first-hand record of a series of eruptions of Vesuvius, including one of the greatest in the century in 1779. Hamilton's text is a typical product of the empirical, enquiring mind of the eighteenth century.

The most notorious of the eruptions of Vesuvius had taken place in 79 AD, totally engulfing the two prosperous towns of Herculaneum and Pompeii. They remained buried until the sites were rediscovered in the early eighteenth century, and systematically excavated from 1738 and 1748 respectively, although serious excavations at Pompeii did not get under way until 1763 (24). Gradually as the rich

Napolitani mangia Macaroni.

variety of artefacts was uncovered from the ruins, the contempo-
rary perception of the ancient world was transformed. The excava-
tions produced far more material evidence about the Roman way
of life than had ever been known before. The cumulative effect of
these archaeological finds (together with new discoveries around
Rome) was both to create a heightened awareness of classical
antiquity and to stimulate a classical revival in the arts.

The finds from Herculaneum were displayed in a museum near the
site, usually the first place visited by tourists after their arrival in
Naples. The impact was stunning, often giving visitors the feeling
that the ancients were better at absolutely everything than the
moderns, even eating. A Roman kitchen had been re-created,

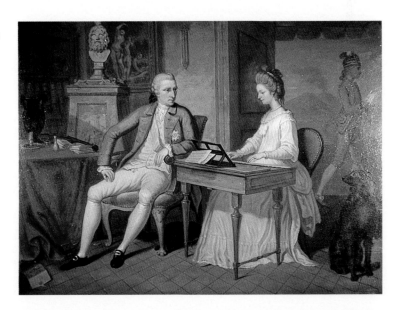

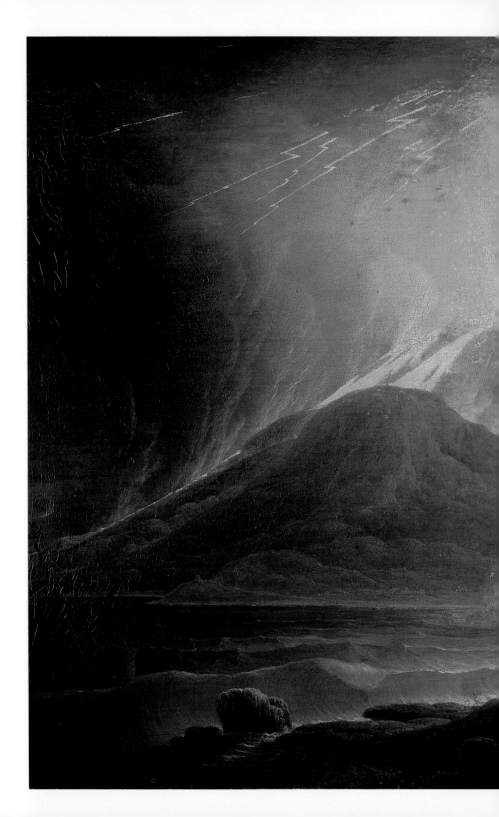

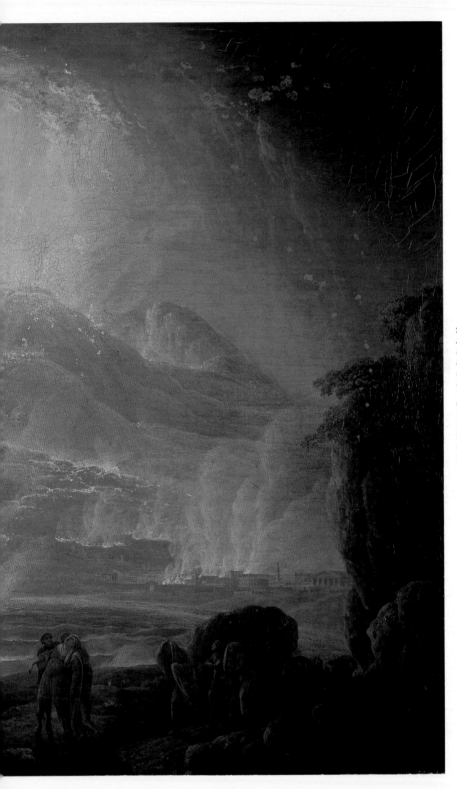

20
Jacob More,
*Mount Vesuvius
in Eruption: The
Last Days of
Pompeii*,
1780.
Oil on canvas;
151×201cm,
59½×79in.
National Gallery
of Scotland,
Edinburgh

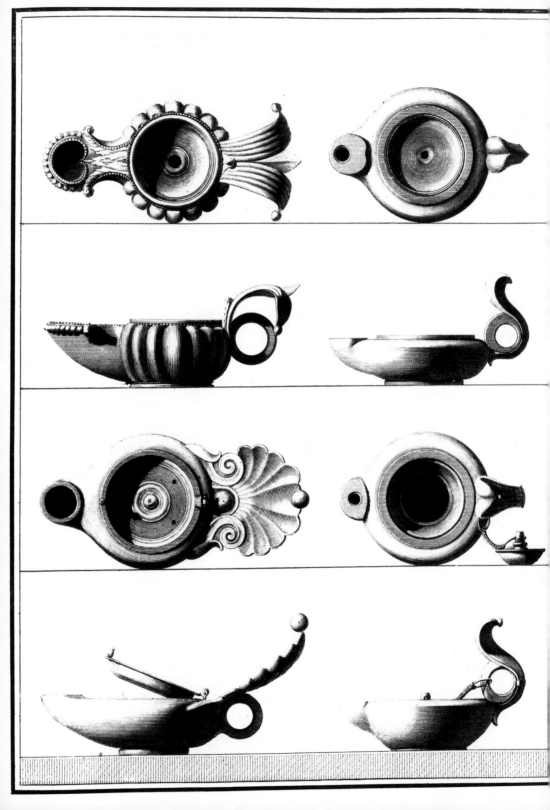

complete with all its utensils, leading one visitor to lament that 'it seems indisputable that the ancients employed more refinements in their entertainments than the moderns and must have served up a much greater variety of dishes than we do.' The exhibits ranged from equipment, utensils and furniture to bronze sculptures and figurines, and wall-paintings.

Because of the uniqueness of the sites, illustrated publications were forbidden, a ban which included sketching on the spot. The only engravings of the Herculaneum finds available in the mid-eighteenth century were those in the lavish folio volumes published under royal patronage by the Accademia Ercolanese from 1755 onwards (21). These were not put on sale, but were given away as diplomatic presents; some tourists would have

21
Plate from
*Antichità
d'Ercolano*,
vol. VIII,
showing a
group of lamps,
1792.
Engraving;
35·4 × 25 cm,
13⁷⁄₈ × 9⁷⁄₈ in

22
**Meidias
Painter**,
Attic Red-Figure
Hydria, showing
the 'Garden of
Hesperides',
c.410 BC.
Painted vase;
h.52 cm,
20¹⁄₂ in.
British Museum,
London.
Formerly Sir
William Hamilton
Collection

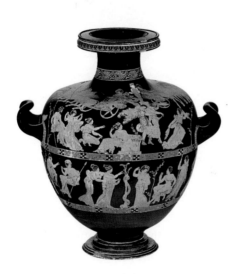

had access to them at home before leaving on their tour, but most would not have seen them. The impact of the museum contents near the Herculaneum site was therefore all the more intense. The restriction on drawing was supervised by guards, and – although surreptitious drawings were made – official exceptions were possible only if the artist had an influential patron or was working for the royal court. This latter reason allowed the German painter Philipp Hackert (1737–1807) to produce some of the rare eighteenth-century pictures of the site at Pompeii (24), as he had been officially appointed Painter to the King. As the century

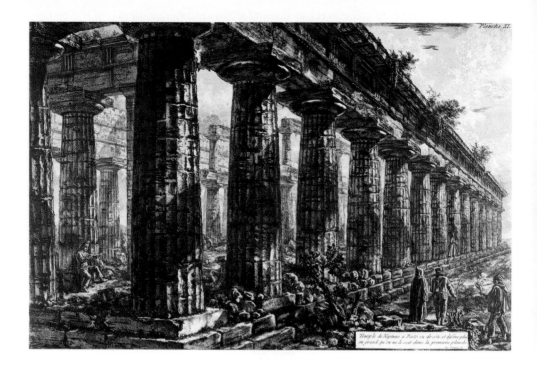

Temple de Neptune à Pesto, vu de coté, et distinctement en grand, qu'on ne le voit dans la premiere planche.

progressed, however, pirating of the official publications under-
mined the prohibitions, and the disruptions resulting from the
French invasion of Italy at the end of the century brought the
restrictions to an end.

Paestum, once an ancient Greek colony, with its three surviving
temples, was among the sites visited by the more enterprising
tourists based in Naples. Although the journey to the gulf of
Salerno was 'an exhausting one', as Vigée-Lebrun had been
forwarned, she and others found the visit rewarding, for the
temples are among the best-preserved examples of Greek archi-
tecture outside Greece itself. The largest temple (23), believed
wrongly in the eighteenth century to be dedicated to Neptune (or
Poseidon), was acknowledged to be 'one of the most magnificent
monuments of antiquity', as a French antiquarian put it. Thick vege-
tation and malarial swamps had prevented access to the site, until
cleared in the middle of the century. Visitors to Paestum were
struck by the grandeur and the isolation of the place, while not
necessarily liking the architecture. Eighteenth-century taste was

not yet receptive to the austerities of the Doric style, finding it 'inelegant' or, in the words of one budding Neoclassical architect, 'rude' (John Soane was subsequently to change his mind). Viscount Palmerston left a vivid record of visiting Paestum on his Grand Tour in 1764: approaching the ruins he was 'more struck with them than anything I ever saw except the first view of Rome'. He particularly enjoyed the absence of modern buildings, in contrast to their all too visible presence on other sites – where 'half an ugly Gothic church is tacked to half an old temple'. For Palmerston and fellow tourists of comparable sensibility, the forsaken and silent temples evoked the lost grandeur of a great civilization – a response that is an integral component of the pleasure of ruins.

Artists, and in particular architects, had an additonal reason for visiting Paestum. They had an opportunity to study at first-hand the earliest form of classical architecture. Paestum may have involved an uncomfortable journey, but to go on to Sicily or even Greece itself to see other examples would have been a great deal more inconvenient. As the author of the first book to publish accurate engravings of the Paestum temples explained to his readers, he wanted to show fully 'the state of Grecian architecture in its infancy, and from thence we may trace the steps of its progressive

23
Giovanni Battista Piranesi, *Paestum: Temple of Neptune*, 1778. Etching; 45·3×67·8cm, 17⁷⁸×26⁵⁸in

24
Georg Hackert, *Pompeii: View of the Gate and the Road Leading to it*, 1795. Etching and engraving after a painting by Philipp Hackert; 43·6×58·3cm, 17¹⁸×22⁷⁸in

improvements, to that elegance, grandeur and magnificence, which have been the admiration of the succeeding ages' (Thomas Major, 1768). In other words, for the mid-eighteenth-century generation, the Greek Doric was a step on the road to progress, not necessarily a stage to which one should return. The Greek Revival, a fully-fledged re-creation of such architecture, was several decades away yet.

The sight of more Greek temples rewarded tourists if they sailed from Naples to Palermo, the overland route being arduous, malaria-infested and bandit-ridden. Once in Sicily, the traveller had to contend with the plague and bandits he had avoided on the mainland, together with inadequate roads and accommodation, unless he was fortunate enough to have letters of introduction to a resident. Wealthy tourists sometimes took artists with them, so that they could return with their own, personally commissioned record, especially valuable for such places as Sicily, where few engravings had been published. As a wealthy young man at the age of seventeen, on the first of two visits to Italy, Richard Payne

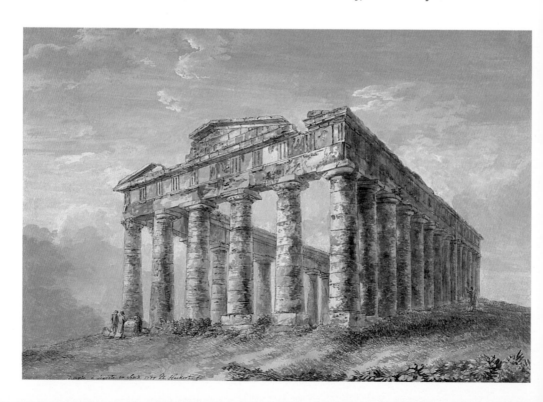

Knight (1751–1824) hired in Naples the services of the artist Philipp Hackert to accompany him to Sicily. A watercolour of the Doric temple at Segesta (25), standing isolated amidst the mountains, is one in the series that resulted from that trip. Knight later became an important collector of classical art and an influential writer, and we shall encounter him again at the time of the controversy over the British government's purchase of the Elgin Marbles.

Apart from Paestum and Sicily, the only other direct contact with Greek art that was possible on Italian soil was in a different medium altogether, namely ceramics. Greek vases, mainly of the fifth and fourth centuries BC (wrongly identified in the eighteenth century as 'Etruscan' because of their discovery in Etruscan tombs), were avidly collected. A few appear on the background shelves of the Neapolitan interior reproduced in figure 17. The most important collection of Greek vases, however, was that formed by Sir William Hamilton (22), and no stay in Naples was complete without a visit to view this.

Hamilton formed two collections, both of which were published. The first appeared between 1766 and 1767 in volumes with hand-coloured plates, a very handsome example of book production. Unfortunately Hamilton got into financial difficulties because of escalating publication costs, and he had to sell the collection. The still young British Museum, which had opened to the public in 1759, was to benefit by acquiring in one go a major addition to its antiquities. As so often happens when a collector empties his shelves or walls, Hamilton started to collect again. The second collection was published between 1791 and 1795, but this time more economically, with the plates no longer coloured (see 172). Hamilton was passionate about his vases, claiming in his preface to the later collection: 'There are no monuments of antiquity that should excite the attention of modern artists more than the slight drawings on the most excellent of these vases; they may from them form a just idea of the spirit of the ancient Greek artists.'

25
Philipp
Hackert,
*Temple of
Segesta*,
1777.
Watercolour
and gouache;
44·5×33·1cm,
17½ ×13in.
British Museum,
London

Hamilton's collections of vases were to profoundly influence the development of Neoclassical art, aided by one of Winckelmann's theories that has not so far been discussed in this chapter. He stressed the importance of contour or outline in sculpture, but his comments could also apply to the painted decoration on Greek vases, about which he says little. Here was a source of ancient art virtually unknown until the mid-eighteenth century, that astonished and delighted visitors to Hamilton's collection. In his *History*, Winckelmann enthusiastically praised the quality of the drawing on Greek vases, in which 'the figures might deservedly have a place in the drawing of Raphael' (high praise indeed, since Raphael was revered as the greatest artist of the Renaissance); but he did not expand his ideas on contour in that context. Winckelmann believed that modern artists could only learn precision of contour from the Greeks. It was contour that 'unites or circumscribes every component of the natural and ideal beauty of the figures of the Greeks'. Even when sculpted figures were covered with drapery, the Greek artist's chief aim, according to Winckelmann, was to make sure that the contour prevailed so that the beautiful physique – and he is not thinking exclusively of the male body here – stands out 'even through the marble', as if it were a transparent fabric. This linear interpretation of sculpture, combined with the more obvious linearity on Greek vases, was to underlie the stress on contour and line, as well as a markedly two-dimensional interpretation of nature, that characterize much Neoclassical art.

Among the many sites to be visited around the Bay of Naples, one had purely nostalgic connotations and was regarded as a place of pilgrimage. This was Virgil's Tomb. Of all the principal classical writers whose works were familiar to any eighteenth-century traveller, only Virgil had a tomb which could be visited as part of the Grand Tour. A plain, circular structure, sited just outside Naples to the west, had been accepted for centuries as Virgil's Tomb (26). Ancient literary sources are vague about the precise location of the poet's tomb, but by the eighteenth century it was firmly identified with this particular ancient Roman

26
Hubert Robert,
The Tomb of Virgil at Posillipo, near Naples, Plate in Abbé Richard de Saint-Non, *Voyage pittoresque ou description des royaumes de Naples et de Sicile*, volume 1, 1781–6. Engraving (after Robert's painting); 44·5×60cm, 17½×12¼in

monument, in spite of a few sceptics who thought otherwise. The construction of the long, adjacent tunnel (known as the Grotta di Posillipo), cut under the mountains by the Romans in order to create a main road, was even attributed to Virgil, since legend had endowed the poet with mathematical and engineering skills. The Grotta had also acquired the power of sanctuary, thanks to Virgil's supposed magical powers. Steeped in associations supposedly Virgilian, the tomb and Grotta were irresistible attractions (even in the Age of Reason, the average tourist was clearly gullible when it came to mythologizing).

Artists contributed to the myth-making process, and no illustrated publication on the Bay of Naples was complete without a picture of Virgil's Tomb. When the French painter Hubert Robert (1733–1808) contributed a view of the tomb to the lavish series of four hundred plates in the Abbé Richard de Saint-Non's *Picturesque Voyage or Description of the Kingdoms of Naples and Sicily* (*Voyage pittoresque ou description des royaumes de Naples et de Sicile*), he helped to perpetuate the myth like anyone else. He claimed to have drawn the scene 'from nature', but included a self-portrait in the act of reading an inscription pointed out to him by a guide. That inscription had supposedly

Vūe du Tombeau de Virgile, près de Naples.
dessiné d'après Nature par M. Robert peintre du Roy.

N° 15.

A. P. D. R.

been written by Virgil himself, recording that this was indeed his grave. It had disappeared long before Robert painted the scene, but so strong was the tradition that Robert mixed fact and fiction without scruple. Readers of the book were doubtless untroubled by such licence.

For the eighteenth century, as today, Virgil's famous epic of the *Aeneid* together with his pastoral poems were regarded as the greatest Latin poetry of ancient times. Artists found in his works many ideas for history paintings. Landscape gardens in the

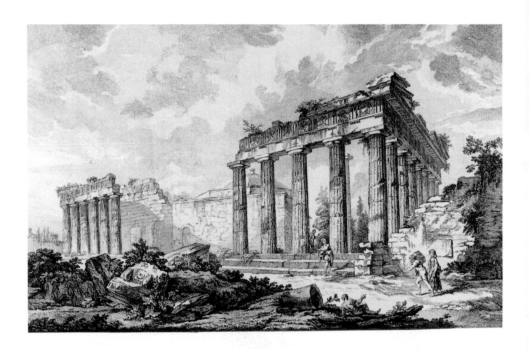

Neoclassical period might include the re-creation of Virgil's Tomb in a woodland glade, as at Wilhelmshohe just outside Kassel in Germany, where the tomb forms a counterpart to one in another glade dedicated to Homer. A knowledge of the *Aeneid* is important for the appreciation of the garden layout at Stourhead in Wiltshire (see Chapter 4). Virgil's deep love of the countryside evident throughout his pastoral poems, the *Eclogues* and the *Georgics*, combined with his vision of a Golden Age set in Italy, had a profound influence on the way the eighteenth century looked at nature, and above all at the landscape that had been so familiar to

the poet himself. The *Aeneid* in its concern with the greatness of ancient Rome and the deeds of its founder Aeneas, and in its debt to the influence of Homer's *Iliad* and *Odyssey*, was at the heart of the classical Roman tradition. Eighteenth-century readers found its breadth of timeless, human experience relevant to their own day, and the popularity of Virgil's so-called tomb with the traveller on the Grand Tour is hardly surprising.

Unlike Italy, the classical world further afield remained inaccessible to most eighteenth- and early nineteenth-century travellers. They read about it and saw engravings of its antiquities, but most did not visit Greece itself and the Near East. These regions were not geared to a tourist industry: facilities for travel and accommodation were poor, social life of the kind enjoyed in Italy was non-existent, detailed guidebooks had not been published, and since Greece was under Turkish control special permissions were needed for moving around. Thus only the most highly motivated of tourists undertook Greek and Near Eastern journeys.

A systematic study of the ancient architecture of Greece was not begun until the mid-eighteenth century, by expeditions from London and Paris. Before then, published accounts were not sufficiently detailed, and the few engravings were crude and inaccurate. This early material had little impact on the European appreciation of Greek art, which continued to be evaluated through the intermediary of Roman copies. That misconception was gradually to change. The initiative was taken by the British architects James Stuart (1713–88) and Nicholas Revett (1720–1804) when they set out for Greece in 1751, funded by the Society of Dilettanti. The Society had been founded nearly twenty years previously, in 1732, as a London dining club for gentlemen who had been on the Grand Tour. Although primarily a social gathering, members channelled their interests into the patronage of music and archaeology. Their sponsorship of Greek expeditions was to be of major importance.

The work of Stuart and Revett entailed a two-year stay in Athens, followed by visits to Salonica, Smyrna and the Aegean

27
Julien-David Le Roy,
Plate from *Ruines des plus beaux monuments de la Grèce*, showing the Parthenon, Athens, 1758.
Engraving; 28·3 × 44·8 cm, 11 1/8 × 17 5/8 in

28
James Stuart and Nicholas Revett,
Plate from *Antiquities of Athens*, showing a measured drawing of the Choragic Monument of Lysicrates, 1762.
Engraving; 45·5 × 28·5 cm, 17 7/8 × 11 1/4 in

islands, returning home in 1755. The publication of their findings as *The Antiquities of Athens* began in 1762, but in the meantime their French rival, Julien-David Le Roy, who went out to Greece later than Stuart and Revett, had published his *Ruins of the Most Beautiful Monuments of Greece* (*Ruines des plus beaux monuments de la Grèce*) in 1758. These British and French publications covered most of the important sites, illustrated not only with picturesque landscape views, but also – for the first time – carefully measured and meticulously drawn plans, elevations and details (27 and 28).

29
Robert Wood,
Plate from
the *Ruins of
Palmyra*,
1753.
Engraving;
36·5×23·2 cm,
14³⁄₈ × 9¹⁄₈ in

These publications fuelled a crucial antiquarian debate in the eighteenth century: the Greek versus Roman controversy. This was no mere pedantic squabble – it involved major differences in the evaluation of two great ancient civilizations and their relative influences on eighteenth-century culture. Stuart and Revett in their first volume demote Rome: 'Greece was the great mistress of the arts, and Rome, in this respect, no more than her disciple.' Rome, they argued, 'never produced many extraordinary artists of her own', pointing out that 'when the Roman authors themselves celebrate any exquisite production of art, it is the work of Phidias', along with the contributions of other artists in the great period of Greek creativity in the fifth and fourth centuries BC. Stuart and

Revett's project was aimed not only at 'lovers of antiquity' but also at practising artists, who could now 'draw their examples from the fountain-head'. On their return home, however, Stuart and Revett were given few opportunities to put their Greek experiences into actual practice in the form of architectural commissions executed in a Greek style. The challenge to the pro-Greek faction by those who favoured ancient Rome, taken up by Giovanni Battista Piranesi (1720–78) and others, will be discussed in the next chapter.

One of Piranesi's friends who belonged to the pro-Roman camp was Robert Adam. He was to fall under the spell of Palmyra in Syria and Baalbek in Lebanon, which, like his contemporaries, he knew only through engravings. These remote ruins were visited by few tourists, and the first accurate descriptions of them, accompanied by detailed engravings, were not published until Robert Wood (1717–71) brought out his books in 1753 and 1757 (29). The plates were to influence profoundly some of the first generation of Neoclassical architects and designers, because here was evidence of richly carved ornament of great beauty from the Roman Empire, of a kind which they admired and could use.

The Grand Tour in reality or imagination went no further than Palmyra and Baalbek. In the imaginative world, the most interesting publication was a fictionalized account of a traveller in ancient Greece in its heyday, in the fourth century BC. It became a European best-seller at the end of the eighteenth century, contributing to the continuing interest in the ancient world into the early nineteenth. *The Travels of Anacharsis the Younger in Greece (Le Voyage du jeune Anacharsis en Grèce)* by the French abbé and archaeologist Jean-Jacques Barthélémy (1716–95) is a lively re-creation of the ancient Greek way of life which appeared in Paris in 1787 and was soon translated into the main European languages.

The young traveller, up at dawn in Athens, sees 'the inhabitants of the country enter the city with their provisions, singing ancient ballads. At the same hour, the shops open with no little noise,

and all the Athenians are in motion.' The reader accompanies Anacharsis when he dines out with friends, and observes farmers in the vineyards and athletes in the gymnasium. Music, food, books, clothing, all are conjured up as if from first-hand observation. He meets Plato and Aristotle; the mathematician Euclid takes him round his library; he watches the sculptor Praxiteles erect a statue. The many footnotes attest to the abbé's thorough scholarship, condensed from myriad antiquarian publications into an enjoyable work of fiction. On one occasion, Anarcharsis visits Plato's academy (or 'lyceum'), located near Athens in 'a garden surrounded by walls, adorned with delightful covered walks, and embellished by waters which flow under the shade of the plane and various other kinds of trees':

At the entrance is the altar of Love, and the statue of that god; and within, the altars of several other deities. Not far from hence Plato has fixed his residence, near a small temple, which he has dedicated to the Muses, and on a piece of ground belonging to himself. He comes every day to the academy, where we found him in the midst of his disciples, and I instantly felt myself inspired with that respect which everyone must feel in his presence. Though about sixty-eight years old, he still retained a fresh and animated complexion. Nature had bestowed on him a robust body … He received me with much simplicity and politeness.

The artist Elisabeth-Louise Vigée-Lebrun found *The Travels of Anacharsis* so appealing that in her Paris home she re-created for her friends a Greek dinner described in the book. She instructed her cook to prepare a meal according to recipes in the book, she borrowed ancient Greek vases from a neighbour, and she and all her friends dressed in ancient Greek costume. One of Vigée-Lebrun's friends played a guitar which had been transformed for the occasion into a golden lyre, accompanying everyone as they sang a chorus from one of the classically inspired operas by the contemporary composer Gluck. On her subsequent travels around Europe, Vigée-Lebrun found that the fame of her dinner had preceded her.

Like all travellers, tourists returned with souvenirs. Rome was

usually where they had their portraits painted. Artists who were themselves travelling on the Grand Tour often earned money by acting as guides, dealers or portraitists, but some of the best of the Grand Tour portraits were executed by resident Italians, most notably Pompeo Batoni (1708–87). From the 1750s to 1780s a stream of Europe's aristocacy and gentry passed through his studio, taking home with them – mostly to Britain – a fine memento of their Grand Tour. Batoni painted many bust-lengths to suit the more economical purses of his sitters, but he came into his own with his full-lengths. For these he evolved a standard

composition, showing his client standing in a nonchalant pose, with legs elegantly crossed and one arm leaning against some piece of antique sculpture. In the background there are usually one or two more sculptures, perhaps even a Roman ruin. Batoni's painting of the Duke of Hamilton at the age of nineteen is a typical example (30). Hamilton was on his Grand Tour with John Moore as his tutor, and the tour, which lasted just over four years, was nearing its end. After arriving in Rome, Hamilton wasted little time before sitting to Batoni, arranging to pay him not all at once

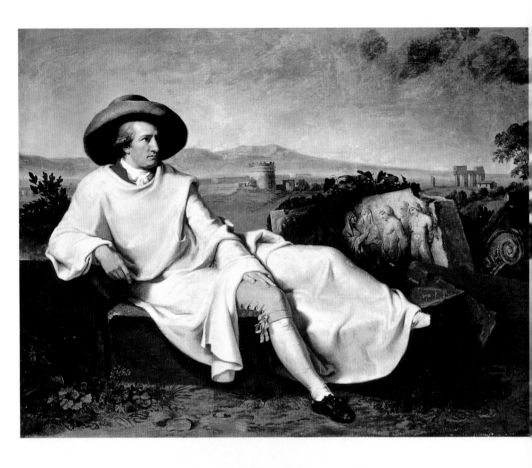

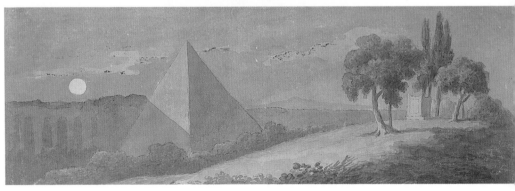

'but as he proceeds, and therefore there is reason to believe he will not delay so very much as is his custom'. This canny tactic seems to have worked, since the portrait was ready within six months. Moore had seen to it that his young pupil viewed the works of antiquity thoroughly, and this classical awareness is well represented in the portrait. The duke is leaning against a pedestal supporting a statue of a seated *Roma*. The carved relief of a weeping woman symbolizes one of the Roman provinces, was much admired in the eighteenth century, and copied in a variety of materials including Wedgwood's ceramic reliefs. In the background is one of the most frequently visited sites near Rome, the Temple of the Sibyl at Tivoli. Hamilton also commissioned while in Rome, from the British artist Gavin Hamilton (1723–98), a large Neoclassical canvas inspired by Homer's *Iliad*, illustrating the scene when Hector bids farewell to his wife Andromache, before going off to fight and meet his heroic end (see Chapter 3).

The portrait of the Duke of Hamilton epitomizes the balance between pleasurable relaxation and intellectual stimulus that was so essential to the Grand Tour, brilliantly captured by one of the great portraitists working in the Neoclassical period. Batoni died two years before the outbreak of the French Revolution, so he did not live to see the disruption caused to the Grand Tour, resulting from war and the invasion of Italy by the French. The tourists left, returning in large numbers only after the cessation of the Napoleonic War.

Among the foreign artists who had to flee from Italy was the German painter Johann Heinrich Wilhelm Tischbein (1751–1829), who left Naples in 1799 when it fell to the French. The most famous tourist from his native Germany visiting Italy during his stay was Goethe (1786–8), whose European reputation had already been established by his romantic, tragic novel *Sorrows of Young Werther*. Tischbein introduced him to fellow Germans in Rome and acted as the writer's companion and guide. Goethe's journal makes frequent references to their joint activities, but also shows that he wanted to keep a low profile, adopting countless ruses to

31
Johann Heinrich Wilhelm Tischbein, *Goethe in the Roman Campagna*, 1786–7. Oil on canvas; 174×206 cm, 68 1/2 ×81 1/8 in. Städelsches Kunstinstitut, Frankfurt am Main

32
Johann Wolfgang von Goethe, *Pyramid of Caius Cestius, Rome*, 1788. Pen and ink and wash; 13·5×38 cm, 5 1/4 ×14 7/8 in. Goethe-Nationalmuseum, Weimar

33 Overleaf
Hans Ditlev Christian Martens, *Thorvaldsen's Studio in Rome (with Pope Leo XII Visiting in 1826)*, 1830. Oil on canvas; 100×138 cm, 39 3/8 ×54 3/8 in. Statens Museum for Kunst, Copenhagen. On loan to Thorvaldsens Museum

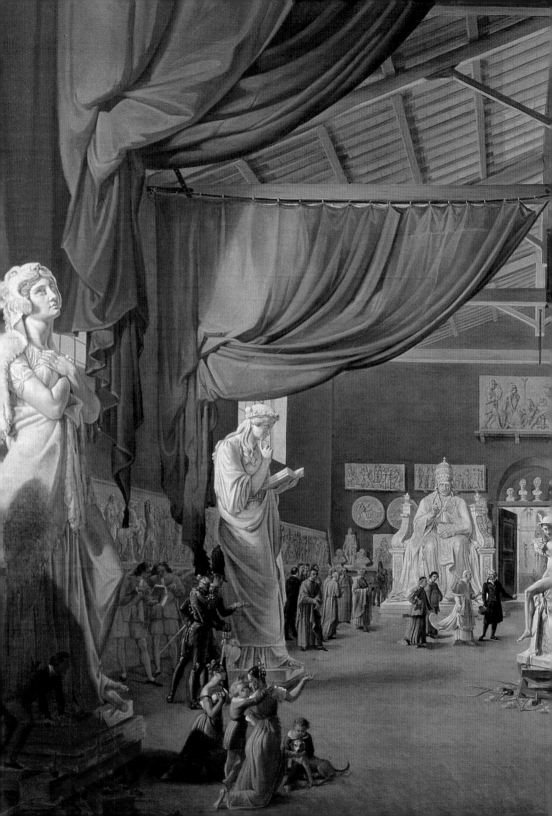

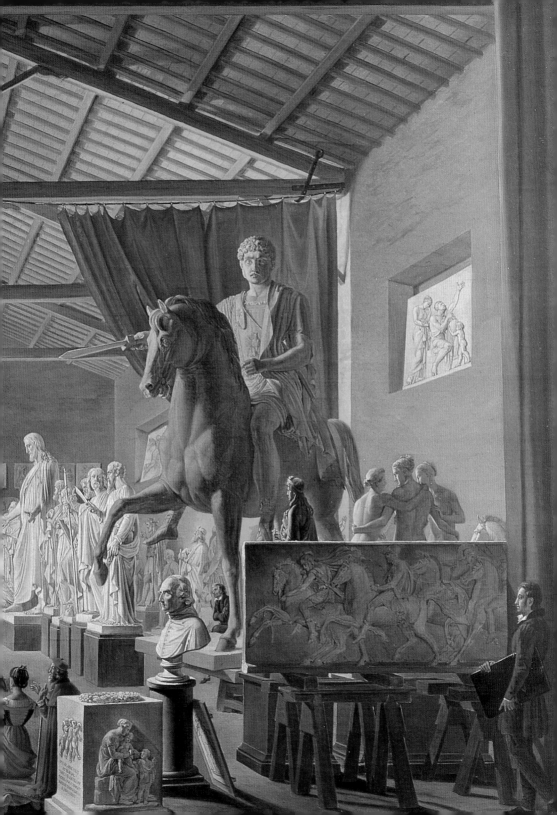

avoid social invitations. He preferred to spend his time sightseeing, writing and drawing (32).

Tischbein originated the idea for the portrait that was to become one of the most famous of all Grand Tour images, *Goethe in the Roman Campagna* (31). The writer had noticed that the painter was often 'attentively regarding me', and when Tischbein suggested the portrait it was clear that he had already decided how Goethe was to be posed. He would be shown wearing a white cloak, seated on a fallen obelisk, against a background of the landscape to the south of Rome filled with antique remains, the Roman Campagna. The artist alludes to Goethe's fascination with the historical past by including references to the three ancient civilizations in which Goethe and his contemporaries were so absorbed – Egypt, Greece and Rome.

The first is represented by the broken obelisk, a monumental form adopted by the Romans from Egypt. While in Rome Goethe had been enthralled by the traces of Egyptian civilization there: 'I have taken up Egyptian things again', he wrote, and it is perhaps partly because of its Egyptian origins that he included the Pyramid of Caius Cestius, one of Rome's most famous ancient monuments, among his Italian drawings. Greece is represented by the fragment of a relief, carved in a style which would have been loosely identified as 'Greek'. Its subject matter is also Greek, and relates directly to Goethe's own writing at the time. The scene is from the story of Iphigenia: she has become a priestess of the goddess Artemis on Aulis, and is suddenly confronted by her brother and his friend, who have come to steal the goddess's image. As strangers they must be sacrificed, having already been taken prisoner, but Iphigenia arranges their escape. The story had fascinated Goethe for many years, and he finally completed his own version of *Iphigenia* while in Rome. The third civilization in the portrait, Rome itself, is represented by the capital, but above all by the background which is dominated by the imposing circular Tomb of Caecilia Metella. Tischbein thus epitomized the ideas and interests of one of the greatest writers in Europe at a particular stage in his

development, when classical antiquity meant so much to him.

Acquisitions of contemporary art while on the Grand Tour were usually commissioned portraits, and occasionally also landscapes, subject-paintings (such as Hamilton's *Iliad* piece just mentioned) and modern sculpture. Because of the many potential clients thronging Italy, especially Rome, artists often displayed some of their work permanently in their studios for visitors to view. The greatest Italian Neoclassical sculptor, Antonio Canova (1757–1822), kept such a studio, as did some of the foreigners. One of the most ambitious and successful of these foreign studios

was that maintained in Rome by the Danish sculptor, Bertel Thorvaldsen (1768/70–1844), who remained in the city for forty years. A painting of his studio records a visit by the pope in 1826 (33), and gives a good indication of the variety of work that might be on display at any one time. In this case, one can see classically inspired figures and reliefs, portrait busts, and tombs and religious figures for churches.

Other purchases made on the Grand Tour included Old Master paintings, prints, classical statuary and gems, in the form of cameos, many of which were copies, as well as being available as plaster casts. These gems were among the most easily transportable souvenirs, for display in cabinets or mounted as jewellery. A carved cameo, for example, after the famous statue of *Hercules*, which was in the Farnese palace in Rome until moved to Naples in the 1780s, was mounted as a gentleman's ring in the late eighteenth century (34), a typical re-use of such small-scale pieces.

Equally transportable and easily affordable were prints, and in

this field one artist towered over all others in Rome, the great
Piranesi. As one contemporary notes of Piranesi's prints: 'They are
esteemed the best here, and we have made an ample collection of
the most valuable of them.' In a range of etchings that go beyond
mere topography, Piranesi captured imaginatively the grandeur of
the past. The glorious architectural achievements of a Roman
Empire long since fallen into decay, half buried and overgrown,
were presented by Piranesi with a unique boldness (35). Some of
his etchings provided a far more extensive coverage of ancient
Roman buildings than had ever been published before, based on
his detailed knowledge of the sites. Not satisfied with just one
view, he etched several of both the exterior and interior, as well as
cross-sections, plans, and even diagrammatic analyses of contruc-
tion (36) . Such etchings provided valuable information for archi-
tects and archaeologists, and complemented his more obviously
picturesque views, which satisfied most tourists' desire for
souvenirs. Prints could be bought either individually or as
complete volumes. Piranesi's *œuvre* encompassed both ancient
and modern subjects, and amounted to over a thousand prints. His
impact on the contemporary vision of Italy, especially its ancient
classical past, was so considerable that for some tourists it was

the cause of disappointment, since the sites themselves did not always seem to match up to the grandeur of Piranesi's vision.

In addition to being a printmaker, Piranesi was also an archaeologist, dealer, architect, designer and writer. Some of his etchings show classical items that had passed through his hands; in some cases not only had these been heavily restored, they had also been imaginatively re-created with considerable artistic licence. This is especially true of the tall marble candelabra he sold – one pair was bought by a British connoisseur for presentation to the University of Oxford, where it still is (38). The ornateness of the design and intricate detailing of such pieces were much admired at the time, and inspired other designers to copy them. But usually only a few parts were original, fragments excavated from such sites as

Veduta di una parte de' fondamenti del Teatro di Marcello

Hadrian's Villa, which were then combined with new pieces fashioned to Piranesi's own design.

This kind of imaginative restoration was not untypical of the eighteenth century. Contemporary taste would not accept broken sculptural fragments in their own right, as we do today. If the limbs or head were missing from a marble, then they had to be supplied. Present-day museum displays have largely removed these additions, but in eighteenth-century Rome, restorers' studios were kept busy, because, as one dealer put it, collectors 'have no value for statues without heads' and would not even pay a guinea 'for the finest torso ever discovered'.

In the sculpture gallery at Newby Hall (37), the *Venus* in the left-hand niche is the most notorious example of such restoration, going even further than usual. While on his Grand Tour, the gentleman landowner William Weddell put together a large collection of marbles for his country house, including a very expensive version of the *Medici Venus* bought in 1765. He was unaware that the body had been found on one site and the head elsewhere, and that the head had been recarved to remove its original veil. This newly concocted *Venus* was created in the studio of Rome's leading restorer, Bartolomeo Cavaceppi (39), who thus had on his hands a much more marketable product than the original incomplete parts. However, Weddell was delighted with his new acquisitions, and commissioned Robert Adam to extend his country house to include a new sculpture gallery. Adam also designed the pedestals and laid out the collection, which is still intact today, a rare surviving example of Neoclassical Grand Tour taste.

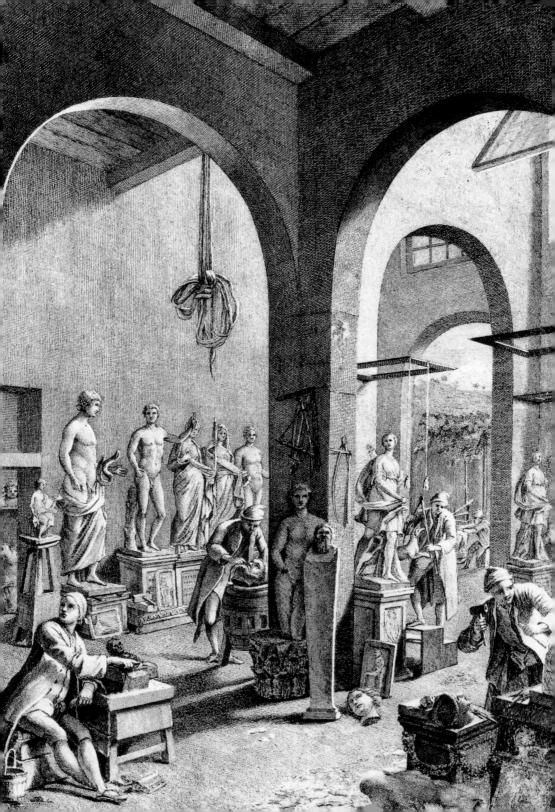

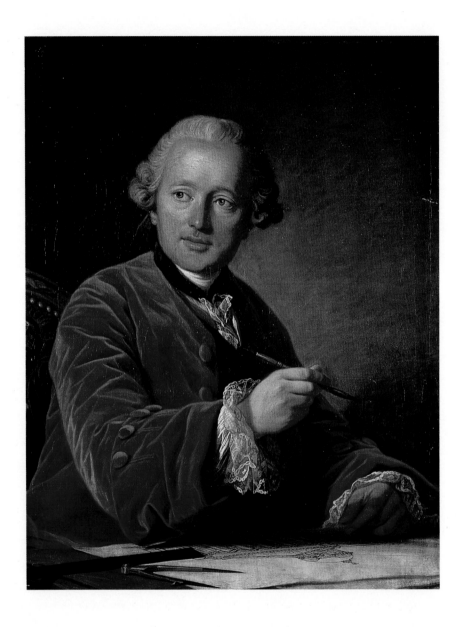

At the time of the French Revolution the major Neoclassical church in Paris, dedicated to the city's patron saint, Ste Geneviève, was deconsecrated and renamed the Panthéon (as it is still known). This building is among the earliest manifestations of Neoclassical architecture in France, and as that country played such an important role in the dissemination of the style, Paris is an appropriate place to begin a discussion of Neoclassical architecture. The church of Sainte-Geneviève was conceived by Jacques-Germain Soufflot (1713–80), who worked on it from 1757 until his death, frequently amending his designs. So central was the church to his career that when he sat for his portrait he was shown working on the front elevation of Sainte-Geneviève (40). Soufflot was a talented and imaginative architect, but he was also fortunate in his personal contacts, without whom he might not have been given this major commission.

Soufflot went on the Grand Tour to Italy for a second time in 1750, having already been there at the age of eighteen when he had been accepted at the French Academy in Rome, returning in 1738 to become municipal architect in Lyons. His second visit was as tutor in architecture to the future Marquis de Marigny, the young brother of Madame de Pompadour, who was already the king's mistress, and intended her brother should take charge of royal building projects (as Surintendant des Bâtiments du Roi). His overall control was going to enable him to appoint Soufflot controller of building in Paris. Soufflot enjoyed the active social life of the capital, including regular attendance at the fashionable salon hosted by Madame de Pompadour's friend Madame Geoffrin. Here Soufflot met many leading contemporary painters, sculptors, architects and antiquarians. His position in Parisian society, together with Marigny's patronage, smoothed the path to the Sainte-Geneviève commission.

40
Louis-Michel van Loo,
Portrait of Jacques-Germain Soufflot,
1767.
Oil on canvas;
77×60 cm,
30³⁄₈×23⁵⁄₈ in.
Musée du Louvre, Paris

41 Overleaf
Pierre-Antoine de Machy,
Laying the Foundation Stone of Sainte-Geneviève,
1765.
Oil on canvas;
81×129 cm,
31³⁄₈×50⁷⁄₈ in.
Musée Carnavalet, Paris

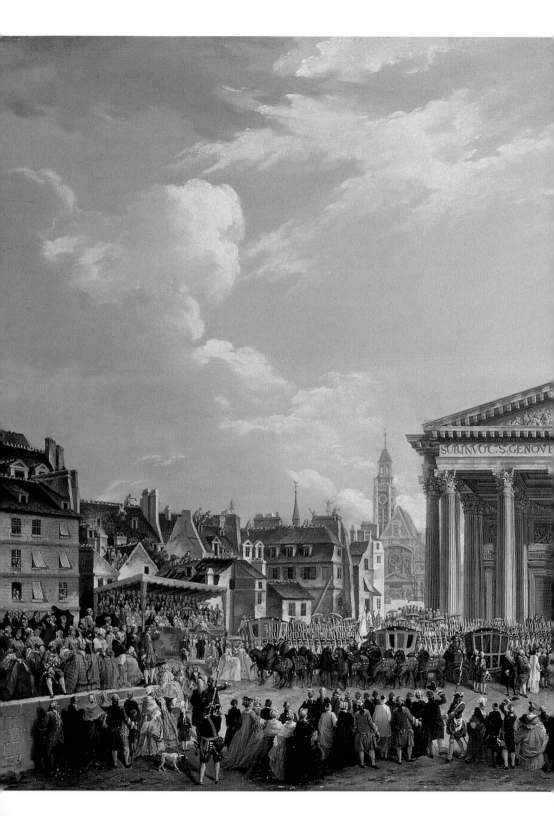

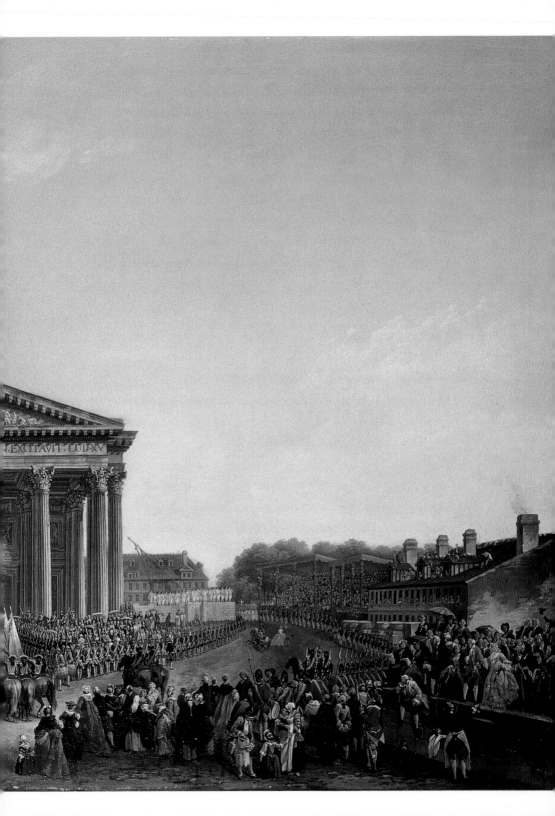

Louis XV was keen to replace the old medieval church by a more imposing building worthy of comparison with famous cathedrals in Rome and London. The new church was to be one of the grandest of the king's architectural projects; the idea for it had originated in the reign of Louis XIV and been revived earlier in Louis XV's own reign in 1744 as a form of thanksgiving. In that year he had been taken seriously ill at Metz, in northeast France, when he had gone to the battlefront during the War of Austrian Succession. Believing he was going to die, the 34-year-old Louis had publicly confessed his profligate life and dismissed his current mistress. Now, twenty years later, the church of Sainte-Geneviève was at last going to be rebuilt – the delayed thanksgiving was to be a monument to the king's reign and a major addition to the increasingly modernized cityscape of Paris.

The foundation stone was laid in 1764 by Louis XV himself (41). For this occasion Soufflot had the inspired idea of employing artists to execute a vast canvas of the intended portico, which was erected like a piece of stage scenery on the site. Low walls of plaster indicated the plan of the church and the layout of the proposed square. In addition, through the main doorway on the canvas the illusionism portrayed the length and height of the nave. In the interior (42), Soufflot was to be particularly original: on first entering the space seems uncompromisingly classical, more like a temple than a church; but closer observation reveals the incorporation of ideas from medieval architecture, a source that Soufflot was increasingly to appreciate. The antique and the Gothic are fused uniquely into one.

42
Jacques-
Germain
Soufflot,
Interior of
Sainte-
Geneviève,
Paris, 1764–90

Behind this unexpected fusion lay current architectural theories. In 1753, only a few years before Soufflot started work on the church, one of the most influential books for the future development of Neoclassical architecture had been published. *An Essay on Architecture* (*Essai sur l'architecture*) was written not by a practising architect but by a Jesuit priest, Abbé Marc-Antoine Laugier (1713–69). Some of his ideas can be found in earlier eighteenth-century treatises on architecture, but Laugier's

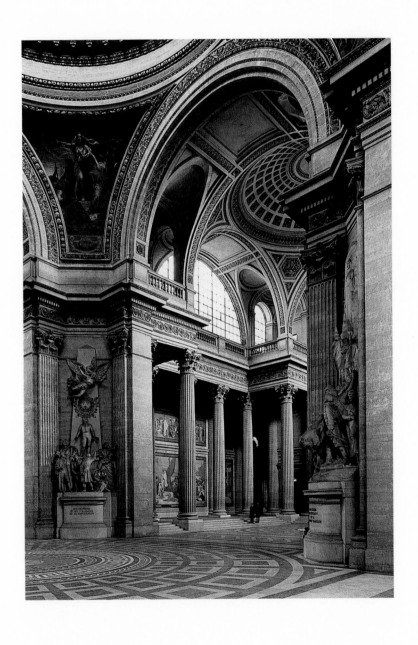

contribution was to turn this material into a coherent argument, dominated by two of the leading concepts of the eighteenth century, reason and nature. In the spirit of the Age of Enlightenment, Laugier's book goes back to fundamentals, in this case the origins of architecture.

Laugier's main argument is brilliantly summarized in visual terms in the frontispiece to the second edition (43). Seated on a pile of broken classical capitals and columns, an allegorical figure of the Genius of Architecture points to a rustic cabin consisting of four still-living trees which support the cut branches of the roof. As a structure it is primitive, elemental and natural. The ancient Roman writer on architecture, Vitruvius (fl. 46–30 BC), whose treatise was widely read from the Renaissance onwards, had argued that the rustic hut had been one step in the evolution of architecture. Laugier, however, advanced a case for the relevance of the hut in a modern context. It is clear from the gestures of the figures in Laugier's frontispiece that the hut is not there just to be observed, but to be inspirational as well.

Central to Enlightenment thought was the conviction that through rational enquiry a knowledge of basic laws and principles was attainable and doctrines could be formulated afresh, in politics, religion, art or any other sphere of human thought. In the process, a quest for the primitive, in the widest sense of the word, became an important element. The primitive could embrace, among many things, the simple, natural life of a golden age as envisaged by Rousseau; an appreciation of hitherto neglected early Italian art pre-dating Raphael; or a re-evaluation of the earliest form of architecture then known, the Greek Doric, or even further back in time to the supposed rustic hut. In the hut, Laugier admired the simplicity of a structure which formed the basis of the future development of architecture:

The pieces of wood raised perpendicularly have given us the idea of columns. The horizontal pieces which surmount them have given us ideas of lintels. Finally, the sloping pieces which form the roof, have given us the idea

43
Abbé Marc-
Antoine
Laugier,
Frontispiece to
second edition
of his *Essai sur
l'architecture*,
1755.
Engraving;
15·5×9·5 cm,
6¹⁄₈×3³⁄₄ in

of pediments. That has been recognized by all the masters of art. But one should be on one's guard. Never has an idea been more fertile in its consequences.

One must distinguish, he argued, between a style of architecture in which the elements are essential and one in which the component parts only fulfil some whim. If necessity and not whim is to be an architect's guiding principle, then he should 'never lose sight of our little rustic hut'.

That model of inspiration was devoid of superfluous decoration, and was composed of clearly defined verticals and horizontals. For Laugier, that clarity and purity of form was exemplified not only in early classical architecture but also in the spacious interior of a Gothic cathedral. This he describes at length in his *Essay*, combining in an ideal church this particular merit of Gothic architecture with a classical order in the actual structure.

This is precisely what one sees inside Sainte-Geneviève. As a contemporary architect observed, the interior combined 'the lightness of construction of Gothic buildings with the purity and magnificence of Greek architecture' (using 'Greek' in the frequently loose eighteenth-century sense of 'classical'). In this case purity is achieved by freestanding columns and a clearly defined straight entablature – the posts and lintels of Laugier's hut. Soufflot's Sainte-Geneviève, dedicated to Christianity, was designed as part cathedral and part pagan temple – it was soon nicknamed the 'Temple of Sainte-Geneviève'. Such an apparent contradiction did not worry contemporaries, and the future trend within Neoclassicism was for churches to become increasingly classical in inspiration. Pagan temples once again served a new religion as they had done in the later, Christianized years of the Roman Empire. Soufflot's church was an important stage in this trend in the second half of the eighteenth century and the early part of the nineteenth. His own church did in fact become a temple, but Soufflot died before the deconsecration.

Among Louis XV's other architectural ventures, two at Versailles are particularly notable. The château was so vast that even its creator as we now know it, Louis XIV, erected a few miles away a smaller, more intimate place where he could retreat from time to time. Louis XV chose a site within the park itself for the erection of a small house to which his mistress could quietly, and conveniently, withdraw from courtly pomp. The king's official architect designed the Petit Trianon (45) in a pleasantly secluded part of the grounds that had been developed as a fine botanical garden.

The architect of the house, Ange-Jacques Gabriel (1698–1782), executed a great deal of work for the king. He had already designed the Place Louis XV in Paris (subsequently renamed the Place de la Concorde during the Revolution, the name by which it is still known), and he was later responsible for a splendid new opera house at Versailles. Gabriel was very much a court architect, on sufficiently intimate relations with the king for them to work jointly on a project, and he was the natural choice of architect for Madame de Pompadour's house at Versailles. She persuaded Louis XV to build the Petit Trianon for her late in their relationship, in the early 1760s, by which time they were no longer physically intimate, but the house was not completed until 1764, the year she died. It was therefore her successor as mistress, Madame du Barry, who had the use of the Petit Trianon, and after her Louis XVI's wife, Marie Antoinette, followed later by Napoleon's second wife, Marie-Louise.

The Petit Trianon avoids any suggestion of the pomp and monumentality of the main château, while echoing some of its formality. For a royal commission the façade is surprisingly austere, but this may reflect the restraint of Madame de Pompadour's own taste and that of the court at the time. Ornamentation is minimal, restricted to such details as window decoration (44). Gabriel relied on careful proportions, a clear articulation of each part, and a sequence of façades that are lively and different from each other. Elegance without frivolity, perfection without dullness: the Petit Trianon is a masterly achievement.

Gabriel also excelled with his opera house at Versailles. 'I had never known what expense could do when pushed to the utmost had I not seen the King of France's theatre', exclaimed an ecstatic foreign visitor, sharing the contemporary admiration of the opulent interior. In a building constructed for private performances before the king and court, no expense had been spared on the richness of the decoration and the latest technology in stage scenery. Gabriel's large budget for the theatre meant that he could excel on decorative details, rich carving, gilding and mirrors. Versailles had lacked adequate provision for the performance of operas and plays. About a thousand aristocrats resided in the town and in the château itself, and some form of entertainment at the court was highly desirable, even necessary. Paris was at least an hour and a half away by fast carriage. The situation was remedied by the building of Gabriel's opera house, one of the greatest theatres in Europe.

The opera house was finished in 1770 in time to be inaugurated with a series of lavish entertainments celebrating the marriage of the Dauphin (the future Louis XVI) to Marie Antoinette of Austria. The original design for the last part of these celebrations, reproduced here (46), shows on the left the stage transformed for the Bal Paré, and on the right the auditorium with its circle of boxes, and the entrance foyer. The temporary structure of columns and balustrade was painted gold and silver, with hangings of blue and silver brocade. Cupids and other sculptural and painted allegories of love were everywhere, executed by a team of craftsmen to exacting standards worthy of a permanent décor. From the time Louis XV decided on the building of a new opera house to its inauguration only twenty-two months had elapsed, and the result was a triumphant success.

Buildings for the sole purpose of pleasure, theatrical or otherwise, proliferated across Paris in the later eighteenth century. They were more abundant than in any other European capital. Masked balls, firework displays, orchestral concerts, magic lantern shows, balloon ascents, swings, see-saws, conjurors, acrobats: the variety

44–45
**Ange-Jacques
Gabriel**,
Petit Trianon,
Versailles,
1761–8
Above
Fanlight
Below
View of garden
façade

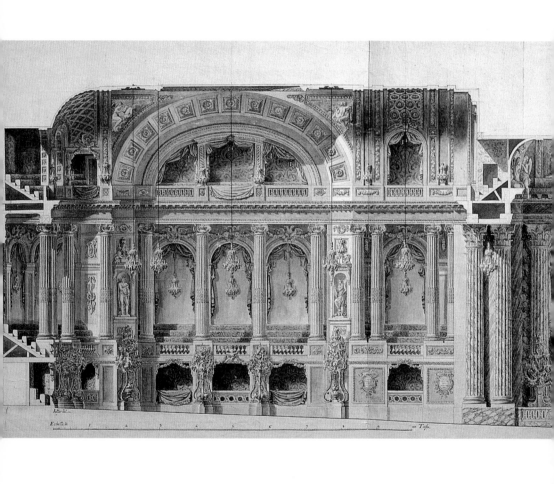

46
**Claude-Jean-Baptiste Jalliers
de Savault**, *Interior of the
Opera House, Versailles, as
Prepared for the Bal Paré
in 1770 Celebrating the
Marriage of the Dauphin and
Marie Antoinette.*
Pen and ink and watercolour;
49×134·6cm, 19³⁄₈×53in.
Bibliothèque Municipale,
Besançon

of daily amusements was limitless. They took place in surroundings designed in Chinese, Turkish, or classical styles, in large spaces that could cope with a mixture of theatre, circus and fairground. The eighteenth century saw the birth of today's amusement parks and similar places of public entertainment.

Many of the Parisian places catering for such mixed forms of entertainment were known as 'Wauxhalls', a French variant of the name of the famous equivalent in London, the Vauxhall Gardens. Some of the Parisian names were classical, such as the Garden of Apollo (Jardin d'Apollon), Elysium (L'Elysée) and the most celebrated of them all, the Colosseum (Colisée). The last of these opened in 1771, occupying a large site near the Champs Elysées. The focal point of the building was a large rotunda (47), surrounded by classical, fluted columns supporting a glass dome, constructed on a lavish scale to cope with the crowds that came to dance, to listen to the orchestras and above all to be seen. The Parisians, as foreigners often noted, loved being on display. Off the rotunda opened a succession of indoor rooms and outdoor

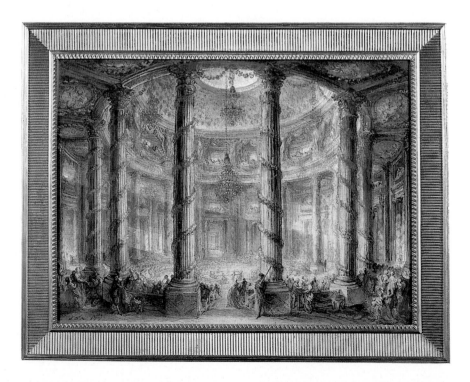

green spaces; there was a large pool for water sports, and a space for firework displays. The building delighted contemporaries, and for its brief lifespan of twenty years was immensely popular. The Colisée, like other Wauxhalls, was built of perishable materials and disappeared, recorded in a few contemporary pictures, and commemorated in the occasional street name.

There were great popular celebrations in France to mark the end of the War of American Independence. Britain, after recognizing the new United States early in 1783, later in the same year signed a peace treaty with France, which had backed the American cause. France, which saw itself as the defender of democracy and freedom, could celebrate a victory over a tyrannical and imperialist rival. Louis XV appeared in a new light as a successful, liberal ruler, and he was going to capitalize on that role in the hope that it might halt the decline in his popularity.

With this end in view, Louis provided a generous budget for celebrations in Paris, to be overseen by the city's own architect, Pierre-Louis Moreau-Desproux (1727–93). An experienced designer, he had already carried out the decorations for the festival celebrating the birth of the Dauphin in the previous year, and also rebuilt the Paris opera house. For the 1783 celebrations he devised a monumental column of Peace, shown here in a popular print (48) that records the great firework display that followed a celebratory 'Te Deum' sung in the cathedral of Notre-Dame. Several days earlier, the public's appetite had been whetted by a published description of the column, which listed the various classical, allegorical figures used in its decoration and gave precise descriptions of the types of firework to be used. Even the crude print captures something of the dazzling excitement of the occasion.

The freestanding monumental column was now to become one of the most popular means of expressing a triumphant celebration. Deriving ultimately from ancient Roman celebrations, the column was to play a significant role in Neoclassical design as both a temporary and as a permanent structure. Only a few years later, for example, on the site of the Bastille prison demolished in 1789,

47
Gabriel de St Aubin,
The Pleasure Gardens at the Colisée, Paris, 1772.
Ink, water and bodycolour; 16·8 × 22·6 cm, 6⁵⁄₈ × 8⁷⁄₈ in.
Wallace Collection, London

an isolated column dedicated to Liberty was to have been erected. Political events moved too fast in the Revolutionary years, however, for the project to be realized.

One of the most grandiose architectural projects of the entire Neoclassical period resulted not from the celebration of political events but the improbable combination of idealism, salt and taxation. Not far from Besançon, in northeast France, one can still enter through a tall classical portico, unexpectedly combined with a rugged grotto, into an enormous semicircular courtyard of the royal saltworks of Arc-et-Senans (51).

Salt would seem, at first sight, to be an unlikely commodity to fire the imagination of a great architect (53). However, in the eighteenth century salt played a far more important role than it does today. Before refrigeration, salt was needed to preserve food, notably fish, meat and cheese. Fodder for cattle also needed preservation. Only at the end of the century did scientists begin to discover chemical substitutes for some of the many uses of salt essential in industrial processes, which included tanning leather, making ceramics, metalwork and soap. In addition, salt was used in some medicines. These irreplaceable uses of salt meant that owners of mines had a valuable source of income from what was known as 'white gold'. Some governments, including the French, established state monopolies, placing lucrative taxes on salt. The lavish lifestyles of French kings, including the building of Versailles, were partly made possible by salt. The Arc-et-Senans saltworks were commissioned by Louis XV in 1773, and were intended to generate a substantial income under strict controls designed to prevent pilfering. The architect of the project, Claude-Nicolas Ledoux (1736–1806), rose to the challenge with a visionary solution that, partially at least, was actually built. The saltworks were to continue functioning until the end of the nineteenth century. Ledoux (49) demonstrated that architecture can be both practical as well as visionary, a combination of qualities that raises architecture into a realm in which exciting aesthetic experiences can become part of everyday surroundings.

48
Fireworks in the
Place de Grève
(Hôtel de Ville),
Paris 1783,
Celebrating the
1783 Peace
between Britain
and France,
1783.
Engraving;
37·6×21·8cm,
14⁷⁸×8½in

49
Antoine
Vestier
(formerly
attributed to
Fragonard),
Portrait of
Ledoux,
1782.
Oil on canvas;
140×85·4 cm,
55 1/8 × 33 5/8 in.
Musée
Carnavalet, Paris

Ledoux had been fortunate in his patrons, having already worked
for such wealthy and influential people as Louis XV's mistress
Madame du Barry. Shortly after completing a pavilion in the
grounds of her country house at Louveciennes outside Paris,
Ledoux was appointed by royal decree an engineer-inspector to
oversee salt production in the east of France. The salary was
handsome, and Ledoux could have treated the post as a sinecure.
Instead, he took the opportunity to exploit the terms of his
contract which referred not only to the maintenance of existing
facilities but also to the contruction of any new buildings that
might be needed.

Salt production and its taxation were controlled by the Ferme
Générale, the royal general tax farm whose members raised
money for the state in return for a share of the profits. Among its
officials Ledoux found several who both supported his imaginative
architectural schemes and shared his liberal ideals. Their liberal-
ism included the hope of reforming contemporary society; if this

had been achieved peacefully through political debate, it would have prevented idealism's more aggressive development leading to the French Revolution in 1789. Ledoux was not sympathetic to that Revolution, and his links with royal extravagance under Louis XV and with the tax-gathering of the much-hated Ferme Générale, put him in a very difficult personal situation in the 1790s. Imprisoned, threatened by the guillotine, and with no possibility of work, it was a sad end to a brilliant career, fired in the 1770s and 1780s by the finest ideals of the Enlightenment. That generation could not foresee that their beliefs were to be diverted down a road different from the one they had envisaged.

Ledoux's vision for the development of Arc-et-Senans included an ideal city, creating the perfect conditions for a fruitful working life (52). The project was too ambitious to be fully realized in the political and financial uncertainty of the Revolutionary period, but those parts that were finally built provide ample evidence of his stature, from the bold concept of the entrance to the treatment of such details as the wall decorations, sculpted to resemble urns out of which water has spilled and crystallized into salt (53).

The design of Ledoux's salt mines was influenced by the ideas of Freemasonry. A secret order, established early in the eighteenth century in England, on the foundations of earlier secret and occult societies, Freemasonry spread throughout Europe during the 1700s. The secrecy did not necessarily apply to a public knowledge of the identity of Freemasons, who included Voltaire, Mozart, Goethe, George Washington, Benjamin Franklin and many members of the ruling classes. There were other occult, secret bodies sharing similar ideas: Ledoux belonged to such a society. The Freemasons and related societies were more than just social clubs, although that aspect was important, and in terms of the visual arts was a useful way in which patrons could find artists, and vice versa. Rituals varied from one society or lodge to another, but members shared a belief in the importance of brotherhood and mutual support, which would contribute to the creation of a perfect society or utopia. The occult rituals of Freemasonry and

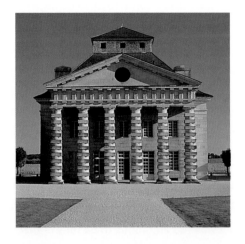

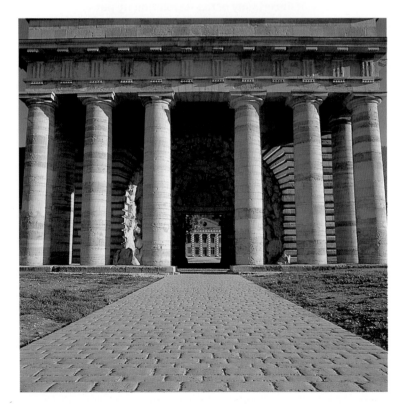

related societies, employing an exotic iconography which blended ancient Egypt with other sources, are apt to shroud this essential utopianism of the brotherhood of man, a key concept belonging to the mainstream of liberal and progressive thought in the eighteenth century.

The Freemason's initiation ceremony involved a route along which he encountered symbolic trials with fire and water. This route can be traced in many areas of art, literature and music in the eighteenth century, gardens and buildings included. Examples range from a seemingly innocuous notice at the entrance to a labyrinth which reads 'Choose, traveller, your path with reason' (at Wörlitz in Germany, see pp.119–20), to the approach to Ledoux's saltworks, which terminates at the director's house (50) in the centre of the complex.

This may sound far-fetched, but clues to the hidden masonic programme at the saltworks are provided by the architect himself in his published writings. Using the device of a fictionalized traveller, Ledoux takes the reader along the route from the old salt mine that predated his own, along the basins, rivers, canals and bridges, to his own new buildings. These features mark the stages of descent into the underworld (the salt-mine caves), the crossing of the Styx (the river of the classical underworld over which the souls of the dead were ferried), the ascent into light and the crossing of the River of Life. The journey is followed by a dream, in which Ledoux sees a decaying Babylonian city, where philosophy is no longer meaningful, just like the biblical Babel. Lightning destroys the dream city, and its architecture is reconstructed. Architecture provided the central imagery of Freemasonry, with the Great Architect of the Universe at the core of its beliefs. In Ledoux's dream the rebuilding of the city represents the reconstruction of the world. The traveller then makes his way to Ledoux's hospice (planned but not actually built), which will admit only those considered eligible for initiation into an ideal society. That ideal society was Ledoux's concept for his proposed new city at the saltworks.

Admission to that city was through the grotto of the entrance portico, which was constructed, as was the director's house, at the end of this symbolic route. In masonic terms, the house was a temple at the heart of which was the chapel. It was not designed for any specific religious creed, but for the more generalized concept of the religion of light. Light fell only on to the altar. If Ledoux's chapel came close to any religious precedents it was those of the Druids, whom he describes as worshipping at altars in the midst of forests. Ledoux wanted to go back, like the Freemasons, to religions that predated Christianity and other world religions. He tiered the rows of seats in the chapel, representing symbolically a primitive mountain. On this mountain, gathered together to worship the Supreme Being in the form of light, would be all those who worked at the salt mine. Stripped of individual rank, the congregation would be a masonic Brotherhood of Man.

To a modern reader this must seem more like an exotic oriental tale than an account of a real work of architecture which one

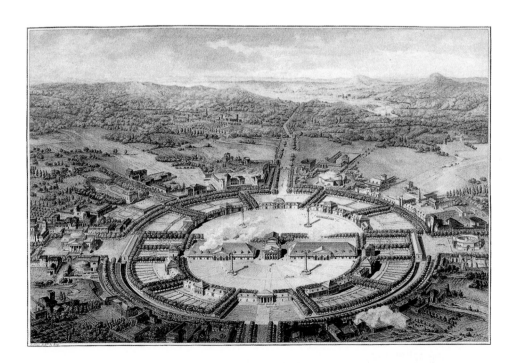

52
Pierre-Gabriel
Berthault,
General
Perspective of
Ledoux's Ideal
City of Chaux,
1773–9.
Engraving;
32·8 × 48·4 cm,
13 × 19 in

53
Claude-
Nicolas
Ledoux,
Detail of carving
of crystallized
salt on the
exterior of the
Salt works,
Arc-et-Senans,
1775–9

can still visit (although the chapel does not survive). Many vision-
ary or utopian idealists, however, live in the borderland between
fact and fantasy, and Ledoux was no exception. He was, neverthe-
less, fundamentally a rational man of the Enlightenment, whose
architectural forms belong to the world of Neoclassicism.

The visionary nature of his work was also evident in one of the
private houses he designed in Paris. Some private houses in the
city were open to the public in the eighteenth century, and were
listed in tourist guidebooks. A particularly famous one was the
Hôtel de Thélusson, so popular that admission tickets had to
be issued (54). It was built by Ledoux between 1778 and 1781
for a banker's wealthy widow in the rue de Provence. Madame
Thélusson allowed her architect free rein, resulting in the most
original, unorthodox and costly private residence in the city.
Instead of the customary wrought-iron entrance gates and fore-
court, Ledoux devised a massive entrance arch through which
carriages passed across a half-sunken garden with trees, a grotto
and miniature river. The route continued under the house itself
through a passage which opened out into the courtyard which was
unexpectedly at the back of the house.

Not only was the approach to the Hôtel de Thélusson novel, so
was the combination of architectural elements. The garden and
house were clearly visible from the street, which was not quite

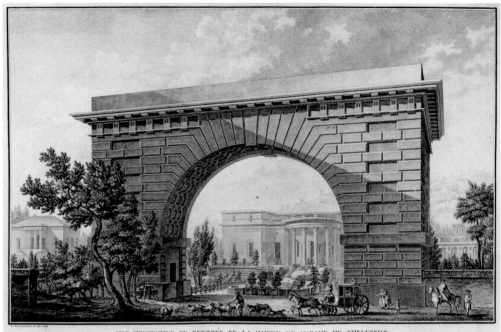

VUE PERSPECTIVE DE L'ENTRÉE DE LA MAISON DE MADAME DE THÉLUSSON.

the pastoral setting Ledoux implies in his own illustration. The entrance arch had the proportions of a half-buried ancient Roman arch and framed the public's view of the house like a carefully composed picture. That picture combined the ruggedness of a grotto with the clean lines of a classical building rising above it, mixing Neoclassical forms with a miniature 'picturesque' or natural garden. Ledoux's client had wanted a house that was 'half urban and half rustic'. Little could she have imagined how dramatically her architect would juxtapose her two apparently contradictory requirements.

Ledoux's visionary designs were paralleled by those of another contemporary French architect, Étienne-Louis Boullée (1728–99), who was less fortunate in seeing any of his grand projects even started. His vision was almost megalomaniac, conceiving structures that surpassed available technology and entered a world of pure fantasy, for example his proposal for a monument to Sir Isaac Newton (55–6). The great English scientist and mathematician was

idolized in the Enlightenment as the paragon of rational thought, a man who had discovered laws governing the motions of the planets and expressed them in simple mathematical equations. Rational scientific knowledge could be measured and codified, and thus by inference Christian and mystical views of the world, not resulting from rational analysis, were unacceptable. Newton was to become a touchstone for two opposite viewpoints in the eighteenth century. While for many, Newton had discovered absolute truth, his rationality was attacked by the Romantics, who saw in it a force destructive to the creative powers of the imagination. William Blake (1757–1827) detested him as the embodiment of rational materialism devoid of imagination. In Blake's famous image, Newton measures – and thus imprisons – knowledge with a pair of dividers (57). On the other hand, Boullée in his proposed monument produced designs that are among the most imaginative and powerful images of the century.

54
Charles-Nicolas Ledoux,
Plate from
Architecture considerée
showing the exterior of the
Hôtel de Thélusson,
Paris,
1778–81.
Engraving;
32·5×51cm,
12⁷⁸×20in

55
Étienne-Louis Boullée,
Interior of the Newton Monument,
1784.
Ink and wash;
39·8×64·7cm,
15¾×25½in.
Bibliothèque Nationale, Paris

56 Overleaf
Étienne-Louis Boullée,
Exterior of the Newton Monument by Night, 1784.
Ink and wash;
40·2×65·3cm,
15⁷⁸×25¾in.
Bibliothèque Nationale, Paris

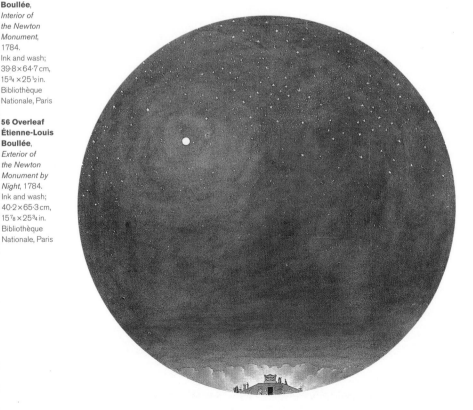

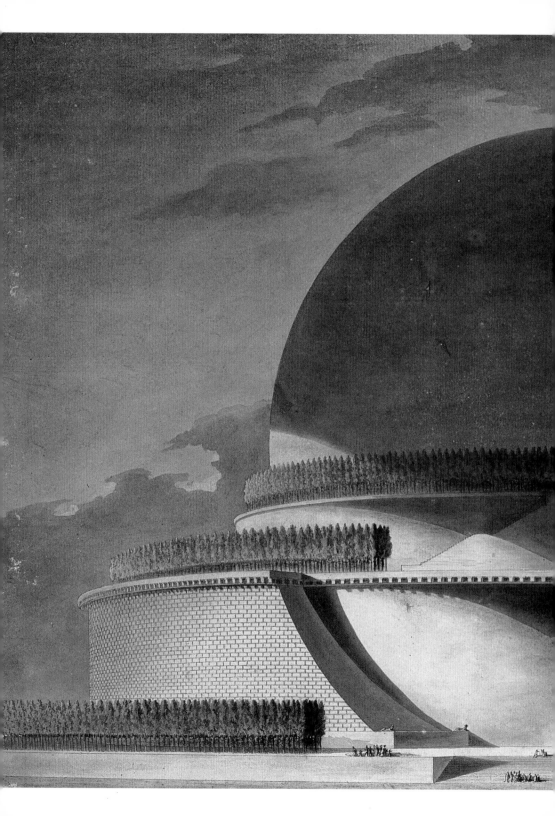

Boullée expressed unbridled adulation for Newton: 'Sublime mind! Vast and profound genius! Divine being! Newton, accept the homage of my feeble talents!' His homage took the form of a giant sphere resting in two circular rings, each planted with cypresses and flowers. His drawings show human beings dwarfed by the universe. The starkness of the undecorated exterior is echoed inside, where Boullée created two effects, by day and by night. For the daytime effect he suspended from the roof a vast lamp within an armillary sphere, creating he hoped a 'sublime' impression. For the night-time effect, the empty space is illuminated only by

57
William Blake,
Newton,
1795.
Colour print
finished in
watercolour;
46×60cm,
18¹⁄₈×23⁵⁄₈in.
Tate Gallery,
London

the natural light entering through tiny shafts pierced in the shell of the globe. They created the illusion of stars, a theatrical cosmic space exceeding even that of today's biggest planetarium. In his choice of the sphere, the 'perfect form' for Boullée, he represented two aspects of scientific knowledge. Externally, his sphere is our planet, a finite, geometrical shape. Internally, Boullée's illumined vault is the sky, infinite in its immensity but now understood and condensed by mathematics into Newtonian physics. The whole universe is presented as an ordered system, a cosmos.

The success of Boullée's design rests on his simple and smooth masses, almost devoid of ornamentation, skilfully arranged to exploit natural shadows. Boullée wanted architecture to be 'virile', and in the uncompromising austerity of his Newton Monument he achieved this. The bold simplicity of ancient tombs, especially the pyramid form with which Boullée would have been familiar, has been transformed into a work of stunning originality. His Newton Monument is architecture of pure geometry. His references to the ancient past are sparing: the decoration on the main supporting ring is Greek, the entrance door is flanked by Egyptian sphinxes, and the central portion of the interior space is occupied by a Roman sarcophagus. The three ancient civilizations so important for the Neoclassicists are all present, but overwhelmed by a new visionary architecture. That vision remained on paper: ahead of their time, the Newton Monument and other projects by Boullée were later to inspire architects towards the end of the twentieth century.

Boullée's style represents one pole of Neoclassicism: the heroic. The style representing the other pole, the elegant, is that of Robert Adam. Adam and Boullée were born in the same year and both died in the last decade of the century. Though contemporaries, their contributions to the development of Neoclassicism were markedly different.

Soon after his return from his Grand Tour in 1758, Robert Adam and his brothers built up a flourishing practice. They had been in business before he went abroad, taking over from their father William, the leading architect in Scotland in the early eighteenth century. Robert was increasingly asked to design and furnish private houses in both town and country, partly as a result of the personal contacts he had made in Italy. He was also to receive public commissions, but these never formed a major part of his output.

The Duke of Northumberland was among his early clients after Italy. Adam was to work on three houses for him: Syon on the outskirts of London, Alnwick Castle in Northumberland, and a

house in London itself. The Duke had a vast income, and wide interests in the arts and sciences (he was sufficiently knowledge-able in classical architecture to spot if a craftsman was not carving a detail correctly). In Northumberland, Adam had found a sympathetic and astute patron.

Adam's work on the interior of Syon House in Middlesex led to the creation of a sequence of rooms frequently described as the architect's masterpiece. As so often during his career, Adam had to cope with the existing fabric of an older house, rather than building a totally new structure. The consequent restrictions, however, could be a rewarding challenge, and at Syon from about 1761 onwards Adam created his version of the Neoclassical style. Apart from the entrance gates to the estate, added in the next decade, visitors were unprepared for classical splendours until they stepped through the front door.

58
Robert Adam,
Ante-room in
Syon House,
Middlesex,
c.1761–5

The entrance hall is a masterly understatement, its cool black and white décor contrasting with the opulent ante-room reached up a few steps at one end (58). The ante-room forms a prelude to the main suite of rooms, and its affluence ostentatiously affirms the wealth and power of the aristocratic owner. Its design evolved round the ancient Roman marble columns imported from Italy while Adam was working on the house. A further touch of classical authenticity is added to the room by the gilded panels of trophies, copied from Roman examples which Adam's friend Piranesi had published as engravings.

Adam's interiors at Syon rely largely on the quality and variety of detail, and on his use of colour. He coped brilliantly with the sometimes awkward proportions of the rooms, nowhere more successfully than in the Long Gallery, where Adam inherited a space whose proportions had no classical precedent. He therefore adopted an alternative strategy in designing a room specifically for the delight of the ladies of the household and their visitors. He broke up the long wall into decorative units interspersed with doors and fireplaces, incorporating portraits of Northumberland's ancestors and medieval kings (59). Complete with specially

designed furniture, Adam produced a room that was 'finished in a style to afford variety and delight'. Its delight derives very much from the variety of intricate decorative patterns Adam devised, patterns of a type from which his name became insep- arable. Unlike many of his contemporaries, Adam regarded colour as a very important element in architecture. Instead of the pre- vailing palette of white, greys and natural tones he used a multi-coloured palette, favouring paler shades interspersed on occasions with richer and deeper colours, sometimes in un- expected combinations.

Adam's version of Neoclassicism in the Long Gallery at Syon, with its delicacy, elegance and gaiety, almost bordering sometimes on the pretty, made a profound impression in Britain and in the colonies, especially North America, and briefly on the Continent. This aspect of his style tended to predominate, in the eyes both of his contemporaries and of later generations, being given the ubiquitous label 'Adam Style'. It has survived in a variety of revivals right into the twentieth century, and was so influential at the time that the Neoclassical period in Britain up to the 1790s is often called the 'Age of Adam', as if hardly any other architects and designers existed independently of him. William Chambers (1723–96) for one, who was to emerge as a rival, would certainly not approve, although for a few years they both shared the appointment of Architect of the King's Works.

Adam's style was essentially classical, constituting an inventive re- use of ancient motifs from a variety of sources. The knowledge he had acquired while in Italy was obviously of prime importance, and his borrowings from classical antiquity could be bold, as in his re- use of the Arch of Constantine in Rome for the central feature of the south façade of Lord Scarsdale's country house in Derbyshire, Kedleston Hall (60–1). The addition of a staircase to the original arch and the blocking up of openings to form windows and niches, while transforming the material, still leaves it readily recognizable. To the stock repertoire of classical source material and the rework- ing of some of its forms in the decoration of Renaissance architec-

ture, Adam added sources of his own special interest. He studied
in detail the ruined palace of the emperor Diocletian at Split
(or Spalatro as it was called in the eighteenth century), close to the
border with Italy, and published a scholarly archaeological folio a
few years after his return. Architects could gain added credibility in
aristocratic and intellectual circles by a display of classical erudi-
tion, and in aspiring to that higher goal Adam astutely chose an
important monument on which a monograph had not been
published. Familiar with the classical architecture in the Near East
at Palmyra and Baalbek, through the publications of Robert Wood

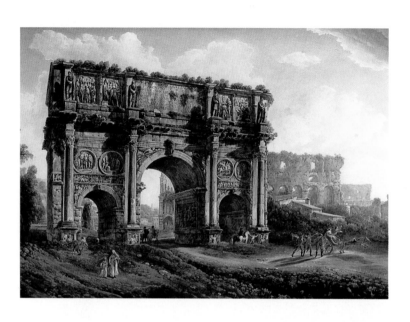

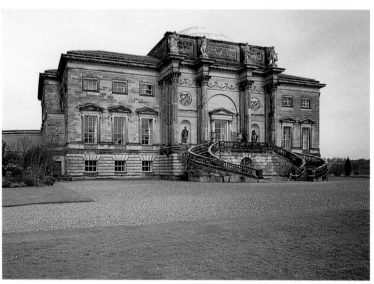

(see 29), Adam also plundered the 'Etruscan' motifs, but as misunderstood via the supposed 'Etruscan' vases, in reality associated with the Greek colonies in Italy. The colouring of the vases, combined with other classical motifs, inspired the so-called 'Etruscan' style, well represented in one room in Adam's remodelling of Osterley Park near London for the banker Robert Child (62). A vast body of archaeological knowledge was blended into a distinctive contribution to the development of the Neoclassical style.

In Adam's hands that development embraced the whole interior. Although he did not invent the concept of a unified design, with fittings and furnishings in complete harmony with the architecture, he developed the idea to a far greater extent than any of his predecessors or contemporaries. Architects in France in the seventeenth century had sometimes controlled the total appearance of the main rooms, including ceiling murals, tapestries and other furnishings. But Adam pushed the concept further. Not only was the decoration of walls and ceilings designed by him, but also – at least in the main rooms – the carpets and furniture, down to the smallest details. Adam's clients needed deep purses to finance their indulgence in fashionable taste. Each commission involved a great deal of special design work, and clients had sometimes to pay for a vast number of working drawings, costing anything from about £5 to £12 each (in present-day terms £500 or $750 upwards). The Adam firm was not unusually greedy in this respect, it is merely that their business transactions are more fully documented than many of their contemporaries'.

Adam's dining room at Saltram in Devon (63) is a good example of this multifaceted work carried out for a local landowner, in this instance John Parker, later created Lord Boringdon. The room was part of Adam's work for Parker's recently inherited country house and started as a library, designed by Adam in the late 1760s. In 1780 it was changed into the dining room, again by Adam, and the new furnishings included a sideboard table and accompanying urns and pedestals, carved and painted cream, green and white to match the décor. The urns are both ornamental and functional,

60
Abraham Louis Ducros,
Arch of Constantine,
c.1788.
Watercolour and gouache;
76×112 cm,
30×44 ⅛ in.
Hoare Collection,
Stourhead

61
Robert Adam,
South front of Kedleston Hall, Derbyshire,
c.1765–70

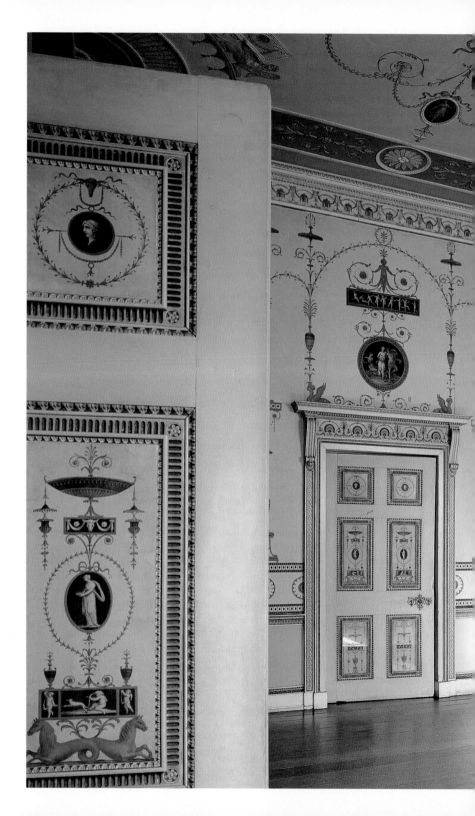

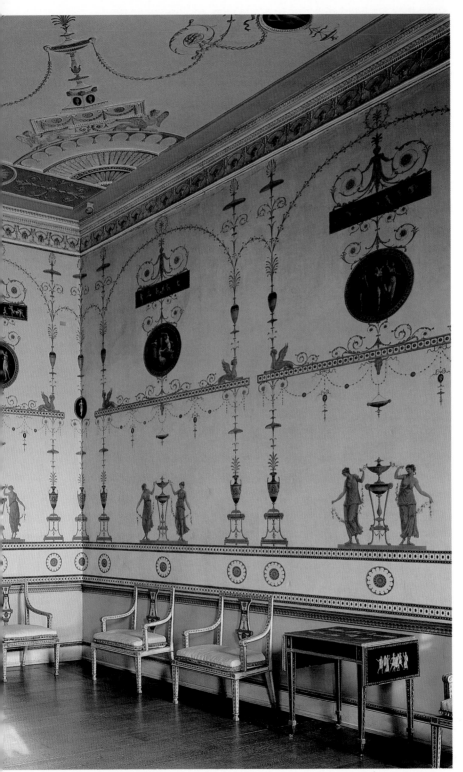

62
Robert Adam,
Etruscan
dressing room,
Osterley Park,
Middlesex,
c.1775–6

since they are lined with zinc to act as wine coolers, while the pedestals are fitted out as cupboards. The flanking niches were formerly windows, blocked up by Adam when converting his original design so the space could display imitation 'Etruscan' vases.

The volume of work passing through Robert Adam's office meant that he needed to employ a variety of talented assistants. He also needed a good reference library, together with a collection of prints, drawings and sculptures, all potential sources of inspiration. Robert and his brother James (1732–94) built up a large collection of drawings and prints which included architectural and topographical works acquired by them on their Grand Tours. The architectural material was the most relevant to the Adams' practice, 'giving hints to the imaginations of we modern devils', as Robert put it. The drawings also provided a standard of draughtsmanship against which apprentices in the office could measure their own capabilities. The Adam collection also included sculptures, antique pieces both in the form of original marbles and as plaster casts. These were on show in their London house, along with their paintings, as a permanent semi-public display of their taste, since the house was used for consultations with clients.

63
Robert Adam,
Dining room,
Saltram House,
Devon,
1768–9 and
1780–1

Robert and James Adam, together with other members of the family, established one of the largest architectural practices of the time. Designing, drawing, measuring and estimating were all handled in the office by a permanent staff, some of whom were recruited abroad. The Adams maintained links with firms of craftsmen skilled enough to execute their intricate designs, paying them handsomely for their services, especially for plasterwork and cabinet-making. They also employed painters who were sympathetic to their style for the execution of decorative, figurative panels. One of these was Antonio Zucchi (1726–95), who executed the ceiling and wall paintings for the Saltram dining room. He was to become in 1781 the second husband of a more famous artist, Angelica Kauffmann (1741–1807), whose Neoclassical paintings were much admired at the time. John Parker of Saltram had acquired four of her paintings (64), probably with the intention of incorporating

them as panels in his large saloon, also being designed by Adam at the same time as the original library. The paintings' fashionably classical subject matter and style are rendered in a gentler and prettier manner than the more austere approach of some of Kauffmann's contemporary history painters, whom we will be discussing in the next chapter.

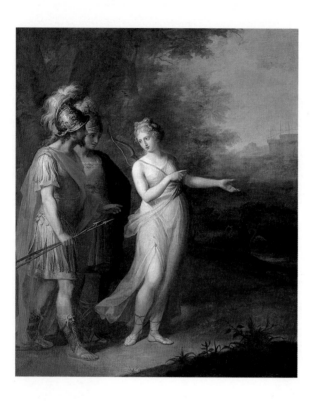

64
Angelica Kauffmann,
Venus Directing Aeneas and Achates to Carthage,
1769.
Oil on canvas;
127×101·5cm,
50×40in.
Saltram House,
Devon

The painters were part of a complex organization, most of the control over which was in Robert's hands. Apart from James, two other brothers were involved in the business: William (1738–1822) who later became involved unsuccessfully in property speculation, and John (1721–92) who ran an Edinburgh office. The Adam brothers also either owned or had business interests in timber, bricks, cast iron, stone, stucco and sand. By the end of the century roughly two thousand people were working either directly or indirectly for the various Adam enterprises. But within a decade of Robert's death in 1792 the family firm was bankrupt.

In his native Scotland, apart from country houses, Robert Adam's work was concentrated in Edinburgh, a city which was to gain the sobriquet of 'Athens of the North'. To this day, the overriding character of the principal part of the city is classical, and in visual terms the association with the roots of Neoclassicism is apt. Edinburgh was one of the earliest European cities to be developed according to a Neoclassical town plan, partly drawn up by a local architect, James Craig (1744–95), in 1767. Expanding populations and a growing distaste for crowded, often squalid conditions prompted civic authorities, planners and architects to try to improve some of the major European cities from the mid-eighteenth century onwards. Some schemes involved the reshaping of a whole metropolis as an ideal Neoclassical town. But while these plans remained on paper, in the decades around 1800 several cities were transformed dramatically without having to start from scratch. Edinburgh's New Town, as an extension to the old, medieval city, was not only built, but was to be extended in the early nineteenth century to form one of the few relatively unspoilt examples of a Neoclassical town to survive in Europe.

The old town had grown up, like countless other medieval examples, in a random manner, with narrow streets, and in Edinburgh's case with unusually high tenements. All classes of society lived on the same staircase, with the aristocracy when in town occupying the middle floors, and tradesmen the lower and upper. This novel social mix was initially to prove one of the stumbling blocks to a successful beginning of the New Town: it may have been untidy in planners' eyes, but people had become accustomed to living in this way. The New Town was to be built on a virgin site to the north of the old town, on the far side of a loch. Houses rather than tenements were to line wide streets and large squares. No shops, market-place or forms of entertainment were initially planned. It would be a domestic suburb, in which the social classes did not mix as in the old town. The aristocracy, affluent members of the legal and other professions, and wealthy tradesmen acquired property in the new streets and squares, while the lower classes were confined to the subsidiary

streets. Taxation on the new dwellings was so high that only the prosperous could in any case afford them.

Although originally conceived like the British flag, with the vertical and horizontal form of the cross of St George (England) inter-locked with the diagonals of that of St Andrew (Scotland), repre-senting the union of the two countries in 1707, the street plan as built was a grid running parallel to the old town. Three principal streets ran from east to west. The southernmost one (Princes) was nearest the old town, and had uninterrupted views across to the castle since only one side of the street was developed. The north-ernmost street (Queen) likewise had an open outlook, across the countryside to the sea, until it was partially built over with the development of the second wave of the New Town. The middle street (George), the central axis of the plan, terminated at each end in a square with churches intended to act as focal points to the vista. However, the site allotted for a church at the eastern end was acquired by Sir Laurence Dundas, who built on it his own town house, designed by Sir William Chambers (65). Dundas House was the largest and most elegant Neoclassical private residence in the city. The spacious, picturesque garden to its rear has been built over, but the house still stands (now a bank) with some of its original interior décor intact.

At the western end of the central axis, St George's church was designed by Chambers's rival, Robert Adam, but completed only after his death by another architect who amended his ideas. The church dominates Charlotte Square, also designed by Adam and one of his outstanding contributions to Edinburgh's townscape, along with his Register House (an equivalent of the Public Record Office) on the edge of the New Town, and his new building for Edinburgh University in the old part of the city. Adam had grand ideas for Scotland's capital, which had to find a new role for itself after the seat of government had gone south to London as a result of the Union. His most grandiose plan was for an imposing street flanked by porticoed houses as the main entry to the city from the south. It would have been one of the most magnificent

Neoclassical streets in Europe, comparable to slightly later schemes constructed on this scale in London and Berlin. Adam's scheme, unfortunately, was too costly and was not realized.

Adam's more modest plans for Charlotte Square six years later in 1791 actually went ahead, in the following year, just after he had died (66). This time Adam was asked to produce a design that was 'not much ornamented but with an elegant simplicity', in the words of the Lord Provost who commissioned him on behalf of the city authorities. They paid him for his designs for the square, but thereafter private capital paid for the erection of the houses themselves, reflecting the increasing prosperity of the Scottish economy in the later eighteenth century. The initial development of houses in the New Town had resulted in characterless and monotonous street frontages, and Adam seized the opportunity to produce for Charlotte Square an appearance of great variety within an overall harmony. The north side of the square is the only one completed to

his original design. The entire frontage has been treated like that of a country house, with a central feature of columns and pediment flanked, as it were, by side wings, avoiding the repetition of an identical frontage for each house. When completed in the early nineteenth century, the houses flanking the originally circular central garden of Charlotte Square formed a spacious focal point to the fashionable part of the city.

Adam was on friendly terms with Piranesi, as far as was possible given the Italian's difficult temperament. As Adam commented once, 'Piranesi is a most changeable, interesting madman.' Piranesi did, however, include Adam's portrait along with his own on a classical medal that formed part of a dedicatory plate to one of his books (67). Engraver, architect, designer, archaeologist,

66
Robert Adam,
North side of
Charlotte
Square,
Edinburgh,
1791

67
**Giovanni
Battista
Piranesi**,
Joint portrait of
himself and
Robert Adam,
1756.
Engraving;
diam. 4·5 cm,
1¾ in

writer and dealer, Piranesi had many fields of activity, the focal point of them all being classical, especially Roman, antiquity. He became increasingly concerned with archaeology, both in terms of new knowledge acquired from fresh excavations, and as a dealer and restorer, building up his own collection of antiquities.

It was the growing knowledge and appreciation of the Roman past that inspired his attack on the school of thought that claimed Roman art was largely a derivative form of Greek art. Since Roman works lacked originality, or so it was claimed, Greek art was demonstrably superior. As Winckelmann was the leading figure in this school of thought, Piranesi was taking on the ultimate scholarly authority on these matters in Rome itself. Piranesi's initial

salvo was in his *Magnificence and Architecture of the Romans* (*Della magnificenza ed architettura de' Romani*) published in 1761. The Romans, Piranesi argued, inherited the 'highest perfection' of all the arts solely from the Etruscans, building on their achievement to create the greatest works of classical antiquity in architecture and engineering, from temples to aqueducts. By contrast, the Greeks debased what they inherited, even producing architecture that was pretty – the most extraordinary of Piranesi's accusations, since prettiness is the last characteristic one would associate with ancient Greek buildings. Piranesi's unhistorical assessment of the classical world, for which there is not a shred of evidence, achieved the desired purpose of stirring up a Roman versus Greek debate. Bizarre his interpretation of history may be, but his zealous questioning of the long-established belief in Greek supremacy fully accords with contemporary Enlightenment thought, which subjected everything to rigorous reassessments. Piranesi was living in a period of radical intellectual ferment, and this is reflected in his writings.

Piranesi wrote some of the most pugnacious texts of the Neoclassical period. He stuck out for individual expression, and argued that the creative artist should not be bound to one set of rules. Piranesi saw there was a danger in relying too heavily on classical precedents, especially if they were selected from a narrow range. He wanted fellow artists to be more wide-ranging. As he argued in one of his later books, published in 1769, 'The law which some people would impose upon us of doing nothing but what is Grecian, is indeed very unjust.' He was having another swipe at his arch-enemy Winckelmann. Piranesi went on to ask:

Must the genius of our artists be so basely enslaved to the Grecian manners, as not to dare to take what is beautiful from elsewhere, if it be not of Grecian origin? But let us at last shake off this shameful yoke, and if the Egyptians and Etruscans present to us in their monuments, beauty, grace and elegance, let us borrow from their stock, not servilely copying from others.

By combining a knowledge of Greek, Roman, Etruscan and Egyptian art, an artist should be able to show that he is inventive,

'he ought to open himself a road to the finding out of new orna-
ments and new manners'. And should any of his readers think that
there is nothing left to discover from ancient monuments, they are
much mistaken. 'This vein is not yet exhausted. New pieces are
daily dug out of the ruins, and new things present themselves to
us, capable of fertilizing and improving the ideas of an artist'.

Piranesi himself had no qualms about plucking out of the past
combinations of motifs that would have startled the ancients. The
quotations above come from his *Divers Manners of Ornamenting
Chimneys* (*Diverse maniere d'adornare i cammini*), in which,
while admitting that the ancients did not have modern chimney-
pieces, he presents a range of designs in a Neoclassical style
which is an eclectic blend of those ancient civilizations that he
advocates in his text. He intended 'to show what use an able archi-
tect may make of the ancient monuments by properly adapting
them to our own manners and customs'. Some of his chimney-
pieces would have been acceptable to contemporary taste, while
others were extravagant, propaganda pieces (69).

Of Piranesi's architectural projects, only one came to fruition:
his reconstruction of the priory church of the Order of the Knights
of Malta in Rome, Santa Maria del Priorato. The commission came
from the pope's nephew, Cardinal Giambattista Rezzonico, who
was Grand Prior of the Order and whose family were among
Piranesi's main patrons. The piazza in front of the priory and the
gatehouse were both designed by Piranesi, but it was the church
itself that was his outstanding contribution. Both outside and in,
the design shows a highly individual version of Neoclassicism,
partly classical in origin, partly sixteenth- and seventeenth-century.
The interior is particularly exuberant with the eye immediately
drawn to an altar (68) that is partly a fantasy of antique detailing
worthy of one of his own classical fake candelabra and, in the
upper half, partly a reincarnation of the extravaganza of a seven-
teenth-century altar.

Piranesi much admired a newly decorated room in Rome and
intended to publish prints of it, but never did so (70). He would

undoubtedly have found its playful eclecticism sympathetic to his own taste, an interior of a kind that he himself never had the opportunity to realize. The so-called Ruin Room, in the convent of Santa Trinità dei Monti (at the top of the Spanish Steps), was created for two celebrated mathematicians, Père le Sueur and Père Jacquier, by Piranesi's French friend Charles-Louis Clérisseau (1721–1820). The room survives, but without its original furnishings. The architect's drawings and a contemporary description give a better impression of the original appearance:

On entering, you think you are seeing the cella [interior] of a temple enriched with antique fragments that have escaped the ravages of time. The vault and several parts of the wall have partly crumbled away and were held up by rotting scaffolding, which allowed daylight to enter and seemed to open a way for the sun's rays. These effects carried out with skill and truthfulness produced a perfect illusion. To enhance this effect, all the furniture was in keeping. The bed was a richly ornamented basin, the fireplace a combination of various fragments, the desk a damaged antique sarcophagus, the tables and chairs a piece of cornice and inverted capitals. Even the dog, faithful guardian of this new kind of furniture, was housed in the remains of a vase.

The books in the bookcases were also part of the illusion. They included one labelled Newton, presumably as an allusion to the special interests of the room's occupants. Reason may have been of paramount importance, but that did not prevent mathematicians from wishing to surround themselves daily with nostalgic fantasy, in a room that did not even allocate space for a real bookcase.

The Ruin Room was one form of escapism. A country retreat was another. Escaping from the rigours and the heat of city life to a summer residence had long been the practice of the privileged classes, and a commission for a summer residence for an enlightened patron could be an architect's dream. So Clérisseau must have thought when approached by Catherine the Great in 1773 for a house in the 'antique' style to be erected in the grounds of her favourite summer residence, at Tsarskoye Selo, near St Petersburg. She wanted a modest house in a garden setting, containing intimate rooms rather than grand ones. When

**68
Giovanni
Battista
Piranesi**,
Altar, Santa
Maria del
Priorato, Rome,
1765

**69
Giovanni
Battista
Piranesi**,
Fireplace from
*Diverse
maniere*,
1769.
Engraving;
38·5×25·2cm,
15¹⁄₈×10in

**70 Overleaf
Charles-Louis
Clérisseau**,
*Ruin Room in
Santa Trinità dei
Monti in Rome*,
c.1766.
Pen and ink and
gouache;
36·5×53·3cm,
14³⁄₈×21in.
Fitzwilliam
Museum,
Cambridge

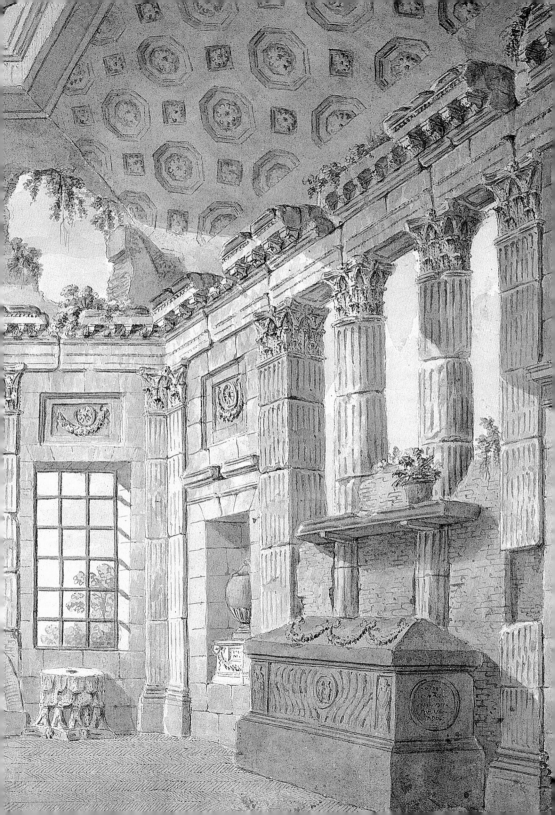

Clérisseau, somewhat tactlessly, designed instead a gigantic Neoclassical palace, she rejected it and turned to another foreigner, Charles Cameron (c.1745–1811), a British architect who arrived in Russia around 1774. His credentials as a classicist were impeccable: he had published his folio volume on *The Baths of the Romans* as recently as 1772. His work was to be much admired in his new-found country, and he was to remain in Russia for forty years, working for Catherine and other members of the imperial family. The empress admired him because, as she once wrote, he was 'a great designer nourished on antiquity'.

At Tsarskoye Selo, from 1780 onwards, he created the first major example of Neoclassical architecture in Russia, a style which was to remain in favour with Catherine's successors into the early nineteenth century. The dominance of Neoclassicism in Russia, at least in the western part, and especially in the development of St Petersburg and the erection of new country houses, was a constant visual reminder of the Westernization of Russia that had been going on steadily since the early eighteenth century under Peter the Great. It was a process that transformed the military and the economic aspects of life as well as the cultural.

Like her eighteenth-century predecessors, Catherine had strong cultural links with France. Cameron was not French, but his style in interior decoration was similar to that of both Clérisseau and Robert Adam. As Catherine wrote about Cameron to one of her correspondents, 'I have here all the works of the Adam brothers.' In the early eighteenth-century palace of Tsarskoye Selo, which Catherine found too large and pretentious, Cameron constructed a series of intimate rooms and added a gallery, baths and the Agate Pavilion, the furnishings of which were of unparalleled luxury (71). The variegated colours of agate and the rich green of malachite ornamented columns and walls, with capitals and bases cast in bronze. Ceramic plaques were imported from Wedgwood for inclusion in the wall décor. Walls throughout were intricately patterned with garlands and swags copied from antique prototypes, some of which were based by Cameron on designs by Clérisseau.

The garden that surrounded this Neoclassical country retreat was designed in the fashionable picturesque or 'English' style (see Chapter 4). As Catherine wrote to Voltaire, 'In a word, Anglomania dominates my Plantomania.' Catherine was not alone on the Continent in enjoying such a combination of styles in architecture and garden; the country estate of Wörlitz near Dessau, in Germany, is another example.

Travelling through Europe together, more as friends than as patron and architect, the young German Prince Franz of Anhalt-Dessau and his protégé Friedrich Wilhelm von Erdmannsdorff (1736–1800) had first met at the court in Dessau when they were aged eighteen and twenty-two respectively (in 1758). The meeting was to be

71
Charles Cameron,
Design for Great Hall, Agate Pavilion, Tsarskoye Selo, 1782–5.
Pen and ink and watercolour;
36×61cm,
14 1⁄8 × 24 in.
Hermitage Museum, St Petersburg

crucial for Erdmannsdorff's future, changing his career from that of a court official to that of a fully occupied architect. His initial training was gained not through apprenticeship but by the study of buildings and antiquities on three European tours in the early 1760s. On two he was accompanied by the prince, travelling through Italy, France, England and Scotland. During one of his stays in Italy, Erdmannsdorff made friends with leading Neoclassical figures, regularly meeting Winckelmann who used to accompany the prince on his sightseeing. Erdmannsdorff also became friendly with Piranesi, who later dedicated an engraving to him. He also knew Clérisseau in Rome, and in Naples visited Sir

William Hamilton's collection of vases. He travelled to Paestum, and even on to Sicily. By the time he settled down in Dessau, therefore, he was well educated – in eighteenth-century terms – as an architect, and could turn his hand to the commissions which the prince was to shower upon him. The prince was a man of the Enlightenment, sympathizing with the new philosophical and artistic ideas especially of France and England. His buildings and gardens were to reflect current fashion.

Erdmannsdorff's principal commission from the prince was Schloss Wörlitz, built between 1769 and 1773 as a summer residence. It was one of the earliest Neoclassical houses to be built in Germany, and it shows how skilfully Erdmannsdorff could combine ideas from new buildings with his knowledge (either first- or second-hand) of ancient sites in Rome and Palmyra. The intricate style of decoration in the main rooms was close to that of Robert Adam, and nearly all the furniture was imported from England. The Englishness extended into the park, one of the earliest on the Continent to be laid out in the picturesque manner. It included the prince's homage to the much-admired Rousseau in the form of an adaptation of the Isle of Poplars at Ermenonville with its famous tomb. Erdmannsdorff later added a range of small classical buildings set into the landscape garden, including a Temple of Flora, a

Temple of Venus, and the Villa Hamilton. This last building (72) was an exquisite example of Neoclassical taste, its design being based on one of Sir William Hamilton's houses near Naples. It was furnished with copies of ancient Greek '*klismos*' chairs (with curved back and legs) and the walls were decorated with copies of dancing figures from Herculaneum, views of ancient ruins, and Wedgwood plaques. The extensive estate of Prince Franz at Wörlitz epitomized a great deal of the age of Neoclassicism, and showed the firm grip which the style had established on German taste by the end of the century, and which became even firmer in the next generation.

Neoclassicism was also the preferred style of one of the youngest republics. After gaining independence from Britain in 1783, the United States of America set about building new headquarters for its legislatures. These buildings were symbols of the new era, and republican ideals, going back to ancient Rome, were enshrined in the Latin name chosen for them: capitols, after the Capitoline Hill in Rome where once stood a temple of Jupiter.

The first capitol was to be inspired by a Roman temple, which made its earliest appearance in an architectural form in the United States at Richmond, Virginia. Only two years after independence, Thomas Jefferson (1743–1826) was asked to find an architect to design the State Capitol for Virginia, where he had been brought up and of which he had been governor. By now, 1785, he was in Paris as Minister to France, having succeeded Benjamin Franklin in the post. Jefferson had a long-standing interest in architecture. He had been remodelling his own house at Monticello, Virginia, since the late 1760s, and he was later to take part, unsuccessfully, in the competition for the new President's House in Washington, better known today as the White House. Later still, he designed and built his grandest architectural venture, the new University of Virginia in Richmond, from 1817 onwards.

The public buildings office of the state asked Jefferson for a Capitol which combined 'economy with elegance and dignity', and he approached Clérisseau for help. Jefferson had already

72
Friedrich Wilhelm von Erdmannsdorff,
Villa Hamilton, Wörlitz, 1795–6

conceived the Capitol as a temple, and Clérisseau had published a book on the famous ancient Roman temple at Nîmes, in the south of France. This well-preserved temple, the Maison Carrée, was to become the model for the Virginia State Capitol. What Jefferson regarded as 'the most perfect and precious remain of antiquity in the world' was to be transported to the other side of the Atlantic to serve a new, eighteenth-century republican function.

For reasons of economy, the Virginian adaptation was built of brick, stucco and wood, not stone like the original. But this did not diminish the dominating presence of this Roman temple in the Virginian landscape, a daring concept in a new America, and a profound influence on subsequent capitols and other public build- ings. European Neoclassicism was imported into a former colonial territory, into a hilly, rural countryside that struck contemporaries as remarkably English in appearance. Subsequent building devel- opments have changed Jefferson's original vision, but it can be recaptured in contemporary drawings, such as one (74) executed in the late 1790s by a recently arrived British architect, Benjamin Henry Latrobe (1764–1820). He was rapidly to establish himself at the turn of the century – partly with Jefferson's encouragement – as America's leading Neoclassical architect.

The rotunda in the Capitol in Virginia was to be the setting for the official portrait of George Washington (73), for which the Virginia Assembly voted public funds. As it was recognized that no contem- porary American sculptor could undertake such an important commission, it went to one of France's leading Neoclassicists, Jean-Antoine Houdon (1741–1828). Jefferson was instrumental in the choice, telling Washington that Houdon was the greatest sculptor in Europe, and that he insisted on modelling Washington from the life. Houdon therefore sailed to the United States in 1785, modelling a bust at Washington's house, Mount Vernon. From the start he had wanted to be portrayed in modern dress, and in the finished marble he is wearing his uniform as commander-in-chief. Like Washington, Jefferson thought 'a modern in an antique dress as just an object of ridicule as a Hercules ... with a periwig'.

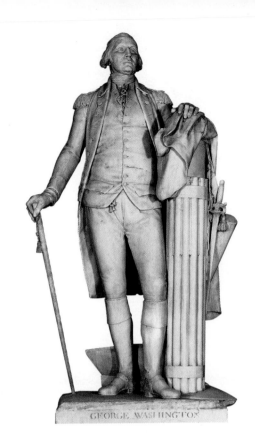

73
Jean-Antoine
Houdon,
*George
Washington*,
1788.
Marble;
h.189 cm,
74 ½ in.
State Capitol,
Richmond,
Virginia

However, Houdon had toyed with the idea of an idealized image of Washington, draped in a toga. All that survives of this idea in the final version are the plough and the fasces, symbolizing agriculture and authority, although in some of Houdon's replica busts Washington is shown with a classical drape.

Also while in Paris, Jefferson was active on yet another important commission for the new United States. Congress had voted that medals be given to the victorious officers who had fought in the American Revolution. The series had started with a medal of George Washington, but it was not until Jefferson took over the supervision of the set of medals in Paris, where they were designed and cast, that the project was finally realized. The medals' restrained classical imagery accords with Jefferson's views on Houdon's image of Washington. However, the most classical of these medals had been initiated by Jefferson's

predecessor in Paris, Franklin. He had commissioned from
Augustin Dupré (1748–1833), who later cast some of Jefferson's
set, the *Libertas Americana* medal (75). On the reverse side an
infant Hercules is in his cradle strangling the serpents; symboliz-
ing the young United States he watches while Minerva (here repre-
senting France) overpowers a lion (Britain). The Latin quotation
reads: 'The courageous child helped the gods.' The obverse depicts
Liberty with her cap, an image that was to be re-used on early
American coinage.

Fresh requirements in the new United States also included official
residences, not least for the President. Before Jefferson himself
was elected to that office in 1801, he had submitted an entry to the
competition for a Capitol in Washington organized in 1792 by the
commissioners whom Washington, at that time President, had
appointed to oversee the development of the new seat of govern-
ment. In the event, the commission was awarded to an emigré Irish
architect, James Hoban (c.1762–1831). Jefferson, as Washington's

Secretary of State, took an active interest in the proposed architectural developments of the new federal capital. He was anxious that the house should not be ostentatious, as this would be inappropriate to the state of the country's economy, but he wanted the design to reflect some of the best recent French architecture. The commissioners even went further. They wanted to recruit craftsmen from Bordeaux (Revolutionary France was at war with Europe but not the United States), and wrote saying that the President's House should show 'a grandeur of conception, a Republican simplicity, and that true elegance of proportion which corresponds to a tempered freedom excluding frivolity, the food of little minds'.

These fine ideals, however, were not matched by either the quality or the imagination of the competition entries: few native Americans entered, and Jefferson himself submitted, anonymously, a disappointing reworking of an influential sixteenth-century prototype, the Villa Rotonda at Vicenza by Palladio. The

74
Benjamin
Henry Latrobe,
*View of
Richmond
Showing
Jefferson's
Capitol from
Washington
Island,*
1796.
Watercolour on
paper;
17·7×26·2cm,
7×10³⁄₈in.
Maryland
Historical
Society,
Baltimore

75
Augustin
Dupré,
Libertas
Americana
medal,
1776–7.
Die-struck silver;
diam. 4·7 cm,
1⁷⁄₈in.
Massachusetts
Historical
Society, Boston

76 Overleaf
James Hoban,
Benjamin
Henry Latrobe
and others,
White House,
Washington, DC,
begun 1792

winner, Hoban, who had settled in Charleston, South Carolina, where he seems to have been modestly successful, produced an essentially early eighteenth-century design, reflecting none of the developments of Neoclassicism. This was the house into which Jefferson was to move, and which he was to be instrumental in altering to its present appearance. He appointed Latrobe as surveyor of public buildings, whose addition of colonnades and porticoes both gave the house a more imposing presence and injected into the design a better and more up-to-date architectural taste (76). What had started as a modest provincial dwelling,

became a house appropriate for a president of a newly developing, dynamic country. Today the White House is among the most familiar of all Neoclassical buildings.

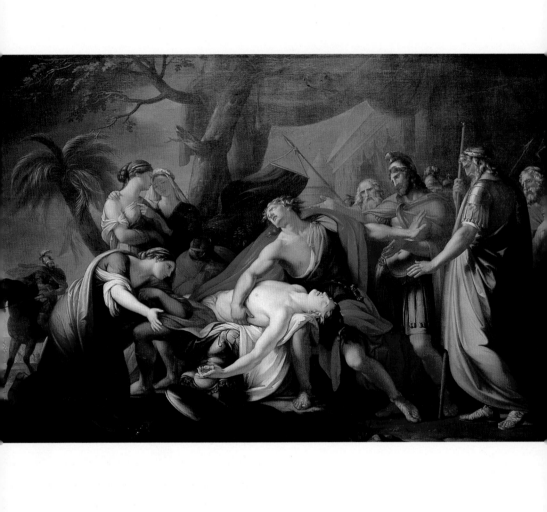

In 1760 a landowner living in the north of Scotland, Sir James Grant of Grant, commissioned a large canvas from the British artist Gavin Hamilton (1723–98), then living in Rome (77). The agreed subject was taken from Homer's *Iliad*, and depicts *Achilles Bewailing the Death of Patroclus* in a manner that aroused in the viewer a sense of compassion which, according to the artist, gave an 'inward satisfaction'. The patron was delighted, and was prepared to pay the handsome sum of £300 (equivalent to £30,000 or around $45,000 today).

The subject chosen for Grant's picture calls for some explanation, as does the question of why an arousal of compassion was considered so desirable in a work of art, especially when it was such an expensive commodity. The enquiry will take us to the heart of the eighteenth-century attitude to painting, in which pictures were expected to satisfy not only aesthetic criteria but also intellectual demands, often by illustrating a theme of morality, such as heroic virtue or compassion. History painting dominated the canvases of Neoclassical artists, whose subject matter ranged widely from the distant classical past to events occurring in their own lifetime. As the painters roamed so widely in search of their topics, we will consider their output thematically, rather than chronologically. (The chronology at the end of the book provides a sequential overview.)

Hamilton was among the forerunners of the Neoclassical style in painting. Unusually for an artist he had been to university, Glasgow, and then gone on to study painting, settling for most of his life in Rome. There he became a leading light in the cultural activities of the city, had a wide circle of friends, and became one of the most prosperous foreign artists in Italy. His history paintings sold well, usually to clients who had commissioned them, and he

7
Gavin
Hamilton,
*Achilles
Bewailing the
Death
of Patroclus*,
1760–3.
Oil on canvas;
252×391cm,
99×153in.
National Gallery
of Scotland,
Edinburgh

also turned out the occasional portrait. He also became – again unusually for a painter – an archaeologist, selling the statuary that he excavated, as well as trading in Old Master paintings. He was an interesting man of many parts.

Achilles Bewailing the Death of Patroclus depicted one of the most poignant scenes in Homer's account of the Trojan War. Both men were superb fighters, lovers, stalwart together in battle. After Patroclus has been struck down, Achilles is inconsolable. His grief later turns to anger, and his violent temper is unleashed on the dead body of Hector, the leading Trojan warrior, which he drags behind his chariot around the walls of Troy. Homer's tale of hero-ism and passion was (and is) one of the world's greatest poems on eternal themes. Above all, it was Greek, belonging to a culture that had laid the foundations of European civilization. Patrons of history paintings commissioned from Hamilton and his contempo-raries were familiar with the imagery of Homer's verses, and would readily respond to them.

In the early 1760s Hamilton also painted the scene of the anger of Achilles, as well as others from the *Iliad*. He sought out a good engraver to reproduce the paintings accurately, and in this form the set of prints helped to establish his European reputation. He topped this success with a further series of paintings on Homeric subjects in the 1780s, which were commissioned by the wealthy Prince Borghese for a room in his house on the edge of Rome, the Villa Borghese. The theme for all the works in the room, not only Hamilton's large canvases but also the sculptures commissioned from an Italian, was the story of Helen.

Hamilton always chose serious subjects. Even in his only scene from Shakespeare, he opted for one of the histories, choosing an incident from the classically set *Coriolanus*. The reason for his choice of sombre rather than playful subjects lay in the contempo-rary belief that art and morality were closely interrelated. This connection, so unfamiliar to us today in the context of modern art, is probably the largest single obstacle to be overcome in order to understand a significant part of eighteenth-century painting.

The philosophical writings earlier in the century of the third Earl of Shaftesbury (1671–1713) were one of the most influential sources for the dissemination of these ideas on morality. Shaftesbury elaborated a conviction, going back to Aristotle's *Art of Poetry*, that instruction was nobler than pleasure, that the mind should be satisfied before the eye. Speaking of the arts in general Shaftesbury asked: 'Who can admire the outward beauties, and not recur instantly to the inward, which are the most real and essential?' He saw his own writings as striving 'towards the raising of art and the improvement of virtue in the living, and in posterity to come'. Shaftesbury therefore saw the artist as having an active and important role to play in society, not merely a commentator on the sidelines, but someone with a positive influence on how people behave. 'The most delightful, the most engaging and pathetic' subjects to inspire poets, musicians and artists are those drawn from 'real life and from the passions', and these should encompass 'the beauty of sentiments, the grace of actions, the turn of characters, and the proportions and features of a human mind'.

Shaftesbury's general theories were expounded in his *Characteristicks*, first published in 1711. Shortly afterwards he published an essay which included the practical application of his philosophy to art, effectively providing a recipe for a painting on the subject of *The Judgement of Hercules*. The subject is a traditional one, depicting Hercules between the goddesses of Virtue and Pleasure, deciding which of the alternatives to pursue. Hercules should not be shown talking to the goddesses, said Shaftesbury, but be silent, stressing the concentrated thought of 'our pondering hero'. Shaftesbury chose the moment when Pleasure is beginning to lose ground to Virtue, the best point to show the 'consequent resolution of Hercules, and the choice he actually made of a life full of toil and hardship, under the conduct of virtue, for deliverance of mankind from tyranny and oppression'.

Shaftesbury went on to tell his imaginary painter in some detail how to set about organizing the composition, basing his

instructions on an actual painting of *The Judgement of Hercules* which he had just commissioned and which he reproduced on the title-page of the essay (78). Virtue, said Shaftesbury, should resemble Pallas Athena, patron goddess of Athens and goddess of war as well as the arts. To emphasize that the path of virtue was 'arduous and rocky', one foot of Virtue should be shown advanced 'in a sort of climbing action, over the rough and thorny ground'. The background should not be distracting, since architecture or 'other studied ornaments of the landscape-kind' would only be a 'mere incumbrance to the eye'. A golden rule for Shaftesbury was that 'whatever appears in a historical design, which is not essential to the action, serves only to confound the representation and perplex the mind'. Shaftesbury's principles were clearly and emphatically stated. They also seem potentially restrictive, capable of hampering creativity. But as Sir Joshua Reynolds (1723–92) later stated in one of his discourses at the Royal Academy, rules were 'fetters only to men of no genius'. Herein lies a sparking point in the later controversy generated by Romanticism: should rules be accepted or rejected? The Neoclassicists, for the most part, accepted them.

Hamilton's painting of *Achilles Bewailing the Death of Patroclus* and Shaftesbury's philosophy share a concern for morality, which Hamilton has tried to depict with historical accuracy, re-creating classical dress as best he can. For the very early period in Greek history about which Homer was writing there was no archaeological evidence available, and Hamilton has dressed his figures in the earliest classical garb that he knew. In the case of another painting in this Homer series, which required an architectural background, he used Doric forms, the earliest architecture known in the mid-eighteenth century, but in terms of the Homeric period actually too modern. This aim at historical verisimilitude was to be given great importance by the Neoclassical painters, who could not tolerate the historical vagaries of the previous, carefree generation in the first half of the eighteenth century. Examples of this new concern for authenticity abound, echoing the concept of *decorum* as expressed in seventeenth-century paintings by Nicolas Poussin (1594–1665) and others. If a painting of the *Flight into Egypt* was

78
Paolo de Matteis,
The Judgement of Hercules,
1712.
Oil on canvas;
198×256 cm,
78×100⅞in.
Ashmolean Museum, Oxford

being executed, Poussin had argued, then the artist must pay particular attention to Middle Eastern costumes and landscapes, not produce a generalized European image of no precise date. Many Neoclassical paintings show a similar line of thought. And because Poussin was such a strong force on the classically minded artists of the mid-eighteenth century, he was also stylistically influential on the first generation of Neoclassicists. They looked at classical antiquity for their inspiration, but it was filtered through the eyes of seventeenth-century classicists. Hamilton's *Achilles* is the heir equally of Roman bas-relief panels and of canvases by Poussin (80). The reinvigorated classicism of the mid-eighteenth century received a vital injection in its early stages from antecedents a century before.

Attempts at historical accuracy could be taken to greater lengths than Hamilton's *Achilles.* A more elaborate setting was one way of providing a virtuoso performance in historicity. One such opportunity arose out of a conversation over dinner in London between the

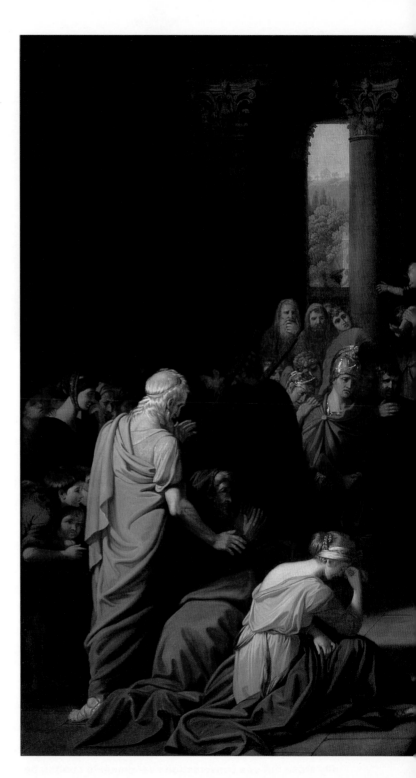

79
Benjamin West,
*Agrippina
Landing at
Brundisium with
the Ashes of
Germanicus*,
1768.
Oil on canvas;
164×240 cm,
64⁵⁄₈×94¹⁄₂ in.
Yale University Art
Gallery,
New Haven

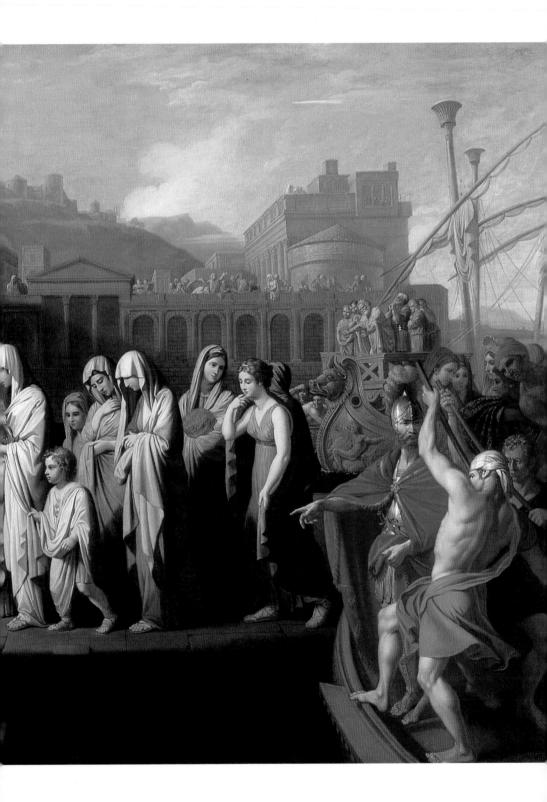

Archbishop of York, Dr Drummond, and the recently arrived American artist, Benjamin West (1738–1820). He had been on the Grand Tour, and while in Italy had been befriended by Gavin Hamilton, and met other leading figures in the newly emerging world of Neoclassicism. At the age of twenty-five West settled in London, in 1763, remaining a British resident for the rest of his life. The dinner-table conversation of a few years later led to the artist receiving his first commission for a history painting. He was already developing into a promising portraitist, and had also executed some history paintings. But this commission confirmed West's future career as one of the most important

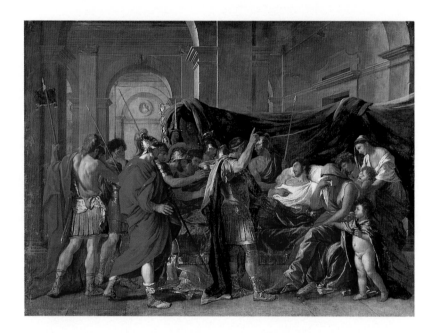

Neoclassical painters in Britain, the favourite artist of George III, the most highly paid painter of the period and President of the Royal Academy. His career is one of the great success stories of the Neoclassical period.

Dr Drummond wanted West to illustrate a poignant scene recounted by the Roman historian Tacitus, and read out the passage in which he described Agrippina with the ashes of her husband Germanicus Caesar landing at the port of Brundisium, now Brindisi, in southern Italy (79). Germanicus had been the

nephew and adopted son of the Emperor Tiberius, who feared him as a potential rival and, it was believed, had arranged for him to be poisoned while on an eastern Mediterranean campaign. This story of unmerited suspicion and treachery, ending in an unjust death and a pious widowhood, touched eighteenth-century sensibilities. As a demonstration of inconsolable but restrained grief, the story of Agrippina was to be illustrated by a variety of Neoclassical artists, including Gavin Hamilton. Agrippina joined the growing company of inconsolable widows who frequent the canvases and marbles of the Neoclassical period, widows who are historical and mythological, as well as contemporary. The sobbing female clutching or leaning on an urn became one of the most popular of images on mourning jewellery, funeral invitations and above all church monuments. Such imagery aroused in the virtuous viewer what at the time was regarded as a desirable state of 'pleasurable melancholy'.

In order to portray a scene worthy of Tacitus's story, West has tried to reconstruct the Roman port of Brundisium. Lacking archaeological evidence from southern Italy, West has used his knowledge of ancient Rome and also drawn on the illustrations in Robert Adam's book about the remains at Split. The result is one of the most ambitious historical re-creations painted in the 1760s, exemplifying the Neoclassical ideal of accuracy or *decorum*. In historical paintings of whatever period, West believed the scene should be presented as correctly as available knowledge would permit. The history painter had to be something of a scholar. The approach resembled that of modern film or television productions when historical veracity is required: close-up viewing necessitates accuracy in all details.

In the hands of the second-rate artist, history paintings could easily become stultified exercises in accurate re-creation. Vast numbers of this type of painting were executed during the Neoclassical period and later. But the good artist transcended these apparent restrictions, they were in no sense fetters (to use Reynolds's metaphor again).

80
Nicolas
Poussin,
*The Death of
Germanicus*,
1626–8.
Oil on canvas;
148×198cm,
58³⁄₈×78in.
Minneapolis
Institute of Arts

Agrippina's emotional state of mind as she lands in southern Italy is not revealed in her dignified bearing, and even the waiting crowd shows no signs of extreme distress. Such moderation, as advocated by Winckelmann, extended even to private encounters, as depicted in *Augustus and Cleopatra* (81) by Winckelmann's friend, the German painter Anton Raphael Mengs (1728–79), whom he regarded as one of the greatest of contemporary artists.

Mengs's *Augustus and Cleopatra* was commissioned by Henry Hoare (1705–85) for his country house at Stourhead in Wiltshire, where he had been developing his estate (see Chapter 4), and building up his art collection. Mengs's literary source for the picture was the famous *Lives* by the ancient Greek biographer Plutarch, whose accounts of historical figures in the classical past formed the basis of the eighteenth century's perception of them. The scene chosen from the life of Mark Antony is shortly after his death. His infatuation with the Egyptian princess Cleopatra, who aspired to the conquest of Rome, was one of the best-known episodes in Roman history. After Antony's death, she was visited, according to Plutarch, by Antony's rival and enemy Augustus. The visit was ostensibly one of condolence:

81
Anton Raphael Mengs, *Augustus and Cleopatra*, 1760–1. Oil on canvas; 118×83cm, 46½×32¾in. Hoare Collection, Stourhead

She was then in an undress, and lying negligently on a couch, but when the conqueror entered the apartment, though she had nothing on but a single robe, she arose hastily, and threw herself at his feet; her hair dishevelled, her voice trembling, her eyes sunk … and still some gleams of her native elegance might be seen to wander over her melancholy countenance.

This tense moment is dramatic yet calm; and readers would have been familiar with Cleopatra's subsequent disillusion and suicide, making this meeting between the conqueror and the vanquished all the more poignant.

At the same time that Mengs was working on this painting in Rome, he was executing a ceiling fresco for Winckelmann's patron, Cardinal Albani (1692–1779), for his new villa designed to display his growing collection of classical antiquities. The

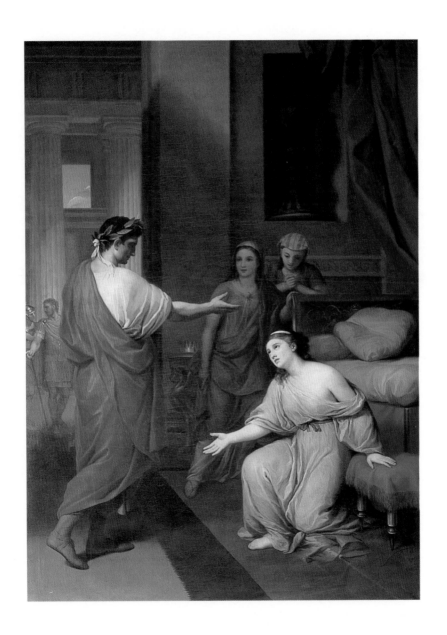

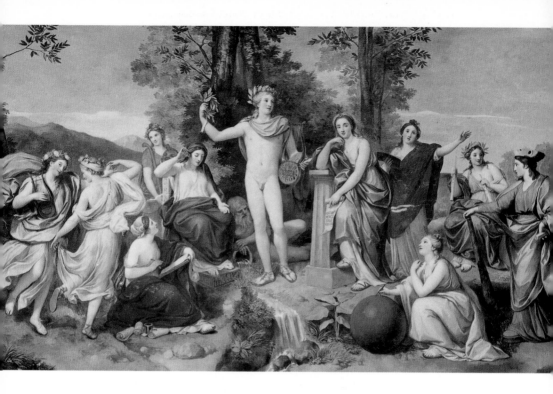

most appropriate subject for the ceiling's central picture was a
Parnassus, showing Apollo surrounded by the Muses (82).
The choice of Apollo, protector of the arts, was an allusion to the
role of Albani himself. Although in the small flanking roundels
Mengs used the customary perspectival illusionism to create
the effect of figures being viewed from below, he treats the main
picture as if it were a wall-painting. This enables him to create
a composition devoid of elaborate perspective, recalling the wall-
paintings recently discovered at Herculaneum. Mengs seems to
have set out to create a ceiling painting as unlike those of his
precursors in the seventeenth and early eighteenth centuries
as he could. The composition as a whole is not borrowed from
Herculaneum, but his treatment of the dancing figures to the
left undoubtedly derives from wall-paintings discovered there.
Dating from the early 1760s, and exactly contemporary with
Gavin Hamilton's Homer series, the Villa Albani ceiling is among
the earliest Neoclassical paintings. But unlike Hamilton's works,
Mengs's ceiling was in a villa frequented by travellers on the

83
Joseph-Marie
Vien,
*Seller of
Cupids*,
1763.
Oil on canvas;
95 × 119 cm,
37 ½ × 46 ⅞ in.
Musée National
du Château de
Fontainebleau

Grand Tour, and therefore a prominently visible statement of the newly emerging style.

In 1761, shortly after completing the ceiling and the Hoare commission, Mengs left Rome for Madrid, to work as court painter for Charles III of Spain; he stayed until 1769, returning then to Rome. It was in Italy that he was most active, and in the decade before his departure he was at the centre of Roman cultural life, and maintained a studio which attracted many young foreign artists (including West) as well as many Grand Tour patrons. While in Rome he also wrote his *Thoughts on Beauty* (*Gedanken über die Schönheit*), which he eventually published in 1762. Translated into several European languages, it helped spread the aesthetic principles Mengs shared with Winckelmann. They were even planning to write a book together on Greek taste, but it did not materialize.

The best-known reinterpretation of an ancient Roman wall-painting

82
Anton Raphael Mengs,
Parnassus,
1760–1.
Fresco;
3×6m,
10×20ft.
Villa Albani,
Rome

was the French painter Joseph-Marie Vien's (1716–1809) *Seller of Cupids* (83), exhibited in Paris in 1763. The artist based this work on an engraving published the year before by the Accademia Ercolanese, although the wall-painting in this instance was not from Herculaneum itself but from the nearby site of Gragnano (84). The composition of this wall-painting proved a popular one with Neoclassical artists, reappearing in countless forms, including ceramics, textiles and plaster decorations (see 212). Vien's painting, however, is not a straightforward copy, since apart from reversing the engraving, many of its details and its setting are different. Stimulated by the print, he created a new work in a classical spirit that is not a mere pastiche. It is a work full of charm, telling a straightforward story, with no underlying moral message. It represents a lighter side to Neoclassical history painting, at an early point when the style was just emerging. From then on, austerity and lightness would run in tandem.

In the latter vein, one of the most popular subjects in classical

84
Plate from
*Antichità
d'Ercolano*,
volume III,
showing
a Seller of
Cupids,1762.
Engraving;
23×32cm,
9×12⁵⁄₈in

mythology during the Neoclassical period concerned the origin of the art of drawing. The story tells of a girl in Corinth, on the Greek mainland, drawing the silhouette of her lover on a wall, to serve as a permanent reminder during his absence. For Neoclassical artists the charm of this amorous scene had an added significance, since it stressed the importance of outline in the earliest development of art. Outline was regarded in the Neoclassical period as a prime characteristic of ancient art, as we have seen expounded by Winckelmann, and that characteristic is strikingly demonstrated in paintings and illustrations of the *Corinthian Maid* or *The Invention of Drawing*, as such compositions were often entitled. In its simplest and most popular form, this kind of outline drawing of a portrait head formed the basis of the countless silhouettes, coloured in matt black paint or cut out of paper, produced in the Neoclassical period. Images of the Corinthian Maid frequently occur in the work of artists across Europe, both professional and amateur.

Queen Charlotte (1744–1818), wife of George III, drew throughout her life; her daughters also drew profusely. Drawing was a desirable attainment for amateurs of either sex, and Queen Charlotte tackled flowers, landscapes and people. When learning how to draw the human figure, one instructor taught her to use principles of geometry to build up figures; the resulting works include *The Invention of Drawing* (85). In terms of anatomy the figures are badly proportioned and articulated; but the drawing provides a fascinating example of an amateur artist in a position of considerable influence in terms of patronage herself trying out the Neoclassical style, and choosing to illustrate one of the most popular of classical scenes.

In France in the later eighteenth century, members of the royal household sought out talented artists who could produce works to furnish the many royal residences. Jacques-Louis David (1748–1825), one of the most promising painters of the younger generation, was approached. (His early altarpiece of *St Roch* will be discussed later in this chapter.) The outcome

was the royal commission for the *Oath of the Horatii* (86), which not only established the artist's European reputation in his own lifetime, but became one of the best-known images of all Neoclassical art.

David (87) was allowed to choose his own subject. He selected an incident combining heroism and patriotic self-sacrifice. The Horatii were triplet brothers living in the kingdom of Rome in the seventh century BC at a time when cattle raids along the border with the neighbouring kingdom of Alba were becoming warlike. To settle the conflict each side agreed to nominate three men to fight it out. The emotional complications of the story are ignored by David for his painting, since one of the three Horatii was married to the sister of one of the three opposing fighters from a family representing Alba, and one of them in turn was married to the sister of one of the Horatii. David instead concentrates on the Horatii – the eventual winners – and invents the incident of them swearing an oath in the presence of their father. In other words, David took a classical story well known to contemporaries in either book or play (as *Les Horaces* by Pierre Corneille, 1640), and even as a ballet, and adapted it to suit his own ends.

His composition is dominated by the taking of the oath which anticipates a future act of heroism. Proud and defiant, grouped in harshly angular poses, the men are in marked contrast to the group of women and children, whose bowed forms signify resignation at the inevitable. The active and passive halves of the composition are both handled with restraint: the men do not shout, the women do not cry. The intensity of emotion is all the greater for being implied rather than made explicit; it is the restraint Winckelmann regarded as a prime characteristic of classical art.

An examination of David's preliminary drawings for the *Oath of the Horatii* shows that he deliberately worked towards this restraint. He altered the position of figures so that they do not look at us, except for the little boy, creating a self-contained world undisturbed by contact with the spectator. Although the

85
Queen
Charlotte,
*The Invention of
Drawing*,
Not dated.
Pen, brush and
ink;
25·3×30·6cm,
10×12in.
Royal Collection,
Windsor Castle

setting is a room, it is stark and scarcely furnished, devoid of superfluous elements which might distract attention. A background staircase and irrelevant extra figure were removed (88). Even the space within which the scene is being enacted is restricted. The figures do not twist and turn, but instead present a sequence of clear-cut forms from left to right, acting out their roles as if on a very narrow stage.

David derived this treatment of space mainly from Roman sculptural reliefs, which he drew extensively while studying in Rome in the later 1770s; he had even invented classical friezes showing soldiers fighting and dying, worked up into elaborately finished drawings. The enormous importance to him of the classical ambience of Rome led David to return there to the paint the *Oath of the Horatii*. In the light of the reception given to the finished painting, the special journey back to Italy was fully justified.

Occasionally pictures acquire a retrospective intepretation, a meaning not intended by the artist at the time of executing the work but found relevant at some later date. The *Oath of the*

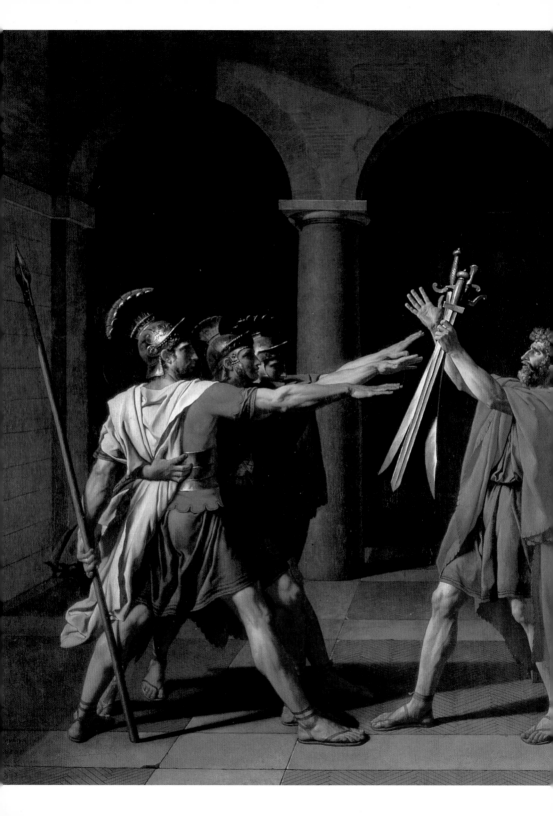

86
Jacques-Louis
David,
Oath of the
Horatii,
1784–5.
Oil on canvas;
330×425 cm,
130×167 ½ in.
Musée du
Louvre, Paris

Horatii is a case in point. The French Revolution was five years away when David painted it, but in the early 1790s the painting acquired a new interpretation as a gesture of allegiance to the newly declared French Republic, re-enacted at a demonstration in Paris in 1794 organized by David and Robespierre. Until the Revolution, David was not involved in contemporary politics, but the events of the 1790s changed that. On one level, therefore, the *Horatii* resembles classical moral history pieces discussed earlier, but on another level it has become politically engaged. That new dimension became more evident in some of David's subsequent art.

Heroism and loyalty were major themes in David's works in the 1780s. In the year before he executed the *Horatii* but was already considering it as a subject for the royal commission, he had completed a painting of *Andromache Bewailing the Death of Hector* (89). Its composition went through a gestation very similar to that of the *Horatii*, with David gradually reducing the anxiety on the widow's face, and changing a distraught child into one that is still troubled, but has been comforted. The viewer can therefore concentrate on Andromache's grief and on the noble body of the great hero. The furnishings are more ornate than in the *Horatii*, allowing David to depict an elaborately carved bed that illustrates the anticipatory hopes and the actual horror of battle. David is showing all his skills as a superb observer of nature combined with his scholarly antiquarian knowledge; his composition borrows ideas from Gavin Hamilton and before him Poussin (80). David's large canvas, executed as the 'reception piece' which would enable him to become a full member of the Academy, was one of the finest Neoclassical paintings inspired by the *Iliad*.

For a private commission, David chose an even more austere subject from Greek history, *The Death of Socrates* (90). The philosopher Socrates had been ordered to commit suicide by poison, having been found guilty of corrupting the minds of young men, in particular some of the outspoken critics of

87
Jacques-Louis David,
Self-portrait,
1791.
Oil on canvas;
64×53 cm,
25¼×20⅞ in.
Galleria degli
Uffizi, Florence

88
Jacques-Louis David,
Preliminary
drawing for *Oath
of the Horatii*,
c.1782.
Pen and ink and
wash;
22·9×33·3 cm,
9×13⅛ in.
Musée des
Beaux-Arts, Lille

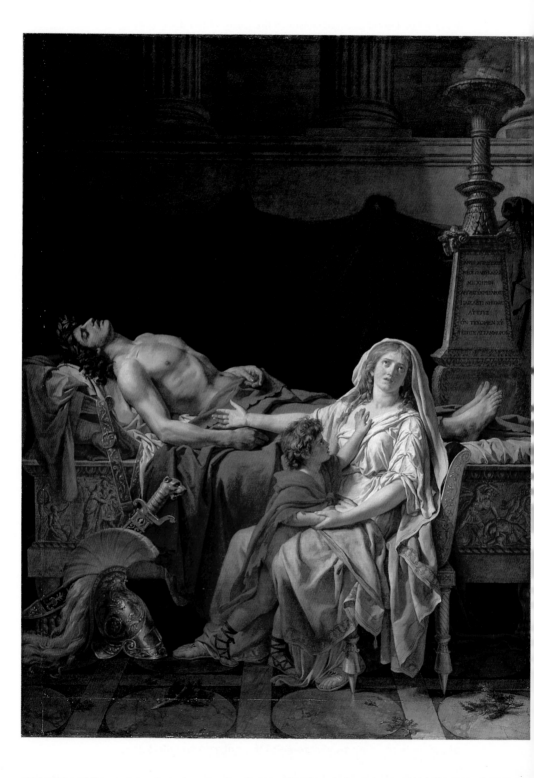

democracy. Partly based on Plato's account, but including some disciples who were not actually present, David's Socrates sits in the centre preaching, with one arm raised in emphasis while the other stretches towards the cup of poison. Seemingly indifferent to his imminent death, the great advocate of an ideal was not prepared to recant. Underlying David's choice of subject may be a critique of the injustices committed by the authorities in contemporary France, implied rather than overt since David was not yet an active politician. Like the *Horatii*, this painting was later endowed with a new meaning, being engraved as a propaganda print in 1795 as part of the campaign against Robespierre, who was largely responsible for the instigation of the period of the 'Terror' and its guillotine.

The austere stoicism of *The Death of Socrates*, with its repressed emotion comparable to that of the *Horatii*, was echoed in an important canvas David painted in the year the Revolution broke out. So successful had his first royal commission been that David was asked to execute a second work. He chose *The Lictors Returning to Brutus the Bodies of his Sons* (92). The full title from the exhibition catalogue in 1789 tells most of the story David selected: *Brutus, first consul, has returned to his house having condemned his two sons who had joined the Tarquins and plotted against Roman liberty; lictors bring back the bodies so that they may be given burial*. As in a Greek tragedy when the full horror of an event is not shown on the stage but is left to the audience's imaginations, so David does not portray the actual executions, although he had earlier thought of doing so. All we see are the half-hidden stretchers borne by the lictors (officers who attended rulers and magistrates), the bright light shining through the doorway picking out the sons' limbs. The outcome of their treacherous act is made emotionally more intense because of this restraint, since we read the event indirectly through the gestures of the distraught mother and daughters (91). Only then do we focus on Brutus himself, resolutely alone, sitting in a shadow. Behind him, interposed between father and sons, looms the silhouette of a statue of

89
Jacques-Louis
David,
*Andromache
Bewailing the
Death of Hector*,
1783.
Oil on canvas;
275×203cm,
108⅜×80in.
École Nationale
Supérieure des
Beaux-Arts,
Paris

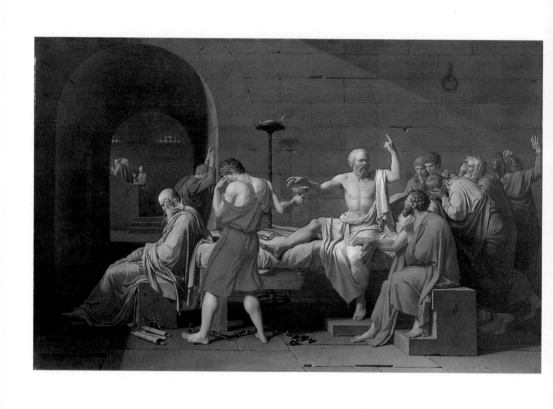

Roma. Brutus is having to face the consequences of putting his duties to the Republican state, as first consul, before his personal duties as a father. This priority of the Republic over all other matters was rapidly accepted as the picture's meaning, and was to be seized upon by the Revolutionary idealists in the 1790s and given a contemporary relevance. As David planned the painting before the outbreak of the Revolution, it is impossible to say whether *Brutus* was intended to be a political statement, especially in view of the patron. What is certain, however, is that it became a political statement, of great visual power. (For a discussion of the political role of David's art at the time of the Revolution, see Chapter 6.)

Stirring tales of valour and virtue did not always have to come from the classical past of Greece and Rome. Events from the Bible, from Dante, Shakespeare and other writers, as well as from the chronicles of the medieval period, provided an enormous store of subject matter for history paintings. When artists illustrated scenes from the histories of their own countries, they contributed – not necessarily consciously – to the growing awareness of national identities that emerged during the eighteenth century.

A defiant example of incipient nationalism was commissioned for the Town Hall (Rathaus) of Zurich from a Swiss artist who had settled in London. Henry Fuseli (1741–1825) was returning to England after a lengthy Grand Tour spent mostly in Rome. Shortly before leaving the city he started to make drawings of an important incident in Swiss medieval history, and completed the oil painting back in London in 1780. *The Oath of the Rütli* (93) records an event in 1307, when the oppressive domination of the country by the Austrians had become intolerable. The most famous name associated with the struggle for Swiss independence was the semi-legendary hero William Tell. But rather than concentrate on one individual, the subject considered appropriate for the commission was the occasion when an anonymous representative from each of the three Swiss cantons gathered secretly in a wood called the Rütli, to the west of Lake Uri. There they swore

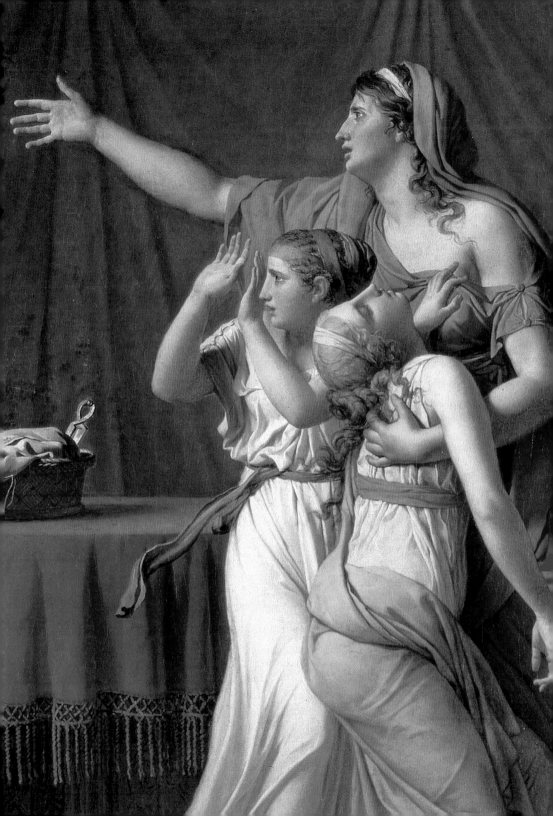

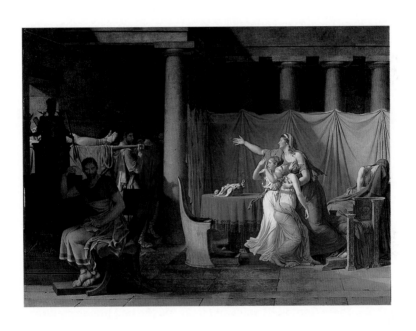

an oath to drive out the Austrians, the Habsburgs, in an uprising which was soon to be successful.

The subject of Fuseli's painting was based on legend rather than documented fact, and probably derived from a chronicle written two centuries after the event; a more popular account of the origins of modern Switzerland appeared in the year Fuseli's painting was completed (it was this publication that later inspired Schiller's play *William Tell* in 1804). While Fuseli's *Oath* is heroic, the anonymity of the participants makes its message universal, symbolizing allegiance to a political cause, and the courage of the oppressed in any period of history. Fuseli did not set the scene specifically in the medieval period, and later in life was to express considerable scorn for what he called 'the lumber rooms of heraldry and drapery', dismissing the merit of accurate historical re-creations. The three conspirators in the *Oath* are dressed in an ambiguous, vaguely medieval manner, suggesting that Fuseli meant his picture to be read in both a particular and a more general sense.

A few years later George III set aside the Audience Chamber in Windsor Castle for a permanent display of scenes depicting the glorious military achievements of the English medieval monarch Edward III. He had built the castle in the form that George III had inherited it, so that the chosen theme for the Audience Chamber was particularly appropriate. The king was fond of Windsor, and the royal family had made it their main residence from the late 1770s. There George III enjoyed family life (he had fifteen children), as well as tree-planting, farming and hunting. As part of the refurbishment of the castle, the series of paintings for the Audience Chamber commissioned between 1786 and 1789 from the king's favourite artist, Benjamin West, were to be the most important medieval subject paintings executed in Europe during the eighteenth century. Unfortunately the Audience Chamber was subsequently remodelled and West's series of canvases dispersed.

While on display the room presented a unique statement of national pride in an important public space used by the monarch. His fourteenth-century predecessor had undertaken successful

93
Henry Fuseli,
The Oath of the Rütli,
1780.
Oil on canvas;
267×178 cm,
105⅛×70⅛ in.
Kunsthaus, Zurich

military campaigns against the French. His daring crossing of the River Somme in northern France in 1346 had led immediately to the Battle of Crécy, where the victorious English forces had been outnumbered three to one. This had been followed by Edward III's taking of Calais. While abroad, his wife had fended off the invading Scots, who were French allies, at the Battle of Neville's Cross, near Durham in northern England. Ten years later, at the Battle of Poitiers, the King of France had been captured by English forces under the command of Edward the Black Prince. All these incidents were depicted by West, some on an enormous scale. He also included in the series Edward III's chivalric institution of the Order of the Garter (94). This order of knights was closely connected with Windsor, where it was instituted and where a college was founded to act as its spiritual centre. In West's painting the altar is flanked by the kneeling figures of the king and Prince of Wales, with Edward's wife, Queen Philippa, kneeling in the centre; in the shadow of the balcony above the altar, the King of Scotland, captured at Neville's Cross, looks down on the ceremony.

The enormous undertaking of this series involved West in a great

deal of research in archival and other sources, such as the royal armoury, to make sure that historical details were as acccurate as he would have made them for a Greek or Roman history piece. He made a mistake with the architecture, however, since the Gothic nave in St George's Chapel at Windsor was not built until a century and a half after the order was instituted. Apart from this slip (not the only such instance in his career), West's series was a brave attempt at medieval revivalism, justifying his official appointment as 'Historical Painter to the King', who rewarded the artist to the tune of £6,300, roughly equivalent today to half a million pounds or three quarters of a million dollars.

The combined impact of these scenes must have been over-whelming, accompanied as they were by all the decorative pomp of a room dominated by a throne. Audience chambers and throne rooms were important spaces for the display of images of power: a point that was not to be lost, a few years later, on Napoleon. No other monarch in Europe in the late eighteenth century conceived a scheme comparable to George III's, which perhaps had been suggested to him by Richard Hurd, author of *Letters on Chivalry and Romance* (1762). West's paintings are not just re-creations of important incidents in English medieval history, but also record the chivalrous and compassionate aspects of Edward III and the Black Prince. These military virtues could only be demonstrated – according to the code of chivalry – by the nobility and gentry.

94
Benjamin West,
The Institution of the Order of the Garter, 1787.
Oil on canvas; 287×448cm, 113×176½ in.
Royal Collection, on loan to the Palace of Westminster

West made other significant contributions to the decoration of Windsor Castle, using markedly different source material: the Bible. However, the name by which the eighteenth century is sometimes known, the Age of Reason, implies a period dominated by humanism. By the 1790s, Revolutionary France was overtly anti-Christian, and the apparent decline of religion, at least in its Christian manifestations, as the century progressed is borne out in the visual arts. Altarpieces and murals, once commissioned on a regular basis, were far less prominent among the works of contemporary artists by the time the Neoclassical period began. New movements within the Christian faith during the

eighteenth century did not improve the situation, since such movements as John Wesley's Methodism and the mysticism expounded by Emanuel Swedenborg were not concerned with a visual promotion of their message but relied on preaching and publications.

The great days of religious painting were over. But commissions from churches and private patrons did not completely dry up, and artists still painted the occasional speculative religious piece in the hope of finding a buyer. It is easy to see the eighteenth century in pagan terms, but that would be misleading. Commissions, some of them important, were being given for new religious works in both old and new buildings, ranging from altarpieces to the newly fashionable painted glass windows that were replacing the traditional stained ones. Works such as these, however, pale beside the uninterrupted flow of religious musical commissions throughout the Neoclassical period. There is no pictorial equivalent, in terms of stature, to some of the masses and other Christian works composed by Mozart, Haydn and Beethoven. Only with the full flowering of Romanticism was sacred painting to flourish again. Then artists would recognize, as the great Romantic writer Chateaubriand wrote in his *Genius of Christianity* (*Génie du christianisme*) published in 1802: 'Religion has provided the arts with subjects more beautiful, more rich, more romantic and more touching than mythological subjects.'

A visitor to the Salon exhibition in Paris in 1767 would have noticed on the crowded walls of the main room two colossal new altarpieces towering over the other paintings. Classically inspired history pieces were in abundance, as were antique-inspired marble figures and portrait busts. In this pagan context, the two altarpieces prompted a lively debate. The church of St-Roch in Paris had commissioned them for two of its chapels, in what was one of the most important new ecclesiastical buildings in Paris in the late seventeenth and eighteenth centuries. Joseph-Marie Vien was given the subject of *St Denis Preaching*

the Faith in France (95) and Gabriel-François Doyen (1726–1806) *The Miracle of the Plague* (96). Doyen was given the moment when Ste Geneviève, the protectress of Paris, had halted the disastrous epidemic of 1129. He captured all the turbulence and excitement appropriate to a scene of disaster, in a style reminiscent of that of the Baroque period of the previous century. Vien's subject and his treatment of it, on the other hand, are far less dramatic. St Denis is shown preaching on the steps of a Roman temple to an enthralled crowd of Gauls in third-century France. The subject is intrinsically more static than Doyen's, more in keeping with the restraint Vien had shown in his *Seller of Cupids* (83). In works of that kind his absorption in the art of the classical past was used to good effect. But Vien unfortunately showed in his altarpiece that, in a different context and on a bigger scale, classical rigour could become stylized and frigid. He was being more innovative than Doyen, in trying harder to get away from the overpowering influence on religious art of the Renaissance and the seventeenth century. But in doing so, Vien's altarpiece highlights early in the development of Neoclassicism a potentially dangerous flaw in the style, which in the hands of less talented artists resulted in works of lifeless insipidity. Restraint need not be synonymous with emptiness.

In his comments on these two altarpieces, the French philospher and writer Denis Diderot (1713–84) identified this problem. While admiring Vien's clarity and nobility of composition, Diderot had to admit that his altarpiece was lifeless. The saint, according to Diderot, should be preaching with more obvious zeal which in real life would undoubtedly have had a profound impact on his listeners. Diderot's comments and those of his fellow critics, in which most favoured Doyen's altarpiece, make interesting reading. Some argued that Vien was not to blame, the fault lay in the subject. It was too static, and perhaps an alternative incident in the saint's life would have made a better picture. Vien should have chosen, one critic said, the moment when the Gauls, inspired by St Denis's preaching, smashed up all their idols in a scene of wild disorder, demonstrating the positive and instant results of the

95
Joseph-Marie Vien,
St Denis Preaching the Faith in France,
1763–7.
Oil on canvas;
665×393cm,
261×154in.
St-Roch, Paris

96
Gabriel-François Doyen,
The Miracle of the Plague,
1767.
Oil on canvas;
665×393cm,
261×154in.
St-Roch, Paris

saint's ability to proselytize. But this scene would have been alien to Vien's way of thinking. Throughout his long life, he remained committed to a concept of art based on classical restraint. It was this sense of unswerving dedication that the younger generation of Neoclassicists, especially in France in David's circle, much respected. Even the *St Denis* altarpiece came to be admired later in the century for precisely those qualities which critics had condemned when the painting was first exhibited.

Interestingly, David's first critical success was not a classical piece but a religious commission. The Public Health Office in Marseilles, as controllers of the quarantine hospital, wanted a new work for its chapel to commemorate the plague of 1720 in which thousands had died. David, while studying at the French Academy in Rome, was chosen for the commission and he completed the painting in 1780: *St Roch Interceding with the Virgin for the Plague-stricken* (97). Plague, little understood medically, was regarded as one of the many natural disasters to which mankind was inevitably subjected. Artists in the eighteenth century, however, rarely tackled disease, since the transformation of the human body into a repulsive image was far removed from concepts of ideal beauty.

David's interpretation stresses both the anguished and pathetic expressions of those stricken and the pious earnestness of the pleading saint, who had himself suffered from a plague in the fourteenth century. Contemporaries admired the strength and naturalism of David's powerful imagery. Here was an unpleasant side of the real world combined with the aspirations of the Christian religion: the actual and the ethereal combined in one image as in traditional Christian iconography. David went to Italian seventeenth-century pictorial sources rather than the antique to produce a painting of horror, but it is a horror modified, as Diderot expressed it, by both 'the taste of art and your admiration for the artist'. 'Taste' is that most useful of words – hard to define yet immediately conveying the sense of an acceptable norm beyond which, in this case, an artist has not transgressed.

97
Jacques-Louis
David,
*St Roch
Interceding with
the Virgin for the
Plague-stricken*,
1780.
Oil on canvas;
260×195 cm,
102½×76⅞ in.
Musée des
Beaux-Arts,
Marseilles

For sheer range of religious paintings one has to cross the
Channel and return to the flourishing studio of Benjamin West,
who was employing five assistants to cope with a constant
stream of large-scale commissions. They were mainly ordered by
George III for Windsor Castle, but others included altarpieces in
cathedrals, parish churches and hospital chapels. It is ironic that
the Protestant Church in England, not a great patron of art in the
eighteenth century, should have been responsible for this outburst
of energy by an American emigré. George III as sovereign was the
head not only of government but also of the established Church,
a dual role that undoubtedly influenced his refurbishment of
Windsor Castle. Commissions for paintings included, in addition
to the medieval history series, numerous religious works, oil
paintings as well as window designs, for the Royal Chapel and
St George's Chapel.

The largest picture in the world: so claimed a contemporary
guidebook in describing West's cartoon for the east window of
St George's Chapel, commissioned in 1796. Measuring 10 by 9 m
(some 33 by 30 ft), the full-scale drawing of the *Crucifixion*
prepared for the glass-painter was truly monumental. West had

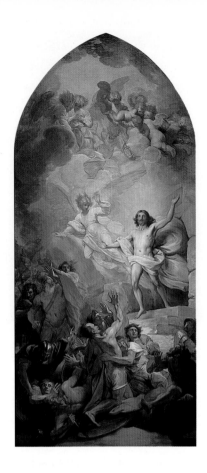

**98
Benjamin
West**,
Resurrection,
*c.*1782.
Oil on canvas;
300×132 cm,
118¼ ×52 in.
Museo de Arte
de Ponce,
Puerto Rico

already in about 1782 removed the equally large west window and replaced it with a *Resurrection*. He had also installed three aisle windows, and painted a large altarpiece of the *Last Supper*. Eighteenth-century glass windows were treated like paintings. Artists would produce an oil on canvas to show the complete composition, with figures spreading across the surface regardless of where the large panes of glass would join. One such oil by West (98) shows the central portion of his *Resurrection* window. New church windows were no longer composed of many tiny pieces of coloured glass, like medieval stained glass windows. The colours of the forms of the composition were brushed on as if the surface was a transparent canvas.

West's windows were sombre in colouring, restricting the amount of daylight entering the chapel. They lacked the jewel-like colours

of older glass windows, and therefore completely transformed the appearance of an important medieval chapel. The windows at either end of the nave were so vast the effect must have been akin to film screens in a darkly lit cinema. West seems to have been given a completely free hand in a project that was almost megalo-maniac, and was certainly considered by some contemporaries to have committed an act of vandalism. They would have been delighted when all West's windows were dismantled in the mid-nineteenth century.

The path of the Neoclassical artist, therefore, was not necessarily narrowly bounded by reference to Greek and Roman art. In terms of style and sources of inspiration, West's religious paintings and windows for Windsor had little to do with the classical past. Any hint of that past disappears in the proposed Revelation Chamber commissioned by the immensely wealthy William Beckford. His architect's brief was for a room with walls one and a half metres thick, in order to accommodate coffins, including Beckford's own. Strangers would not be admitted into the room, but only allowed to view it through metal gratings. All the paintings and glass windows were commissioned from West, illustrating scenes from the last book of the Bible, the Book of Revelation. This macabre commission, not in the end carried out, would have formed part of the vast new country house being built for Beckford from 1796, in the Gothic Revival style, on the scale of a medieval abbey or cathedral. West's contributions to this project were ultimately displayed throughout the house, Fonthill Abbey in Wiltshire, where they formed part of Beckford's extraordinary magpie collection. The styles in which Neoclassical artists worked could be equally varied.

Contemporary history, an important source of inspiration, raised a particular dilemma for Neoclassical artists. How do you dress a contemporary hero when commemorating his death, either on canvas or in marble? Do you portray him in the naval or military uniform in which he would have been recognized at the time, or in a classical toga or even naked, placing him in the timeless, heroic

classical past? These questions (already touched on in the discussion of Houdon's marble sculpture of George Washington in Chapter 2) were regarded as important in the Neoclassical period. The debate revolved especially around West's painting *Death of General Wolfe* (100). James Wolfe had died in battle in 1759 after his daring, and successful, scaling of the Heights of Abraham in order to capture Quebec from the French. The painting thus commemorates a turning-point in the struggle for domination of North America, and although other artists also painted the death of Wolfe, West's version of 1771 was by far the most famous. Here was an icon of a great contemporary hero to which the general public responded, buying hundreds of the reproductive prints of the picture issued a few years later and generating a substantial income for the artist.

At first sight the painting looks convincingly realistic. West had taken trouble to get the topography right, and has summarized the events of the battle in the background. Centre stage is dominated by the dying general, who the night before together with his troops had climbed up to the Plains and taken the French by surprise. His daring strategy paid off, and Wolfe became the greatest British national hero of the century, rivalled only later by Nelson. However, West has amended the truth. He has gathered around Wolfe a group of men, some of whom were not actually present at the scene. The most notable extra person is the North American Indian, included at a time when none were serving with the British army. He represents the original inhabitants of Canada, and of British imperialist ambitions there. He is a noble ideal, analogous to an ancient god: as West had said of the *Apollo Belvedere* when he first saw it in Rome, 'My God, how like it is to a young Mohawk warrior.' But the most striking element in the composition is the pose of the dying Wolfe. He is supported in exactly the same way as the dead body of Christ when taken down from the cross, represented for centuries in depictions of the Deposition, and therefore familiar to any viewer. A well-known Christian image has been secularized to heighten the potency of the hero's martyrdom. (Another example of such a secularization, this time during the

French Revolution, is discussed in Chapter 6.)

West, however, was not prepared to take his idealization to the point of heroic nudity. The first biography of the artist (1820) included what claimed to be a report of a conversation between West and Reynolds at the time the *Death of Wolfe* was being painted. Although probably apocryphal, the opposing views held by the two painters are concisely expressed. Modern dress, Reynolds argued, was not suitable for the 'inherent greatness' of the subject, a point he reiterated a few years later in a discourse at the Royal Academy: 'The desire of transmitting to posterity the shape of modern dress must be acknowledged to be purchased at a prodigious price, even the price of every thing that is valuable in art.' West countered by saying that, as the battle in Canada had taken place in the current century, the appropriate dress would be that of the present day, not that of ancient Greece and Rome:

… a period of time when no such nations, nor heroes in their costume, any longer existed. The subject I have to represent is the conquest of a great province of America by the British troops. It is a topic that history will proudly record, and the same truth that guides the pen of the historian should govern the pencil of the artist. I consider myself as undertaking to tell this great event to the eyes of the world; but if, instead of the facts of the transaction, I represent classical fictions, how shall I be understood by posterity? The only reason for adopting the Greek and Roman dresses is the picturesque forms of which their drapery is susceptible; but is this an advantage for which all the truth and propriety of the subject should be sacrificed? I want to mark the date, the place, the parties engaged in the event.

'Marking' a contemporary event or aspect of life by a Neoclassical artist was not always as clear-cut as West in this purported conversation would have us believe. Solutions to the death of Nelson could be more complex than this, as he was to find (see 161–2). If one looks beyond the confines of contemporary and patriotic hero-worshipping to the wider expanse of modern life, one finds no straightfoward or consistent solutions, in visual terms, to the growth of commerce, manufacturing and science in

the eighteenth century. West again provides some good examples of painters' responses, but before examing two further paintings by him, let us look at one from a series of large canvases executed for the Society of Arts in London by the painter James Barry (1741–1806).

The Society had been established in 1754 to encourage not only the arts but also industry and agriculture, through prizes, lectures, exhibitions and other means. It was the only institution of its kind in Britain. In the early 1770s it moved into handsome new Neoclassical premises designed by Robert and James Adam. The principal room was designed for lectures and formal occasions, and it was for the walls of this room that James Barry undertook in 1777 a grandiose scheme of paintings on the theme of the progress of civilization from ancient Greece to the present day. Barry planned the layout and subject matter himself, starting with a scene of Orpheus singing to the accompaniment of his lyre, and including among the modern subjects *Commerce or the Triumph of the Thames* (99).

In this composition, Thames, based on sculptures of ancient Roman river gods, is borne along by some of the great seamen of British history, including Raleigh and Drake, and more recently Cook, aided by a mariner's compass, which had enabled modern navigation to arrive at 'a certainty, importance and magnitude superior to anything known in the ancient world'. This added gloss comes from Barry's own published explanation of the series, which provides information that might otherwise escape notice. Overhead hovers Mercury, as god of commerce, 'summoning the nations together'. To the left, the four corners of the globe bring their produce to Father Thames: Europe brings wine and grapes, Asia silk and cottons, Africa slaves and America furs. To the right, naked figures of nereids, or sea-nymphs, carry produce from Britain's newly developing industrial cities such as Birmingham and Manchester.

In the absence of any accepted tradition on how to handle an allegorical representation of industry, artists in the Neoclassical

99
James Barry,
Commerce or the Triumph of the Thames,
1777–84,
altered 1801.
Oil on canvas;
356×457 cm,
140¼×180 in.
In the Great Room of the Royal Society of Arts, London

100
Benjamin West,
Death of General Wolfe,
1770.
Oil on canvas;
152·6×214·5 cm,
60×84½ in.
National Gallery of Canada, Ottawa

period resorted to classical prototypes and put them to new uses. Barry employs classical deities to perform eighteenth-century duties, combining them with modern figures. Manufacturers also resorted to classical imagery when they wished to represent industry allegorically (see 120); this new tradition lasted well into the nineteenth century, including allegories at industrial exhibitions over entrance doors and on certificates of merit, and elsewhere such as embroideries on trade union banners.

Contemporary reactions to Barry's fusion of old and new in his *Triumph of the Thames* were mixed. The composition was unfortunately not helped by the artist's later addition in 1801 of the background naval pillar, which is irrelevant to the main theme, and is Barry's visionary idea for a commemoration to the Napoleonic war dead, which other artists were also designing at that time. Earlier comments on the large canvas ranged from a newspaper's dismissal of it as 'ludicrous in the extreme' to the more benign reaction of the great writer Dr Johnson that the series as a whole showed 'a grasp of mind which you will find nowhere else'. Whatever the case, Barry's ambitious overall scheme for the room was unique in Britain in the Neoclassical period, and in his *Triumph of the Thames* he was attempting to embrace a new range of subject matter opened up by the country's modern commercial prosperity.

A more ambivalent response to the use of classical imagery in the context of modern commerce occurs in a set of paintings on this theme commissioned from West in 1787 for a ceiling in the Queen's Lodge at Windsor. Although he treated some of the scenes as full-blown traditional allegories, when he came to the scenes devoted to agriculture and manufactures, he adopted the approach of a genre painter, depicting a contemporary, rural idyll at harvest time, and a crowded workshop that is ambiguously ancient and modern (101). The latter subject is known only from West's preparatory design, usually by the title of *Etruria* or *Manufactory Giving Support*

101
Benjamin West,
British Manufactory; a Sketch,
1791.
Oil on paper mounted on wood;
51×65cm,
20×25⅝in.
Cleveland Museum of Art

to Industry. Various activities are going on, but pride of place goes to ceramics. Since one of the naked boys in the foreground is holding what is presumably Josiah Wedgwood's first copy of the famous antique Portland Vase, which he was making at the time West was designing the ceiling, this painting was subsequently named after Wedgwood's Etruria factory at Stoke-on-Trent. West clearly had the great industrialist in mind – the only occasion when a contemporary painter paid homage to him in this way. In view of where the painting was to be sited, it is also an oblique reference to the fact that Wedgwood had called his basic range of pottery 'Queen's Ware', in honour of Queen Charlotte's patronage.

The ceramic industry in the Neoclassical period was still close to its classical counterpart in the use of materials and techniques, making an alliance between present and past within the same composition not too incongruous. The discovery of electricity, on the other hand, posed more of a problem. Thus, when West came to paint a posthumous portrait of his fellow American and

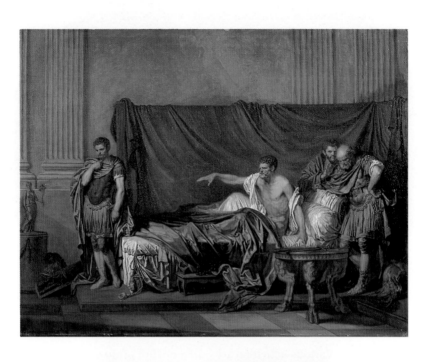

friend Benjamin Franklin, proving the identity of lightning and electricity, the discovery is attended by helpful cupids (103). Against a background of lightning, Franklin is shown closely observing a spark of electricity passing from a key threaded to a kite string on to his clenched fist. These details were well documented, and West has followed them meticulously; but he has added the fiction of classical laboratory assistants. The fusion of one of the newest scientific discoveries with antique imagery was acceptable, so strong was the overriding influence of classicism.

Queen Charlotte's experiments in Neoclassical subject matter were symptomatic of a much wider contemporary trend. Many artists who were not wholly committed to Neoclassicism as the main style of their careers, nevertheless produced a small body of work that can be regarded as Neoclassical. Such artists were often trying out the currently fashionable style, and finding it unsympathetic, abandoned it. Some, such as Goya and Blake, one would normally expect to find in a book on Romanticism. Occasionally an artist would paint an untypical Neoclassical work, almost as an act of bravado, but never repeating the exercise. One such artist was Jean-Baptiste Greuze (1725–1805).

In 1769 he exhibited in Paris a canvas depicting *Septimius Severus Reproaching Caracalla* (102). Nearly every reaction was hostile, epitomized by one commentator who said bluntly that 'the historical genre is foreign to you'. Up to this point in his career, Greuze had concentrated on portraits and contemporary genre scenes, including such subjects as *Filial Piety* and *A Marriage Contract*. However, he wanted to be accepted for full membership by the Academy in its highest category, that of history painting. A hierarchy of types of painting had become firmly entrenched by the mid-eighteenth century, with history painting taking precedence over genre scenes, portraits, landscapes and still-lifes. With this in mind, Greuze began experimenting with historical subjects in the late 1760s, and

obviously hoped that with *Septimius Severus* he would achieve his goal of rising above the category of a mere genre painter. The gamble did not pay off. Not only did contemporaries dislike the painting, the members of the Academy were fed up with his dilatoriness in presenting this 'reception piece' – Greuze had kept them waiting for fourteen years. The painting was accepted, but only as a genre piece.

In order to prove his intellectual seriousness, Greuze seems to have deliberately chosen an obscure subject from Roman history at the beginning of the third century AD, recorded in a contemporary account that he would probably have known through a seventeenth-century French translation. As a scholarly exercise in classical erudition, Greuze's painting could not be faulted. While the Emperor Septimius Severus had been in Scotland, his son Caracalla attempted to murder him. Returning to camp, he presented his son with a challenge: if he wanted the emperor dead, then he should use the sword that was to hand, and order the captain of the guard to carry out the deed. As a demonstration of courage and moral dilemma, Greuze's choice of subject was in line with the usual content of history paintings. But, as one commentator pointed out, his first fault had been to 'choose a word and not an action to paint'. The event rests entirely on dialogue, and an unfamiliar one at that, resulting in a totally static composition.

Four years earlier another French painter wishing to become a member of the Academy had also thought it prudent to produce a large history-piece in the Neoclassical style. Before 1765 Jean-Honoré Fragonard's (1732–1806) pastoral idylls, nudes and other works belonged essentially to an early eighteenth-century idiom, unaffected by Neoclassicism. But in that year Fragonard produced his *Coresus and Callirhoë* (104), a story even more obscure than that chosen by Greuze, but with more pictorial potential. Fragonard's canvas was rapturously received, he was accepted for membership by the Academy, and the painting was purchased by the king with a view to being

104
Jean-Honoré Fragonard,
Coresus and Callirhoë,
1765.
Oil on canvas;
311×400cm,
122×157in.
Musée du Louvre, Paris

copied at the royal tapestry works. Fragonard's triumph did not
persuade him, however, to become a dedicated Neoclassicist,
and his subsequent works developed his earlier style, with
only the occasional hint of Neoclassicism. Membership of the
Academy was essential for patronage and exhibitions in a
period when it controlled the French art world, before the profes-
sion of independent dealers with their own picture galleries had
emerged. Fragonard was not necessarily being cynical in painting
his *Coresus and Callirhoë*, but it was a wise move. Greuze, on
the other hand, did turn his back on the Academy after his great
disappointment, and contrary to expectations became very
successful through the support of private patrons.

Fragonard was certainly playing the Academy at their own game
of recondite subject matter. The story of Coresus and Callirhoë
had been turned into an opera, but Fragonard could not have
seen a performance until it was revived a few years after he
painted the picture. Recorded briefly in only one ancient literary
source, this romantic legend involved Coresus, high priest of
Dionysus in ancient Greece, who fell passionately in love with
a virgin, Callirhoë. But she remained indifferent to him, so he

105
Francisco
de Goya,
*Sacrifice to
Priapus*,
1771.
Oil on canvas;
33×24 cm,
13×9½ in.
Private
collection

called on Dionysus for help, who responded with a plague of
madness among the local inhabitants. Coresus could only halt
the disaster with a sacrifice, which the god decreed must be
Callirhoë. Her beauty, however, overcame him at the sacrificial
altar, and Coresus killed himself. The theme of love and death
was not new, but Fragonard showed some ingenuity in his
choice of an example.

The two paintings by Greuze and Fragonard were painted after
the artists had returned from their Grand Tours in Italy. The
Sacrifice to Priapus (105) was painted by the young Francisco
de Goya (1746–1828) while he was still there. This early painting
seems quite untypical of Goya's work, and dates from Goya's
visit of 1770–1. Goya painted several classical scenes in
Italy, which might have included the painting he entered for
a competition at the Parma Academy, where he won an
honourable mention. Many of these early works have disap-
peared, but it is obvious from *Sacrifice to Priapus* that he was
well aware of current developments in Neoclassicism. He

abandoned the style when he returned to Spain, and these classical scenes may have been painted while he was in Rome merely because he needed money. There was a ready market for such products and they also stood a reasonable chance over other subjects of winning prizes. Italy provided Goya with experience, but not a style.

The English artist and poet William Blake (1757–1827), on the other hand, never even went to Italy. Friends encouraged him to undertake the Grand Tour, and offered to provide funds, but no trip ever materialized. Blake was one of few major artists of the late eighteenth and early nineteenth centuries who did not travel abroad; his knowledge of classical antiquity was largely second-hand, and that of his much-admired Michelangelo entirely so. In the mid-1780s when he was writing some of the finest lyrical poetry in the English language, published as *Songs of Innocence* (1789), he was also beginning to develop as an artist. He published the text of his *Songs* accompanied by his own illustrations, but whereas his verse showed a poetic mastery, his drawings are more hesitant. In visual terms Blake was a slow developer, only beginning to produce original works of importance from the mid-1790s onwards. Thereafter his art belongs firmly under the label of Romanticism, although showing some Neoclassical traits in his style surviving from his early works. Throughout his life Blake was very ambivalent in his attitude towards classical antiquity, swinging between admiration and condemnation. But in his early works during the 1780s Blake shows a commitment to Neoclassical history paintings in a range of watercolours illustrating scenes drawn mainly from the Bible, English medieval history and English literature. Typical of this early series is a watercolour illustrating Shakespeare's *A Midsummer Night's Dream* (106). It shows the principal characters, Oberon, Titania and Puck accompanied by a group of dancing fairies in the final scene of the play. Although Blake's treatment of anatomy is awkward, the emphasis on outline body rhythms which stress the linearity of the figures, combined with their clinging and revealing draperies, suggest

that Blake has been studying classical sculpture, wall-paintings from Herculaneum and Greek vases. Such watercolours are tentative steps in the direction of Neoclassicism, from which he was to turn away in the creation of his own highly idiosyncratic style, although his circle of friends included the Neoclassical sculptor John Flaxman and the painter Henry Fuseli, and he admired the achievements of James Barry.

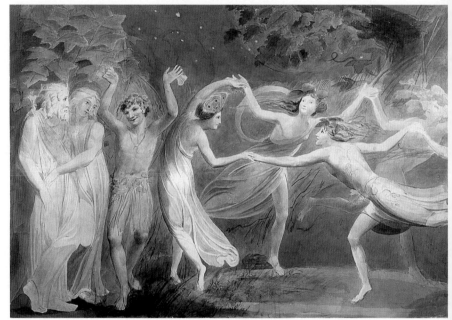

106
William Blake,
Oberon, Titania
and Puck with
Fairies Dancing,
*c.*1785.
Watercolour;
47·5×62·5 cm,
18³⁄₄ ×24⁵⁄₈in.
Tate Gallery,
London

Tombeau de J.J. Rousseau dans l'Isle des Peupliers à Ermenonville, de l'Ordonance de M. le Marquis de Gerardin.

Rousseau est mort le 2 Juillet 1778 à Ermenonville

'Let your tears flow, never will you have shed more delicious and more worthwhile ones.' Reading the guidebook to the garden, recently laid out in the new 'picturesque' or natural style, where the great writer and philosopher Jean-Jacques Rousseau (1712–78) had been buried, the visitor had reached the point on the walk where his tomb had come into sight. Erected on the Isle of Poplars in the lake, it was the part of the garden where Rousseau had expressed a wish to be buried (107). Tears flowed in abundance in the eighteenth century, men as well as women responding openly in this way to plays, works of art and gardens. The coolness of reason was a dominant characteristic of the period, but it did not occlude emotional responses. Compassion and intellect were but two aspects of the same person.

In the case of Rousseau's tomb, its setting inspired a sensation enjoyed by eighteenth-century sensibilities which was described as 'pleasurable melancholy'. Country house gardens at the time often set aside a spot where one could quietly contemplate one's mortality, thoughts usually prompted by a carefully sited tomb. It was almost always Neoclassical in style, taking the form of an urn, obelisk or sarcophagus. Such monuments were recommended in magazines devoted to fashionable taste as desirable furnishings for one's garden, along with seats, bridges and picturesque buildings, since they not only constituted the most beautiful of ornaments, but they alone combined the possibilities of 'sensibility and taste for the arts'. Tombs in gardens, or set in wild nature, were ubiquitous in the imagery of this period, even decorating fans and teacups (108). Each piece of this tea set is painted with a different wooded landscape in which is set an imaginary tomb slab, each inscribed not with the name of a famous hero or writer but with a variety of generalized feelings, such as a desire to be happy (*Sey Glüchlich*) in the afterlife. Rousseau's tomb can still be

107
Hubert Robert,
Rousseau's
tomb on the Isle
of Poplars at
Ermenonville.
Plate from Le
Rouge, *Jardins
anglo-chinois*
(second version),
1780.
Engraving;
23·5×38·5 cm,
9½×15⅛in

seen in the garden at Ermenonville, about 50 km (30 miles) east of Paris, on the estate where he had been living for the last few weeks of his life under the patronage of the Marquis René de Girardin and where he died. One face of the sarcophagus simply bears the inscription 'Here lies the man of nature and of truth' ('Ici repose l'homme de la nature et de la vérité'). The sculpted side, visible from the edge of the lake, is more elaborate. It depicts in the centre a woman symbolizing Fecundity holding in her hand a copy of *Emile*, a treatise on education which he had written in the

108
Fürstenberg,
Teacups and
saucers, 1810.
Porcelain; cup
h.7·5 cm, 3 in.
Saucer diam.
13·5 cm, 5¼ in.
Werksmuseum
der Porzellan-
manufaktur,
Fürstenberg

guise of a novel, its anti-Christian views getting the author briefly into trouble with the French authorities and forcing a temporary exile. To the left, women are offering flowers and fruit at an altar dedicated to Nature, while children to the right dance with the cap of Liberty. Flanking figures represent Love and Eloquence. The imagery sums up Rousseau's philosophic interests, but gives prominence to his passionate concern for the enjoyment of nature and the liberty of the individual.

The tomb, designed by the painter and garden designer Hubert
Robert (1733–1808) who was later to record the ceremonial
removal of Rousseau's remains to Paris at the time of the
Revolution (see 144), was the most important sight in the garden.
Ideally it should be viewed by moonlight, according to the guide-
book quoted earlier; under these conditions, with the monument
reflected in the calm waters of the lake, 'this clarity, so gentle,
joins with the calm of all nature and disposes you to a profound
meditation.'

The rest of the garden, laid out by the marquis from 1766 onwards,
was less melancholic, and would be seen to best advantage in
daylight. His landscaping at Ermenonville followed the new ideas
of the 'picturesque' garden. The 'stiff and extravagant stairs' of
Versailles were out of favour, and geometric layouts were gener-
ally giving way to landscapes artfully contrived to look as natural
as possible. As at Ermenonville, in the words of the landscape
painter Pierre-Henri de Valenciennes (1750–1819) whose art (115)

will be discussed later, 'the artist has combined and traced on Nature, he has conserved the physiognomy and the charm.' Of all the gardens in France, Valenciennes continued, Ermenonville is 'perhaps the only one that pleases the thinker and the philosopher, because it speaks to the soul, it excites sentiment, it caresses the senses, it moves the imagination.'

In such a garden these reactions were partially stimulated by the landscaping of trees, grass and water, but also by the sequence of buildings and other structures encountered in the course of a walk. At Ermenonville these numbered several monuments, a grotto, and temples, including one based on the ancient Roman one at Tivoli dedicated to the Sibyl (visible in the background to the left in figure 107). The copy at Ermenonville is dedicated to Modern Philosophy, inscribed with the names, among others, of Rousseau, Voltaire and Newton. Like its prototype this modern temple is incomplete, not because it is a ruin, however, but because it was left unfinished to suggest that the task of philosophy can never be completed. On a broken column at the entrance is a Latin inscription 'Who will finish this?' ('Quis hoc perficiet?'). In addition, along the way were a variety of inscribed plaques bearing quotations from such nature poets as Virgil, from his *Georgics*, including lines beginning 'Happy is he who knows the gods of those who live in the countryside.' This elaborately contrived walk was on offer to the south of the house; another one to the north offered rustic and Italian-style farms and mills, and a medieval tower dedicated to the beautiful mistress of a French king. As was often the case in such gardens, other styles and historical references were incorporated into the layouts along with the classical.

Classically inspired buildings and other structures set into 'picturesque' landscape gardens were the nearest the late eighteenth and early nineteenth centuries got towards the creation of a Neoclassical garden. Such gardens were not re-creations which an ancient Greek or Roman would have recognized, since little was known about gardens in the antique world. The scant

information that was available from archaeological sites and the letters of Pliny the younger (in which he describes some of his own gardens) pointed to predominantly formal layouts near the house itself, of the very kind that went out of fashion in the mid-eighteenth century, at the same time that Neoclassicism was emerging as a new style. Further away from the house, however, an element of informality was incorporated into the design. The classical buildings erected in European, and occasionally colonial, gardens reflected the love of the antique past that was so evident on the Grand Tour. The temple at Tivoli copied at Ermenonville is only one of countless examples of the re-use of this particular monument. Two other examples, re-creating the Pantheon in Rome (110) and the Tower of the Winds in Athens (113), will be discussed shortly.

The informal siting of such buildings amidst trees or beside lakes, rather than in the more architectural setting of terraces and straight vistas, is among the most striking examples of the fundamental change in garden design in the course of the eighteenth century. Two reasons for this change are particularly important. The first one is tied up with political theory. The rigid geometry of vistas and terraces, punctuated by statuary and fountains, in the most famous of all formal gardens created in the previous century, namely Versailles, had been created for Europe's great autocrat, Louis XIV. Its political associations made such a style of gardening unacceptable to early eighteenth-century radical thinkers in England, where the move towards the informal 'picturesque' garden began. (In the eighteenth century the 'picturesque' garden in France was sometimes called 'Chinese', reflecting the increased knowledge of the informal and natural design of Chinese gardens, becoming known through reports and illustrations by Jesuit missionaries and travellers; but it might also be called 'English', as it was elsewhere, being regarded as a cultural export as far afield as Russia, Norway and the United States.) The link between gardens and politics is more straightforward than might at first be apparent. The argument was that any form of autocracy, which by its nature involved absolute and restrictive directives,

in whatever area of life, prevented expressions of individual freedom. Those two words were to become a cornerstone of eighteenth-century thought. Translated into garden design, freedom meant informality. The shaping of the landscape became increasingly natural in design, with evidence of man's extensive handiwork in the transformation (not to mention the vast sums of money involved) kept as unobtrusive as possible.

The second reason for the increasing 'naturalness' of these gardens concerns changing attitudes to nature, found first of all in literature. These new gardens were intended to be viewed as 'pictures', hence the name of the movement. The canvas was Nature, and the materials trees, grass, stone and water. These 'pictures' were intended to be seen to best advantage from specific spots while walking around the grounds, or from the house. Nature itself became a landscape painting, composed in accordance with the idyllic, pastoral vision of the Italian landscape as painted by some of the masters of the seventeenth century, especially Claude Lorrain (1600–82). Looking south from the house at Ermenonville, the view 'offers a picture composed in the style of Claude', according to the guidebook quoted earlier.

Claude had spent most of his working life in Rome, concentrating on the area south of the city known as the Campagna. It was an open landscape, with many classical associations, its numerous ruins a constant reminder of them. As painted by Claude, this scenery was timeless, lit by a golden sky untroubled by storm clouds (109). The people in his landscapes were always insignificant in relation to the surrounding scenery, which dominated the composition. Strategically placed buildings and water drew the eye gently inwards towards the distance, with the spectator's route through the imagined landscape being carefully controlled. Claude's manipulation of nature, and also that of fellow landscape-painters, was to be taken as a model in the following century for the 'picturesque' garden. Although Claude in his sketchbooks drew directly from nature, he sifted his information when transforming it into idealized landscapes, so that his oil

109
Claude Lorrain, *Landscape near Rome with a View of the Ponte Molle*, 1645. Oil on canvas; 74×97 cm, 29 1⁄8 ×38 1⁄4 in. Birmingham Museums and Art Gallery

110
S H Grimm, *Stourhead*, 1790. Watercolour; 19×26·3 cm, 7 1⁄2 ×10 3⁄8 in. British Library, London

paintings are not records of identifiable locations but an amalgamation of the best parts of several. Claude's paintings, and similar contemporary works, very much appealed to eighteenth-century taste. The wealthy competed for original oils to add to their collections, while the less affluent could purchase the countless engravings that were available. As a result, such paintings had a profound influence not only on the changing face of the eighteenth-century landscape itself in the form of garden designs, but also on the course of landscape painting in the Neoclassical period.

The collection of the London banker Henry Hoare included one of Claude's paintings in which the Pantheon at Rome had been re-sited in a landscape setting. It was to influence Hoare's transformation of the grounds of his country house at Stourhead in Wiltshire, on which he was working from about 1743 onwards, shortly after his return from the Grand Tour. A classically inspired Temple of Flora had been erected within the first couple of years on the edge of a newly created lake, but the most significant addition came in the mid-1750s when the Pantheon was erected further along the edge of the water, creating the main focal point of the whole layout. Subsequent planting of rhododendrons and azaleas has altered the original character of the garden, which can be best seen in contemporary drawings and prints (110). On the far right can be seen the Pantheon, in the centre a stone bridge based on designs by the famous sixteenth-century Italian architect Andrea Palladio, and on the left overlooking the lake the last temple to be added in 1765, one dedicated to Apollo. The Pantheon and both temples were the work of the architect Henry Flitcroft (1697–1769). Visitors would walk down from the house to the lake, cross the bridge, follow along the water's edge, looking not only at temples but also a grotto, and on the way back would see the medieval church and village nestling below the house. It was an artfully contrived Claudian landscape into which the realities of present-day life were admitted, a juxtaposition of two worlds that was not usual in 'picturesque' gardens, where idyllic visions were more often self-contained.

The classical world reconstructed around the lake was enhanced by inscriptions, some of which have since disappeared, quoting from Ovid and Virgil's *Aeneid*. The epic account of Aeneas's travels was present in Hoare's mind as he walked round the lake, since he regarded going through the grotto as comparable to Aeneas's journey to the underworld, and he made it clear to visitors (by an inscription on the Temple of Flora) that his lake could be taken as an allegory of Lake Avernus, the immensely deep lake near Naples that was traditionally believed to be the entrance to the underworld. 'Picturesque' gardens appealed not only to aesthetic and emotional responses, but also intellectual ones. These gardens presupposed a knowledge of classical literature and art, as well as other references which could even include contemporary politics.

'Often I flee from the city and seek the deepest solitude', wrote the Swiss writer and artist Salomon Gessner (1730–88) at the beginning of his pastoral prose *Idylls*, first published in 1756 and rapidly becoming one of the international bestsellers in the Neoclassical period. He found that 'the beauties of nature alone banish from my mind all the disgust and all the unpleasing impressions which accompanied me from the town.' Gessner's vision of landscape, inhabited by figures from the classical past, exemplifies the eighteenth century's increasing appreciation of the beauties of nature. Much earlier in the century Alexander Pope had written that 'there is something in the amiable simplicity of unadorned Nature that spreads over the mind a more noble sort of tranquillity, and a loftier sensation of pleasure.' Later writers, among them Rousseau, would echo such sentiments. Gessner continues the introduction to his *Idylls* by enthusiastically saying: 'Enraptured I resign myself wholly to the contemplation of her [Nature's] charms; I am richer than a monarch and as happy as a shepherd of the golden age.' This vision is delightfully captured in visual terms in an imaginary tomb dedicated to Gessner that was published in his lifetime, in the most important German publication on the 'picturesque' garden (111). The five volumes of C C L Hirschfeld's (1742–92) *Theory of Garden Art* (*Theorie der*

Gartenkunst) were published between 1779 and 1785, in Leipzig, culturally one of the most forward-looking German cities. Along with his theoretical discussions and examples of garden design, Hirschfeld included a series of imaginary monuments to German writers. The one to Gessner he introduced as that of the 'greatest modern pastoral poet' to whose writings one could respond because of their 'simplicity, naivety, innocence and gentle pleasures of the golden age'. The monument to such a poet should be sited in a shady grotto beside a stream. The pastoral Muse stands in front of an altar on which are placed a pipe and an etcher's needle (alluding to Gessner's skill as a printmaker), together with flowers. The Muse is teaching Cupid about pure love, demonstrated by the doves at her feet, while a satyr and young faun listen attentively. The grotto with its Neoclassical marble did not become a reality, but Gessner's ideas were visualized in other forms, including, as we shall see in Chapter 8, even in the medium of wallpaper (see 217).

There was a danger in some 'picturesque' gardens of distracting the attention of visitors with too many items of interest. Hirschfeld, among others, castigated this tendency, advising discretion, a restraint noticeably lacking in some Continental layouts. One private pleasure garden, the Désert de Retz, established by the wealthy Parisian socialite Baron de Monville (1734–97) not far from the city, managed to squeeze twenty structures into a site of about forty hectares. The effect, however, was not one of overcrowding because of a judicious use of the site. The garden and some of its structures have been restored, and the famous Broken Column once again looks as it appeared at the time of the garden's creation between 1774 and the eve of the Revolution in 1789 (112). Monville managed to escape the guillotine, having been arrested on a charge of sybaritism, but his garden was largely dismantled on republican orders, with buildings stripped and plants dug up.

The extraordinary dwelling constructed as the Broken Column is the principal feature to survive from a quite remarkable garden,

111
Christian C L Hirschfeld,
Plate from *Theorie der Gartenkunst*, showing the proposed tomb in grotto to Salomon Gessner, designed by Christian Friedrich Schuricht, 1779–85. Engraving; 13×10·2 cm, 5⅛×4 in

112 Overleaf
Plate from Le Rouge, *Jardins anglo-chinois*, showing the Broken Column in the 'picturesque' garden at Désert de Retz,1785. Engraving; 38·5×23·5 cm, 15⅛×9¼ in

in which plants imported from around the world grew in profusion. Visitors to this domain, created by Monville in his roles as botanist and amateur architect, entered from the forest of Marly, one of several royal estates around Paris. They came through a grotto, illuminated at night by flambeaux carried by satyrs made out of sheet tin, adding a very theatrical touch to an evening's entertainment, which might include an open-air concert with Monville playing the harp. Soon, on rising ground, the Broken Column was encountered, furnished with salons, a dining room, laboratory, library and several bedrooms. The décor was elegant, and included modern paintings and Sèvres porcelain figures. Other classically inspired structures in the grounds included a temple dedicated to Pan, protector of shepherds, goat-herds and their flocks; like the one dedicated to Philosophy at Ermenonville this too is derived from the Temple of the Sibyl at Tivoli. Other buildings and ornaments in the grounds were erected in the Chinese, Egyptian and Gothic styles. But it was the Broken Column that captured visitors' imaginations as the most extraordinary garden building in Europe at the time. The dream-like, almost sinister, quality of the building, altered by time and neglect, was to appeal two centuries later to the Surrealists.

Constructed as a ruined column, 16 m (53 feet) high, the building appears as though the only surviving fragment from some vast classical temple. Monville has thus reversed the normal practice in garden design, whereby re-creations from the past were built on a miniature scale, blending in with the surrounding vegetation, such as the Pantheon at Stourhead. Little wonder that contemporaries likened the column to the biblical Tower of Babel, struck down by God. Thomas Jefferson, one of the many visitors to the Désert de Retz, exclaimed in a letter, 'How grand the idea excited by the remains of such a column! The spiral staircase too was beautiful.' Indeed, he was so impressed that he later borrowed the ground plan for one of the buildings on the new campus of the University of Virginia, which he was to design after the turn of the century. There it became a rotunda flanked by square buildings. But in its original context in the garden, Monville's

house in the circular form of the Broken Column blended with the asymmetrical curves of the layout and the contours of the vegetation to create an unusual synthesis of nature and architecture. We do not know, however, why Monville chose a column. The most convincing explanation lies in the column's resemblance to a tree-trunk, suggesting a direct reference, which contemporaries would have recognized, to the architectural debate on the origins of primitive architecture in the early days before the known achievements of ancient Greece. The book at the heart of this debate, by Laugier, has already been discussed, with its famous frontispiece of the primitive hut (see 43). Perhaps the Broken Column is a realization in stone of Laugier's myth, in which case it is a monument to the primitive.

The column uses the earliest form of Greek architecture then known, namely the Doric. For the re-creation of specific ancient Greek buildings in the context of an eighteenth-century landscape garden, by far the best examples are still to be seen in the grounds at Shugborough, in Staffordshire. Here the Doric Temple copied from one in Athens was erected about 1760 to 1761; it is one of the earliest reproductions of its kind in Europe, and one of several such copies in the grounds. Preceded by an artificial medieval ruin and a Chinese House, the Greek garden structures added throughout the 1760s were strikingly new landmarks, all designed by James Stuart. Long since returned from his tour of Greek sites (see Chapter 1), and about to start publishing his findings together with Nicholas Revett as the *Antiquities of Athens*, Stuart was in a unique position to carry out these developments at Shugborough.

It called for an enlightened patron to help pioneer Stuart's Greek ideas. He found one in Thomas Anson, who had inherited a modest estate at Shugborough and transformed it into a prosperous concern. His ambitious plans were probably encouraged by the successes of his younger brother, George, Admiral Lord Anson, whose voyage around the world in the early 1740s had made the family fortunes. Unlike his brother, Thomas

remained unmarried, and devoted his life to the development of both the estate and the family collection. He was a member of the Society of Dilettanti, under whose patronage Stuart had gone to Greece in the 1750s, so the choice of architect for the antiquarian garden follies at Shugborough was a fairly obvious one. In addition, in 1758–9 Stuart had already designed a Doric Temple for the estate of another member of the Society of Dilettanti, Lord Lyttelton, at Hagley, Worcestershire. It was the first archaeologically correct re-creation of a Greek temple in Europe, the original model of which Stuart and Revett had studied and measured in Athens.

The classical buildings erected in the grounds at Shugborough were therefore in the forefront of Neoclassical taste. There is no arcane programme in their layout, or in the choice of prototypes being copied. The siting of each work seems dictated by its visual impact in the landscape at that particular spot, and the choice of design based on a desire for maximum variety of architectural types. The Doric Temple was sited near the house, looking out across the vast expanse of the estate. Other structures were built much further away, providing objects of interest seen against the horizon, framed by trees or reflected in water. The first to come into sight is the Tower of the Winds, copied from the building of that name in Athens and published in the first volume of Stuart and Revett's *Antiquities*. Stuart added windows and porticoes to turn it into a garden building. Originally the Tower was approached by water, by rowing across a lake (113) or crossing a bridge, but later drainage of this part of the estate for land improvement has left the Tower stranded in fields. As originally sited, the Tower was a very attractive addition to the landscape garden, especially when decorated with relief panels of the winds copied from the original building, as shown in the reproduction here. These have now disappeared, and it is possible that the original decoration was only painted to simulate sculpture, a cheap alternative not uncommon in garden buildings.

Among Stuart's other works in the grounds was a re-creation of a triumphal arch from Athens, as well as a monument in the same

113
Thomas Pennant, Plate from *Journey from Chester to London*, showing the 'Tower of the Winds' in its 'picturesque' garden layout at Shugborough, 1782. 12·8×18·2cm, 5×7⅛in

114
Monument to Dr William Roxburgh, Botanical Gardens, Calcutta, erected in 1822

198 Early Development 1750 to 1790

city that was to become popular not only as a garden ornament but also as a form of architectural decoration. This was the Choragic Monument of Lysicrates, also known as the Lanthorn of Demosthenes, which also appeared in the first volume of the *Antiquities* (28). Even before the accurately measured drawings had appeared in that volume, an earlier traveller had commented in his book on Greece that this particular monument would 'make a very proper building' to ornament someone's parkland. Erected to support the winning trophy of a choral competition, the monument was an attractive structure in a good state of preservation, and it is easy to appreciate why it was so often re-used. It was to ornament the tops of Neoclassical buildings as far afield as Philadelphia and Aberdeen, and appear in an early nineteenth-century garden in the rapidly expanding colony of New South Wales (now in the Botanic Gardens in Sydney).

A classically inspired monument almost became an essential component of a 'picturesque' garden, wherever that concept of landscaping was found. In Calcutta, on the banks of the River Hooghly, a large area was turned into the Botanical Gardens, from 1786 onwards. Using indigenous vegetation, including banyan trees, as well as European imported plants, the terrain was converted as far as was practicable into a 'picturesque' garden, a distant heir to the layout at Kew. The second Superintendant of the Gardens was a great botanist, Dr William Roxburgh. Shortly after he took over the post, he built a handsome Neoclassical house and devoted his energies to developing the Gardens. He was a pioneer in classifying Indian flora. Illness forced him to return home, where he died in 1815. Out in Calcutta, a few years later, he was commemorated by a small classical temple housing an urn, sited on rising ground amidst trees in the Gardens, looking – if it were not for some of the vegetation – as if it were back home in a British landscape (114).

The monument to Colonel Robert Kyd, on whose initiative the Gardens had been instituted, had also been Neoclassical, an

elegantly carved marble urn mounted on a column, prominently placed near the centre of the Gardens. The imagery on the urn evokes no Indian deities, but the classical goddesses Ceres and Flora. The Botanical Gardens in Calcutta are a good, and still partially surviving, example of the lengths to which colonists transported a European vision to foreign parts, organizing the terrain into a form with which they were familiar, and erecting on it structures in the currently fashionable style, namely Neoclassicism.

Such are the ramifications of cultural influences, that just as gardens landscaped in the late eighteenth century beside a river in northern India show the indirect influence of French seventeenth-century landscape paintings, the same influences, emanating from the works of Claude and his contemporaries, helped shape the way that eighteenth-century landscape painters depicted their surroundings. The influence was just as strong when they were observing scenery in Claude's Italy and elsewhere in Europe as when they travelled further afield, depicting scenery in North America and India and, after the turn of the century when the new colonies were more settled, in New South Wales and Tasmania. The Claudian vision remained dominant: you could even buy a 'Claude glass' to carry in your pocket as an aid to looking at the landscape. It was a small mirror backed by foil in which the reflection of the scene was in the muted tones associated with Claude.

115 Overleaf Pierre-Henri de Valenciennes, *The Ancient City of Agrigentum: Ideal Landscape*, 1787. Oil on canvas; 110×164 cm, 43^7⁄$_8$×64^5⁄$_8$in. Musée du Louvre, Paris

In landscape painting, Claude and his contemporaries came to play the same role as in garden design, in other words substituting for a lack of knowledge about actual classical landscapes. Depictions of landscape in ancient Greek and Roman art were virtually unknown in the Neoclassical period. Even today we do not know a great deal more. The few fragments found at Herculaneum, Pompeii and elsewhere were not sufficient in either number or quality to inspire a revival of classical landscape painting. What we have instead in the Neoclassical period are 'historical' landscapes influenced by a Claudian view of nature, peopled by events from the classical or historical past.

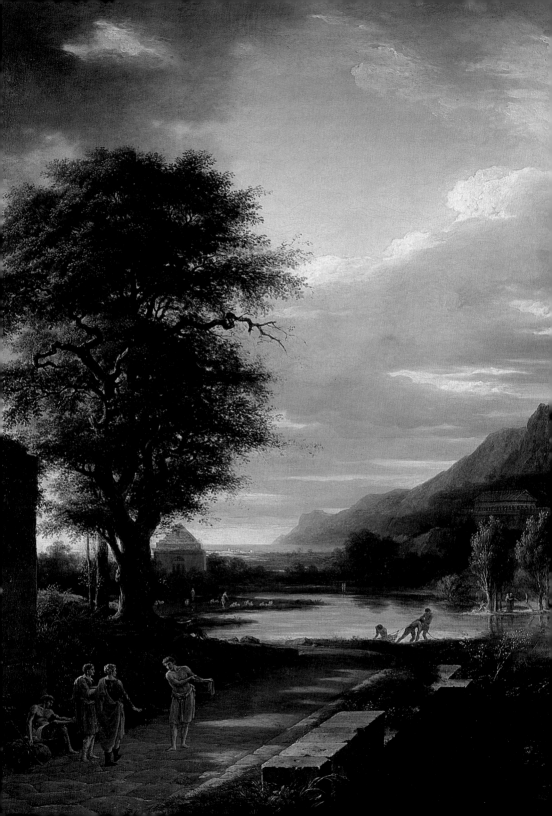

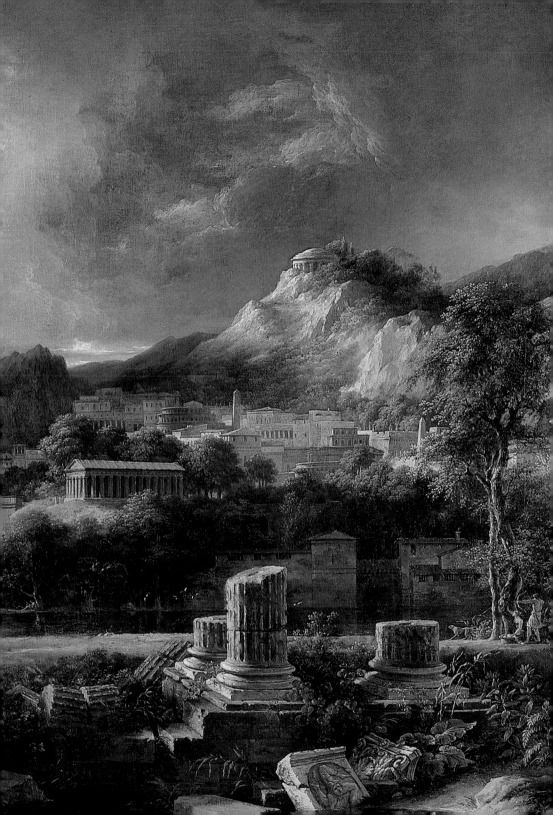

At the exhibition at the Salon in Paris in 1787 one canvas that caught the critics' attention depicted *The Ancient City of Agrigentum: Ideal Landscape* (115). The artist, Pierre-Henri de Valenciennes, had visited Italy for the second time in the previous decade, travelling as far south as Sicily and touring all the main archaeological sites there, including Agrigentum. He found Sicily very beautiful, and was later to advocate (in a book published in 1799) that its rich antique remains ought to be better known to artists. Valenciennes gave an enthusiastic account of what he had seen in Sicily; the hills and rich vegetation at Agrigentum especially appealed to him, providing a 'sublime' setting for the temples. The most famous, that dedicated to Concord, he found 'one of the most beautiful that I know, by its proportions, its purity, its elegance, its severe style and its conservation'. As the best-preserved of the group, saved from destruction through its conversion into a Christian church, the Temple of Concord features prominently in the middle distance of Valenciennes's painting, surrounded by an idealized representation of the scenery. Although ruins dominated the foreground of his composition, as if the scene were set in the present, Valenciennes is in fact re-enacting classical times, as can be seen from the group of people on the left, and by his reconstruction of the town in the background. In that period it was the custom there to welcome strangers by positioning slaves at their masters' doorways to invite newcomers inside to stay. A particularly wealthy man went one step further, sending a slave down the approach road to the town in order to meet strangers on the way: such an encounter is taking place in the painting. Following Claude and similar landscape painters, Valenciennes introduced an anecdotal element, discreetly handled so that it does not distract the viewer's attention too much.

One commentator on this painting of Agrigentum singled out for special praise the artist's handling of the buildings, but castigated Valencienness for lavishing attention on the ruins: 'That recalls English gardens.' What was meant to be an insult, Valenciennes might well have taken otherwise, since he approved of the new

ideas of the 'picturesque' garden. In his book of 1799 he provided advice on their design, objecting to the overcrowding of such gardens with too many items of interest, and advocating a sparser approach. 'It is not necessary to have everything in the garden,' he wrote. 'If ostentation or stubbornness inspires this fantasy of the owner, he will scatter his gold only to produce mere trifles, which will make his garden look like those large dishes of dessert piled up on dinner tables.' A garden's embellishments 'must be adroitly handled, sited without confusion, and always motivated by the locality; without that, all these details [columns, tombs, obelisks, etc.] dazzle and harm each other'.

The idyllic mood of Valenciennes's *Agrigentum* is typical of many similar 'historical' landscapes painted in the Neoclassical period. Nature could, however, be awe-inspiring, even terrifying. Disaster had struck when Vesuvius erupted in 79 AD, destroying the two prosperous towns of Pompeii and Herculaneum, and many eighteenth-century landscape painters recorded Vesuvius as they saw it, dominating the Bay of Naples. There was a ready market for souvenir pictures, but a few painters combined their first-hand experience of the volcano with a re-creation of the historical past.

116 Overleaf
J M W Turner,
The Temple of Jupiter Panellenius Restored,
1816.
Oil on canvas;
116·8 ×
177·8 cm,
46 × 70in.
Private collection

Probably inspired by witnessing the great eruption of 1779, one of the most dramatic of the century, the British artist Jacob More (1740–93) painted *Mount Vesuvius in Eruption*: *The Last Days of Pompeii* in 1780 (see 20). His apocalyptic vision shows the fatal stream of molten lava pouring down the centre of his composition, giving off clouds of steam as it falls into the sea. The buildings of Pompeii are imaginary, based on what More knew of ancient Rome, since the archaeological excavations at Pompeii itself could not have provided enough visual evidence. More would have had to rely for other historical details on Pliny the younger's vivid, first-hand account of the disaster, recording how the eruption looked 'like a pine rather than any other tree, for it rose to a great height on a sort of trunk, and then split off into branches.' The flames, as Pliny noted, were terrifying by night, but even by day the clouds of ash blocked out the light, continuing a semblance of night.

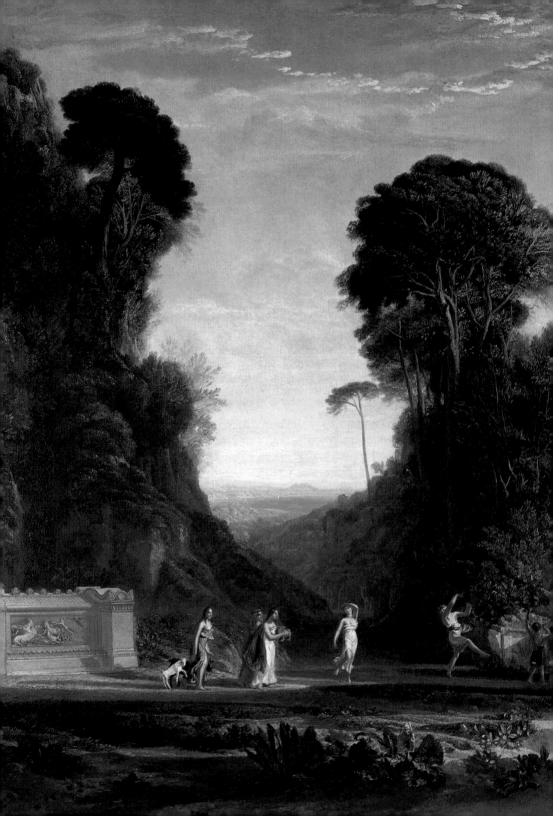

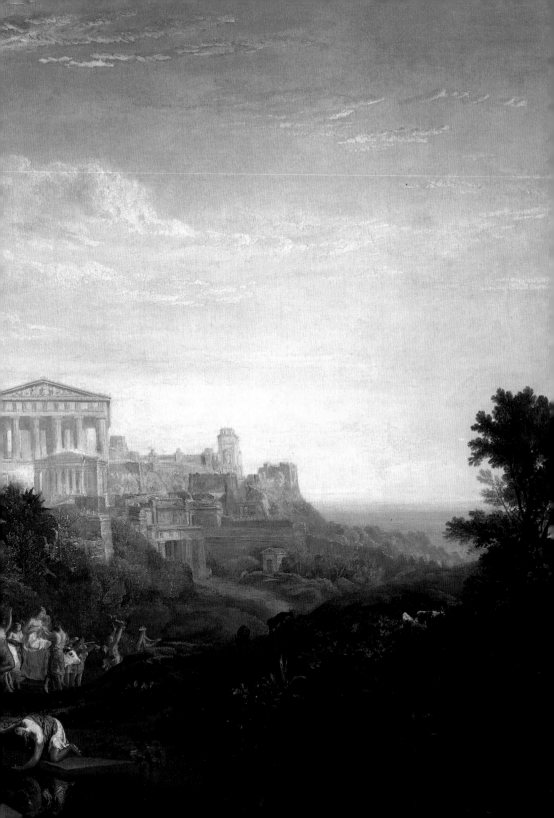

Thousands gathered on the water's edge hoping to escape, but they were overcome by sulphur fumes and pumice. Pompeii and Herculaneum thereafter lay buried, if not forgotten, for centuries, their destruction a permanent reminder of the power and unpredictability of nature. More's painting of Vesuvius is not just another tourist view, just as Valenciennes's depiction of Agrigentum is more than a mere landscape. A fiery Bay of Naples and a tranquil site in Sicily both set the scene and create the appropriate mood, in one case for human disaster, in the other for human kindness. Nature and the actions taking place within it work in harmony. Both More and Valenciennes were giving an added dimension to landscape painting, just as history painters were adding a dimension to their storytelling. Both kinds of artist were concerned with idealizing and ennobling their subject matter – a comparability of aims that was recognized at the time, with Valenciennes even being described as the 'David of Landscape'.

Historical landscapes formed a significant part of the work of the greatest of all landscape painters in the Neoclassical period, a younger man who was to outlive the heyday of the style, J M W Turner (1775–1851). He was not a wholly committed Neoclassicist, but in some of his works he shared their ideals. There is not necessarily a contradiction in one of Europe's outstanding exemplars of Romanticism appearing under the label of Neoclassicism, since both movements shared some common ground. In Turner's case that ground included history painting, classical antiquity and a Claudian vision. As Professor of Perspective at the Royal Academy (from 1807 onwards) he took his job seriously, giving regular series of lectures and illustrating them with specially prepared large-scale drawings and diagrams. Many of them depicted classical as well as modern architecture, including some Neoclassical examples.

Turner was an energetic traveller, but he never visited Greece. At one time, in 1799, Lord Elgin had hoped Turner would join his embassy staff in Athens as a professional artist to draw the Greek antiquities, and Turner was keen to go. But Elgin would not pay an adequate salary and made some unreasonable demands, so

negotiations had broken down. Like many other artists, therefore, Turner's knowledge of Greece was second-hand, largely derived from such publications as those of Stuart and Revett, but also from contact with archaeologists and travellers who had been there.

Among such travellers was a wealthy amateur artist who had accompanied Byron to Greece between 1809 and 1811, Henry Gally Knight (1786–1846). He supplied the drawing Turner used as the basis for the composition of a large canvas which he exhibited in 1816, and which Knight may actually have commissioned. Its full title was *View of the Temple of Jupiter Panellenius, in the Island of Aegina, with the Greek National Dance of the Romaika: the Acropolis of Athens in the Distance*, and it hung as a pair to the equally large *Temple of Jupiter Panellenius Restored* (116). The temple, believed in Turner's time to be dedicated to Jupiter, or Zeus, of all Greece (Panhellenic or Panellenius) but now known to have been the Temple of Aphaia, was one of the major ancient sites on the Greek islands.

These two paintings are one of several instances in Turner's life when he planned pictures as pairs. In the same period, for example, he painted two canvases showing the rise and fall of the ancient city of Carthage, which Turner interpreted as a symbol for the rise and fall of Napoleon. In much the same way, the Aegina pair, while ostensibly re-creating the past, was at the same time symbolizing contemporary history, on this occasion the Greek war of independence against the occupying Turks. The scene with the national dance, specifically identified and called Greek in the title, is shown as a present-day event, set against the background of the ruined temple, much as it looked in Turner's own day. In the other painting, however, we are in classical times, with an ancient Greek wedding taking place against a background of buildings in pristine condition. Here is Turner in the role of archaeologist, restoring ancient buildings with an attempt at accuracy that is new in his work. Dawn shines on this scene of perfection, whereas a sunset illuminates the ruins. Dawn is bright and hopeful, shining on an idyllic scene in a Golden Age. By nightfall all has vanished,

the day is dying and with it has gone the Golden Age, except that there is a hint of hope in the defiantly nationalist dance. The paintings are an understated assertion of an incipient Greek nationalism, fostered in the English-speaking world by Byron, with whose ideas Turner was obviously in sympathy. He had already conceived one of these paintings before the second Canto of *Childe Harold* was published (1812), which is devoted to a poignant defence of Greek liberty and patriotism:

Fair Greece! sad relic of departed worth!
Immortal, though no more; though fallen, great!
Who now shall lead thy scatter'd children forth,
And long accustom'd bondage uncreate?

Wandering through the ruins, the poet's thoughts had been prompted by what had been lost:

Look on its broken arch, its ruin'd wall,
Its chambers desolate, and portals foul:
Yes, this was once ambition's airy hall,
The dome of thought, the palace of the soul.

Turner visualizes comparable sentiments in his two paintings based on the so-called Temple of Jupiter Panellenius on Aegina. The past is given a present-day relevance, and in the tradition of history painting, within which Turner is working, that relevance usually relates to some ideal. Here it is liberty. Just as the designers of landscape gardens could manipulate stone, earth and water to convey symbolic meanings, so painters with the various media at their disposal could probe deeper than the pretty view.

Admission to see Mr Wedgwood's Copy of THE PORTLAND VASE. Greek Street, Soho, between 12 o'Clock and 5.

When Josiah Wedgwood (1730–95) moved his London showroom to better premises in 1774, his partner Thomas Bentley (1731–80) reported that there was 'no getting to the door for coaches, or into the rooms for ladies and gentlemen – and vases all the rage'. That 'rage' was Neoclassical in style, enthusiastically promoted by Wedgwood's pioneering firm, which sold the most expensive British pottery in London. Commercial concerns at both the luxury and popular ends of the market played a major part in the evolution of Neoclassicism, aided by the ease with which the clean lines of shapes and the shallow moulding of decorative details could be adapted for factory production.

Let us start with one of the most familiar of all industrialists' names in the eighteenth century. So conscious was Wedgwood of the important role he came to play in British industry, that when he later displayed his copy of the famous ancient Roman Portland Vase, he issued invitations as if to the private view of an art exhibition (117). This was in keeping with the area of London he had chosen for his showroom, the artists' and writers' quarter of Soho, rather than the traditional commercial heart of the city further east. The Wedgwood showroom later moved to a grander part of town, the fashionable residential square of St James's (just off Piccadilly), where the showroom was to flourish in the early nineteenth century.

Wedgwood's basalt and jasperware pieces, especially ornamental items such as vases, were priced highly enough to attract the aristocracy. As he shrewdly observed in a letter to his partner: 'A great price is at first necessary to make the vases esteemed *ornaments for palaces'.* Wedgwood wanted his ceramics to be accepted as works of art. He also wanted to be accepted himself as a country gentleman, not merely as an industrialist, as can be

seen in George Stubbs's family portrait group (118). The smoke from the factory chimney is scarcely perceptible in the background of the otherwise idyllic setting.

A labour-intensive piece such as the Portland Vase replica was not a typical product of Wedgwood's factory. Rather, it was a technical challenge to capture the public's imagination. Wedgwood had judged correctly that fashionable taste was becoming ever more deeply committed to an antique past, and as a forward-looking manufacturer, he helped to promote that Neoclassical style through his products.

Wedgwood was one of the earliest manufacturers to see himself as a disseminator of good taste, combining public benefit with private profit. That taste was almost exclusively Neoclassical. Other revival styles of the period – Gothic, Chinese and Egyptian – were largely ignored by the Wedgwood firm. This dissemination of good taste was furthered by Wedgwood's catalogues, published in English, French, German and Dutch editions. Unlike other manufacturers' trade catalogues, they were not just bald listings of items, with measurements and prices, and perhaps a few illustrations. In Wedgwood's catalogues customers were told what classical and other sources of inspiration lay behind the designs, giving the text the appearance of a scholarly treatise. Customers were also taught something of the firm's motivation, a rare insight into an eighteenth-century industrialist's mind. Wedgwood (or the author of his early catalogues, perhaps Bentley) shows an almost missionary zeal in extolling the beneficial effects of the Industrial Revolution.

Those who duly consider the influence of the fine arts on the human mind will not think it a small benefit to the world, to diffuse their productions as wide, and preserve them as long, as possible. The multiplying of copies of fine works, in beautiful and durable materials, must obviously have the same effect in respect of the arts, as the invention of printing has upon literature and the sciences: by their means the principal production of both kinds will be for ever preserved, and will effectively prevent the return of ignorant and barbarous ages.

The consumer society in the second half of the eighteenth century was expanding rapidly, and the close link between user and maker was increasingly breaking down. Manufacturers seldom knew the individuals who bought their products, in contrast to earlier craftsmen-dominated periods. The modern manufacturers therefore played a key role in the design of goods they marketed to satisfy an ever-increasing public demand. The wealthy still employed painters, sculptors and craftsmen for special works, but even they did not commission every item for their houses. The less affluent had to rely even more on mass-production. Well-intentioned manufacturers like Wedgwood produced good designs, but as one British commentator was already grumbling in 1766 when the Industrial Revolution was not even in full swing: 'How much more valuable a manufactory would Birmingham be (as well as many others) to this nation if it were in the hands of people of taste.' Greedy industrial commercialism was present from the start, and persisted on the manufacturing scene despite many attempts to improve the general quality of industrial design made by governments, artists and polemicists, as well as by such manufacturers as Wedgwood. When the architect Henry Latrobe was giving a lecture in Philadelphia in 1811, in which he justified the practical utility of the arts in modern society, the first manufacturer he mentioned was Wedgwood, 'whose pots and pitchers, and cups and saucers, and plates, shaped and decorated by the fine arts, have thus received a passport to the remotest corners of the globe'.

118 Overleaf
George Stubbs, *Portrait of Josiah Wedgwood and Family*, 1780. Oil on canvas; 121·5 × 184·2 cm, 47⅞ × 72½ in. Wedgwood Museum, Barlaston

Wedgwood initially ran two factories in Staffordshire. One produced large quantities of inexpensive creamware dinner and tea services, providing the substantial profits which made his experiments in more expensive wares feasible. The expanding population was a ready market for tableware which Wedgwood and other manufacturers exploited. Wedgwood's products for everyday use were partially influenced by classical prototypes in shape and decoration, but the full impact of antiquity was evident in his other products.

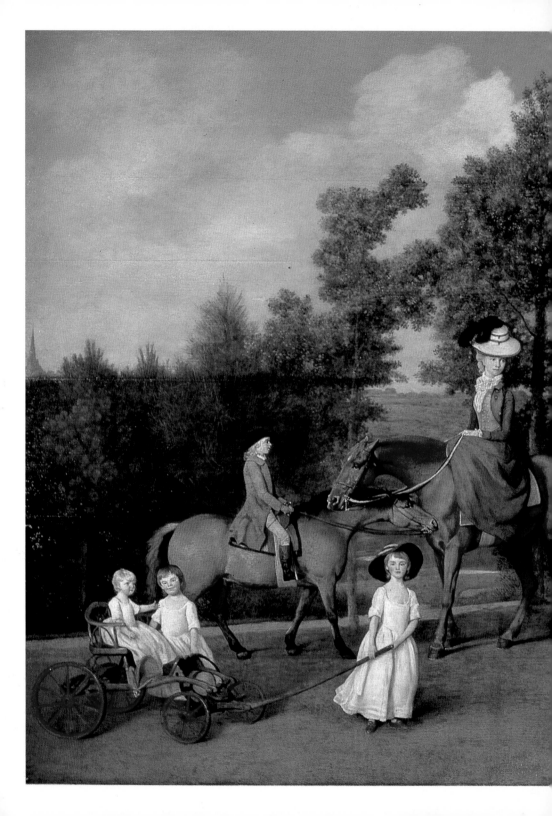

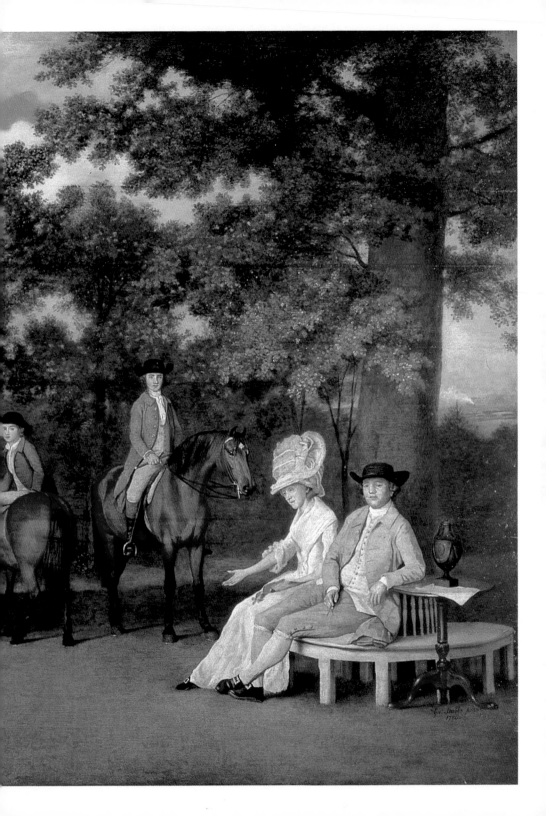

These were made at his other factory, opened in 1769 and appropriately named Etruria after the region in Italy associated in the eighteenth century with the vases wrongly called 'Etruscan' (in fact Greek vases found in Etruscan tombs). This was the factory where the Portland Vase was copied, changing the original dark blue glass into 'black basalt', an expensive kind of stoneware. Basalt was used for the first vase made at the new factory, painted in red and white to simulate the colour scheme of the classical prototypes.

More frequently used was jasperware, another kind of stoneware in which the ground is one colour and the applied decoration another, a technique which Wedgwood perfected in 1775. The decoration was nearly always white, and the base very often in the familiar shade of 'Wedgwood blue', but it could also be lilac, pale green, mustard yellow or other colours. Wedgwood's name became synonymous with jasperware, and on these pieces his international reputation largely rested. These were also among the pieces that foreign factories copied, including ones as famous as Sèvres in France and Meissen in Germany.

For the design of his products, Wedgwood relied heavily on engravings and plaster casts of classical antiquities, building up a large collection at his factory. He persuaded country house owners to let him take casts of sculptures in their collections. He corresponded with Sir William Hamilton and was sent engravings of his first collection of Greek vases in advance of publication. This on-the-spot museum was used by draughtsmen at the factory as a constant source of reference. But as Wedgwood himself said: 'I only pretend to have attempted to copy the fine antique forms, but not with absolute servility. I have endeavoured to preserve the style and spirit, or if you please, the elegant simplicity of the antique forms.'

Wedgwood also employed artists living in London (a three-day journey from the factory), who usually sent drawings and models from their studios. The sculptor John Flaxman (1755–1826) supplied a large body of work in this way. He had been recommended to Wedgwood in 1775 by Bentley, who was largely

responsible for design policy in the early days of the firm's development, while Wedgwood concerned himself more with scientific and technical matters. Bentley probably first came across Flaxman serving in the London shop which sold his father's plaster casts and models largely after the antique. The discovery of 'so valuable an artist' led to a fruitful association that was to last for more than a decade, until Flaxman set off on his Grand Tour in 1787.

Flaxman produced designs for every level of Wedgwood's production, from some of the shapes and decorations of the creamware table services to the more elaborate ornamental plaques and vases, and even a chess set. The largest group of his designs formed part of Wedgwood's long list of jasperware portrait medallions. These 'illustrious' figures from past and present history reached a wide market, mostly selling at what Wedgwood called a 'moderate' price of one shilling. (For comparison, a pair of stockings cost twice this sum.) Buyers could select from an enormous range which embraced kings, emperors and popes, as well as philosophers, scientists and politicians, including recent figures such as Rousseau and Benjamin Franklin. This ambitious project was unique in the European ceramic industry. Flaxman's many additions to the list included Captain Cook, Dr Samuel Johnson, Warren Hastings and Sarah Siddons (119). This last medallion of the famous actress was issued in 1782, just after her return to the Drury Lane Theatre in London. From then onwards her career flourished, her reputation enshrined on Flaxman's medallion as the Tragic Muse, a pose she later adopted in a dramatic portrait by Sir Joshua Reynolds. On the medallion she is shown in profile, in low relief, like other portraits in the series, imitating the appearance of ancient Roman cameos.

The Sarah Siddons medallion is a good example of how Wedgwood, like other industrialists, seized the opportunity of a topical subject to design a new product. Wedgwood wasted no time in commissioning Flaxman to design a jasperware plaque to commemorate the commercial treaty

119
Josiah
Wedgwood,
Sarah Siddons,
1782.
Jasperware
plaque in
'Illustrious
Moderns' series
attributed to
John Flaxman;
11·8×9cm,
4⅝×3½in.
Wedgwood
Museum,
Barlaston

which Britain and France signed in 1786, after the American War of
Independence, in which the French had fought against the British
(120). By now the Neoclassical style was so readily marketable
that Wedgwood saw no incongruity in depicting a contemporary
politico-economic event as two classically dressed women,
representing Britain and France, their hands joined by Mercury,
the god of traders.

In 1786 Wedgwood presented 'the finest and most perfect vase
I have ever made' to the British Museum (121). This unusual
gesture of an industrialist presenting one of his own recent prod-
ucts clearly indicates not only Wedgwood's self-esteem but also
his contemporary fame, since the gift was accepted. The vase
was decorated with a relief designed by Flaxman showing the
Apotheosis of Homer, about which Wedgwood wrote to Sir William
Hamilton: 'I never saw a bas-relief executed in the true, simple
antique style half so well.' The source for that style derived from
Greek vases of the fifth and fourth centuries BC collected by

Hamilton. The antiquarian who had edited the first collection for him had pointed out in his preface that such vases had many possible uses, benefiting not only scholars and artists, but also manufacturers: from the many illustrations, they could 'as in a plentiful stream, draw ideas which their ability and taste will know how to improve to their advantage, and so that of the public.' Flaxman followed this precept, adopting his composition for Homer's apotheosis from one of Hamilton's vases. Initially manufactured as a plaque in a variety of sizes from 1778 onwards, the Homer design proved very adaptable.

With his jasperware and basalt products Wedgwood was helping to create a new market in luxury goods available in a showroom and through a catalogue. No one had catered for the luxury end of the British market in this way before, and the eighteenth-century consumer responded.

The industrial promotion of Neoclassicism, however, inevitably meant some standardization in the dissemination of the style. Household items, architectural details and garden ornaments became increasingly available from a wide range of factories, initially in Britain and then on the Continent. Some of these products were promoted in illustrated catalogues, offering variants from which the customer could choose. A page from such a catalogue, issued by a Leeds pottery firm (122), shows a familiarity with ornate Neoclassical silver candlesticks and candelabra that have been successfully, if unimaginatively, transformed into the much cheaper medium of creamware.

Architects and decorators were not averse to using ready-made items, especially if they cut costs. Moulded, artificial stone was one such solution. The flourishing business run by Eleanor Coade (1733–1821) in London from 1770 onwards is a particularly noteworthy example of individual initiative. Here was a product that was not only cheaper than the real thing, but infinitely more durable. With the help of the Neoclassical sculptor John Bacon (1740–99), who acted as her manager and principal designer, she built up a large stock of wall decorations, columns, keystones,

120 Overleaf Josiah Wedgwood, Mercury joining the hands of Britain and France to celebrate the Anglo-French commercial treaty of 1786, 1787. Jasperware plaque; 25×25 cm, $9\frac{7}{8}\times9\frac{7}{8}$ in. Castle Museum, Nottingham

121 Overleaf Josiah Wedgwood, Vase with relief of Apotheosis of Homer, 1786. Jasperware; h.46 cm, $18\frac{1}{8}$ in. British Museum, London

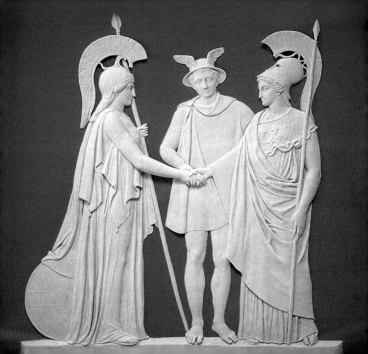

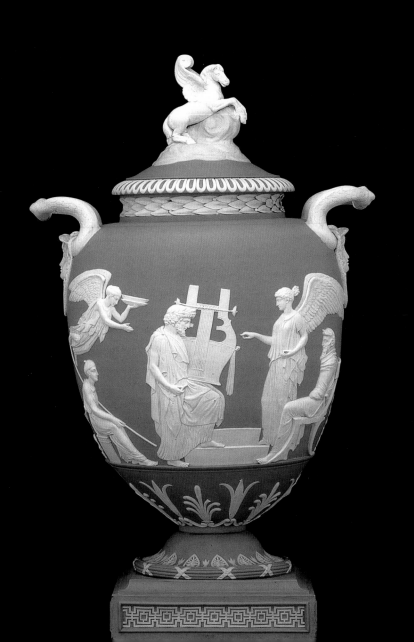

chimney-pots, even fonts, pulpits and tombs, as well as garden ornaments and sculptures, of which a *River God* was the largest (123). At £200 it had a high price tag, equivalent to £12,000 or some $18,000 today, but considerably less than a comparable marble would have cost.

So successful had the Coade enterprise become by 1799 that she opened at the factory a 'Sculpture Gallery', easily accessible across the river from the fashionable north shore by the Westminster

122
Hartley,
Green & Co,
Plate from
*Designs of
Sundry Articles*,
1794 edition
(originally
published 1783)
Engraving;
22·5×20·3cm,
8⁷⁄₈×8in

123
William Blake,
Plate showing
Coade stone
River God,
1790.
Engraving;
27×20·8cm,
10⁵⁄₈×8¼in

124
Matthew
Boulton,
Insurance
certificate,
*c.*1770–80.
Engraving;
23×33·5cm,
9×13¼in

Bridge. (The site was near today's Festival Hall.) Even Wedgwood did not call any of his showrooms a 'gallery'. The new Coade catalogue which accompanied the opening is liberally scattered with classical and modern literary quotations. Among these she included Ovid, whom she had already quoted on her trade card, to the effect that the poet too had created a work that time could not destroy ('nec edax abolere vetustas'). The durability of her products and the quality of her designs kept the kilns of the Coade factory busy, supplying not only to the British market, but dispatching goods as far afield as Poland and Jamaica.

From Art, Industry and
Society, Great Blessings flow

The new British manufacturers identified themselves in many ways with the classical past. The engraving that appears on a health insurance certificate issued by the Birmingham manufacturer Matthew Boulton to his employees is a good case in point (124). Boulton developed the famous steam engine along with James Watt, but he also manufactured a large range of products that included jewellery and buttons (125), clocks (126) and door-handles, electroplated ware and even reproduction oil paintings.

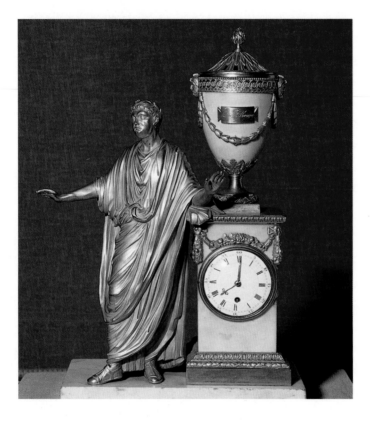

125
Josiah
Wedgwood
and Matthew
Boulton,
Jewellery
incorporating
a Wedgwood
cameo,
c.1785–95.
Blue jasper with
white reliefs
mounted in cut
steel; top buckle
w.11·3 cm, 4 ½ in;
bottom buckle
h.6·8 cm, 2⅝ in;
button diam.
2·1 cm, ⅞ in.
Victoria and
Albert Museum,
London

126
Matthew
Boulton,
Titus clock,
c.1776–7.
Ormolu and
marble;
h.42 cm,
16 ½ in.
Birmingham
Museums and
Art Gallery

Like his friend Wedgwood, he was a pioneering industrialist, and his insurance scheme was an early form of social welfare. Contributors received a certificate listing the rules and regulations of the scheme, printed under an engraving which shows a worker sitting in front of Boulton's factory, surrounded by classical figures symbolizing various arts and trades. A cartouche at the bottom proclaims 'From Art, Industry and Society, Great Blessings Flow'. Those blessings helped to fill Boulton's coffers, while at the same

On the Continent, where the commercialism associated with the Industrial Revolution got under way later than in Britain, the dissemination of the Neoclassical style in the decorative arts initially relied more on aristocratic and state patronage, rather than on free enterprise. The outstanding example of such patronage was the Sèvres ceramic factory on the outskirts of Paris. Flourishing under the protection of royal patronage, the Sèvres factory had no need to sell in the market-place, but its products were of course not restricted to French royal court clients. Consequently the factory produced some of the most luxurious ceramics in Europe during the Neoclassical period, including the two most lavish royal dinner services of the later eighteenth century, one for Louis XVI and the other for Catherine the Great. Wedgwood also supplied the empress with a dinner service (the 'Frog' service), but it was not on the same opulent scale, although large and ambitious in the range of its decorative ornament.

During the eighteenth century the serving of dinner had become increasingly elaborate, following a fashion that had originated in France in the previous century. The dining table would be laid with a central ornament, flanked by dishes for the display of fruits and delicacies. Each place setting might have specially designed plates, with glasses and cutlery engraved with coats of arms. The varied dishes served at each dinner necessitated an equally large number of tureens and other serving dishes. The less formal partaking of tea, coffee or chocolate in other rooms was subjected to the same meticulous attention to presentation, involving both taste and status.

The centrepiece of the Sèvres Russian service, totalling nearly 750 pieces, was an 85 cm (33 in) high allegorical sculpture representing the Parnassus of Russia, or the Apotheosis of Catherine the Great (127), modelled by Simon-Louis Boizot (1743–1809), a Neoclassical sculptor in charge of modelling at the factory. He

was a prolific designer while he held this part-time post, but in terms of spectacle nothing matched this Russian centrepiece. A helmeted bust of Minerva, goddess of war but also of the professions and the arts, symbolizes the empress, mounted on a fluted column. Around the base an elaborate group of figures represents the arts, letters and sciences. The creation of the group, one of the most elaborate of all Sèvres pieces, involved the making of 110 moulds.

The dining tables of the great were therefore status symbols, evidence of power and wealth as tangible as any larger display

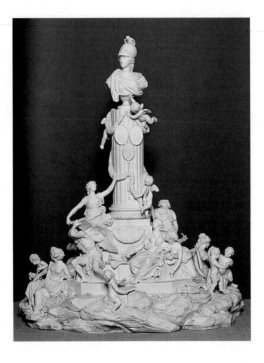

127
Sèvres
(Modelled by
Simon-Louis
Boizot),
Centrepiece
featuring the
Apotheosis of
Catherine the
Great, 1779.
Biscuit
porcelain;
h.85 cm,
33 ½ in.
Musée National
de Céramique,
Sèvres

in architecture. For the most ceremonial of occasions the table ornaments would be in silver-gilt, and such a service commissioned for presentation to Napoleon (see 155) will be discussed in the next chapter. Ceramic pieces, however, were the norm, and although Sèvres produced some of the most splendid examples, the French factory did not have a monopoly.

The royal ceramic factory in Berlin, for example, was commis-

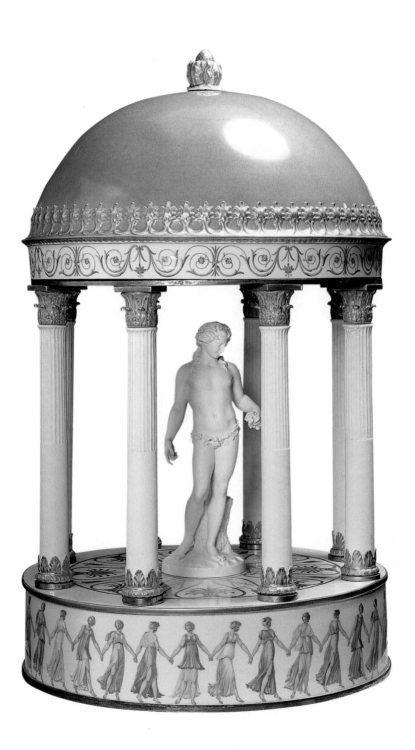

sioned in 1791 by Frederick William II of Prussia to produce a table-set on the theme of 'The Kingdom of Nature'. Two elegant temples housing statues of Bacchus (128) and Venus were the largest pieces, joined by the Hours and Graces, the Elements and the Seasons, sphinxes and obelisks. This elegant miniature gallery of classical antiquity was intended to remind those dining, according to one contemporary, of the prodigalities and mysteries of Nature for which mankind should be continuously thankful. Such allegories on the dinner tables of the great were not unusual, giving an added dimension to the food and wine.

Other ornamental ceramic sculptural groups and figures were usually not so elaborate. Like the piece for Catherine the Great and the figure of Bacchus in his temple, these miniature sculptures in the Neoclassical period were usually made of biscuit, an unglazed white porcelain that has the colour and texture of marble. Sèvres was the first factory to see the potential of this material, and from the 1750s onwards made a large number of such decorative sculptures. They became popular all over Europe, appealing to the aristocracy and the rich middle class. These miniature sculptures were perfect ornaments for mantelpieces and bureaux, as well as the dinner table. When buying a dinner service from the Sèvres factory, customers would add one or more of these biscuit figures to the order to complete the table decoration.

One of Boizot's predecessors in charge of modelling had been another Neoclassicist, the sculptor Etienne-Maurice Falconet (1716–91), one of the leading artists of the late 1750s and early 1760s. He played a key role in developing Sèvres models. Falconet's reputation had been established by a marble *Cupid* (*L' Amour menaçant*), commissioned by Madame de Pompadour for her Paris house and exhibited in 1757, the year that Falconet took charge of the modelling at Sèvres. The following year he produced a smaller biscuit model of his *Cupid* (129), and later added to his range of models a *Psyche*, so that the amorous pair could be united. Such was the demand for the two statuettes that in the decade from 1761, when the *Psyche* was first produced, 230

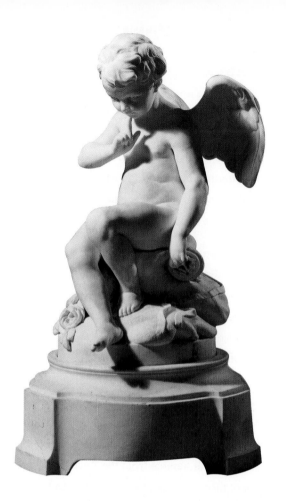

129
Sèvres,
Statuette of
Étienne-Maurice
Falconet's
Cupid (*L' Amour
menaçant*),
c.1761.
Biscuit
porcelain;
h.23·7 cm,
9⅜in.
Metropolitan
Museum of Art,
New York

examples were sold, a large number for a luxury item. Falconet's *Cupid* was one of the most famous and frequently copied eighteenth-century sculptures, not only in Sèvres biscuit. A bronze version appears, for example, among the scientific equipment of the physicist Abbé Nollet. The *Cupid* sat on top of his Leyden jar, used for electrical experiments, its charge perhaps analogous in Nollet's mind to the flight of Cupid's arrow.

Falconet's *Cupid* has an attractive vitality which contemporaries obviously admired. Cupid's posture is delicately balanced between the silence implied by the raised finger and the imminent action evident from the other hand, which is reaching for an arrow. The *Cupid* lives up to Falconet's own aspirations as a sculptor, expressed by him in a discourse a few years later:

In attempting the imitation of the surfaces of the human body, sculpture ought not to be satisfied with a cold likeness, such as man might be before the breath of life animated him. This sort of truth, although well rendered, can only excite by its exactitude a praise as cold as the likeness, and the soul of the spectator is not moved by it. It is living nature, animated, passionate, that the sculptor ought to express.

Falconet's 'living nature' dominated the painted decoration of the vases and tableware which formed the substantial part of the Sèvres output. Flowers in particular were prominent, a reflection initially not only of the taste of Madame de Pompadour, but also that of the overall artistic director at the factory, Jean-Jacques Bachelier (1724–1806). His reputation as a painter was based on his flower-pieces. Because of these preferences in taste, the Neoclassical style only gradually came to dominate the painted decoration of Sèvres products.

A fuller commitment to Neoclassicism only materialized later in the century, when Bachelier had to share artistic direction with another painter, Jean-Jacques Lagrenée (1739–1821). He was much more deeply interested in classical antiquity than Bachelier, as can be seen in one of the sets of china the factory produced in 1788, for Marie-Antoinette to use in the new Neoclassical dairy at the royal hunting estate of Rambouillet. The drinking of milk had become a fashionable health fad, to be pursued in elegant surroundings built for the purpose, and furnished with appropriate china, but of a far more luxurious nature than would be found in a farmhouse dairy. Pails, bowls for rising cream, together with cups and saucers, suitably decorated with cows and goats, were supplied by ceramic factories throughout Europe to satisfy this new fashion. Those made for Marie-Antoinette excelled in refinement, their perfection reflecting the extravagant expenditure of the French royal court on the art of good living.

The dairy set made for Rambouillet (130) is among the most Neoclassical pieces produced by the Sèvres factory in the late eighteenth century, before the total dominance of the style there once Napoleon came to power. So classical were the Rambouillet

pieces that the original design for the cup is labelled 'with Etruscan handles'. It had been copied from Greek vases recently given to the factory by the minister of state in charge of the enterprise, the Comte d'Angiviller, which were 'to be used as models of simple, pure forms, and to change, by these examples, the bad direction given to the shapes of porcelain under the recent regime'. In other words, the minister did not think that the Sèvres products sufficiently reflected the current Neoclassical taste. Other European factories in this respect were far more up-to-date. The royal factory in Naples, for instance, had begun work in 1785 on a very Neoclassical 'Etruscan' dinner service (131) which was to be presented to George III, its shapes and decorations inspired by ancient Greek vases and the antiquities of Herculaneum. Other

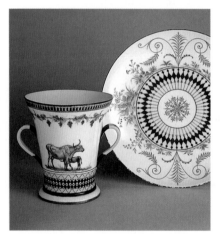 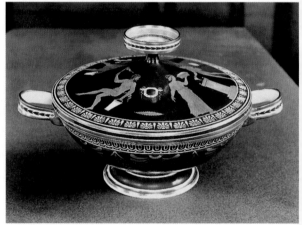

factories in the 1780s were also making fuller use of classical sources. An elegant coffee set made by the Vienna porcelain factory is another good example of Herculaneum antiquities being adapted for modern use (133). Across the other side of Europe, in Spain, where Charles III had established a porcelain factory in 1759 in the grounds of the Buen Retiro palace in Madrid, Neoclassicism had taken a firm hold in the design of its products by the 1780s, especially vases (132).

The dominant role in Europe of French taste embraced other areas of the decorative arts, with other French manufactured goods

selling as widely as its expensive ceramics. Among these products were printed cottons and wallpapers. When shopping for printed cottons in the late eighteenth and early nineteenth centuries, a customer might be offered, among a range of furnishing fabrics dominated by floral repeats, designs of a different kind. The pattern might be based on a famous seventeenth-century ceiling fresco, or some peasant idyll or historical scene which had originated as an oil painting by a recent painter. In order to make a repeating pattern, these images were combined with a variety of foliage and flowers, animals and figures, and engraved on copper plates and cylinders. This kind of pictorial printed cotton has come to be known universally as *toile de Jouy*, named after the village

near Versailles where the first printed textile factory in France was established. Set up by Christophe-Philippe Oberkampf (1738–1815), who had been brought up in the textile industry, the factory began production in 1760. It was to be the start of one of the most successful industrial ventures in eighteenth-century France. Conveniently situated near the court, the factory attracted a wealthy and influential clientele. They appreciated the high quality of Oberkampf's designs and production, not only of his pictorial prints but also his floral and geometric patterns. The finely drawn engravings were made possible by the British invention of copper-

130
Sèvres,
Cup and saucer made for dairy at Rambouillet, 1788. Hardpaste porcelain; Cup h.8 cm, 3¹⁄₈ in. Musée National de Céramique, Sèvres

131
Royal Factory, Naples,
'Etruscan' dinner service presented to George III, soup tureen, 1785–7. Porcelain; h.26·5, 10¹⁄₂ in. Royal Collection, Windsor Castle

132
Buen Retiro,
Vase, late 18th century. Porcelain painted with enamel colours; h.60·3, 23¾ in. Victoria and Albert Museum, London

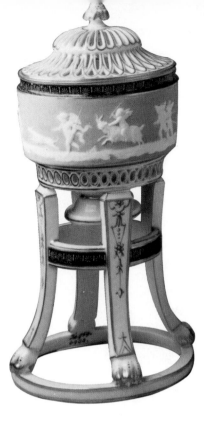

plate printing, which Oberkampf introduced into France, and which was taken up by other manufacturing centres, such as Mulhouse and Nantes. By the time he commissioned two large portraits of himself, his wife and family (134) from Louis-Léopold Boilly (1761–1845), Oberkampf was in his sixties and at the peak of his achievement. He had a Paris showroom, a considerably enlarged factory, a workforce of over 250 printers and a stock of 30,000 engraved plates. He was amply justified in standing proudly in his portrait, backed by his factory and surrounded by fields covered in lengths of fabric stretched out for the bleaching process. Official recognition came in the 1780s when he was ennobled and his factory was added to the few on the list of *manufactures royales* (by royal appointment), a list which already included Sèvres. In spite of his royal patronage he managed to survive the Revolution by funding patriotic causes and by incorporating republican themes into some of his pictorial textiles. Oberkampf is the nearest equivalent in France during the Neoclassical period to

**133
Vienna
Porcelain
Factory**,
Coffee set,
decorated with
figures from
Herculaneum,
c.1789.
Porcelain; dish
29×33·5 cm,
11³⁄₈ ×13¹⁄₄ in.
Österreichisches
Museum für
angewandte
Kunst, Vienna

Wedgwood, the epitome of the modern, design-conscious indus-
trial capitalist.

In the early days at Jouy, patterns for printing on the cotton were
produced by draughtsmen working at the factory. But in 1783, the
year in which Oberkampf gained the royal licence, he started to
employ the part-time services of a Parisian painter, Jean-Baptiste
Huet (1745–1811). He was to be responsible for many *toiles de
Jouy* pictorial designs, starting with one depicting the printing
process itself, portrayed as an imaginary outdoor idyll with each
stage of the printing taking place under the shade of trees. The
imagery may have been inaccurate, but this rural idyll became typi-
cal of many of the *toiles* in the 1780s, in which modern and increas-
ingly classical figures were combined with the delights of nature.
Austerely printed in only one colour (usually red), the designs were
a charming version of Neoclassicism, illustrating contemporary
events, traditional customs and popular novels.

One of Huet's designs depicted the traditional village festival of the crowning of the *rosière*, the virtuous young maiden rewarded by a wreath of roses and a small dowry. Modern political events included one cotton marketed as *American Liberty*, for which Huet's original design was quickly amended so that Oberkampf could cash in on the colonists' recently won independence. A profile portrait of Benjamin Franklin was incorporated into the pattern, a scanty concession to topicality surrounded by the existing, unaltered range of goats, fishermen, fountains and Gothic ruins. Oberkampf's most up-to-the-minute *toile* was one sold as the *Fête de la Fédération*, the main celebration commemorating the first anniversary in 1790 of the outbreak of the Revolution (136). Huet himself would almost certainly have been present at the celebration in Paris, which took place simultaneously with celebrations in many other cities, including Rome. At the Paris celebration Louis XVI stood before an altar dedicated to Liberty and swore an oath of allegiance, to the accompaniment of the joyous cries of the citizens dancing on the ruins of the hated prison of the Bastille, which had been demolished at the start of the Revolution the year before (see 142).

That Revolution had seen one of the first of the rioting mobs unleashing its fury on a wallpaper factory, the Paris premises of Jean-Baptiste Réveillon (d.1811), France's leading producer of this commodity. He had set up business in a lavish seventeenth-century house which was on tourists' regular itineraries of the city. It was so beautifully decorated that the surroundings must have provided much 'material to excite the imagination of the artists employed in the workshop', according to a Paris guidebook published shortly before the Revolution. Réveillon had by that time pushed the standard of wallpaper design to new heights (135). His elegant and brightly coloured Neoclassical designs, largely inspired by ancient Roman wall-paintings, had earned his establishment the title of *manufacture royale*, and he had received the award from Necker, the Finance Minister, of a prize-winning medal for the encouragement of the decorative arts. He had built up a prosperous concern by the time the mob rampaged through

his premises destroying everything in revenge for unjust taxes believed to have been levied by Réveillon on his workers. There is thus no record of the identity of the 'very distinguished' artist on his payroll who was receiving a substantial annual retainer. The name of Huet is one of several that has been suggested. This and other tantalizing pieces of information are provided by the pamphlet Réveillon published immediately after the riot, attempting to justify himself in the eyes of the Revolutionary authorities. The pamphlet could not restore what he had lost, however, and he fled for safety to England.

While manufacturers played an important role in disseminating the Neoclasical style, credit should also be given to the publication of design pattern-books and their widespread use, both in the hands of patrons and in those of factory designers. France, as the most design-conscious country in Europe, was responsible for a large proportion of these publications, which found their way into many other countries. These books supplemented the large body of archaeological illustrations plundered by artists, decorators and manufacturers alike. The number and variety of pattern-books increased considerably from the mid-eighteenth century onwards. By the mid-nineteenth century they had become a flood. There were two kinds: those published specifically for use by designers, usually without a text; and those which were primarily treatises on architecture. Illustrations for the first kind of book were often published in groups or individually, leaving purchasers to buy only those they wanted, so that when eventually bound the set might well be incomplete.

These pattern-books catered for one form particularly well: the vase. Vases were ubiquitous in the Neoclassical period, large and small, three-dimensional, in relief and linear, made of stone, metal, ceramic, wood and plaster, woven in silk and wool, and printed on fabric and paper. From balustrades and tombs, cast-iron stoves and fireplace fenders, to clocks and coffee pots, the vase was inescapable. It was a very adaptable shape, available in a multi-plicity of contours and details, derived mainly from Roman and

135
Jean-Baptiste Réveillon, Wallpaper panel depicting an allegory of Autumn, c.1789. Block-printed panel; 213×54 cm, 83⁷⁄₈ × 21¹⁄₄ in. Musée des Arts Décoratifs, Paris

136
Toile de Jouy, Fête de la Fédération. c.1790. Copperplate print on cotton. Victoria and Albert Museum, London

Greek sources. One of the earliest Neoclassical pattern-books is devoted exclusively to vases. It is a volume by the painter Joseph-Marie Vien, published in 1760, consisting of a sequence of twelve engravings of his own invention 'in the taste of the antique' (137). The publication could not have been intended as a scholarly archaeological one, since none of the plates are of identifiable antiquities. But as Vien provided no text we must guess his intentions, and assume that he meant his book to be useful to artists and craftsmen alike. He was certainly interested in design, because much later in life he was a member of the jury for industrial exhibitions in Paris, an innovation in the period of the Revolutionary 1790s. His painting of the *Seller of Cupids* (see 83), executed only three years after the pattern-book, amended the Herculaneum fresco from which he had borrowed the composition (84), by incorporating the vase on the background pedestal and an incense burner on the table. Both these additions are in the same style as the items in his *Suite de vases*. Indeed, the whole painting, while ostensibly reinventing a scene in the classical past and thus representing one of the earliest Neoclassical history paintings, is at the same time an imaginary architectural setting that could be a contemporary interior, designed and furnished in the newly emerging robust, heavy forms that characterize French Neoclassicism in the mid-eighteenth century.

The French did not have quite a complete monopoly of design pattern-books in the early phase of Neoclassicism. Other countries produced a few examples, most notably Britain. After the turn of the century important examples started to be published elsewhere, in Germany for example. In Britain the leading design publication was *Works in Architecture* published by Robert and James Adam in two volumes in 1773 and 1779 (with a third posthumous volume in 1822). The range of engravings was unusually comprehensive, providing not only the customary elevations and plans of their buildings, but ample examples of tables, mirrors, wall-lights, clocks, doorknobs and even sedan chairs (138). The wealth of visual material was a marvellous resource for designers, craftsmen, builders – anyone looking for ideas to transform into any

scale and any medium. As the architect John Soane was to say of Robert Adam in the next generation (1812): 'Manufacturers of every kind felt the electric power of his revolution in art.' The Adam office had little direct contact with manufacturers, since they designed for specific clients, and this 'electric power' therefore came mostly through the intermediary of the plates in the *Works*. The volumes were primarily a form of self-publicity, immodestly

trumpeting the 'approbation of our employers' and the adulation in the form of imitation by other artists. The result, as the Adam brothers put it, was a transformation of the 'whole system of this useful and elegant art', which would afford 'entertainment to the connoisseur, but also convey some instruction to the artist'.

Artists were increasingly confronted by a new challenge against the backdrop of the Industrial Revolution: should they be

concerned with mass design or turn their backs on it as unworthy of an artist's studio? This chapter has presented examples of artists designing for the decorative arts and for industrial products, but this collaboration was not automatically taken for granted. Should the artist be involved in the 'useful' arts or exclusively in the higher realm of the 'fine' arts? The question is a fundamental one, raised from the mid-eighteenth century onwards, and involves not only the relationship of the two kinds of art to each other, but also – on a wider front – the relationship of the artist to society. The debate, art versus industry, became intense from the mid-nineteenth century, galvanized by the Great Exhibition of 1851 in the Crystal Palace in London. The foundations of that debate, however, were laid in the Neoclassical period.

A constant thread in the discussions was the conviction that the 'fine' arts of painting, sculpture and architecture were superior to other kinds of art, such as ceramics, textiles, and so on, because they were intellectual. They would then be on a level with the long-established seven 'liberal' arts, comprising grammar, rhetoric, logic, arithmetic, geometry, astronomy and music. Reynolds, when delivering his discourses at the Royal Academy, was worried about accepting even architecture into the fine arts because it served 'our wants and necessities', but he did concede that architecture was also concerned with 'higher principles'.

To the theoretical arguments were added practical worries. Some artists objected to factory-made wares making them redundant. For example, the increasing popularity of wallpaper, it was felt, supplanted the architect's role as interior designer and that of the painter as a muralist. No one in the Neoclassical period, however, pushed the argument to the extreme of the 'art-for-art's sake' stance that was to emerge in France in the mid-1830s, culminating later in the century in the writings and art of such figures as Oscar Wilde and Whistler. The Goncourt brothers, best known for their reassessment of French eighteenth-century painters, even wrote in a virulent tract of 1854: 'Industry sets out from the useful; it goes for the profitable for the greatest number. Art starts from the

138
Robert and James Adam, Plate from *Works in Architecture* showing a variety of furnishings, including lock plates and girandoler, 1773–1822. Engraving; 88×44·3 cm, 34⅝×17½ in

useless; it aims at what is agreeable for the few.'

Less extreme positions were adopted in eighteenth-century arguments on either side of the debate. Denis Diderot (139) faced it in his article on 'Art' in the encyclopedia which he co-edited. Under a subheading 'Distribution of the arts into the liberal and mechanical', he maintained that earlier thinkers had treated the mechanical, or useful, arts unjustly. While admitting that the arts should be separated into those which are 'more the work of the mind than the hand' and those that are 'more the work of the hand than the mind', he continued with a caveat.

Though it is well founded, this distinction has produced an undesirable effect. Firstly, it has vilified some eminent, respectable and very useful people, and secondly, it has enhanced a kind of natural laziness which tends to make us believe all too readily that for us to devote our constant and sustained attention to particular experience and to tangible, material objects was something unworthy of the human mind.

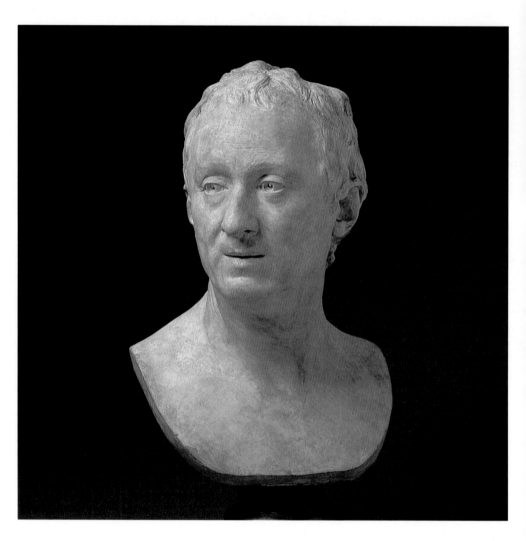

Here speaks a man of the Age of Reason, who in his youth would have seen the errors of such thinking, since his father was a master cutler. His encyclopedia devoted many articles and illustrations to the mechanical or useful arts, including porcelain manufacture, textile weaving, wallpaper printing, silversmithing and iron casting (140) – information that remains to this day one of the most important sources for our knowledge of manufacturing processes in the eighteenth century.

Diderot's argument was taken up by Jean-Jacques Bachelier (1724–1806), who had started a free drawing school for artisans (the first of its kind in Europe) and campaigned on behalf of art

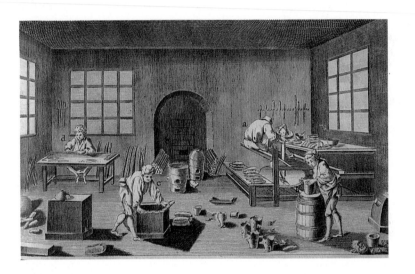

139
Jean-Antoine Houdon,
Bust of Diderot,
1771.
Terracotta;
h.52 cm,
20 ½ in.
Musée du Louvre, Paris

140
Denis Diderot and Jean le Rond d'Alembert,
Plate from
Encyclopédie,
showing pottery manufacture,
1751–72.
Engraving;
32·3 × 43 cm,
12¾ × 17 in

education. Artisans were unjustly scorned, he argued: 'In what system of physics or metaphysics can one see more intelligence, more shrewdness, more accuracy, than in the machines for spinning gold thread, for making stockings, and in the trades of trimmers, gauze workers, cloth manufacturers or workers in silk?' The skills of such people were 'essential to public utility, which need intelligent hands and eyes enlightened by taste'. That taste was being developed, he hoped, at his drawing school.

Discussions about the interrelationship of art and industry were increasingly to focus on art education, especially in the

nineteenth century, when the notion of taste for its own sake had been replaced by the recognition that better design increased marketability. The direct equation between art and commerce was to be appreciated and acted upon at government level, most notably by the establishment of art schools for design and also the founding of museums of the decorative arts as sources of inspiration and mentors of good taste. These developments began throughout Europe from the 1830s, later becoming a movement of major importance.

'It was precisely on the ruins of the despotism of France that the French people celebrated the first anniversary of liberty.' So runs part of the inscription under a print (142) of the giant ball given in July 1790 on the site of the ruins of the Bastille prison in Paris, that had been stormed at the start of the French Revolution. On the site a tall column dedicated to Liberty was to be erected, but events and personalities succeeded each other so rapidly, and money was always in such short supply, that the project was never realized. Art has often been manipulated for the purposes of propaganda, and the Neoclassical period is no exception. There is no better place to start a discussion than with the French Revolutionary and Napoleonic period.

The revolutionaries took over a former theatre as the assembly hall for their Convention, which became the scene of acrimonious debates in the mid-1790s, leading to the guillotining of the infamous period of the 'Terror'. Here Robespierre held sway, and here the vote was taken to execute the king and queen. On either side of the president's rostrum hung paintings of two martyrs of the newly declared French Republic, both of whom were assassinated in 1793. Both death scenes were painted by Jacques-Louis David, himself a deputy of the Convention, who had already organized both the funeral celebrations.

On the eve of Louis XVI's execution, a noble deputy of the Convention who had voted for the king's death, Michel Le Pelletier de Saint-Fargeau, was assassinated by a soldier in the king's guard. Later in the same year Charlotte Corday plunged a dagger into the radical thinker Jean-Paul Marat while he was taking his sulphur bath for a skin complaint. Both deaths had immediately been publicly commemorated; David had already painted the *Death of Le Pelletier* and given it to the Convention by the time it

141
Jacques-Louis David,
Death of Marat,
1793.
Oil on canvas;
165×128cm,
65×50½in.
Musée Royal
des Beaux-Arts,
Brussels

251 Art in the Service of Politics

ordered the *Death of Marat* (141). As reported in a contemporary newspaper, one of the deputies lamented Marat's death thus: 'He sacrificed himself for liberty. Our eyes still look for him amongst us. O terrible spectacle, he is on his deathbed! Where are you David? You have transmitted to posterity the image of Le Pelletier, dying for his country, there remains a picture for you to do.' To which David cried out in reply, 'I will do it too.'

In both pictures David represented ideals of heroism and virtue. Pictures of martyrs were reminders of causes for which they had died, and should be a source of contemporary inspiration. David made these points explicitly in his speeches to the Convention when he presented his pictures. With the *Marat* he exhorted a diverse public:

Rush up everyone! the mother, the widow, the orphan, the oppressed soldier: all you he defended at the risk of his life, approach! and contemplate your friend; he who was watchful is no more; his pen, the terror of traitors, his pen falls from his hands. Oh despair! Your tireless friend is dead! Your friend is dead, giving you his last piece of bread; he is dead without having the means to be buried. Posterity, you will avenge him; you will tell your nephews how he could have possessed riches, if he had not preferred virtue to wealth.

142
Louis Le Coeur (after Swebach-Desfontaines),
*Dance at the Bastille,
18 July 1790.*
Coloured aquatint;
33×27 cm,
13×10⁵⁄₈ in

With these words David presented 'the homage of my brushes' to the Convention. Rarely has an artist made such a poignant speech about one of his own works.

The Convention ordered that engravings be made of both paintings, and, in addition to their display in the assembly hall, the paintings were exhibited briefly to a wider public in the courtyard of the Louvre. The two martyrs were further honoured by being buried in the Panthéon, the renamed church of Sainte-Geneviève (see Chapter 2) where heroes of the Revolution were commemorated. Pantheons in classical times housed statues of the major deities, the most famous example being that in Rome itself (transformed however into a Christian church). The great and the famous gathered together under one roof as a mark of respect was the ultimate secular honour a country could offer.

BAL DE LA BASTILLE

Swebach Desfontaines del. *Le Cœur sculp.*

Ce fut précisément sur les ruines de cet affreux monument du despotisme que le Français célébra le premier anniversaire de la liberté. La célérité des préparatifs de cette fête dut étonner sans doute, mais comment exprimer le sentiment qu'on éprouvait en lisant cette inscription.

Ici l'on danse.

When David's contemporaries painted Marat's death they either showed the assassination itself, with Charlotte Corday playing a prominent role, or alternatively the turbulent scene after Marat's supporters had rushed into the room. Such interpretations were either too distracting or insufficiently heroic for an artist of David's temperament. His first thought had been to show Marat still writing at his makeshift desk, penning 'his last thoughts for the salvation of the people'. He abandoned this plan, kept the pens and inkpot as evidence of Marat's writing, and showed Marat instead 'at his last gasp'. Death in a bath-tub may seem an unpromising setting for a hero or martyr, but in the hands of David the result is a masterpiece – stark, understated and poignant, arguably the greatest work of art to come out of the French Revolution.

David knew and admired Marat. He compared him to the greatest thinkers of ancient Greece and Rome, including Socrates, whose enforced suicide David had already painted in 1787 (see 90). The austerity of Marat's beliefs is indicated by his self-imposed poverty, which is emphasized in the painting. For Marat, poverty in itself was not a virtue; it only became virtuous if wealth was deliberately rejected or given away. On the edge of the box, David has painted a promissory note with an accompanying instruction that it was to be given to a widow with five children, whose father had died for his country. Marat himself has been deliberately posed by David to suggest the familiar image of Christ in his tomb. David has borrowed a Christian image and secularized it, just as the Revolutionary leaders had deconsecrated all churches. His canvas is on the scale of an altarpiece, conceived for the adulation of a contemporary hero in a secular context.

A hero of a different kind was celebrated by the crowds that lined the Paris streets in July 1791 to watch the progress of a special funeral car on its way to the Panthéon. The remains of the great writer Voltaire (1694–1778), who had died more than ten years before the Revolution broke out, were being transferred there from the remote church where he had been buried (143). Voltaire was admired in the Revolutionary period for his deism, his hostility

to intolerance (especially by the Catholic church) and his defence of the rights of man. He was seen as a forerunner of the Revolution itself, and the National Assembly had voted to award him the highest honour at its disposal.

The elaborate ceremonial procession was probably organized by David. Though subsequently altered for different events, the ornate Neoclassical funeral car survives to this day in the Panthéon. On a house-drawn carriage draped in blue velvet, with four candelabra burning incense and perfume at the corners, was mounted a sarcophagus bearing a life-size figure of Voltaire about to be crowned by Immortality. Involving mourners wearing ancient Roman dress and carrying classical trophies, the ceremony bore all the signs of a pagan ritual presented as a modern spectacle.

Rousseau's remains were also transferred to the Panthéon, despite the fact that his tomb on the Isle of Poplars at Ermenonville (see 107) had become a place of pilgrimage and was in any case not too far from Paris. His 1794 procession, in keeping with the man, was simpler than Voltaire's. His effigy, seated under a tree, was carried on bearers' shoulders. As a philosopher for whom nature was of paramount importance, it was appropriate that his remains rested overnight in the Tuileries gardens. The sarcophagus, surmounted by the urn containing his remains, was placed under a simple classical canopy, flanked by candelabra (144). The temporary structure was erected on an artificial island planted with poplars in the centre of the gardens' large circular basin, recalling the setting of the original monument out at Ermenonville. When the torches and lamps were lit, the ceremony *en route* to the Panthéon briefly acquired an additional ingredient of theatricality.

Many temporary structures were erected during the Revolutionary period for celebrations and festivals, both in France and in other countries to which the Revolutionary ideals had spread. In Amsterdam, Brussels, Cologne, Basle, Rome and elsewhere, public squares became sites for a simple Tree of Liberty or the more eleborate imagery associated with Festivals of the

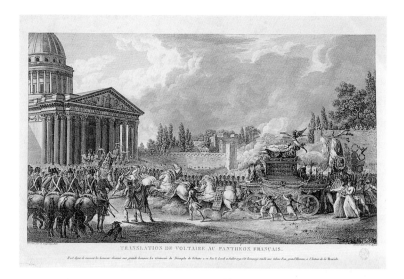

TRANSLATION DE VOLTAIRE AU PANTHÉON FRANÇAIS.

Il est digne de consacrer les honneurs donnés aux grands hommes La Cérémonie du Triomphe de Voltaire a eu lieu le Lundi 11 Juillet 1791 Cet hommage rendu aux talens d'un grand Homme, à l'Auteur de la Henriade.

Federation, which commemorated the outbreak of the Revolution.

Celebratory structures were erected in 1798 in the square in front of St Peter's in Rome, in the heart of Catholicism, making the festival even more defiantly anti-Christian than the big displays in Paris. This particular Festival of the Federation celebrated the declaration of the Roman republic in the previous year, and had been devised by Ennio Quirino Visconti (1751–1818). He had become Minister of the Interior in the new republic, was one of the leading archaeological scholars in Italy, and author of several catalogues of antique statuary – the ideal impresario for such an occasion. He reinvented the classical past on a giant circular stage that filled most of the enormous square. Four Doric columns topped by trumpet-blowing Victories framed a central altar, on which stood three figures representing Rome between Liberty and Equality. The carved relief around the altar showed France trampling underfoot totalitarian government, while taking oppressed Rome by the hand and presenting it to Liberty, the River Tiber, the cardinal virtues and the liberal arts.

Temporary structures were also erected in deconsecrated churches, transforming them into temples of Reason. Gothic interiors became the backdrops for rocky mountains and trees, appropriate settings for statues dedicated to the new deity of Reason, such as the one set up in the medieval church of St-Maurice in Lille in northern France (145).

Private buildings also provided plenty of scope for everyday reminders of the new revolutionary ideals of Liberty and Equality. Wallpaper manufacturers in France and Germany produced papers printed with republican symbols and apotheoses of heroes (146), providing ample evidence of lively commercial enterprises capitalizing on current fashion in the market-place. More expensive items designed to special order included a beautiful pair of candelabra commissioned in 1791 from a leading French Neoclassical sculptor, Joseph Chinard (1756–1813), by a Lyons businessman (147). The supporting figures on one candelabrum depict Jupiter striking down the aristocracy with his thunderbolt, while on the other

143
S C Miger
after Jean-
Jacques
Lagrenée
(Lagrenée the
Younger),
Translation of
Voltaire to the
Pantheon,
1791.
Coloured
engraving;
82·7×50·3 cm,
32⁷⁄₈×19⁷⁄₈in.
Musée
Carnavalet, Paris

144
Hubert Robert,
Monument
Erected to
Rousseau in
the Tuileries
Gardens,
by Night,
1794.
Oil on canvas;
65×80·5 cm,
25⁵⁄₈×31¾in.
Musée
Carnavalet, Paris

Apollo crushes Religion. For the figures of Jupiter and Apollo, the artist relied heavily on classical prototypes. For Religion he used a familiar image in Christian iconography, that of Faith, thus deliberately juxtaposing the pagan and the Christian. Such a bold expression of republican sympathies got Chinard into trouble, as he was working in Rome at the time. The Catholic authorities in the Vatican disapproved, and Chinard was briefly imprisoned. Released after a couple of months, he went back to his native Lyons, where he sculpted a bas-relief of Liberty and Equality for

145
François Verly
Altar of Reason in the Temple of Reason, Saint-Maurice, Lille,
1793.
Watercolour;
30×35cm,
11⅞×13¾in.
Archives
Départmentales
du Nord, Lille

146
Pierre Jacquemart and Eugène Balthasar Crescent Bénard de Moussinières,
The Apotheosis of a Military Hero in the Year IX of the Revolution,
1801.
Wallpaper.
Bibliothèque
Nationale, Paris

147
Joseph Chinard,
Apollo Crushing Religion,
1791.
Terracotta
candelabrum;
h.51·5cm,
20¼in.
Musée
Carnavalet, Paris

the town hall (the Hôtel de Ville), and contributed to the designing of Revolutionary festivals.

Napoleon's rapid rise to power during the next decade led to the creation of France's First Empire, with Napoleon as its Emperor. In 1804, shortly after Napoleon's coronation, the young painter Jean-Auguste-Dominique Ingres (1780–1867), still in his twenties, was officially commissioned to paint a large portrait of the new emperor in his coronation robes (148). The painting was to hang in the seat

of the National Assembly. Ingres's approach to this commission throws light on Napoleon's increasing recognition of the importance of visual propaganda in his campaign of self-promotion. For the artist, however, there was a problem. Napoleon was a usurper. He had not inherited his imperial throne. Neither had he inherited the divine right of kings, any vestiges of which had been destroyed by the Revolution. To paint Napoleon as Emperor in an official portrait, the state robes, insignia and throne of an eighteenth-century monarch would not only have been inappropriate,

but also repugnant to Napoleon. A new image had to be created which both conveyed Napoleon's authority and suggested a factitious historical lineage. A myth had to be invented.

Part of the myth came from classical antiquity. The opulence of the late Roman Empire, so much loved by Napoleon, is reflected in the portrait's extensive use of intricate gold pattern, combined with the richness of ermine and velvet. These ornate trappings present an image of Napoleon that derives partly from a Roman

148
Jean-Auguste-Dominique Ingres,
Napoleon I on the Imperial Throne,
1806.
Oil on canvas;
260×163 cm,
102×64 in.
Musée de l'Armée, Paris

149
Quatremère de Quincy,
Frontispiece from *Jupiter Olympien* showing a reconstruction of the Olympian Jupiter,
1815.
Engraving;
30·5×24·4 cm,
12×9⅝ in

gem depicting Jupiter, which Ingres would have known from an engraving. Ingres, however, has replaced Jupiter's traditional thunderbolt by the hand of justice in Napoleon's regalia, while Jupiter's eagle has become part of the woven design of the carpet. What is particularly interesting about the original gem according to the antiquarian who published it (the Comte de Caylus) is that it was believed to derive from a famous statue of *Jupiter* by the foremost ancient Greek sculptor, Pheidias (149). Napoleon on his throne in this painting of 1806 goes back to the heart of the ancient Greek world, and by inference to the greatest of the gods of its mythology.

Napoleon identified himself with the glories of the Roman Empire, but he also aspired to be the successor to Charlemagne, the great Holy Roman Emperor and King of the Franks in the ninth century, who controlled an enormous area of central Europe based on today's Germany. In an earlier equestrian portrait, by David, Napoleon is shown crossing the Alps into Italy in 1800. Only two men in history had previously dared cross these mountains for a military purpose, first Hannibal when Carthage was fighting Rome, and second Charlemagne. Their names, along with Napoleon's, are inscribed on rocks in the foreground of David's portrait. The Charlemagne association was to be continued in the imperial regalia featured in Ingres's painting. The ivory hand of justice and the sword with its ornate scabbard were reputedly once Charlemagne's. They had been so heavily restored, however, by one of the leading silversmiths working in Paris, Martin-Guillaume Biennais (1764–1843), that they look more like newly fashioned Neoclassical objects. The links with the Holy Roman Empire went even further, since Napoleon's sceptre had reputedly belonged to another emperor, Charles V; while Napoleon's personal emblem of the bee had originally been used by the Franks, reinterpreted by Napoleon to symbolize industry and work.

As well as classical and medieval references, there is yet one more layer of association in Ingres's portrait: a biblical one. This last audacious reference would be blasphemous if the Revolution had not declared itself anti-religious. Among the European artistic

plunder that Napoleon had removed to Paris and displayed in the Louvre was a famous fifteenth-century altarpiece from Ghent by Jan van Eyck (d. 1441). Ingres found works of this period a revelation. By the end of the eighteenth century, in their quest for a greater 'purity' in art, the Neoclassicists had begun looking not only at classical sources, but also at art from the medieval period on to the early Renaissance. The artistic significance of this development in taste will be discussed in the next chapter. All that need be said here is that for Ingres to derive inspiration from Van Eyck was not too unexpected for the more progressive of the Neoclassicists at this time. Ingres took from Van Eyck's altarpiece the hieratic, other-worldly presence of God the Father, as well as the richness and intensity of the colouring of his robe (152). These unusual elements in Ingres's portrait were noticed by critics who dismissed it as 'gothic', an adjective normally used in the period as a form of abuse. Some of Ingres's contemporaries did not understand his deliberately archaic style, complaining that the artist 'intends nothing less than to move art back four centuries, to take us back to the beginning'. This was indeed what Ingres was trying to do, and doing it in a startlingly original portrait.

An entirely different image of Napoleon, as Mars the god of war, was completed by Antonio Canova (1757–1822) in the same year as Ingres's portrait (150). A colossal sculpture, over 3 m or 11 ft in height, it had evolved from a suggestion initially made by a francophile Italian, Giovanni Battista Sommariva (1760–1826). A wealthy patron of contemporary art and an astute politician, he exerted great influence in Lombardy during the French occupation of Italy, and the creation there of the newly named Cisalpine Republic.

The creation of that republic by Napoleon was to be commemorated in a large canvas by David, which Sommariva was partly responsible for commissioning. He also suggested to Canova that he should design a monument to Napoleon. The intention was to site it in the centre of Milan in a vast new forum, the Foro Bonaparte, with temples and monuments being planned by the Italian architect Giovanni Antonio Antolini (1756–1841) from 1801

onwards (151). Inspired by ancient imperial splendour, where power was expressed in the vastness not only of buildings but also of public spaces and their approaching avenues, some exceptionally spacious town-planning schemes were designed in the first decades of the nineteenth century, including the Piazza del Plebiscito (Square of the Plebiscite) in Naples, commissioned by Joachim Murat, the French military commander who had been made King of Naples by Napoleon. The Foro Bonaparte was the most grandiose of several projects planned while Napoleon's stepson Eugène de Beauharnais was viceroy of Lombardy. Only some of the Milan projects came to fruition, such as a modernized street system, and a large triumphal arch to celebrate the viceroy's marriage to Princess Augusta-Amelia of Bavaria (eventually completed in 1838). But the new forum was so vast (600 m or nearly 2000 ft in diameter), and the number of proposed military monuments so numerous, that completion was impossible before the reversal of French military fortunes.

Plans for Canova's monument and its destination developed differently from what had originally been envisaged. The year after Sommariva made his suggestion, Canova was in Paris in 1802 to model a bust of Napoleon. The two men discussed the possibility of the monument. Although Napoleon was still only First Consul, he was already acutely aware of the value of artistic propaganda. For the statue he had originally intended to be portrayed in contemporary dress, and he is shown in this way in a plaster model made from life. But after lengthy discussion Canova persuaded him to be naked, arguing that modern clothing was ungainly. Canova had a point, since the consul's uniform had a high collar, which distorted the line of the neck and shoulders. A Roman toga had the advantage of falling in elegant folds, allowing the artist to drape it at will, either concealing or exposing an otherwise naked body. In the end, Napoleon's toga was slung over one shoulder, creating an image of a timeless ancient god or hero, a Mars or a Hercules.

The head of Napoleon which Canova produced in 1802 was over

150
Antonio Canova, *Napoleon as Mars*, 1803–6. Marble; h.340 cm, 134 in. Apsley House, London

151
Felice Giani, *Design for Monuments for the Proposed Foro Bonaparte in Milan*, c.1801. Pen and ink and wash; 39·2×52·4 cm, 15½×20⅝ in. Private collection

life-size, and intended for incorporation in the full figure. On its own, however, the bust became the most frequently copied sculptural portrait of Napoleon, reduced to normal life-size in marble, or scaled down into miniature replicas in ceramic or plaster. Many of the latter were manufactured in the village of Coreglia, in Tuscany, and exported throughout Europe. The example shown in a print (153), on the left of the tray on the boy's head, could well be from there. The portrait head is not an idealized classical one but rather a contemporary and realistic one, capturing the intense eyes and firm chin of a leader and hero whom contemporaries knew and would recognize. This head, retaining its essential qualities, was then copied as part of the enormous block of marble that became *Napoleon as Mars*. The hero is of the present, the god is eternal: Canova combined the fact and the myth of Napoleon.

Canova's statue was to have a chequered history. He produced two versions, one in marble commissioned by Napoleon himself, and one in bronze ordered by Eugène de Beauharnais. Napoleon was

never able to display his version. It arrived in Paris in 1811 at a time when he was coping with military disasters on two fronts, in Spain and Russia, followed by a progressive loss of control and final defeat. The marble remained in a store room until the British government acquired it after the war and gave it to the Duke of Wellington, who installed it in his London house, where it remains to this day. The fate of the bronze version was different. As the intended site in the Foro Bonaparte in Milan was never completed, and the cast was not ready until 1812, it was felt politically inexpedient to display it publicly in a prominent open space. Instead, the court of the Senate in Milan was chosen, from where it was subsequently moved to that of the city's main museum (the Brera). The destinations of *Napoleon as Mars* were as fickle as the fate of the man himself.

Not all portraits of Napoleon have classical allusions, and many show the man as he was in daily life. That is how he was always painted by David, from the time he depicted Napoleon as a young and successful military commander, following his Italian campaign in 1797, to the emperor who had conquered most of Europe, alone in his study at night in 1812.

152
Jan van Eyck,
*The Ghent
Altarpiece*
(centre panel
showing God
the Father),
1432.
Oil on panel;
208×79 cm,
82×31⅛in.
St Bavo, Ghent

153
John Thomas
Smith,
Boy vendor of
plaster casts:
'Very Fine Very
Cheap',
1815.
Engraving;
19·2×11·5 cm,
7½ × 4½ in

VERY FINE VERY CHEAP
London Published as the Act directs December 1st 1815
by John Thomas Smith, No1 Chandos Street Covent Garden

154
Jacques-Louis
David,
The Coronation
of the Emperor
and Empress,
1805–7.
Oil on canvas;
610×970cm,
240×381½in.
Musée du
Louvre, Paris

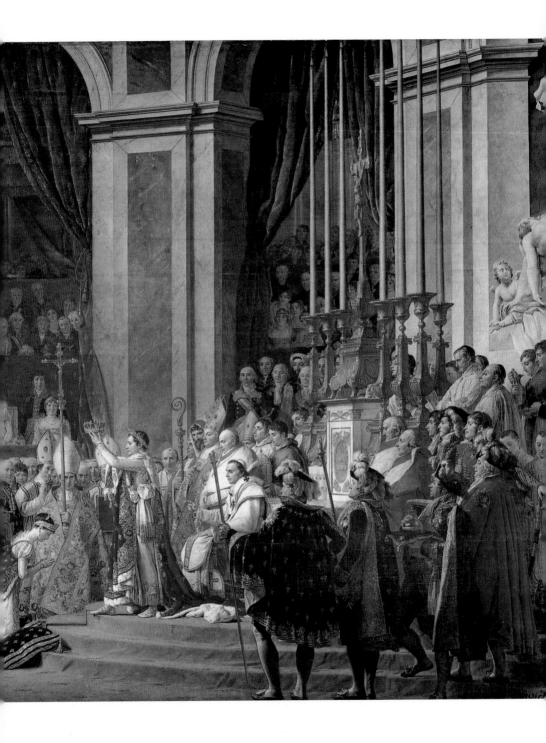

David was fascinated by Napoleon, and in spite of their often difficult relations remained faithful to him. His admiration started at the time of Napoleon's first victories in Italy, when he wrote to congratulate him. They met for the first time at an official dinner in honour of the victorious generals, when David asked Napoleon if he could paint his portrait. After Napoleon had sat for him in his studio, David exclaimed to friends that he was 'a man to whom altars would have been erected in antiquity'. Napoleon for his part admired David sufficiently to want him to accompany him on his planned Egyptian campaign, but David excused himself on the grounds of ill health.

David became increasingly involved in Napoleon's circle in matters concerning all aspects of art, including proposals for the architectural embellishment of Paris. David aspired to be appointed minister of arts and 'First Painter of France', and contemporaries suspected his ambitions of being fuelled by a greedy wife. In the event, his activities during Napoleon's regime were to be based in his studio as a painter, not as a cultural politician. David was eventually given the title of 'First Painter' by Napoleon, but his many enemies among the imperial officials prevented other advancements.

Before Napoleon's coronation and its accompanying celebrations, Napoleon asked David to record the events on four large canvases to be displayed in a special gallery. This was the time when Napoleon gave him the title of 'First Painter'. It involved no remuneration, and as David was to find to his cost, Napoleon and his bureaucrats were going to create a lot of difficulties about paying properly for the set of coronation paintings. David had no written agreement and relied on verbal promises, which turned out to be unreliable. In the end, only two of the series were completed.

David described the subject matter of the four paintings in a memorandum to Napoleon. The artist proposed: the coronation itself; the enthronement with officials, the military and the populace cheering 'Long live the emperor'; the distribution of the eagles (which had been chosen from ancient Rome as symbols for the

new empire) to the national guard; and Napoleon's arrival at the Hôtel de Ville, symbolizing the first act of obedience by the people to their emperor.

The project was an ambitious one. The *Coronation* (154), the preparation for which alone took a year, was conceived as an enormous canvas, measuring over 6 by 9 m (nearly 20 by 30 ft), one of the largest pictures ever painted by a French artist. Its detailed record of the ceremony in the church of Notre-Dame in Paris involved a composition with two hundred people, many of them accurate portraits. The church had been specially decorated by Charles Percier (1764–1838) and Pierre-François-Léonard Fontaine (1762–1853), Napoleon's favourite Neoclassical architects, and the costumes were designed for the occasion by a painter, Jean-Baptiste Isabey. The decorations included, outside on the west front, a triumphal entry arch supported by four columns, two symbolizing the Carolingian and Frankish dynasties, and two representing the 'good towns of France'. David's painting of the ceremony inside was based on sketches made on the spot from a good vantage point, in the choir close to Napoleon's family. He shows the moment when Napoleon, having crowned himself, then crowns the kneeling figure of Josephine. Watching this act of secular arrogance (coronations would traditionally have been handled by the Church) is Pope Pius VII. He had been persuaded to attend, and had expected to perform the act of crowning. Napoleon's action was an impulsive, last-minute decision.

After David had completed the painting, Napoleon insisted that the pope be painted not as David had shown him, with his hands on his lap, but with one of them raised in an act of benediction. 'I did not make him come so far to do nothing,' snarled Napoleon. The Church was thus compelled to give its approval to the coronation, in paint at least, if not in actuality. For the viewer and therefore for posterity, Napoleon's changed record of the event became an established fact.

Three days after the coronation, the city of Paris gave a great banquet for their new emperor, at which the exceptionally hand-

some silver-gilt dinner service the city had given him as a present was used for the first time (155). Commissioned from one of the finest silversmiths in Paris, Henry Auguste (1759–1816), who worked from designs supplied by Percier and Fontaine, the service including the tableware consisted of over a thousand pieces. The main pieces are among the most spectacular examples of silver-smithing in the Neoclassical period. The emperor and empress each had their own 'nef', a ship-like table ornament which had traditionally contained the lord's cutlery and napkin but which had become purely decorative. Each nef is ornamented with appropriate allegorical figures. His is supported by the rivers of the Seine and the Marne, and surmounted by Justice, Prudence and Victory, while hers is surmounted by the Three Graces and Charity. The pieces are worthy of Napoleon's imperial ambitions, promoting them even on the dinner table.

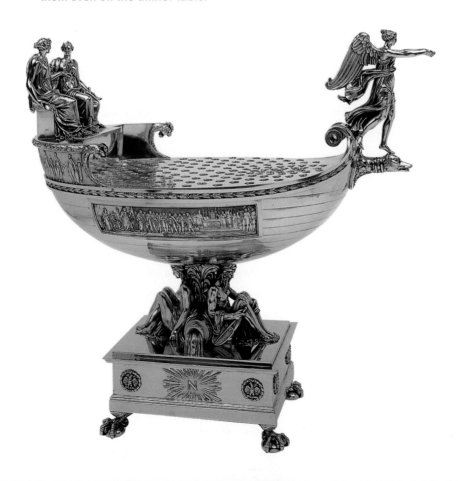

155
Henry
Auguste,
Napoleon's
ef from the
Coronation
ervice,
804.
ilver-gilt;
68 cm,
6³⁄₄ in.
Musée National,
Malmaison

156
èvres,
able des
Grands
Capitaines,
806–12.
able top with
orcelain and
ronze mounts;
am. 104 cm,
0⁷⁄₈ in.
oyal Collection,
uckingham
alace

Napoleon's self-conscious identification with the Roman imperial past was promoted in architecture both by himself and – as in Naples and Milan – by others on his behalf. After he became Emperor, Napoleon became very interested in large-scale architectural projects. One of the earliest, devised in the year that Ingres was completing his portrait, would have combined the palaces of the Louvre and the (now destroyed) Tuileries, flanking an enormous ceremonial courtyard with a triumphal arch.

The palace project was only realized later, in the mid-nineteenth century, in a different form. But Napoleon went ahead not only with the intended arch, but with a second one as well. After his resounding victory at the Battle of Austerlitz in 1805, the greatest in his career, when he defeated Prussia and Russia, Napoleon had good cause for celebration. He decreed that two triumphal arches would be erected to 'the glory of our armies', one near the Louvre, to be called the Arc de Triomphe du Carrousel (meaning 'tournament' from the name of the square on which it was to be sited), and the other at one of the western entries into the city, the Arc de Triomphe de l'Etoile (meaning 'star' from the avenues radiating out from the square). While the latter arch was not completed until 1836, the Arc de Triomphe du Carrousel (158) was finished

within two years, and was ready to be inaugurated by Napoleon when he returned from his Italian campaigns in 1808. The commission was given to Percier and Fontaine, with overall control of the sculptural programme entrusted to Baron Dominique Vivant Denon (1747–1825), Napoleon's principal art adviser. He had recently been appointed as the first director of the Musée Napoléon, the renamed Louvre, now opened as a public museum.

The design of the arch was based on the arch of Septimius Severus in the Roman Forum, which was carved with scenes of

157
Sèvres,
Vase showing transport of the *Apollo Belvedere* and the *Laocoön* from Italy as Napoleonic plu der, arriving at the Louvre, 1810–13. Enamelled porcelain; h.120 cm, 47 ¼ in. Musée National de Céramique, Sèvres

158
Louis-Pierre Baltard,
Arc de Triomph du Carrousel, 1808–15. Ink and wash; 40·4×50·3 cm, 16×19⁷₈in. Musée Carnavalet, Par

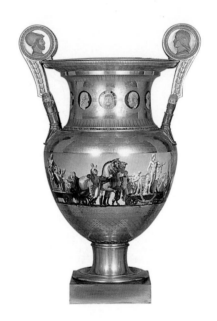

the emperor's military achievements. It was a perfect model for adaptation to Napoleon's conquests, with reliefs illustrating battle scenes chosen by Napoleon himself, among them Austerlitz. Statues of soldiers representing branches of the army were placed above the columns, the most audacious part of the design reserved for the top. Sited dramatically on the skyline were the ancient bronze horses from St Mark's in Venice, which had been plundered by Napoleon's army, now flanked by new statues of Victory and Peace. As the monumental entrance to the courtyard of the Tuileries palace, the arch was a magnificent addition to the cityscape of Paris. Today the horses are back in Venice, having

been returned with other Napoleonic booty after 1815 and replaced by a new chariot group. The arch remains an imposing testimonial to Napoleon's initially successful imperial ambitions.

The year 1806 was a particularly fruitful one for Napoleonic commissions in France. In addition to two triumphal arches and the completion of Ingres's portrait, there were official commissions for eighteen paintings to commemorate Napoleon's German campaign, together with several costly tables ordered from the Sèvres porcelain factory. The top of one of the tables consists of

ceramic plaques with medallion portraits of Napoleon, in the centre, surrounded by his French generals. Another commemorates the most famous military leaders of the past, their portraits painted to simulate antique cameos, with Alexander the Great surrounded by Caesar, Hannibal and others (156). Scenes from Alexander's life complete the decoration of the top, including his entry into Babylon. The classical allusions are carried into the table's support, a tied bundle of fasces or rods, the ancient Roman insignia of authority. These tables were among the most important commissions given to the Sèvres factory during the Napoleonic period. Such commissions also included a tall vase

commemorating the triumphant arrival in Paris of art treasures
plundered from Italy (157). Napoleon was keen to revive the
skills of the luxury trades that had been so badly hit by the
Revolutionary turmoil, and together with his advisers initiated
a series of commissions, ranging from such Sèvres items to thou-
sands of metres of silk ordered from Lyons for the refurbishing
of former royal residences.

The project for the eighteen paintings was discussed by Napoleon
in great detail with Baron Denon, who pushed the complex
scheme through all its planning stages in only a fortnight. One
of the painters invited to contribute was Charles Meynier
(1768–1832), who was also involved in the Arc de Triumphe du
Carrousel project. Some of the eighteen subjects were chosen by
Napoleon himself, among them Meynier's *The Soldiers of the
76th Regiment Recovering their Flags in the Arsenal at Innsbruck*
(159). The giant canvas, with its life-size figures, is one of the
best of the campaign paintings that record scenes of the
Napoleonic wars.

The incident Napoleon chose for Meynier's painting is not a battle
scene but one of emotional patriotism. It had occurred in the 1805
campaign just before the French army entered Vienna. In an earlier
campaign the 76th Regiment had lost three of its flags, and they
were joyfully retrieved in the arsenal at Innsbruck. As Meynier
explained in the Salon exhibition catalogue in 1808, the loss of the
flags had been 'the symbol of a profound suffering', until they were
returned to the regiment by Marshal Michel Ney, the Napoleonic
hero who commanded the sixth corps of the Grande Armée. Ney's
action, which dominates the left side of the composition, made
'tears gush from the eyes of all the old soldiers', and, said Meynier,
'the young conscripts were proud to have played a part in the
recapture of the standards taken from their elders.' Denon was
delighted with the outcome of the commission, which represents a
major achievement of Neoclassical history painting, composed as
a vast, complex frieze – as though a classical sculptured relief had
been transposed into a contemporary setting. It is a passionate

159
Charles Meynier,
*The Soldiers
of the 76th
Regiment
Recovering their
Flags in the
Arsenal
at Innsbruck*,
1808.
Oil on canvas;
360×524 cm,
141×206 in.
Musée National
de Versailles

and intensely patriotic scene; the artist even restricted himself to tones of reds, blues and greys, echoing the colours of the new French national flag. Napoleon hung it in the former royal château at Compiègne, north of Paris, which he had partially refurbished in the Neoclassical style.

The kind of discussion that Napoleon had with Canova, about whether he should be represented in contemporary dress or as a naked hero from a timeless, classical past, was endemic in the later eighteenth century and the early nineteenth. It had occurred in the context of Benjamin West's painting of the *Death of Wolfe* (see 100), and the problem later reached crisis proportions in London. Many heroes had fallen during the Revolutionary and Napoleonic Wars, and heavy demands were being made on church and public spaces for the siting of appropriate monuments, whether contemporary or antique in their imagery. Westminster Abbey was already overfull with centuries' accumulation of tombs. A committee was set up in 1796 to oversee new monuments in the building. The only other major church in the capital, St Paul's Cathedral, had been deliberately kept clear of monuments because of the visual clutter at the abbey, but such aesthetic idealism was no longer tenable when confronted by the realities of recent wars. Space had to be found for dead admirals and generals.

Government funds for memorials were provided by the Treasury, which in 1802 set up a Committee of National Monuments, composed of collectors and other individuals with an interest in the visual arts. This body was responsible for commissioning works to be sited in St Paul's Cathedral. Known as the 'Committee of Taste', it set about its task with such promptness and efficiency that most of the best sites in St Paul's had already been allocated by the time of Nelson's death at the Battle of Trafalgar in 1805. A writer expressed alarm that so many gallant, but not necessarily great, heroes were being commemorated: 'What mausoleum, what pyramid', he asked, 'shall we raise to the memory of the immortal Nelson!'

Napoleon's main strategic weakness was at sea, where the French naval forces suffered several disastrous defeats at the hands of Nelson, the greatest admiral of his day in Europe. The climax of his career, at which he met his end, had made any intended French invasion of Britain impossible to realize. Nelson had also earlier flouted Napoleon's ambition to open up a route through to the east by defeating the French navy at the Battle of Nile.

The choice of sculptor for the principal monument to Britain's most famous hero in the current wars, to be sited in St Paul's, was therefore of great importance. The Italian Antonio Canova, who had many influential British admirers, was considered, but for patriotic reasons alone such a commission would never have gone ahead. Canova did produce a model; he opted for a totally classical approach, with a square, freestanding sarcophagus decorated with reliefs. Contemporaries reacted with disgust: 'What is the English tar to say when he sees his beloved Nelson in a Roman petticoat, why, he will say, are British sailors to imitate a Roman dress, are we not original, as great a people as ever ruled the waves and influenced the world!'

Nelson was not dressed in a 'Roman petticoat' on the monument that the Committee of Taste ultimately commissioned from John Flaxman (160), now firmly established as one of Britain's leading sculptors. Flaxman's Nelson is wearing a contemporary

admiral's uniform, with classical allusions retained for other parts of the design. River gods symbolize Nelson's three great victories of Copenhagen, the Nile and Trafalgar. Minerva, symbolizing war, is pointing out the hero to two young midshipmen, one of whom clutches a sextant.

Flaxman presumably witnessed, along with thousands of other people, the procession of Nelson's funeral car from beside the River Thames at Greenwich to St Paul's. The base of the carriage was carved to resemble the prow and stern of his flagship *Victory* on which he had been killed. On this were mounted four carved palm trees, alluding to his Nile campaign, supporting a classical canopy. The velvet covering of the coffin was elaborately decorated with stock motifs: Britannia, the British lion, Neptune, a figure of Grief, an eagle (for victory),

**160
John Flaxman**,
Monument to
Vice-Admiral
Horatio, Viscount
Nelson,
1807–18.
Marble;
St Paul's
Cathedral,
London

sphinx, crocodile, sea-horse, dolphin and trophies. Such a combination realized in marble, however, would have been visually confusing.

Flaxman went for a simpler, bolder design, incorporating only some of the motifs on the funeral car, which he skilfully combined with other classical and modern elements. His Nelson is a recognizable portrait in modern dress, but he has been idealized by the omission of any indication of his blind eye, and by concealing the loss of an arm by the folds of his outer coat. The midshipmen are likewise in contemporary dress. Their motherly instructress, however, is Minerva, who was frequently interchanged with Britannia. The river gods are standard classical imagery. Although it is a monument in a Christian church, it is devoid of any religious references in either its imagery or its inscription. It is a wholly pagan celebration of Nelson's 'splendid and unparalleled achievements, during a life spent in the service of his country', as the inscription says, 'and terminated in the moment of victory by a glorious death'. Such is the man the younger generation, represented by the midshipmen, should emulate. A similar sentiment was expressed in one of the many poems published to commemorate his death, which imagines a mother taking her child to gaze at such a monument, in the hope that: 'The boy shall turn a hero from the pile, / And rise the future Nelson of the isle!'

When painters came to commemorate Nelson's deeds they had greater flexibility than sculptors in portraying a hero's death, not bound by the constraints of a block of marble. Nelson could be depicted on the deck of his flagship, surrounded by the turmoil of battle. Alternatively, he could be transported heavenwards in allegorical apotheosis, accompanied by a host of appropriate symbolic figures. Both approaches were tried. A third approach was possible, though usually avoided – namely the actual death scene in his cabin (although Nelson was wounded on deck he did not actually expire there). According to Benjamin West, Nelson should not be represented 'dying in a gloomy hold of a ship, like a sick man in a prison hole'. In elaborating this view West neatly

summed up an important contemporary attitude on how, and why, a hero should be depicted: 'To move the mind there should be a spectacle presented to raise and warm the mind, and all should be proportioned to the highest idea conceived of the hero. No boy would be animated by a representation of Nelson dying like an ordinary man, his feelings must be roused and his mind inflamed by a scene great and extraordinary. A mere matter of fact will never produce this effect.'

West himself painted the death of Nelson as a contemporary event on board ship, as well as an apotheosis, and also designed a sculptural relief for a memorial pediment (at Greenwich Hospital). In addition, he did paint the much despised cockpit scene, but only to provide the basis for an engraving to illustrate a *Life* of Nelson. It is the apotheosis that concerns us here. Before the Committee of Taste had started to look for a suitable sculptor for the St Paul's monument, George III had asked the Royal Academy to consider the best way of commemorating Nelson's death. West's response, as President of that body, was to design his own monument (161). When he exhibited this sketch, along with a larger version of the central picture, at the Royal Academy in 1807, he provided a detailed explanation. Nelson is being held up by Neptune so that Victory can present him to Britannia. The dark shadow that covers her symbolizes Britain's grief, while on the other hand the fluttering boys indicate that his genius is still alive. West intended the monument to combine the three arts represented by the academy: architecture in the frame, sculpture in the flanking groups of seamen, and of course painting, 'best calculated to give allegorical figures their full effect'. Unfortunately West's design highlights the problems encountered in contemporary allegory, which was already beginning to show itself as a worn-out vein for creative art. As one contemporary critic dismissed West's *Nelson*, 'The invisible world is not within the artist's province.'

Turner also admired Nelson's achievement. As soon as the *Victory* had started to sail up the Thames on its return from Trafalgar,

Maturity 1790 to 1830

161
Benjamin
West,
Sketch for a
Monument to
Lord Nelson,
1807.
Oil on canvas;
100·5×74·5 cm,
39¹₂×29³₈in.
Yale Center for
British Art, New
Haven

Turner went and made sketches of it. After the *Victory* had docked,
he made many detailed drawings on board. Just over five months
later he had completed a large canvas of *The Battle of Trafalgar,*
as Seen from the Mizen Starboard Shrouds of the Victory (162).

It was unusual for a painter to respond with quite such alacrity to
a contemporary event, but it was such an important one that some
artists began working on their version of the 'Death of Nelson'
within weeks of the news reaching London. Turner waited until he
could study the ship at first-hand. Of the various paintings of the
death on display in 1806, Turner's was the most ambitious. He
combined on one canvas what would normally have been two
scenes: the dying Nelson surrounded by some of his officers and
men before being taken to the cockpit; and the battle itself still
raging. The death scene belongs to the tradition of history paint-
ing, of which West's *Death of Wolfe* is an obvious example. The
battle scene, on the other hand, belongs to a tradition of maritime
painting. Most unusually, however, Turner takes the viewer close
in to the fighting, observing it from one of the sets of ropes

(shrouds) of the aftermost (or mizen) mast. He imaginatively captures the excitement of an action he never witnessed, complete with smoke and flames enveloping the closely embattled ships. Nelson had been wearing his admiral's uniform on deck, refusing to conceal its conspicuous whiteness by a cloak, which made him a clear target for the French sniper's bullet. In Turner's painting the uniform shines out amidst the darker surrounding figures. First-hand knowledge of the ship, combined with news-paper reports of the battle and death, formed the basis for a powerful and dramatic re-creation of the battle which is also fairly accurate (although naval historians criticize some details).

As Turner was so quick off the mark in celebrating the battle, it is surprising that he did not publish an engraving, and therefore profit from the lucrative market in war memorabilia. The painting's size demanded a public space or a private picture gallery with enormous walls, and it never found a purchaser. Perhaps it was because of the novelty of Turner's treatment of the event, or perhaps – more likely – the reluctance of many British collectors to buy history-pieces by contemporary artists, as some of Turner's eighteenth-century predecessors had already found to their cost.

There was no British equivalent to the series of French battle-pieces and other campaign pictures which Napoleon commis-sioned. Turner's oil of Nelson's death in 1806 was an independent, freelance venture, and its only public display was in his own gallery attached to his studio, and briefly two years later in the annual exhibition of the British Institution (a recently estab-lished venue for exhibitions in London in addition to the Royal Academy). Subsequently he painted another *Battle of Trafalgar*, commissioned for what could have been an important permanent commemoration of the wars. It was ordered by George IV in 1822 as one of a series of British victories to hang in St James's Palace in London. Few paintings, however, were commissioned and the scheme never came to fruition. Turner's contribution was not well received. Naval experts found many errors in it, and George IV was not keen on a representation of the battle as realistic as

Turner's. After hanging in St James's Palace for only a few years, Turner's canvas was dispatched to join other naval pictures at Greenwich Hospital (built for naval officers and seamen early in the eighteenth century).

The Napoleonic Wars left their mark in the history books, but in the visual arts in Britain the only coherently planned and actually executed commemoration was a series of portraits of the principal protagonists among the allies, commissioned for the new banqueting hall, the Waterloo Chamber, in Windsor Castle. Other British projects for commemorating Revolutionary and Napoleonic war heroes were either left unfinished or did not materialize. In 1799 a public subscription was opened for the erection of a monument in the form of a column to commemorate recent naval victories. However, not all the artists submitting plans and models agreed with the idea of a column.

Flaxman preferred either an enormous triumphal arch surmounted by Britannia, or better still a colossal statue of her sited on the top of the hill overlooking Greenwich Hospital (163). The project for the statue, which would have been 69 m (some 226 ft) high, aroused much hostile comment. One sarcastic critic said the sculptor was no longer content with 'cutting marble into men, he wishes to hew Greenwich Hill into a woman large enough to graze a couple of goats in her lap.' The statue would indeed have overpowered the hospital complex below; but Flaxman went as far as publishing a pamphlet, illustrated with engravings after his drawings by his friend William Blake, to justify his project. As far as scale was concerned, Flaxman found a justifiable precedent in the Colossus of Rhodes, the famous ancient statue that reputedly stood across the entrance to the main harbour of the island, and was always included in a list of the Wonders of the World. Contrary to the increasingly popular use of the column as a form of commemoration, Flaxman much preferred a human figure. As he explained: 'How much more sentiment and interest there is in a fine human figure than can possibly be produced in the choicest piece of architecture, and especially when that figure represents

163
John Flaxman,
Colossal Statue
of Britannia for
Greenwich Hill,
1799.
Pencil drawing;
19×15cm,
7½×6in.
Victoria and
Albert Museum,
London

BRITANNIA
BY DIVINE PROVIDENCE
TRIUMPHANT

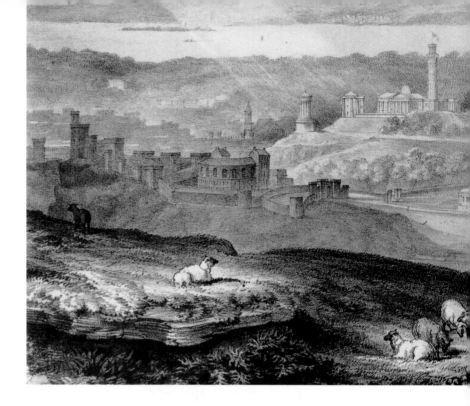

the protecting power and genius of the country.' A decade later the
painter Benjamin Robert Haydon (1786–1846) imagined a colossal
Britannia as a Napoleonic War memorial, sited even more dramati-
cally than Flaxman's: Haydon's would have been erected on top of
the cliffs of Dover looking out across the Channel.

Prominent on the skyline of the city of Edinbugh are a few columns
of a classical temple. This is all that was built of a proposed
National Monument to commemorate those who had died in the
Napoleonic Wars. The memorial was going to take the form of a
full-scale reproduction of the Parthenon at Athens (164), but by
1829 the money had run out, leaving for posterity what looks like
a picturesque ruin. Like its Mediterranean prototype, it would
have stood on top of a hill at the focal point of the city, near where
many handsome Neoclassical streets and public buildings had
been erected over the previous half century. Edinburgh's National
Monument would have been the only one in Britain, and an appro-
priate addition to the 'Athens of the North'.

164
After G M Kemp, *Vision of the Complex on Calton Hill, Edinburgh, Showing the National Monument as if Completed*, 1829. Lithograph; 23·5×38cm, 9¼×15in

Monuments or commemorations can also serve the cause of nationalism. Fuseli's *Oath of the Rütli* is an example of nationalism in paint (see 93), and two more important continental examples will be considered here, one in the form of a tomb in Italy, the other a Neoclassical recreation of the Parthenon erected in Germany, on the banks of the River Danube in Bavaria. The tomb is that of Vittorio Alfieri (1749–1803), one of the foremost writers of his generation, who was later seen as a precursor of the struggle for the unification of Italy (not attained until late in the nineteenth century). The church chosen for a monument to Alfieri was Sante Croce in Florence, which served as a small-scale regional pantheon, commemorating the most celebrated of Italians, headed by Michelangelo.

The monuments in Santa Croce were the starting point for a long poem published in 1807, Ugo Foscolo's *I Sepolcri* (*The Tombs*). The poet and other contemporary visitors to the church found there reminders of Italy's cultural greatness and identity, out of

which they hoped political unity would grow – a hope that increased in intensity the longer the country was occupied by the French. Foscolo's main theme is that tombs to illustrious figures in a country's history have an important patriotic role in the present, inspiring each generation to work for the cause of nationalism. Alfieri, a friend of Foscolo, came 'often to be inspired' surrounded by tombs which aroused in him a deep love of his native land.

Born in Piedmont in northern Italy, Alfieri was the first non-Tuscan to be commemorated in Santa Croce. The sculptor, Canova, also from northern Italy, the Veneto, was the first non-Tuscan to receive a commission in the church. Poet, artist and site combined in a cultural, if not yet political, union of Italy. With Italy occupied by the French, any contribution to the cause of Italian patriotism had an added poignancy, and ran the risk of suppression.

The monument to Alfieri (165) was commissioned by the poet's mistress, the Countess of Albany, wife of the Jacobite pretender Charles Edward Stuart. Initially she intended to fund only a relief panel, but after seeing the model she decided to pay for a large freestanding monument, which was completed in 1810. It was erected on the best site in the right aisle, adjacent to that of Michelangelo's tomb. (Subsequently, unfortunately, the visual impact was weakened by placing a large monument to Dante between the two.) The increase in scale allowed Canova scope for emphasizing the tomb's patriotic theme. The mourning female, present in the original design, now became more prominent than the poet himself. She is not just an elegant Neoclassical mourner, of which there are countless examples. Her crown of crenellated walls and the cornucopia identify her as Italia, the personification of a united Italy, making her first appearance in art.

165
Antonio Canova,
Tomb of Vittorio Alfieri,
1806–10.
Marble;
480×360cm,
189×141in.
Santa Croce,
Florence

It is astonishing that Canova could have been so outspoken in a cause of nationalism at a time when the French authorities were suppressing any signs of national independence in the countries they occupied. But as the most famous sculptor in the Italian peninsula, who had already carved Napoleon's portrait several times, and those of other members of his family, as well as receiving commissions from influential patrons, Canova presumably felt safe. He created the illusion of Italia having walked down the aisle from the west doors, and paused for a while to mourn. Mourning figures were usually more integrated into the composition, clinging to the sarcophagus or urn. In addition, although Italia is classically dressed, Canova has given her the face of an early nineteenth-century woman. Her casualness and modernity did not pass unnoticed. One contemporary observed that she appeared 'rather as an outside spectator, and belongs really to the crowd who mourn for the poet here and not to the tomb itself'. An early biographer was lyrical about Italia 'weeping for a son whose lofty and energetic strains have awakened the love of virtue and patriotism in the breasts of his countrymen, and called forth a race of men animated only by the desire of greatness'. The emergence of patriots such as Garibaldi was still some decades away,

166
Leo von Klenze,
Walhalla,
1836.
Oil on canvas;
95×130 cm,
37 ½ ×51 ¼ in.
Hermitage
Museum, St
Petersburg

but Canova's monument to Alfieri is a contribution to the growing cause of Italian nationalism.

The most triumphant statement of nationalism, however, was to be found much further north. Near Regensburg, in a commanding position overlooking the Danube, King Ludwig I of Bavaria had designated a site for a newly built pantheon. He chose a beautifully wooded landscape away from the town centre, thus enhancing a sense of pilgrimage to a shrine. He named it 'Walhalla', after the great hall in Norse mythology of Odin, the supreme creator, where heroic warriors lived eternally. The Norse myths, which had been collected and published only in the late eighteenth century, provided evidence of an indigenous northern heroic tradition that was not dependent for exemplars of heroism on ancient Greece and Rome. The same Norse mythology was later to be turned into powerful operatic material by Wagner.

Some critics argued that Ludwig's building, like its name, should evoke a northern, rather than a southern, classical tradition. Goethe, for example, had already written that the expression of a Germanic tradition could only be found in Gothic architecture.

The great cathedrals of the Middle Ages, he argued, citing Strasbourg as an example, did not grow out of a classical, Mediterranean culture, but out of the German 'soul'. The Gothic Revival style in the arts (which developed concurrently with Neoclassicism) therefore became, especially in Germany, closely intermeshed with the cause of a national identity.

Paradoxically, however, Ludwig opted for a classical style, and eventually in 1821 approved designs based on the Parthenon in Athens (166), by Bavaria's greatest architect, Leo von Klenze (1784–1864). The actual building work, however, did not begin for another nine years. Ludwig justified his choice of style on the grounds that he wanted an imitation of the best in classical antiquity, namely the form of the Greek temple. By inference, as the building was to be a secular one, the pagan ideal of ancient Greece was more appropriate than the inescapable associations of Christianity and its cathedrals in Gothic architecture.

There was an additional and, for the architect in particular, a stronger motivation for choosing a Greek temple. Klenze's

167
Leo von
Klenze,
Interior of the
Walhalla,
Regensburg,
1830–42.
Engraving;
19·9×14·9 cm,
7⁷⁄₈×5⁷⁄₈in

argument was an anthropological one. He was convinced that the world's population had fanned outwards from two sources, the Himalayas and the Caucasus Mountains. From the latter people spread into Europe, some settling in what was to become the Hellenic empire, others moving further into Europe along the main rivers, including the Danube. Klenze therefore linked Greeks and Germans to a common origin.

Klenze's Walhalla rises in an austere purity above the landscape, breaking loose from earlier 'picturesque' temples which were set into, and partly absorbed by, their settings. The crisp geometry of the flights of steps and the clarity of the detailing create an architecture of elemental purity, which the previous generation of Neoclassicists could scarcely match (apart from a few exceptions, such as Ledoux). Here was a perfect example of the Greek Revival. Klenze's Walhalla has been described as the greatest temple of its kind to be erected since classical times, but its pedimental sculpture and its interior reliefs and portrait busts were all dedicated to the glorification of Germany, not a retelling of Greek or Roman history or mythology. This was a Parthenon serving contemporary German nationalist aspirations.

Ludwig had conceived the project when he was still a young Crown Prince in 1807. That year he had visited Berlin, then enduring French occupation following Prussia's humiliating defeats at the battles of Austerlitz and Jena. Ludwig's sense of nationalism was aroused, and back in the safe haven in his native Bavaria (then an ally of France), imprecise ideas of a national monument began to take shape. His first step had been to commission marble busts of famous men in German history up to the present. By the time Walhalla opened in 1842, there were just over a hundred busts (167). A marble statue of Ludwig himself presides over them in a richly coloured interior. The ceiling is supported by carved figures of the Valkyrie, the beautiful maidens who rescued the bodies of heroes from battlefields and flew them to Odin's Walhalla, and the upper part of the wall is carved with scenes from Germany's early history.

168
Johann Gottfried Schadow, *Bust of Immanuel Kant*, 1808. Marble; h.64 cm, 25¼ in. Walhalla Donaustauf, Regensburg

JMANUEL KANT

The heroes commemorated in this temple of fame are not exclusively military: they include generals such as Blucher, but also poets, composers, philosophers, artists and many others, including Schiller, Mozart, Lessing and Mengs. The poet Klopstock is there, who had wanted German mythology to replace classical subjects in German poetry. The bust of the great philosopher Immanuel Kant (168), by the leading German Neoclassical sculptor Johann Gottfried Schadow, is among the most striking of the series of fifteen which he contributed to the Walhalla. As in his other portraits there, the likeness is recognizably contemporary and unidealized, but the squared-off shoulders which form the base have been carved like those of a classical herm (a head or bust surmounting a four-cornered pillar).

Ludwig himself said of the building that he hoped 'the German might depart from it more German and better than when he had arrived'. Surely nationalism and moral improvement had never been so explicitly united in one building. It conveyed its message to the individual, but also to the crowd forming the ceremonial processions that made their way up the long pilgrimage route from the river below. A century later the message of the Walhalla was to be given a new twist by a recently emerged leader, Adolf Hitler.

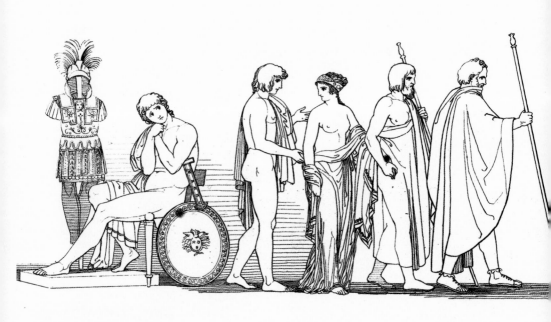

Destroy most of the paintings in the Louvre. Study the only art of
merit, namely Greek vases and archaic sculptures. Read the only
books of genuine worth, which are the Bible and the poetry of
Homer and of Ossian. These radical beliefs constituted the credo
of 'primitivism', views shared by a group of David's followers in
Paris in the 1790s. They even wore ancient Greek robes and grew
beards, much to the consternation of passers-by in the street.
These 'Primitifs' (or 'Barbus', meaning bearded ones) carried to
extreme lengths a fundamental new trend that was emerging
among the most progressive Neoclassical artists at the end of
the eighteenth century. From the 1790s onwards, the Neoclassical

style showed signs of moving towards a greater austerity, or
'purity' as it was sometimes called. The primitivism of other
Neoclassicists, however, was not as restrictive as that of David's
circle, whose self-imposed austerity had no lasting influence,
partly because few works were actually executed according to
the new principles.

The visual revolution in the decades before and after 1800 paral-
leled that taking place simultaneously on a wider political front
across Europe, and it was the first major step towards the artistic
turmoil of a century later. Indeed, it could be argued that Gauguin,
Matisse and Picasso were direct descendants of the Neoclassical
generation of around 1800. In order to retrieve what was believed
to be a lost simplicity and purity in art, much of the European
tradition was rejected by this generation of Neoclassical artists.
Perspectival and spatial complexities, which had been explored in
art from the time of Raphael and Michelangelo at the beginning of
the sixteenth century, were swept aside in preference for a linear
style, in which perspective and modelling play little, if any, part. To
the already much admired Greek vase-paintings were added new
sources of inspiration in the form of Renaissance art earlier than

Raphael, and medieval art as well. Giotto, Fra Angelico, Ghiberti and their contemporaries, hitherto seen only as representing an early stage of evolution towards ever-increasing perfection in the arts, were now appreciated in their own right.

Among the finest manifestations of this new artistic radicalism were the series of illustrations to Homer, Aeschylus and Dante by John Flaxman, first printed in Rome and London between 1793 and 1795. He later added illustrations to the works of Homer's contemporary, Hesiod (1817). Apart from one or two lines of text

170 Right
John Flaxman,
Leucothea
Preserving
Ulysses, from
the *Odyssey*,
1793.
Engraving;
19·2×27·1cm,
7 ½ ×10⅝in

171 Far right
John Flaxman,
Electra and
Chorus of
Trojan Women
Bringing
Oblations, from
Aeschylus's
Choephorae,
1795.
Engraving;
19·5×28·1cm,
7⅝×11in

under each plate, the volumes did not reprint the poems or plays. It could be assumed at this period that any owner of such a book was already fully conversant with the text, just as the artist was. Flaxman's books were not envisaged by him as conventionally illustrated volumes, in which images were scarcely more than decorations; he wanted instead 'to show how any story may be represented in a series of compositions on the principles of the ancients'. As this was a new concept in book publishing, Flaxman was fortunate in having sympathetic patrons. The

Homer volumes were commissioned by Mrs Georgina Hare-Naylor, a cousin of the dowager Countess Spencer; the Aeschylus by the same countess, whose family were regular patrons of contemporary art; and the Dante by Thomas Hope (1769–1831), an important patron of Neoclassicism, and a wealthy member of a banking family.

Flaxman divided Homer's *Iliad* and *Odyssey* into just over sixty scenes, adding a few more for a second edition in 1805. He distilled these great works of literature into a sequence of pure

line drawings, their starkness emphasized by the total lack of modelling and perspective. The proliferation of Flaxman's engravings throughout Europe in a variety of editions, some pirated, is ample evidence of their wide popularity and influence.

Homer's descriptions are vivid and brief, allowing plenty of scope for an artist's imagination. Flaxman responded by reducing incidents to the barest essential elements. Landscape settings and architectural interiors are omitted. Flaxman's austere treatment is signalled in the very first plate (169). The captured Briseis,

Achilles's slave-concubine, is being made to leave his tent by his friend Patroclus, to be handed over to the heralds of King Agamemnon, commander-in-chief of the Greek army fighting the Trojans. We are given no tent, shore or any other indication of a setting, and no suggestion of the presence of an army, only Achilles's armour on its stand and beside his chair, and the five individuals needed to tell the story. Briseis grieves, looking back over her shoulder at Achilles who is equally regretful. It is a poignant moment, handled with restraint, and depicted with economy.

Battles, funeral pyres and near shipwrecks are all subjected to the same ruthless paring down of the composition. In the *Odyssey*, for example, Ulysses is saved from drowning by the sea goddess Leucothea, who quells the violent waves. In Flaxman's illustration (170), Ulysses clings to the mast, gazing up at his saviour who is dispersing the storm.

So abstracted do Flaxman's images become, that his human figures are almost disembodied, refined into the angular and curved shapes of their falling draperies, as in the remarkably forward-looking illustration from the Aeschylus volume (171). Electra, followed by a chorus of three Trojan women, is carrying oblations to the tomb of her murdered father, Agamemnon. The figures' stylized forms anticipate by a century the work of such artists as Beardsley and Klimt. They too were to look at 'primitive' sources, more varied that Flaxman's, but likewise including Greek vase-painting.

While in Italy Flaxman familiarized himself with Sir William Hamilton's large collection of Greek vases. Flaxman already knew the first collection before he left England for his Grand Tour, both from engravings and from the vases themselves in the British Museum. The engravings in the publication of the second collection (1791–5) were markedly different in style from those in the earlier volumes: this time they were purely linear and left uncoloured. The artist was Wilhelm Tischbein, whose work as a painter had included the portrait of Goethe in the Campagna (see

31). The publication of Hamilton's second vase collection was the first major archaeological publication in Europe to be illustrated almost entirely with line engravings (172). The prints were reasonably accurate in recording the details of compositions on the vases, but Tischbein did not adopt the Greek artists' practice of using lines with a uniform thickness. He preferred a subtly varied line more akin to calligraphic penwork, an approach that Flaxman found sympathetic and which gives his 1790s interpretations of the Greek originals an added elegance and grace. Flaxman has reinterpreted a 'primitive' source in the context of the late eighteenth century.

The most ambitious of Flaxman's series was that devoted to Dante's *Divine Comedy*. His 109 plates were the largest group of illustrations to Dante so far published. In designing them Flaxman had been influenced by an additional 'primitive' source, the late medieval sculpture he had studied before leaving England for his Grand Tour in 1787. That interest stayed with him in Italy, widening to encompass the art of the early Renaissance (175). His Italian sketchbooks are full of drawings not only of classical statuary but also of works from these later periods. Some of these drawings may even have been stimulated by the Dante commission, since Italian art would have provided imagery far more appropriate to the *Divine Comedy* than that of Greece and Rome. While medieval and early Renaissance works of art were cited in guidebooks, they were not accorded the attention reserved for Raphael and his period. Late in the eighteenth century, however, a few artists began to sketch paintings and sculptures from these earlier periods, among them members of David's circle and Canova. This new understanding of earlier European art influenced a variety of Neoclassical works, from more explicit instances such as Flaxman's *Divine Comedy* to less obvious examples such as Ingres's official portrait of Napoleon (see 148).

Although Dante is now regarded as one of the giants among European poets, an appreciation of his work came late to Britain, and complete translations of the *Divine Comedy* were not avail-

able until the 1780s. Artists had started to show an interest in Dante in the 1770s, especially Henry Fuseli while on his Grand Tour. What the earlier eighteenth century had found 'wild' in Dante was to become increasingly acceptable as a visionary world which artists could justifiably explore. Dante's world was to form part of the early stirrings of Romanticism, to which Flaxman made a substantial contribution with his *Divine Comedy*. It was thirty years ahead of his friend William Blake's uncompleted project to illustrate the same epic.

Contemporaries noticed the influence of early Italian art on Flaxman's Dante plates. Goethe, for example, observed that he had 'a gift of adopting the innocence of the older Italian School'. Flaxman looked at a wide range of work on his Italian travels, including Madonnas, Nativities, Depositions, Resurrections and Last Judgements, as well as many funerary monuments with their attendant angels. Dante's lines are full of detailed descriptions as vivid as some of the art that Flaxman was studying. In particular, images of Last Judgements often inhabit the same world as the *Inferno*, with its range of punishments embracing ice, pitch, serpents and imprisonment in trees. One of the most striking of Flaxman's plates depicts Dis or Lucifer in the *Inferno* (174). His long talons tear at the body of the traitor Judas Iscariot as he devours him with his front jaws, while his two other mouths devour other sinners. By the time Flaxman reaches the calmer world of the *Paradiso*, images of the Virgin, Christ and angels absorbed from the art of the fourteenth and fifteenth centuries shape his interpretation of Dante's mystical heaven.

Flaxman's *Divine Comedy* was an extraordinary achievement in the context of European art at the time. Although it was made possible by Thomas Hope's patronage, Hope behaved in a very autocratic manner over the commission. Copies of the book printed in 1793 were not for sale – all were for Hope's exclusive use as gifts to his friends; he would not even allow Flaxman a few copies to give away. It was only after a pirated edition had been published that Hope permitted the first of several editions

for sale to the general public to be published. Hope was not the only patron whom Flaxman could regard with mixed feelings in the course of his career.

Flaxman's series of illustrations were among the most important channels for the dissemination of the new wave of Neoclassicism at the turn of the century. It was on these illustrations, rather than his sculpture, that his European reputation rested, and from which artists as diverse as Goya and Ingres were to gain inspiration (173). Contemporaries admired above all what Goethe called their 'naivety', and others described as their 'antique simplicity'. These characteristics announced a new way of depicting the visible world. As one perceptive German critic put it: 'The successful sketch produces a true magic, that so much soulfulness can inhabit a few gentle strokes.'

The 'Primitifs' included on their restrictive reading-list the works of Ossian. What became one of the biggest literary sensations of the later eighteenth and early nineteenth centuries started with the publication of an anonymous volume in 1760 entitled *Fragments of Ancient Poetry Collected in the Highlands of Scotland*. James Macpherson, the translator, followed the success of this modest publication with two more, *Fingal* and *Temora*, in 1761 and 1763 respectively. Thus the name of the ancient Gaelic poet Ossian, who may be mythical or may actually have lived in Scotland and Ireland in the third century AD, became a household word across Europe. Even late into the nineteenth century travellers visited Scotland partly in order to see the land of Ossian's heroes. The works of Ossian were widely read in the Neoclassical period; Napoleon, for example, always had a copy with him. Poets imitated Ossian, and librettists wrote Ossianic operas. His works were often paired with those of Homer: for the novelist Madame de Staël he was the 'Homer of the North', and Goethe, who translated some of the poems into German, gave his fictional character Werther the words 'Ossian has replaced Homer in my heart'. Ossian stood for the Nordic tradition of mythical heroes, Homer the southern.

Even when contemporary critics claimed that the 'translations' were largely Macpherson's own invention, this did not dampen the ardour with which the public devoured Ossian. His writings were translated into several European languages, and provided artists with new inspiration for the timeless themes of heroism and love. But his tales were only accepted gradually as part of the visual stock-in-trade, lacking the familiarity of classical mythology. Fingal and his fellow heroes had emerged fully fledged out of the Celtic twilight, and Europe's artists were not at first ready for them.

In Scotland, however, Ossian's heroes contributed to the growing sense of national identity in the later eighteenth century. They not only stood for an ancient Nordic tradition, hence Ossian's appeal in Germany and Denmark, but more specifically could support the cause of a nascent Scottish nationalism. By about 1800, major European artists became interested in Ossian; before that date the only important depiction of Ossianic subject matter had been on a country house ceiling in Scotland, painted in 1772. At Penicuik, just south of Edinburgh, Sir John Clerk's new house was to be decorated with both fashionably classical and new Ossianic subjects. Clerk initially wanted the Nordic and the Mediterranean traditions to be combined in his décor, but in the end the Nordic prevailed. In the centre of the main ceiling (176) Ossian sat amidst a wild Scottish landscape, playing his harp and conjuring up the spirits of his heroes and heroines. The four corners of the ceiling were filled with classical gods symbolizing Scotland's four main rivers, and the cove around the ceiling contained a sequence of incidents from Ossian's verses. It was an ambitious project by Alexander Runciman (1736–85), whose Grand Tour expenses Clerk had largely met, expecting the decoration of his house in return. He got a ceiling (unfortunately destroyed by fire in the late nineteenth century), which the younger generation were to take as an embryonic display of Scottish nationalism. As one commentator put it: 'the works of art with which a nation adorns itself should be from her own story, and to seek in Scottish poetry for his subjects was surely

175
Duccio di
Buoninsegna,
Rucellai
Madonna,
c.1285. Tempera
on panel;
450×292 cm,
177×114 in.
Galeria degli
Uffizi, Florence

wiser far in a Scottish painter than to have recourse to the trite
and hopelessly defunct mythology of Greece.'

This new brand of nationalism is not evident, however, in the
best of the Ossianic works of art from the early nineteenth century.
The best of the paintings were French, and most were an indirect
result of Napoleon's fascination with Ossian. When Percier and
Fontaine were renovating the country house of Malmaison, near
Paris, for Napoleon and Josephine, it was decided to decorate
the large reception hall with six paintings: four were to depict
Napoleon's battles, with the two remaining subjects taken from
Ossian. The architects' suggestions for these latter works resulted
in François Gérard's (1770–1837) *Ossian Evoking the Spirits on
the Edge of the Lora*, the river which bounded Fingal's castle (177),
and Anne-Louis Girodet's (1767–1824) *Apotheosis of Napoleon's
Generals Presented to Ossian.* Although both artists were pupils
of David, it is Gérard who remained closer to the Neoclassical
style of history painting and whose work David praised, whereas
he hated the wildly Romantic picture Girodet executed for
Malmaison, thinking the artist had gone mad.

In Gérard's painting Ossian is old and blind, alone now that his son

and companions have been lost in battle, playing on his harp and conjuring up Fingal, the last king of Morven in northwest Scotland, the same king after whom the cave had been named on the Isle of Staffa, later immortalized in the music of Mendelssohn. Fingal sits on a throne borne by clouds; beside him is his wife Roscrana, mother of Ossian; against the silhouette of Fingal's castle is the elderly bard Ullin; while to the left the hero Oscar is embraced by his beloved Malvina. Ossian's passion as he plays and sings is echoed in his flying cloak and hair, contrasting with the restrained but intense response of his listeners, who are dressed in vaguely classical garb more reminiscent of Homeric times than primitive Scotland. With his muted colours, illuminated by an eery moonlight, Gérard created an etherial atmosphere, in which heroism and love, the two themes of Ossian's poems, were united. Here, as one contemporary expressed it, was the 'whole system of the poetry and mythology of the Caledonian bard'; never before, he continued, 'have poetic ideas been so happily expressed on canvas'.

Much as Ossian was admired and even compared with Homer, it was ultimately the ancient Greek not the Celt who reigned

176
Alexander Runciman,
Ossian Singing,
1772.
Central panel of a ceiling mural formerly in Penicuik House (destroyed)

177
Baron François Gérard,
Ossian Evoking the Spirits on the Edge of the Lora,
1801.
Oil on canvas;
184·5 × 194·5 cm,
72⅝ × 76⅝ in,
Kunsthalle, Hamburg

**178
Jean-Auguste-
Dominique
Ingres**,
*Apotheosis
of Homer*,
1827.
Oil on canvas;
386×515cm,
152×202in.
Musée du
Louvre, Paris

ΟΝ ΗΡΩΩΝ
ΟΣΜΗ ΘΕΩΙ

ΟΔΥΣΣ

ΟΣ, ΕΝ ΑΘΑΝΑΤΟΙΣΙ ΣΕΙ ΕΣΟΣ
ΕΤΙ ΝΟΜΙΖΕΣΘΩ ΘΕΟΣ ΕΙΝΑΙ

ΛΟΓΓΙΝΟΣ

ANNO 1827

supreme as the great 'primitive' poet. The number of Neoclassical works of art drawn from the *Iliad* and the *Odyssey* far outnumber those from *Fingal* and *Temora.* This situation is summed up in Ingres's large painting of the *Apotheosis of Homer* (178), executed in 1827 as part of a scheme of decoration in the Louvre in a new, Neoclassical suite of rooms dedicated to Egyptian and Etruscan antiquities. Like Gérard, Ingres had been fascinated by Ossian, but it was to the classical world that he was truly dedicated, avoiding what he saw as the dangerous track leading to Romanticism. His *Apotheosis of Homer* is almost a manifesto of the Neoclassical artist's admiration for his hero. A winged Victory is about to crown Homer, flanked below by seated figures representing the *Iliad* and the *Odyssey*. The attendant crowd includes the greatest of ancient Greek painters and sculptors, Apelles, who is leading Raphael on the left, and Pheidias. Together with other classical figures such as Aeschylus and Virgil, Ingres has included a wide variety from the modern world in his pantheon, from Dante to Poussin. The forty-odd figures are arranged in a highly contrived composition, backed by an Athenian temple. Inscribed in Greek with Homer's name, it creates an appropriate setting for a depiction of Homer as a god, surrounded by adoring worshippers of his cult.

Ingres chose a subject from the *Iliad* for the final painting he had to execute as part of his obligations as a student at the French Academy in Rome, where he had been studying since 1806. When his *Jupiter and Thetis* (179) was exhibited in Paris, however, it was greeted with a storm of abuse. Ingres had chosen the lines in which Homer describes Jupiter sitting on his throne, while Thetis, Achilles's mother, pleads on her son's behalf to try and persuade the god to intervene on the Greek side in the Trojan war. She is shown, as in Homer's lines, embracing Jupiter's chin with one hand, while the other rests on his knee. Observing the scene is Jupiter's wife, Juno, justifiably jealous since her husband would have liked to marry Thetis had he been free to do so. In terms of the text Ingres produced an accurate illustration; he had wanted to 'convey the feeling of ambrosia of the place, of the beauty of

179
Jean-Auguste-Dominique Ingres,
Jupiter and Thetis,
1811.
Oil on canvas;
327×260cm,
128×102in.
Musée Granet,
Aix-en-Provence

the characters, of their expressions and divine forms', as he wrote in a letter at the time. 'It should have such a physiognomy of beauty', he said, that 'everyone would be moved.'

Everyone, however, was not moved in the way that Ingres had hoped. He was accused of making fun of the world, producing caricatures and painting badly. The Academy's official report sent back to Paris accused him of trying hard 'to bring himself close to the period of the birth of painting rather than to penetrate the fine principles which are offered by the finest works of all the great masters of art'. In fact, this was precisely what Ingres was trying to do. An intense, almost cobalt sky foils Jupiter's bright pink toga and Thetis's grey-green drape. Ingres's palette would have been acceptable in the 1880s, but in his own day it was unthinkable. For the composition Ingres distilled elements from a range of classical sources, combined with Flaxman's *Iliad* engravings in which the same scene had been illustrated. As with the portrait of Napoleon (see 148), Ingres relied to some extent on reconstructions of Pheidias's famous statue of Jupiter (see 149). To this he added other classical statues and a cameo, but for Jupiter's torso he turned to nature, getting a peasant to pose for him. Harsh colours, unnatural space, anatomical distortions in the body of Thetis and the use of classical sources were fused into a daringly archaistic work. Its very backwardness was to give Ingres's art a relevance for the avant-garde at the end of the nineteenth century.

Primitivism took many forms. When it appeared in architecture it could be lampooned, as these lines addressed to the British architect John Soane show:

To see pilasters scor'd like loins of pork,
To see the Order [of architecture] in confusion move,
Scrolls fixed below and Pedestals above,
To see defiance hurled at Rome and Greece …

This comes from a satirical attack published in 1796, by which time Soane was already at work on his major project of the Bank

of England headquarters in London (180). Interiors here and elsewhere did indeed incorporate pilasters that could be crudely described as looking like a scored loin of pork, or alternatively as a highly original reinvention of a classical form. But Soane had not always been so defiant.

He had not at first responded sympathetically to early Greek architecture, dismissing the columns of the temples at Paestum, when he saw them on his Grand Tour in 1779, as 'exceedingly rude'. But Soane changed his views, partly as a result of reading Laugier's *Essay on Architecture*, and by the time he was lecturing as Professor of Architecture at the Royal Academy, from 1809 onwards, he was stressing the importance of first principles, the utilitarianism of architecture and the dangers of excessive ornament. He was by then hostile to the trivializing proliferation of Neoclassical and other revivalist styles when used by mediocre or unimaginative architects and builders merely to dress up an otherwise ordinary building. Soane was in fact striking at the heart of a problem that was to get out of hand in the next generation, when in the mid-nineteenth century so many different historical periods were being revived simultaneously that the period became known as the 'Battle of the Styles'. Soane advised his Academy audience:

Modern architects, who use the remains of antiquity without reference to first principles, are like those writers who, in their imitations of the old poets, are satisfied with selecting words that have become obsolete from time, and merely adopt some few of the particular modes of expression used by the author, whose style and manner of thinking they profess to imitate …
Sculpture is to architecture what lace is to dress: if it is judiciously introduced, it enriches and pleases by its contrast; if injudiciously, it only produces confusion and disgust.

These were the principles Soane put into practice in the many houses and public buildings he designed throughout a fertile career. As the architect and surveyor to the Bank of England he was given a relatively free hand to create interiors that were at once practical and imaginative. Although much of his work was lost in the remodelling of the bank in the early twentieth century,

much visual evidence survives, and the Bank Stock Office, the first part of his rebuilding programme in 1792–4, has recently been reconstructed. A watercolour of the room (180) by Soane's assistant Joseph Michael Gandy (1771–1843), a brilliant perspectivist, captures the dramatic lighting which moulds the austere architecture into one of the most exciting spaces created in London at the time. The top lighting from the domed ceiling recalls the effect inside the ruins of Hadrian's Villa (see 35), and was to be exploited in other interiors by Soane. Perhaps the most striking example in his interiors of this capacity to prune down to bare essentials and almost reinvent a classical structural form can be seen in the Breakfast Room of his own house (181). There the light is filtered down the sides of an inner, suspended ceiling, like an

open umbrella, both creating an excitingly novel room and providing the best kind of natural daylight to illuminate the artworks displayed on the walls.

This quest for 'first principles', however, formed only part of Neoclassical developments at the turn of the century. Gentler images, likewise referring back to the antique, were also being created. The love affair between Cupid and Psyche was one of the best-known of classical myths, recounted in the Latin novel of the *Metamorphoses* or *Golden Ass* by Apuleius, and many Neoclassical paintings and sculptures derived inspiration from the story, as well as wallpapers and ceramic statuettes. The tale

is of young love requited, in spite of the machinations of Cupid's mother, Venus. The love story allows plenty of scope for treating subject matter anywhere on a scale from the charming to the erotic.

A fine balance between these two extremes was achieved in the marble group by Canova (182), one of the most frequently copied Neoclassical sculptures. Canova's two figures convey all the freshness of youthful, virginal love as understood in the late eighteenth century. Wrapped in a close embrace, transfixed by each other's gaze, the figures create a tension of sublimated passion in the anticipation of a kiss yet to be realized. Psyche's pose is submissive without being provocative; Cupid's by contrast is possessive but devoid of aggression. He seems to have just arrived, his wings still outstretched, poised momentarily while raising her delicate body closer to his own. The movement of the two figures flowing into each other in a complex rhythm of arms, legs and wings – which need to be seen from many angles – is relaxed and natural. The scene is carnal and realistic, yet at the same time ethereal and idealized. It is transitory but also timeless.

Part of the fascination with Canova's version of the story of Cupid and Psyche lies in the ambiguous moment of the kiss. The divine Cupid having fallen in love with the mortal Psyche carried her off to his palace, and the moment of embrace could be at this early stage of the story. When Psyche becomes Cupid's lover, he forbids her to set eyes on him and will only visit her at night. Psyche disobeys and holds a light over Cupid's sleeping body, an act for which she is to be punished with death. Cupid, however, saves her in time, with a kiss. If that is the point represented in Canova's sculpture, then it removes any element of eroticism, and places the sculpture in the realm of social acceptablity, since it is the kiss of life. Canova gave no lead as to which incident his sculpture represented. It had been commissioned in 1787 by a British patron, John Campbell (later first Baron Cawdor) while on his Grand Tour. But Canova did not finish the piece until 1793, by which time the

182
Antonio Canova, *Cupid and Psyche*, 1787–93. Marble; 155×168 cm, 61×66 1⁄8 in. Musée du Louvre, Paris

patron had been compelled to leave Italy because of the French Revolutionary wars. The sculpture was eventually confiscated by Napoleon's general Murat; it was never to reach its intended destination. Campbell must have lamented the loss of such a famous piece of contemporary sculpture, and when he returned to Italy after the Napoleonic Wars, he placed new commissions with Canova.

Commentators have recognized the inherently contradictory elements in Canova's *Cupid and Psyche* since his own lifetime. The sculpture responds fully to the Neoclassical ideal of Winckelmann's calm restraint, but it is tempered both with a modern (*ie* late eighteenth-century) sentiment in the facial expressions of Cupid and Psyche, and with a modern modelling

of the surface textures. Antique sculptures known to Canova and his contemporaries at this date, before they had the chance to see the Parthenon or Elgin Marbles, did not convey surface gradations of a naked body with such subtlety and sensuousness. Canova achieved these effects by always carrying out the final carving and polishing of a marble himself, after studio assistants had done the basic chores of rough cutting.

Canova saw the Parthenon marbles when he visited London in 1815, which is when John Flaxman – who had known him in Rome – drew his portrait (183). These sculptures were a startling revelation to the art-going public. The 7th Earl of Elgin (1766–1841), British ambassador to the Ottoman Empire in Constantinople, had been given permission to remove the marble sculptures from the Parthenon in Athens in 1801. They were shipped to London in several loads over the next decade, with the first group put on display in a large shed in the garden of Elgin's London house in 1807. Reasonably accurate engravings of the marbles had been published in the second volume of Stuart and Revett's *Antiquities of Athens* in 1789, with the somewhat limp comment that they were 'admirable and the subject interesting'. But the public had to wait to see the marbles for themselves. Here, face to face, was Greek sculpture of the greatest period, not filtered through Roman copies or plaster casts. A few art experts would not accept their greatness, among them the connoisseur Richard Payne Knight, who was particularly hostile. The majority, however, would have agreed with Flaxman and other artists who greatly admired the marbles, praising in particular their naturalism. Eventually Elgin persuaded the British government, rather grudgingly and only after an official committee had gathered evidence, to buy the marbles for the British Museum, where they were displayed to better advantage (184). Almost without anyone realizing it, idealism as exemplified in Roman sculptural copies of Greek originals, and as extolled by Winckelmann, was being undermined. The early nineteenth century had to come to terms with the fact that naturalism had a major role to play in ancient sculpture. But some sculptors were already showing signs of moving in that direction,

183
John Flaxman,
*Portrait of
Antonio Canova*,
1815.
Pencil;
18·4×22·2 cm,
7¼×8¾ in.
Fitzwilliam
Museum,
Cambridge

184
Archibald
Archer,
*The Temporary
Elgin Room*,
1819.
Oil on canvas;
76·2×127 cm,
30×50 in.
British Museum,
London

including Canova in such works as his *Cupid and Psyche*.

Grace, elegance and poise, with more than a touch of classicial antiquity, characterized a whole range of Neoclassical female portraits. Judging by the images of the period, salons, studios and streets were teaming with beautiful women, exquisitely and fashionably dressed.

Juliette Récamier was beautiful, coquettish and brilliant, the wife of a banker. The couple lived in a princely style in a large house in Paris and a château a few miles outside. Juliette was a leading Parisian socialite at the turn of the century, who held a regular salon for politicians, writers and artists, and numbered among her friends Madame de Staël and Napoleon's brother Lucien. Her husband had chosen David to paint her portrait, but it remained unfinished because of a row between the artist and sitter, and the commission was transferred in 1805 to Gérard (185). Seated in a relaxed, informal pose on a Neoclassical chair, Madame Récamier is wearing a fashionable 'Empire' style high-waisted dress. Her shawl is probably a much sought-after Indian silk import. The cut of this kind of dress, very revealing of the breasts and the outline of the body, derives from the cling-ing draperies of classical statuary and wall-paintings. Fashion, like everything else, was Neoclassical too. Some women even damped their dresses so that they would cling closer to the body, falling in almost transparent and perfectly classical folds.

Madame Récamier is posing simply as herself – she is not acting out an imaginary role, as a classical goddess or similar fictitious character. That alternative approach to a portrait was chosen by her friend Madame de Staël. She sat in 1808 to Elisabeth Vigée-Lebrun, one of the few outstanding female artists in the Neoclassical period (186). She had established her reputation before the Revolution as the official painter to Marie-Antoinette, and had subsequently travelled extensively. With Madame de Staël she was painting one of the most famous women of the day, well connected in both aristocratic and literary circles, where she was much admired for her writings.

185
Baron
François
Gérard,
*Portrait of
Madame
Récamier*,
1805.
Oil on canvas;
225×148cm,
88¾×58⅜in.
Musée
Carnavalet, Paris

**186
Elisabeth-
Louise Vigée-
Lebrun**,
*Portrait of
Madame de
Staël as Corinne*,
1808–9.
Oil on canvas;
140×118cm,
55¹⁄₈×46¹⁄₂in.
Musée d'Art et
d'Histoire,
Geneva

For her portrait Germaine de Staël posed against a background
of Swiss scenery, inspired by the surroundings of Coppet, near
Lausanne, where she frequently stayed and where she sat for
this portrait. Rather than pose in modern dress, she appears in
antique garb playing a lyre: she is Corinne, the fictional poetess
who is the main character of the successful novel of that name
that she had recently published. In redefining the role of women
in the modern world, Madame de Staël makes Corinne as
independent as the authoress herself. In the semi-autobiographi-
cal novel, the poetess is identified with the Cumaean Sibyl,
priestess of Apollo, as represented in a famous seventeenth-
century painting (by Domenichino) in which she listens for inspira-
tion, holding a music scroll and a book. Although *Corinne* is
set in contemporary Italy, the name was derived from that of an
ancient Greek poetess who lived in the fifth and fourth centuries
BC, fragments of whose poetry survive. When she first appears
in the novel she is dressed like the famous Sibyl, and is riding in
triumph to be crowned as a poetess, just as Madame de Staël

had herself been honoured in Rome. But although the pose in the Vigée-Lebrun portrait relies on that of the seventeenth-century painting, there is one main difference. She is playing a lyre, an accompaniment to her impromptu poetry (here ambiguously fictional and real), which was a fashionable literary pastime at the turn of the eighteenth and nineteenth centuries.

The most audacious of many Neoclassical images of women transposed into a classical role is that of the semi-nude Princess Paolina Borghese by Canova (187). Like her brother Napoleon, she had achieved a meteoric rise from a humble background in Corsica, marrying an Italian prince who was one of the richest men in Europe. Where Madame Récamier and Madame de Staël were both beautiful and intellectual women married to wealthy men who could lavishly furnish their material comforts, Paolina Borghese had to rely solely on her beauty and her undoubted cleverness and strong will to rise to the height she attained. She flaunted her beauty like a modern film star, and her sex appeal is captured in Canova's portrait of her. She knows she is beautiful, turning her bared breasts towards the viewer, while averting her head to reveal the fine detailing of her profile. Life-size, she reclines on a couch carved from differently coloured marbles, embellished with gilded ornaments, its verisimilitude enhancing the illusion of reality of the naked figure. The couch stands on the floor without a pedestal, like a piece of furniture rather than a sculpture. Paolina Borghese is presented as a real woman in a real environment, viewed at the time in the intimate setting of a small room by candlelight. The frankness of the pose made public display unthinkable, and only carefully chosen visitors were allowed to view it.

She is not, however, licentious. She turns her head away, aloofly distancing herself. In one hand she is holding an apple, traditionally a symbol of Venus, the only clue that this is not merely a portrait of Paolina Borghese. She had insisted on being portrayed as Venus, knowing full well that this meant

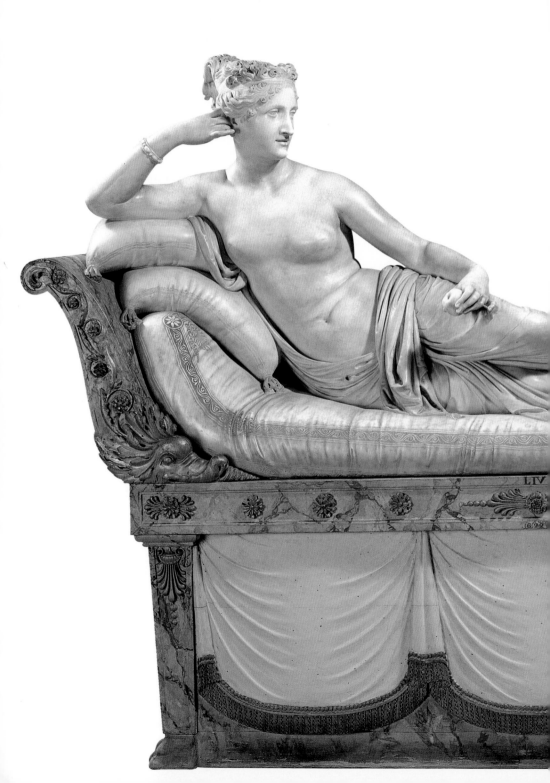

posing in the nude; but by removing herself from a contemporary world to that of a mythological past she became ethereal and untouchable. She is nude, but safe. She is not just Venus, the goddess of love, but Venus Victrix, a victorious Venus who has conquered through her beauty. Her brother, triumphant as Mars, was being carved at the same time in Canova's studio (see 150).

It is a short step from posing in some classical role for a portrait to actually enacting such a part in real life. Sir William Hamilton in Naples not only collected classical antiquities but had presented his youthful second wife with a Greek costume. The beautiful Emma, who was later to become Nelson's mistress, was idolized by 'the old knight', as Goethe wrote in his Naples diary in 1787. Hamilton was 'enthusiastic about everything she does', he went on. 'In her, he has found all the antiquities, all the profiles of Sicilian coins, even the *Apollo Belvedere*.' She would wear the Greek

187
Antonio Canova,
Paolina Borghese as Venus Victrix,
1804–8.
Marble;
1.200 cm,
78⁷⁄₈in.
Galleria
Borghese, Rome

dress, let down her long hair, and put on a performance for the entertainment of guests after dinner 'like nothing you ever saw before in your life' (188). Goethe went along two evenings to witness her perfect figure transformed into an uninterrupted series of emotional states, ingeniously using a variety of shawls to help in the re-creation of Cleopatra and other characters from the past, and basing her poses on visual sources familiar to her audience, particularly Greek vases and wall-paintings from Pompeii and Herculaneum (189). She originally performed these 'attitudes', as she called them, behind a gold frame against a black background, creating a living picture. But the arrangement was cumbersome and difficult to light, so it was abandoned for a more open performance. Emma Hamilton's unique form of entertainment on the Neapolitan social scene was much commented upon, providing a living embodiment of Neoclassical taste.

The past was also re-created on the stage. The curtain went up in a Berlin opera house in 1816 on a strikingly new production of Mozart's opera *The Magic Flute*, which was enthusiastically received. The sets were designed by the architect Karl Friedrich Schinkel (1781–1841), who loved drama and music, and throughout his career designed stage scenery. His designs for Mozart, according to one critic, were 'sublime'. The Queen of Night's domain in the first scene was a grotto housing a temple composed of Egyptian elements assembled in a totally original way, its columns supported by crouching winged creatures of Schinkel's own invention. The opera's theme of the struggle between the powers of darkness and light could not have been given a more sinister start. Later in the act when the Queen of Night appears, it was not in a magnificent chamber seated on a throne, as in the stage directions, but on a crescent moon against a starry sky, conceived as a great vault with stars as its ribs. Ten further scene changes culminated in the magnificent Temple of the Sun (190). The triumph of strength, wisdom and beauty, the main themes of the opera, made it a particularly appropriate choice for performance in 1816, the centenary year of the coronation of the first Prussian king and the first anniversary of peace after the Napoleonic War.

188
Friedrich Rehberg,
Plate from
Drawings Faithfully Copied from Nature,
showing one of Emma Hamilton's 'attitudes',
1794.
Engraving;
26·9×20·8 cm,
10⁵⁸×8¹⁸in.
British Museum,
London

189
Plate from
Antichità d'Ercolano,
showing a Basket Woman,
1762.
Engraving;
28·2×19·5 cm,
11¹⁸×7⁵⁸in

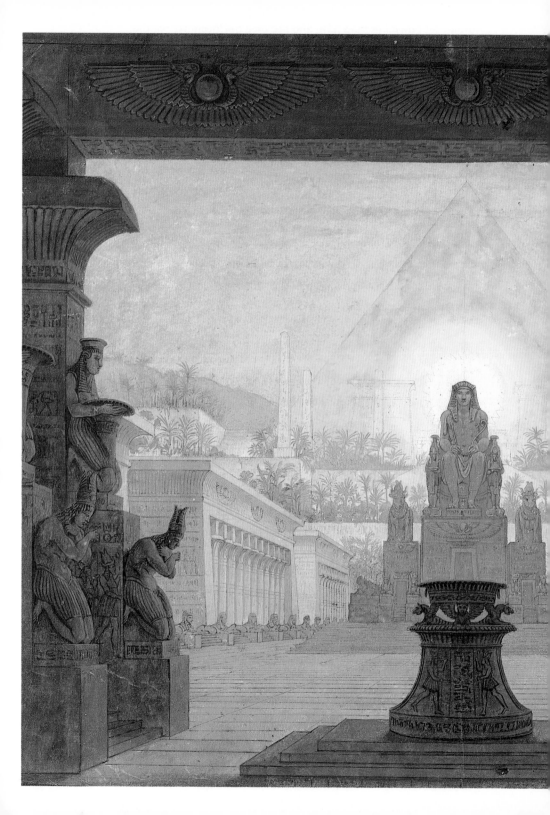

190
Karl Friedrich
Schinkel,
Set from the
final scene of
Act II of Mozart's
The Magic Flute,
showing the
inner court of
the Temple of
the Sun with the
statue of Osiris,
1815.
Body colour over
pen and ink;
54·2 × 62·5 cm,
21³⁄₈ × 24⁵⁄₈ in.
Sammlung der
Zeichnungen,
Nationalgalerie,
Staatliche
Museen, Berlin

Schinkel seized the opportunity to design a sequence of monumental stage sets, of which the finest architectural one was the last, with its colossal statue of Osiris towering over the inner courtyard of the Temple of the Sun. Architecture does not feature in the stage directions, which specify that the whole set should be the sun itself; Schinkel created instead his own imaginative reconstruction of ancient Egypt, symbolizing the dominance of the sun by painting it as a large disc which frames the head of the statue of Osiris, and treating it as a glowing focal point of illumination, closing the 'magical play' with 'astonishment'.

Schinkel wanted to reform the current stystem of theatrical production. He had been appointed in the previous year stage designer to the two royal theatres in Berlin, the Opera and the National, and with *The Magic Flute* he had the first opportunity for realizing his ambition. He replaced traditional fixed, bulky flats with a large backcloth and two wings, framed by a proscenium arch, which was separated from the audience by a lowered orchestra pit. Schinkel's ideas on stage architecture and sets anticipate modern styles of production in opera and drama. He wanted to minimize the traditional illusionism of the scenery, believing that it had been an impediment to an audience's deeper response to a drama. By making stage design 'simpler' he wanted the audience's

191
Plate from Baron
Dominique
Vivant Denon's
*Voyages dans la
Basse et la
Haute Egypte*,
showing the
interior of
Temple at Edfu,
1802.
Engraving;
19·2×27·4 cm,
7 ½ ×10¾ in

'creative imagination' to become more involved in the substance of the words and the music. The libretto for *The Magic Flute* is a timeless fairy tale, set in no particular location. But Schinkel's choice of exotic Egyptian settings may have been dictated by the opera's many Masonic references. Egypt was the prime source for Freemasonry imagery, and analyses of the libretto for *The Magic Flute* have shown how extensive these allusions are. Even without the Masonic link, Schinkel was responding to a new interest in ancient Egypt that was sweeping through Europe.

Napoleon's Nile campaign in 1798–9 had been a military failure, but it was a cultural triumph. Along with the French army of 38,000 men had gone a team of 175 archaeologists, scientists and other scholars, some of whom were responsible for recording ancient Egyptian sites and bringing back a collection of sculptures. The subsequently published volumes of engravings by the leader of that expedition, Baron Dominique Vivant Denon, were the first extensive visual record to be published of the monuments of the Nile Valley (191). These engravings were very influential. Like many of his contemporaries, Schinkel found them an invaluable source of information, borrowing ideas from them for his *Magic Flute* designs.

Europe already had some knowledge of Egyptian art, and there had been earlier Egyptian revivals, including Piranesi's. But these earlier revivals had been localized and short-lived. The Egyptian revival that followed Napoleon's campaign and Denon's volumes was of a different order, sparking off a new mania for things Egyptian. As one of the characters says in an English novel of 1806, depicting fashionable life in London: 'I shall not be surprised if it were to become as fashionable … to construe these Egyptian hieroglyphics, as it is now to decorate our apartments with them. In that case an Egyptian master will become as necessary as a French governess.' The Egyptian revival offered a major ancient civilization whose art had not been extensively plundered before, unlike the civilizations of Greece and Rome. Egypt had the advantage of being exotically different and relatively unfamiliar. It was to be absorbed into the Neoclassical canon along with the two other ancient civilizations.

In the same year that Schinkel was put in charge of theatre design in Berlin, he was also appointed the civil servant responsible for the city's development. Fifteen years later he was to be given overall supervision of new state buildings throughout Prussia, putting him in a strong position to make Neoclassicism the country's official architecture. That architecture, in Schinkel's hands, was to play its part in the re-emergence of Prussia as a much stronger European power after its traumatic defeat by the French at the Battle of Jena in 1806. That defeat had been followed by a Napoleonic occupation of Berlin until 1808. Architecture and nationalism were again to go hand in hand.

A growing awareness of national identity and appreciation of cultural heritage were stimulated around 1800 by France's military domination of Europe. The British, unable to tour the Continent, travelled within their own country looking at the medieval past with renewed interest. Abroad, especially in the area subsequently unified as Germany, medieval studies became a cornerstone of rising nationalism. The philosopher Johann Gottlieb Fichte (1762–1814), whose writings Schinkel knew, was a key figure in Berlin, where he gave an important series of lectures in 1807 and 1808 subsequently published as *Addresses to the German Nation*. The lectures were patriotic, advocating the uniqueness of a culture that had developed on German soil, without relying on the cultures of the ancient classical world. Germany was unique, he argued, with a vital culture identifiably its own. 'Patriotism must dominate the state', he said. To these patriotic theories was added, a year later, the practical step of founding Berlin University in 1809. Its first rector was Fichte. Cultural identity was now to be enhanced through higher education. Fichte strongly believed that the state should play a major role in this – Prussia may have been defeated in military terms, but not intellectually or culturally.

As soon as the war was over a new building programme in Berlin became a key factor in the country's psychological recovery. Schinkel was in charge of that programme, but it had to proceed slowly with an eye to strict economy in post-war conditions.

From 1815 onwards Schinkel contributed significantly to the new appearance of Berlin, imposing a predominantly Neoclassical character. His first work was the Neue Wache or New Guard House (192) on the principal avenue through the heart of the city, the Unter den Linden, running from the Brandenburg Gate in the west to Schinkel's eastern extension, which was to be linked by his Schlossbrucke, a particularly beautiful Neoclassical bridge. Some major public buildings were already sited along this axis, including the gate and the royal palace, and Schinkel added an impressive range of new ones. Schinkel had his own house in this fashionable part of the city, on the Unter den Linden.

The New Guard House signalled Schinkel's austerity as a Neoclassical architect, employing the earliest of the classical orders, the Doric, for the portico. The sculptural decoration on the pediment and frieze celebrate victory, and the building was originally flanked by statues of two Prussian generals. A few years later the National Theatre (Schauspielhaus) was gutted by fire, and was replaced by Schinkel's new building which opened in

1821. Economic restrictions meant he had to reuse the old building's foundations, and thus could not put into practice all his theatrical theories. The building was nevertheless a success, and opened with a performance of Goethe's play *Iphigenia*. The author's dedicatory prologue for the occasion was read in front of a stage set designed by Schinkel, which showed the building in which the performance was actually taking place. The enthusiastic audience called for the architect, but, modest man that he was, he had gone home. So they went and serenaded him outside his house further along the street.

Schinkel designed not only new buildings for Berlin but also the space around them. He was keenly aware of the importance

of a building's setting, and being in overall charge of the architectural programme he was able to design squares and gardens to create a spacious environment. When travelling in Italy on his Grand Tour (1803–4), he had been much more impressed by the settings of buildings in both town and country than by the remains of antiquity, which he felt did 'not offer anything new for an architect'. The environment, on the other hand, had much to offer him in Rome and elsewhere.

Berlin was to benefit from these studies. Schinkel created for the Prussian capital not only a new grandeur but also a humane

environment. The successful fusion of these two ideals can be seen in his design for a museum to house the ever-expanding royal art collection (194). His original design, reproduced here, shows much more clearly than a modern photograph of the building how important these environmental concerns were to Schinkel. He chose the site himself, a big open space created by filling in a canal that linked with the River Spree. From here the museum looked out across a large square to the royal palace opposite. The site was therefore crucial in the development of the city, and 'required a very monumental building', in Schinkel's words. His solution was a vast Ionic temple, with an unusually long façade composed of far more columns than any classical prototype. The result could have been overpowering had it not been for the site's spaciousness, and the softening of the foreground by the creation of an extensive formal garden between the museum and the palace. The impact of the colonnade was further modified for visitors by the siting of the staircase to the upper floor. Most unusually it was an open one within the colonnade, allowing visitors to look out between the columns to the garden beyond.

The early nineteenth century saw the creation of several new major museums across Europe. In Munich an imposing new sculpture gallery, the Glyptothek, was built on the main square from 1816 onwards. It was designed by Bavaria's leading Neoclassicist, Leo von Klenze, in a style as uncompromisingly austere as Schinkel's. Its interior spaces, however, were decorated in a more ornate form of classicism (193), and the Danish Neoclassical sculptor Bortel Thorvaldsen (1768–1844) was responsible for arranging the display. In London, the construction of new premises for the British Museum (195) began while Schinkel was working on his Berlin museum. He was able to inspect the building while visiting Britain in 1826, although at that stage it was still incomplete.

The most outstanding museum in terms of contents was the Louvre in Paris, devoted to the display of Napoleon's artistic loot. Napoleon had plundered Europe, carting off even the *Apollo Belvedere* from Rome. After Prussia's defeat in 1806, treasures

from the Berlin royal palace joined the haul. For a brief period until the plunder was repatriated after 1815, Paris housed Europe's greatest art treasures. The displays were extremely well organized, and in due course new museums elsewhere in Europe were to reflect the merits of such scale and organization. During the eighteenth century few new buildings specifically designed as museums open to the public had been built. The first had been in Kassel in Germany in 1769, but it and its successors were conceived on a relatively modest scale. In the early nineteenth century there was an increasing awareness that museums could be both culturally enriching and morally uplifting. History, aesthetics and morality became inextricably mingled in a new museum ideology which was fundamentally didactic.

'First delight, then instruct': this dictum comes from the report on the newly completed museum in Berlin, written by Schinkel and the museum's future director, Dr Gustav Waagen (1794–1868), one of the century's great connoisseurs. The display of the sculptures and pictures in the museum had been planned by the art historian Alois Hirt, who had taught Schinkel when he was a student. The central room was a two-storey high rotunda devoted to the finest of the classical sculptures, a concept borrowed from the Museo

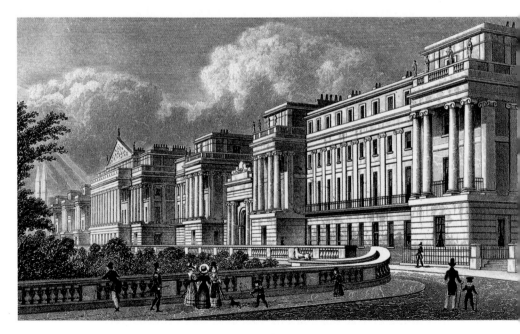

Pio-Clementino in the Vatican (see 6). The first floor was devoted to paintings, which were hung according to schools, an arrangement that became a generally accepted principle in museum displays. Arranging museum exhibits on historical lines had been discussed by writers in the previous century, but none of these ideal schemes had come to fruition.

Schinkel's museum in Berlin was one of the grandest projects of its kind in early nineteenth-century Europe. The Prussian rulers were determined to make their capital one of the finest on the Continent, and its many new Neoclassical buildings, both public and private, helped achieve that aim. The new Berlin would vie with Neoclassical townscapes elsewhere in Europe, including the dramatic alterations to London carried out from 1812 onwards by John Nash (1752–1835). His terraces around Regent's Park (196–7), linked to the shopping axis of his Regent Street, and the processional route of Pall Mall from his enlarged Buckingham Palace, were rare examples in the city's history of an architect's vision of London actually being carried out on a grand, unified scale. Like Schinkel, Nash was very conscious of the relationship of buildings to their surroundings, closely integrating the green spaces of the city's parks with his houses, streets and palace. Nash like Schinkel had an innate sense of the essentials of a fine cityscape.

A few hours' carriage-ride from Berlin, in the countryside near Potsdam and the wide expanse of the River Havel, Schinkel produced another range of significant buildings. The area was ideal for elegant retreats for the Prussian royal family, and the villa in the landscape allowed Schinkel to explore more fully than he could in an urban context the interrelationship of building and setting. He had been fascinated by traditional farm buildings when in Italy. Their simple forms fitted into the landscape as if they had grown there, and that vision, combined with Schinkel's study of Italian villas and his knowledge of classical antiquity, produced some enchanting small country residences. Earlier in the eighteenth century Frederick the Great had set a precedent in the area with the construction of his delightful house and garden named

96–197
hn Nash,
umberland
errace,
egent's Park,
ondon,
826–7
bove
etail of
ediment
elow
ontemporary
ngraving

Sanssouci ('Without care'). In subsequent generations the flat and sandy terrain, interspersed with pine groves, was transformed by villas set in pretty flowering gardens, forming part of a 'picturesque' or natural layout, with careful asymmetry avoiding any sense of formality, and with buildings merging into the landscape. Schinkel, aided by the court gardener, transformed the area near Potsdam into what came to be called 'paradise'.

One of the most enchanting of these small villas is Schloss Charlottenhof (198). The old house on the site had been given to the Crown Prince, Friedrich Wilhelm, as a Christmas present in 1825, on his marriage to Princess Elizabeth of Bavaria. Schinkel remod-

elled the house and constructed new buildings in the grounds, creating an environment inspired by Italian country dwellings and the architecture of the ancient world. During Schinkel's second visit to Italy in 1824 (199), he had visited Pompeii, which produced ideas for a garden arbour, the decoration of the portico, and colour schemes used in some of the interiors. Schinkel also designed the furniture, and the walls were hung with landscapes and views of Roman ruins. The Crown Prince wanted, and got, an idyllic natural paradise, calling his new house unofficially 'Siam'. The name of a faraway country, about which contemporaries knew little, allowed plenty of scope for speculation. Unsullied by the restraints of a European civilization – as they thought – Siam (modern Thailand)

was known as the 'land of the free', a living survival of the Golden Age. The prince, himself an amateur architect who produced some sketches for the project, even signed his drawings 'Fritz Siam'.

Exported from the homeland of Europe, Neoclassicism established itself in the second phase of the movement as the principal style of architecture and decoration in the colonies of Southeast Asia and the Pacific, as well as continuing to develop in the former colonies of North America. Britain was the only large power extending its colonial empire in the later eighteenth century and the early nineteenth. France had lost its imperial possessions in Canada and India to the British, and as a result of losing its American colonies, Britain started to look elsewhere, and towards the end of the century began colonizing further afield in Australia. Wherever colonists went, they took with them both artefacts and ideas from the mother country to create a culturally safe home in potentially hostile territory. Where there already existed an indigenous architecture in a colony, it was generally ignored, being culturally supplanted by buildings mentally transported from the banks of the Thames.

India and Australia still preserve numerous Neoclassical buildings as evidence of this colonial and cultural imperialism. A European style of architecture was employed on the Indian subcontinent, where no attempt was made to relate it to the longstanding Buddhist, Hindu and Muslim cultures. Neoclassicism was the style familiar to the new rulers, and no one dreamt of making aesthetic concessions to the conquered. It was not until Edwin Lutyens (1869–1944) designed the capital of New Delhi, as the newly constructed centre of British rule in India after 1911, that a style was evolved fusing the Indian and the European traditions. In the Neoclassical period only the occasional detail on a building, such as a capital or window-frame, shows an awareness of Indian traditions. There was a greater willingness to accept Indian design in interiors, where a style of Ango-Indian furniture evolved, using traditional woods and inlays of the subcontinent for chairs and tables that were essentially European in design. The interaction

between the two cultures is more evident, however, in the reverse direction: the new houses of Bengali merchants along the banks of the River Hooghly in Calcutta show the marked influence of the Neoclassical style.

Calcutta was extensively developed in the later eighteenth century, after the British had successfully recaptured it in 1757 following the notorious Black Hole of Calcutta incident, when the briefly victorious local ruler had incarcerated British prisoners in a cell far too small for the numbers. The city became the centre of what had come to be realized was the wealthiest country in the British Empire, with considerable potential for exploitation. The indigenous population was cleared away from the banks of the river in order to create uninterrupted views over the surrounding countryside in the event of a future attack. This openness had the incidental effect of creating a spacious water frontage for the new city, on the banks of one of the biggest rivers in the world.

The British authorities in Calcutta felt the desirability of a full complement of public buildings, including a Government House, a town hall, a mint, a court, a banqueting hall and a hospital, as well as churches, a bank, theatre and club. Many of these facilities already existed in the city's fort, but with greater security combined with an expanding population and increased trade, they could be better housed elsewhere. All these new buildings were to be Neoclassical in style, along with the private dwellings, many of the latter being concentrated along the road beside the cleared waterfront (200).

Private houses, mostly for merchants and civil servants, were built as distinctive individual villas, each surrounded by a large garden arranged on an irregular street pattern, there being no overall city plan for the expansion. The one concession to the climate in the design of these villas was the proliferation of colonnades at ground and first-floor levels to provide shade and ventilation. These villas, the first buildings of the city to be seen by travellers sailing up the river from the Bay of Bengal, gave Calcutta an air of opulence; it soon became known as the 'city of

palaces'. As one traveller wrote: 'From the deck the view of the land has a magnificent appearance; the different offices have … the appearance of stone [actually plastered brick], and they are formed along the beach in a beautiful manner.' In its heyday, Calcutta was a handsome city, its decline only beginning after 1911 when it was no longer the capital of India.

The imposing new Government House in Calcutta (201) was an extremely unwelcome expense for the authorities back in London – the East India Company which then controlled British interests in India. They failed to appreciate that the governor-general's official residence should reflect his position in India, which ought to be 'ruled from a palace, not from a counting-house'. The new governor-general, Marquess Wellesley, had decided within a month of his arrival in 1798 that the house was needed. He opted for a grand scheme drawn up by a local army lieutenant, Charles Wyatt, who borrowed some of his ideas from the Neoclassical country house of Kedleston in Derbyshire, partly the work of Robert Adam. From another of Adam's houses, Syon, came the design for one of the entrance gates. The new Government House was the grandest European building yet erected on the Indian subcontinent. It still survives, but now surrounded by more buildings; one gets a much better impression of its original grandeur

from contemporary prints and paintings. As Wellesley sat on his gilded throne in the hall used for official presentations, he must have felt fully justified in the building's large expenditure. He believed that Britain must make its mark as the ruler of a country that had known the magnificence of the Mughal emperors. Wellesley arranged lavish festivities for the building's opening ceremony. Two temporary classical temples were erected on either side of the house, dedicated to Fame and Valour. On the banqueting table was a miniature temple dedicated to Peace, as well as Egyptian obelisks inscribed with hieroglyphics, a reflection of the current Egyptian taste.

While the funds for the Government House had been provided by the East India Company, a decade later, for the new Town Hall built on an adjacent site, money was raised by public lottery. In the absence of a local income tax, this was an appropriate means of collecting funds for a public building to be used for meetings, mercantile business and entertainments on special occasions. The architect was the chief engineer for Bengal, Major-General John Garstin (1756–1820). The main hall on the ground floor was decorated with statues of famous men, the most impressive of which was a large Neoclassical statue of Marquess Cornwallis (202), a predecessor of Wellesley as governor-general who was greatly admired for his military successes which contributed

200
Thomas Daniell,
Plate from *Views of Calcutta* showing houses on Chowringhee Road, looking north, 1787.
Coloured etching with aquatint;
40·5×53 cm,
15⁷⁄₈×20⁷⁄₈ in.

201
James Moffat,
Government House, Calcutta, 1798–1803,
c.1802.
Watercolour;
44×67·5 cm,
17³⁄₈×26¹⁄₂ in.
India Office Library, London

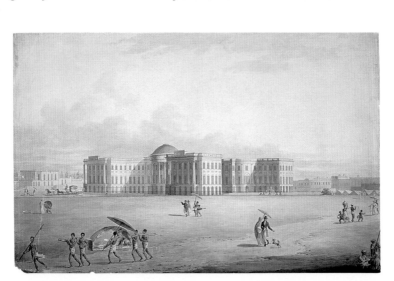

significantly to the British domination of India. His victory over the fierce enemy Tipu Sultan and the conquest of his state of Mysore had captured the public's imagination. Cornwallis was worshipped as a hero, with statues and monuments erected to his memory both in India and back at home, many during his lifetime. The Calcutta monument was commissioned by the East India Company in 1793, the year after the Mysore campaign, from the London Neoclassical sculptor John Bacon, for the handsome sum of £525 (roughly £26,000 or $39,000 in today's terms). Finally completed by his son and shipped out ten years later, it was one of the most impressive Neoclassical sculptures exported to India. The engraving reproduced here shows the statue in its original position in the Town Hall (it is now in the Victoria Memorial, Calcutta). Bacon opted for classical timelessness, dressing Cornwallis as an ancient Roman, standing proudly above seated figures of Prudence and Fortitude; the armour at the foot of the pedestal includes the club of Hercules. The imagery is entirely European, part of the culture of the empire-builders. They took their Neoclassicism with them even in death: the principal British cemetery in Calcutta, in South Park Street near the then fashionable part of the city, is largely

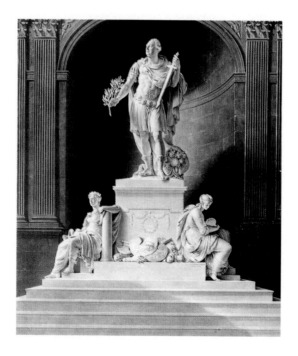

filled with the standard repertoire of classical sarcophagi, urns and obelisks.

For a sculptural response to the Indian subcontinent one has to look elsewhere in the art of the period. Other statues in the Calcutta Town Hall included one of the famous orientalist and founder of the Asiatic Society in Calcutta, Sir William Jones. But the only commemoration of him to record visually the important part he played in Anglo-Indian understanding is not in Calcutta but in Oxford (203). Commissioned from Flaxman by his widow, the sculpture was destined for India; she donated it instead to her husband's old college having learned that another monument to him in Calcutta had already been commissioned. Flaxman responded to the commission with one of his most intricate and original wall monuments. The central panel records Jones's scholarly achievements as author of the pioneering *Digest of Hindu and Mohammedan Laws*. Before him sit representatives of the two religions, while Jones writes down their comments. Beside him is a folder on which is written, 'A nation should be judged by its own laws', a quotation from Hindu law which Jones had translated. Jones was an important figure in building a bridge between Eastern and Western cultures; his many articles included ones on Indian music and botany, interests incorporated into the monument in the form of the Indian vina next to the European lyre (at the top), and the large banana tree in the main panel. The Neoclassical forms have been tempered by an understanding of a different culture, providing a visual counterpart to a career epitomized by one of his most famous bridging essays, 'On the Gods of Greece, Italy and India'.

Unlike the colonists in India, those in Australia were not confronted by an older civilization embodied in major buildings, works of art, or religious and secular musical traditions. Aboriginal culture in Australia was totally different, and colonial settlers saw themselves as starting with virgin land. After erecting the basic structures necessary for subsistence survival, colonists began to construct the more important buildings, both public and private, in the familiar style of Neoclassicism. Occasionally

202
View of the Marquess Cornwallis monument *in situ*, 1793–1803. Engraving; 66·2×53cm, 26×20⅞in

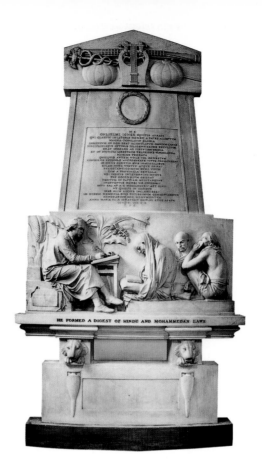

203
John Flaxman,
*Monument to
Sir William Jones*,
1796.
Marble;
h.366 cm,
144 1/4 in.
University
College Chapel,
Oxford

204
**Frederick
Garling** (attrib-
uted),
*View of
Ballroom at
Henry Kitchen's
Henrietta Villa,
Point Piper,
Sydney*,
1816–20.
Watercolour;
21·9 × 30·2 cm,
8 5/8 × 11 7/8 in.
Mitchell Library,
Sydney

there was a preference for the Gothic Revival, but if classicism
did not monopolize this virgin landscape, it was nevertheless
the predominant style in the early decades of the new colony.
Settled from 1788, Sydney and its environs soon provided ample
evidence of the contemporary British home transported to the
antipodes. By the 1830s Australia had a large number of buildings
demonstrating an extensive range of Neoclassical features from
a cautious incorporation of a few details to the more confident
sweep of an entire façade, or a whole building, including its
principal furnishings.

The extensive foreshore of Sydney Harbour provided idyllic loca-
tions for new houses set in extensive grounds. The Governor of
New South Wales granted one of the best sites of 190 acres to a
naval captain, on which he built near the water's edge a fashion-

able and expensive villa, completed in 1820. Captain John Piper is thought to have engaged the services of a London architect newly arrived in the colony, Henry Kitchen (c.1793–1822), who designed an attractive Neoclassical house incorporating two large, domed rooms. One of these was used as a ballroom, and a contemporary watercolour (204) preserves a charming record of social life in early nineteenth-century Sydney, looking no different from that in contemporary London. The setting for the ball is in the most advanced form of the Neoclassical style, showing the currently fashionable austerity combined with the boldness of a top-lit domed space, with which the architect would have been familiar from the work of such men as Soane. Many items of furniture and decoration, all in the Neoclassical taste, would have been exported from Britain. An oil portrait of Piper's wife surrounded by their children shows them all wearing fashionable, imported clothes. Piper seems to have known how to spend lavishly his large income, derived from his five per cent share of all the import duties collected at Sydney. This enabled him to retain a huge staff, to maintain a band of musicians for the regular playing of dance music, and to provide a table, as one contemporary expressed it, with 'a vast profusion of every luxury that the four quarters of the globe can supply'. The end of this tale is almost inevitable: Piper

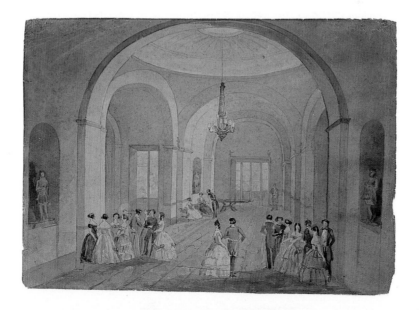

lost all his money, and retired inland to a humbler residence. His house has long since disappeared.

More fortunate in the long term was the family that established the wool industry in Australia, the Macarthurs. The large house they built in New South Wales survives as one of the most handsome colonial Neoclassical residences, and still preserves its original furnishings (205). As part of the British government's policy to encourage the development of farmland in its new colony, John Macarthur in 1793 had been allocated a large tract of land in the hinterland of Sydney. He had been out in New South Wales since 1790 as an officer in the army. On his newly acquired land he erected a commodious farmhouse, and in due course hoped to build a really grand mansion. This project had to wait until the next generation with James Macarthur and the completion of the present house in 1835. It was designed by John Verge (1782–1861), who had emigrated to the colony only a few years earlier and soon became the best-known architect in the Sydney area. His clients the Macarthurs kept up to date with current tastes in Britain; the library in the house preserves plates from one of Soane's architectural publications, perhaps brought out in Verge's luggage. Once the house was finished James Macarthur made extensive purchases of furnishings and china in London, which complemented perfectly the Neoclassical detailing of the interior. The grounds too reflected European taste, allowing extensive, yet controlled, views of the owner's land from both the front and the back of the house. Radiating avenues between tall trees take the eye to distant hills that are part of the property, a church, and to John Macarthur's funerary urn. A Neoclassical design set in a copse, the monument evokes the 'pleasurable melancholy' of earlier picturesque gardens in Europe.

On the other side of the world, in the former colonies that had become the United States of America, a confident, distinctly American version of Neoclassicism begins to emerge around 1800. Earlier Neoclassicism in New England had been a European import, with the result that even such important buildings as the

205
John Verge,
Garden front
of Camden Park
House,
Menangle, New
South Wales,
1831–5

Richmond Capitol or the Washington White House (see 74 and 76)
were not distinctively American. From the 1790s onwards, although
English and other architectural treatises and engravings were
still being imported into the United States, there are increasing
signs of independence and experiment.

When Henry Latrobe included the Richmond Capitol among
his sketches, he had only recently arrived from England. He had
run a modestly successful practice as an architect and engineer,
but emigrated because of personal distress caused by his
young wife's death in childbirth, illness and bankruptcy. In his
adopted country, where his mother had been born, he was to
produce his finest work, contributing significantly to the
development of Neoclassicism down the eastern seaboard,
especially in Philadelphia, Washington and Baltimore. His earliest
work included, appropriately, the completion of the exterior of
Thomas Jefferson's Richmond Capitol. He was later to assist
Jefferson again, when working on his scheme for the University
of Virginia. It was also Jefferson who was responsible for
Latrobe's appointment as surveyor of the public works of the
United States, in 1803, which resulted in his major contribution
towards the completion of the Washington Capitol.

Neoclassicism in architecture was given a new dimension in the United States. The purity which the movement in Europe sought by getting back to the roots of architecture meant for American architects a youthfulness which they found sympathetic. Furthermore, the classical architecture of Greece and Rome was associated by the Americans with political systems characterized by democratic and republican ideals, which formed the foundation of their own country's creed. For similar reasons the architecture of the French Revolution had been Neoclassical. Aspirations of new republicanism, united with aesthetics and archaeology in the medium of architecture, signs of which could be seen in the Richmond Capitol, now become more evident.

The clearest evidence of an American reinvention or adaptation of Neoclassicism can be seen in Latrobe's use of indigenous corn-cob and tobacco plants in the sculptural detailing of column capitals that would normally use the classical Ionic or Corinthian orders. These new orders (206) Latrobe introduced into his parts of the Washington Capitol, where they received, so he told Jefferson,

'more applause from members of Congress than all the works of magnitude that surrounded them'. Much of that 'magnitude' had been the result of Latrobe's designs, following the reconstruction of the Capitol after the British set it on fire in 1814.

Elsewhere Latrobe demonstrated his originality by freely combining Greek and Roman sources in classically inspired buildings that were not themselves strict copies of any prototype. This is apparent in his temple-like Bank of Pennsylvania in Philadelphia (1798–1801), in the design of which he introduced the Greek Ionic order into the United States (207). When the frequency of yellow fever epidemics encouraged the Philadelphia authorities to build new waterworks, Latrobe combined Greek forms of architecture

with America's first comprehensive use of steam-power in such a structure. Wherever appropriate, Latrobe incorporated the latest technology into his otherwise classical buildings.

His greatest work, and the largest Neoclassical building of its kind so far erected in the United States, was the Roman Catholic Cathedral in Baltimore, begun in 1805 (208). In close consultation with the enlightened archbishop, Latrobe produced a grand classical rotunda or pantheon combined with the traditional church plan of a nave and side aisles. Inside, the spatial grandeur, austerely plain surfaces and light filtered down from the dome recall

206
Henry Latrobe,
Corn-cob capital
in the Capitol,
Washington, DC,
1809

207
William
Russell Birch,
Henry Latrobe's
Bank of
Pennsylvania,
Philadelphia,
1799–1801.
Engraving from
City of
Philadelphia,
1804.
27·5×21cm,
10⁷⁄₈×8¹⁄₄in

208 Overleaf
Henry Latrobe,
Interior of
Baltimore
Cathedral,
Baltimore,
1805–18

Soane's work, and before him Piranesi, but the overall design is Latrobe's. To this bold vision Latrobe added structural daring, building for the first time in the States a vault of such dimensions entirely in stone. The very scale of the building, together with those of his public projects in Washington, Philadelphia and elsewhere, showed not only the confidence of the new country, but also the masterly skills of a well-travelled and well-read architect who could respond to the growing demands of an emerging society. From the discussion of politics to the care of souls, there was no aspect of daily life left unaffected by Latrobe's architectural and

engineeering activities. More than any other architect of his gener-
ation working in the United States, he laid the firm foundations for
Neoclassical architecture to flourish there in the hands of younger
practitioners. Because of Latrobe, Neoclassicism remained the
officially recognized style of American architecture until the 1860s,
the Civil War period.

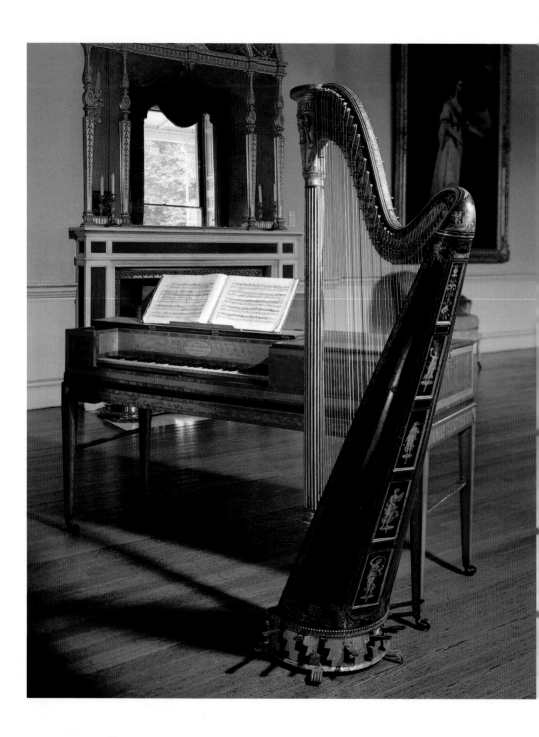

Visiting Paris shortly after the conclusion of the Napoleonic War, a British traveller commented on the 'general taste shown in the elegancies of art'. Wallpapers, he noted,

are commonly after classical designs, and the bourgeois seem to have the same feeling for statues and pictures, as the rich and fashionable. Galignani's public library has a fine cast of Cupid and Psyche in the garden; at Tortoni's you eat your ice under a Grecian group; in the Palais Royal [a shopping arcade], the ornaments and nicknacks of ormolu and jewelry, show a general acquaintance with the fine memorials left us of the unrivalled taste of antique times.

**209–210
Sebastien
Erard**,
Harp,
1811.
Japaned and
gilded beech
and pine;
h.170·3 cm, 67 in.
Iveagh Bequest,
Kenwood,
London

If the same traveller had included musical instruments, he could have observed 'unrivalled taste' even in this field, with Sebastien Erard's popular, newly improved harp retailing as the 'Grecian' model because of its Neoclassical decoration (209–10).

Throughout the Revolutionary and Napoleonic period, Paris maintained a dominant position in the visual arts in Europe, both in the fine arts and in the everyday surroundings of cafés and shops, and their items displayed for sale. That role was sustained

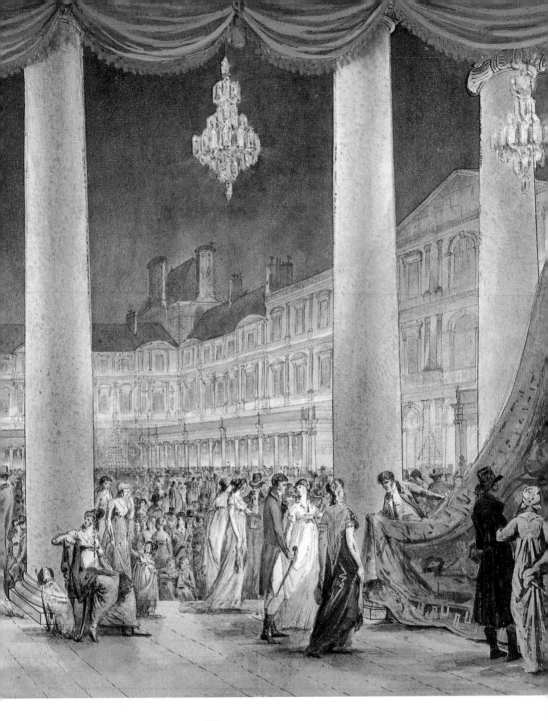

211
Anonymous French artist,
*Exhibition of Industrial Products
in the Courtyard of the Louvre*,
1801.
Watercolour and gouache;
43·2 × 69·5 cm, 17 × 27³⁄₈ in.
Musée Carnavalet, Paris

by a significant French innovation of the period, the industrial exhibition. Until the advent of big departmental stores in the late nineteenth century, these exhibitions provided the only chance for the public to see a wide cross-section of currently available decorative arts under one roof. They not only fostered public awareness of contemporary design, but were also major events in the commercial marketplace.

The 1851 Exhibition in London was the first international industrial exhibition. It had, however, been preceded by a series of national exhibitions, mostly in France, where the first one took place in 1797. The economic crisis following the Revolution had disrupted French industry. One remedy was to start with an exhibition of unsold luxury goods, which then developed in subsequent exhibitions to include all kinds of products. By 1797 many luxury items produced by the former royal factories, including Sèvres, were lying unpurchased because the aristocratic clientele had either fled the country or been guillotined. Unemployment and poverty among artisans could be alleviated only by finding new markets. One of the many royal residences that had been stripped, St Cloud near Paris, was turned into a temporary commercial emporium and filled with expensive ceramics, textiles and carpets. The courtyard was crammed with carriages and the sale rooms crowded.

By the time of the fourth exhibition in 1801, the programme announced that 'No art ought to be excluded, statues will be placed beside plough-shares, paintings will be hung next to fabrics', a truly revolutionary way of displaying art, in which hierarchical distinctions had been eliminated. The main courtyard of the Louvre was set aside for the exhibition, which was a glittering social occasion. The five-day event is recorded in a contemporary watercolour (211) which shows in the left foreground furniture by the Jacob family, the leading cabinet-makers in Paris at the time, and on the right a tapestry by the former royal Beauvais workshop. Wallpapers shown by the leading Parisian firm of Jacquemart and Bénard, who won a bronze medal, might well have included an example (see 146) depicting the apotheosis of a military hero,

probably designed by Alexandre-Evariste Fragonard (1780–1850), son of the famous painter. The Lyons silk-weaver Joseph Marie Jacquard (1752–1834) demonstrated his innovatory loom that was to transform the textile industry, facilitating the weaving of complex patterns for a mass market.

The jury's report summarized the exhibition's importance: 'It stirs up the competition of manufacturers; it increases their instruction; it forms the taste of the consumers in giving them knowledge of the beautiful; that is to say, it develops the surest and most energetic causes for the progress of the arts'. These industrial exhibitions were to become increasingly important shop-windows for consumer and manufacturer alike. After visiting the next exhibition, held in 1806, Napoleon was enthusiastic about the high quality of the products on display: 'The moment of prosperity has come', he exclaimed. 'Who will dare fix its limits?' 1806 was indeed a glorious year for France, both in terms of commercial revival and of military conquest. But continuing wars and post-war difficulties prevented the next exhibition from taking place until 1819. The erratic series of these industrial exhibitions then picked up again.

The display of Lyons silks at these exhibitions highlighted one of the many areas in which France dominated the European market. At the outbreak of the Revolution, Lyons already housed as many as 18,000 looms. Designers were highly trained not only in the technicalities of the process but also in the history of art. Silk designing was regarded, in fact, as a form of painting 'in which the silks correspond to colours, the bobbins to brushes', to quote a technical dictionary published in Lyons in 1773. The autobiography of one of the main silk designers, Jean Démosthène Dugourc (1749–1825), shows how versatile such artists could be. Apart from his work at Lyons, he was also an architect, he designed theatrical costumes for the Paris Opéra and the King of Sweden, attempted to set up wallpaper and playing-card factories, and was also an engraver. As a young man he had been to Rome, where he had met Winckelmann, 'who inspired him with the taste for the antique with which he has been occupied ceaselessly'.

Dugourc was an obvious designer to be involved in Napoleon's refurbishment of the former royal residences. Lyons was given special encouragement, in order to remedy the massive unemployment resulting from the 1790s economic crisis. Napoleon's lavish patronage of the Lyons silk industry included in 1802 the redecoration of the château of St Cloud, his official residence as First Consul. The contract went to the leading factory in Lyons, Camille Pernon's, for which Dugourc had already designed for many years, having introduced the Neoclassical style – so he claimed – into the silk industry. By 1802 the second phase of the style was in full swing with its emphasis on stark, isolated motifs, stripped of the earlier trails and swags, a form of Neoclassicism seen in textiles

212
Hippolyte Le Bas,
designer,
Doves and Wild Boar,
1816–18.
Toile de Jouy textile.
Musée de la Toile de Jouy, Jouy

213
Jean Démosthène Dugourc,
Textile woven in Lyons at the factory of Camille Pernon, 1802–4.
Silk brocade; each panel h.54 cm, 21¼ in.
Mobilier National, Paris

214
Baron François Gérard,
Empress Josephine, early 19th century.
Oil on canvas; 80×64·5 cm, 31½ × 25⅜ in
Musée National des Châteaux de Malmaison et Bois-Préau

ranging from the cotton products of Jouy (212) to the silks of Lyons (213). Dugourc's silk brocade on a blue ground is typical of the period. Intended for Josephine's apartments at St Cloud, it was to be installed a few years later in her apartments of the Tuileries palace in Paris.

Napoleon's and Josephine's commitment to Neoclassicism in architecture and decoration was firmly established by the commissions given to the architectural team of Percier and Fontaine, whose triumphal arch (158) and coronation dinner service (155) have already been discussed. Earlier, in 1799, they had altered the château of Malmaison, near Paris, a property purchased by Josephine and where she was to enjoy the happiest years of her

brief marriage, continuing to live there after the divorce (214). In the garden at Malmaison she developed her passionate interest in roses, many of their blooms becoming famous through the paintings she commissioned from Pierre-Joseph Redouté (1759–1840).

Among all the rooms in the house – from Napoleon's conference room fitted out like a war tent, to the drawing room decorated with scenes from Ossian – it is Josephine's own bedroom that is the triumphant success in décor (215). The red-draped walls interspersed with gilded poles, rising to an open vista of the sky, create a theatrical tent-like setting for the ornate wash-basin and the spectacular bed, with its mounts carved as swans and cornucopias. It is similar to one that Percier had designed for Madame Récamier's Paris house, but for Josephine a more richly coloured and gilded variant was created, in 1810, the year Napoleon married Marie-Louise.

The year before Percier and Fontaine received the Malmaison commission, the architects had presented Josephine with a copy of their first book, on the Renaissance palaces of Rome, a diplomatic gesture that soon bore fruit. Their second book, published three years later in 1801, was to encapsulate the Neoclassical style at the turn of the century. Their *Recueil de décorations intérieures* (*Collection of interior decorations*) gave wide publicity to their decorative schemes, greatly enhanced by the enlarged edition that appeared in 1812 (216). The engravings, in the uncompromisingly linear style that had emerged in the 1790s, most notably in Flaxman's classical illustrations, reproduced a wide range of furnishings. The plates were offered by Percier and Fontaine as models for other designers and architects to follow; thus the *Recueil* aimed at spreading, in the authors' words, 'the principles of taste that we have derived from antiquity'. Such principles, they assert, are 'bound to those general laws of the true, the simple, the beautiful, which ought to govern for ever all productions of the kingdom of imitation' and should spread from architecture to 'the least works of the industrial arts'. Their preface is a manifesto for good design, set within the context

215
Charles
Percier and
P F L Fontaine,
Empress
Josephine's
bedroom at
Malmaison,
redecorated
1810

of Neoclassicism, announcing the first full-scale treatise on design in the industrial or decorative arts. 'Who cannot distinguish', they ask, 'the direction of the spirit and taste in each period by the details of domestic utensils, the objects of luxury or necessity to which the worker involuntarily gives the imprint of the shapes, outlines and patterns in use in his day?'

In one area of the decorative arts France made a unique contribution to the 'spirit and taste' of the Neoclassical period, namely in the manufacture of a new type of wallpaper. Its novelty justified the following American advertisement in a Washington newspaper in 1820: 'An assortment of views [including] the Views of Helvetia, in gay colours, affording a beautiful prospect of the country, the Views of Hindostan, rich colours. Telemachus, representing an interesting and familiar tale of his adventures on the island of Calypso, in rich colours'. The 'views' are panoramic scenes printed as wallpapers, which could decorate the walls of a room like a continuous mural. This new kind of wallpaper had been introduced in 1804 by two rival French manufacturers whose products are listed in the advertisement: Jean Zuber (1773–1852) produced the landscapes of Switzerland and India, and Joseph Dufour (1752–1836) the scenes inspired by the frequently reprinted utopian vision of *Telemachus* by the French seventeenth-century writer François Fénelon. As the century progressed, wallpaper

216
Charles Percier and P F L Fontaine
Plate from *Recueil de décorations intérieures*, 1812 edition. Engraving (detail); 12·7×17·2 cm, 5×6¾ in

217
Jean Zuber, *Arcadia*, 1811. Wallpaper; Deutsches Tapetenmuseum Kassel

manufacturers became increasingly ambitious, offering such
varied subjects as the struggles in the Greek War of Independence,
the jungles of Brazil and scenes from Romantic literature. The
fashion for such papers in aristocratic and especially in bourgeois
houses was to last into the 1860s.

Panoramas had in fact started as a form of popular amusement.
Invented in Britain in 1787, they crossed over to France in 1799
and rapidly became a European mania. A paying public showed
increasing enthusiasm for a form of entertainment that consisted
of a long, continuous painting of a cityscape, landscape or battle-
field stretched out over many metres, often completely encircling

the viewer. The illusionism was so convincing that when the painter David took pupils to see the new panoramas, he commented that 'it is here that one must come in order to study nature.' The first French panoramas had been erected in Paris on the Boulevard Montmartre, and it was there that Dufour opened a gallery to display his panoramic wallpapers, conceived only five years after the mania had hit France. Popular entertainment and sophisticated fashion lived side by side.

When Zuber first printed his *Arcadia* panorama in 1811 (217) he promoted it as if it were a history painting. He referred to 'this picture' that had been 'composed in the heroic style', presenting 'the appearance of a happy and peaceful country, and it is for that reason that we have called it *Arcadia*, the celebrated part of Greece.' The paper is however not just an Arcadian landscape. It is, as Zuber pointed out, based on scenes from the best-selling *Idylls* of Salomon Gessner. There could hardly have been a Zuber customer who had not read the volume. The *Idylls* are about virtue, love, and childhood innocence, imbued with an unmistakable late eighteenth-century sentiment. The part of the panorama repro-duced here illustrates the idyll describing the tomb of Mikon, who had made provision after his death for shade and refreshment, in the form of a fountain, for any travellers. The paper sold well, and customers obviously appreciated an evocation of their much-loved classical past set amidst the unspoilt beauties of nature. The paper was printed in seven tones of grey, designed by the landscape painter regularly employed by Zuber, Antoine-Pierre Mongin (1761/2–1827). The muted colour scheme would have been a perfect foil to the glow of wood and the sparkle of ormolu, produc-ing an interior of both richness and sobriety. Sitting in a room decorated with such a paper, one could 'dwell with pleasure on every picture of calm tranquillity, of sweet, uninterrupted happi-ness', in the poet's own words.

Recovery from war usually involves the revitalization of a nation's economy. That process, combined with a conviction that poorly designed goods contributed to economic decline, led to the first

ever government-sponsored enquiry into industrial design. Established in Prussia in 1819, it took the form of a Ministry of Trade committee (the Königliche Technische Deputation für Gewerbe), with the architect Schinkel as one its members, under the direction of Peter Christian Wilhelm Beuth (1781–1853). From now onwards Beuth was to devote himself to numerous trade projects, and in 1826 visited Britain with Schinkel, looking at its industries and museums.

The committee got down to work quickly. They started to publish as early as 1821 a series of prints, donated to Prussian schools, academies and institutes concerned with industry. The prints were collected in an edition of ninety-four plates in 1830 under the title *Vorbilder für Fabrikanten und Handwerker* (*Examples for Manufacturers and Craftsmen*), followed by an enlarged edition in 1837. The illustrations covered architecture, decorative orna-ments, and household furnishings. The designs were based by Schinkel, and a group of artists helping him, on 'principles origi-

218
Karl Friedrich Schinkel,
Detail of carpet design from *Vorbilder für Fabrikanten und Handwerker*, 1830–7. Coloured lithograph

219
Karl Friedrich Schinkel,
Chair, 1825–30. Cast-iron; h.80 cm, 31 ½ in. Victoria and Albert Museum, London

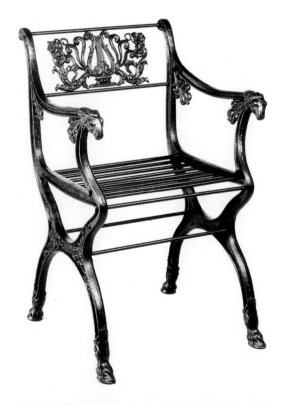

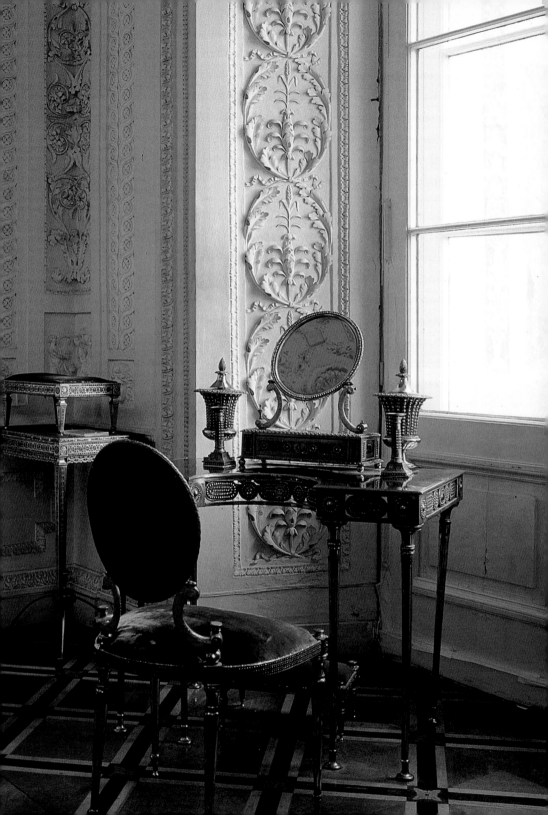

nating from the days of antiquity', as Beuth explained. But as the project developed, additional sources were explored, especially Renaissance and Islamic art, reflecting a gradual move towards the eclecticism that was to become more prominent by the mid-nineteenth century. The range of objects illustrated was the most extensive published to date in any country in a design pattern-book, and embraced copies of historical specimens as well as modern reinterpretations, many by Schinkel himself. The carpet design reproduced here (218) is a particularly good example of one of his contributions, using a colour scheme of green and brown for a group of motifs based on ancient Roman floor and ceiling patterns.

Schinkel was a prolific designer and architect. His commissions for palaces and other buildings included the furnishings, not only internally but also for garden pavilions and terraces. For the latter he often employed traditional materials of marble and wood, but he also designed furniture and ornaments in cast-iron (219). As an innovative architect, it is not surprising that he was attracted by the potential of iron, which designers had previously largely ignored. The most notable exception had been the furnishings in steel produced in Russia at the imperial armoury at Tula, which during the Neoclassical period manufactured some particularly beautiful pieces in finely cut, faceted steel, usually inlaid with other metals, such as bronze (220).

In Prussia by the 1820s the technique of casting iron was highly developed. Since the mid-eighteenth century, stimulated by the lack of raw materials on Prussian soil, industries had been exploiting at least what was available, and thus expanded cast-iron production. By the end of the eighteenth century, pieces as large as life-size copies of the *Apollo Belvedere* were being cast, as well as small, intricate pieces of jewellery, worn to replace gold items donated to the war effort. Schinkel therefore had access to a sophisticated technology able to cope with tasks more difficult than the casting required for the solid pieces of stoves and fire-backs, elaborate though such pieces became in the Neoclassical period in Prussia as well as in Norway, with gods and goddesses

contributing to an efficient heating system (221). Schinkel's elegantly linear and pierced cast-iron chair demanded considerable skill, of which at that date only the Prussian ironworks were capable. Most of Schinkel's pieces were made at the Royal Ironcasting Foundry in Berlin (Königliche Eisengiesserei), achieving a lightness and simplicity combined with strength and durability unique in cast-iron. Initially made for royal patrons, Schinkel's chairs became more widely available, continuing in production as late as the 1860s.

In contemporary Vienna a different version of Neoclassicism was developing. After the Napoleonic War, with the re-establishment of Habsburg rule in Austria, the middle classes were almost completely excluded from political life and free-thinking was suppressed by censorship. The oppression was to be blown to pieces by the 1848 Revolution, but in the meantime the middle classes found alternative channels for the expression of new ideas, aided by their commercial prosperity. As a consequence the visual arts and music flourished, in a period often called the 'Age of Schubert'.

The Viennese middle class lived an orderly and comfortable life, in domestic surroundings where the role of the family was important. Houses were small and intimate, furnishings were plain. The

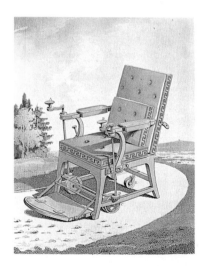

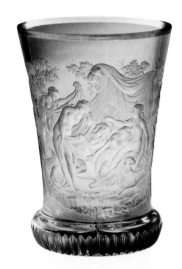

grandeur and ornateness associated with the old order were rejected, and rooms were furnished to be lived in daily, reflecting the character and interests of the family. Rooms appeared natural in a way that would be taken for granted today, but which at the time was unusual above the social level of the peasant farmhouse. This new style in Vienna was later to be named Biedermeier (from 'bieder' meaning unpretentious, and 'Meier', one of the commonest German surnames). It was a unique contribution to Neoclassicism. Although essentially a middle-class style, some pieces of furniture were made for aristocratic patrons sympathetic to this kind of plain décor. Plainness was often combined with considerable imaginativeness in the shapes of pieces of furniture (225), an originality much admired later in the Art Nouveau period and subsequent stirrings of the Modern Movement. The style was so successful that the most prosperous of the Biedermeier furniture makers, Joseph Ulrich Danhauser (d.1830), was able to take over a former Viennese palace: under one roof he could display his products in elegant surroundings, as well as housing all his craftsmen, including twenty-three joiners.

The individual, stark and often idiosyncratic style of the Biedermeier period is most clearly evident in furniture. Elaborate decoration was tolerated only on smaller pieces. Flowers, animals

and landscapes, together with classical figures, often fill the
surfaces of ornaments and tableware, any suggestion of excess
being modified by the simple shape of the object itself. A scene
depicting the goddess Diana engraved on a cut-glass beaker (223)
is typical of this restraint, and a good example of the glass indus-
try's rare response to Neoclassicism, which as a style had less
impact on this area of design than on any other.

From a mobile chair devised for the sufferer from gout to a swing
for children (222 and 224), the Neoclassical style was seemingly
inescapable, whether seen merely in the Greek-key pattern deco-
rating the chair or in the more pronounced antique forms and
detailing of the swing. Even today the Neoclassical period's inex-
haustible love of the antique vase, in all its possible re-uses from
garden ornaments to tea-urns, lives on in sporting trophies,
although today's specimens are distant echoes of their
Neoclassical precursors. One fine example illustrates this point
(226), its design being based on an ancient vase with a particularly
interesting historical lineage. Among the antiquities excavated at

Hadrian's Villa by Gavin Hamilton had been a vase which he sold to an aristocratic British collector for his country house collection, and which was engraved by Piranesi. That engraving was re-created several decades later as the Doncaster Racing Cup in 1828, a silver-gilt version of a marble urn that made a particularly handsome trophy for the horse's winning owner to carry off in triumph.

This continuation of Neoclassicism into the early nineteenth century was evolving simultaneously with three significant developments: larger shops, pictorial advertisements and gas-lighting. All reflected in their design the Neoclassical style. Shopping in the spacious surroundings of what were described as 'warehouses', such as the premises in Glasgow illustrated here (227), the affluent upper and middle classes were able to choose from an extensive range of household furnishings in the latest

fashionable taste. A few of the items on display in the Glasgow store would have been made locally, but most would have been bought from manufacturers in the Midlands and the south of England, as well as from importers. The marketing of goods, in terms of distribution and display, was developing a pattern that we nowadays take for granted, but was essentially new in the Neoclassical period.

Equally new at the time was the printing of advertisements that incorporated a visual image, not relying exclusively on a mixture of typography. While reflecting Neoclassical taste, these pictures could be crude, for example an advertisement (228) for a powder

228
English advertisement for Hubert's Roseate Powder, September 1809. Wood engraving; 20·9×14 cm, 8¼×5½ in

229
French advertisement for Violet and Guenot's Soap, 1827. Engraving

230
Plate from Frederick Accum's *A Practical Treatise on Gas-Light*, showing a variety of light fittings, 1815. Coloured aquatint; 15·4×24·4 cm, 6×9⅝ in

to remove superfluous body hairs which are 'the greatest blemish to female delicacy'. Statues of the Three Graces in a rotunda, accompanied by roses, convey in visual terms the message of attainable beauty. More sophisticated pictorial advertisements are represented by a French example (229) promoting scented soap at the stand of a firm of Parisian perfumers at an industrial exhibition. Here the public is wooed by Apollo himself, dancing with the Muses in an idyllic picturesque landscape, watched by Flora, who scatters flowers from her cornucopia on to the assembly below. The trappings of classical mythology could hardly have been put more charmingly at the disposal of commercial interests.

The rapidly expanding consumer society was to be increasingly lit by gas. First used in factories and streets, its potential was then developed in domestic interiors. About 1812 in London, the leading art publisher Rudolf Ackermann (1764–1834) installed gas-lighting in his warehouse and workshops, as well as in his private apartments, probably the first person to do so. He contrasted the benefits of the new lighting over candles and oil lamps in a letter to Frederick Christian Accum, a resident German chemist from whom Ackermann had commissioned the installation. He said it 'bears the same comparison to them as a bright summer sunshine does to a murky November day'. Ackermann went on to publish Accum's

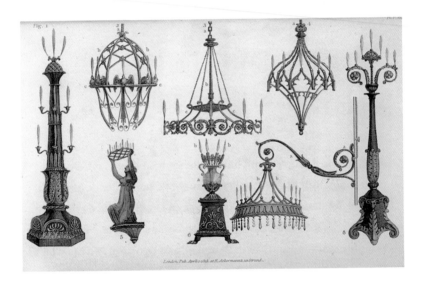

A Practical Treatise on Gas-Light (1815), which included illustrations of light-fittings mostly in the heavier Neoclassical style that had become fashionable in other furnishings (230). The book went through several reprints and was also translated into the main European languages. Gas-lighting became increasingly popular in the next few decades.

Thomas Hope's decoration of his London house, however, just predates this development. Hope had settled in London in the late 1790s after a sojourn in Italy, during which his commissions had included Flaxman's *Dante* illustrations (see 174). This chair (231),

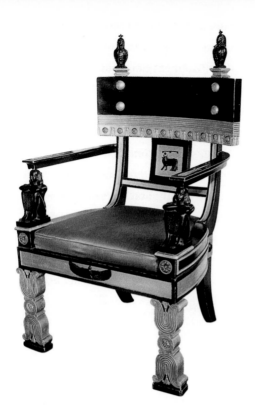

which Hope designed and had made for his London house, is a clear indication of a strong, individualistic talent. Its boldness of form is not dissimilar to that of the gout chair, but its decoration is strikingly different, being partially derived from ancient Egypt. Roughly contemporary with Schinkel's designs for *The Magic Flute* (see 190), the chair signals the eclecticism that was to over-whelm the visual arts by the mid-nineteenth century.

In 1807 Hope published a book with the apparently innocuous title of *Household Furniture and Interior Decoration*. In reality a manifesto for what he regarded as 'true elegance', it consists of a room-by-room account of his newly furnished London mansion, bought in 1799. Recently settled in London, Hope was determined to make a cultural and social mark on the capital: the rooms housed his collection of classical antiquities and modern art, and provided a spectacular setting for balls and parties attended by London society.

On entering, the visitor encountered in the hall the owner's portrait in Turkish dress, a reminder of Hope's eastern Mediterranean travels and a foretaste of the exotic Romanticism of his novel *Anastasius*, published in 1819 but written during his extensive travels in the 1780s and 1790s. On the first floor, opened by Hope on a regular basis to the public, the visitor could circulate through rooms decorated in styles derived from the classical world, not only of Greece and Rome but also of Egypt and India. The Indian subcontinent was beginning to be accepted into the classical canon because of the growing understanding of the influence of ancient Greece on the art of the north, as a result of Alexander the Great's invasion. Indeed, the first work Hope commissioned for his new house was a large oil painting of an Indian architectural scene by Thomas Daniell (1749–1840). Anyone not able to get an admission ticket could view the whole house through the illustrations in Hope's *Household Furniture*, which provides an unusually complete record of the interiors of an early nineteenth-century

231
Thomas Hope, Chair, 1807. Mahogany painted black and gold with bronze mounting; h.121·9 cm, 48 in. Faringdon Collection Trust, Buscot Park, Oxfordshire

232
Duncan Phyfe (attributed), Side chair, c.1810–15. Mahogany; h.84 cm, 23⅝ in. Winterthur Museum, Winterthur, Delaware

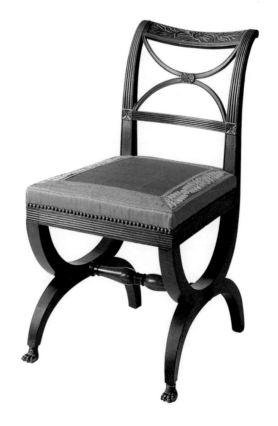

fashionable house. The Hope family itself lived on the second floor, where the rooms were carefully organized to display different aspects of the antique past. In each case meticulous attention was paid to correct colour schemes, and an arrangement and choice of ornamentation that were iconographically meaningful. The décor of these rooms had an additional message – it is what the French call 'architecture parlante', speaking architecture.

The chair illustrated here was part of a suite of furniture for the Egyptian room in the house. As Hope explains in his book, the colouring of the granite, porphyry and other materials of his Egyptian antiquities was so different from the pure white of his Greek marbles that he wanted to keep them separate. The room was decorated appropriately with motifs from mummy cases and papyrus scrolls. The dominant colours of walls and furnishings were 'that pale yellow and that blueish green which hold so conspicuous a rank among the Egyptian pigments, here and there relieved by masses of black and gold'.

Hope's passionate concern for 'true elegance' contributed to the wide-ranging influence of his book, a possible source for the design of chairs with 'Grecian-cross' legs made in New York c.1810–15 (232).The eastern seaboard of the United States reflected in its furnishings the affluence and elegance on the other side of the Atlantic. Much outstanding furniture in the latest style of Neoclassicism was made by the firm of Duncan Phyfe (1768–1854), from whose workshop this chair almost certainly came. He had emigrated from Scotland in the early 1780s, almost immediately after the British government's recognition of America's independence.

Initially Phyfe worked in the style of Thomas Sheraton (1751–1806), whose *Drawing-Book* (1791–4) illustrated a wide range of furniture designs frequently copied in the trade. The Sheraton style dominated British furniture at the end of the eighteenth century and was still influential in the 1820s in the far-flung, recently established colony of New South Wales. Much

33
James Oatley,
Longcase clock,
1822.
Cedar and pine;
h.259cm,
102in.
The Mint and
Barracks,
Museum of
Applied Arts
and Sciences,
Sydney

early Australian furniture was based on English pattern-books. A long-case clock (233) made in Sydney in 1822 by James Oatley (1770–1839) employs a style long out of fashion back at home. Like many early settlers in Australia, Oatley had arrived as a convict, seven years before. He had been transported for life, but official recognition of his skills led to a pardon and a grant of land. He built up a good business because, as he said in a newspaper advertisement, his clocks gave the true time 'without the hazard of sending them on a sea voyage, where a contrary wind might spring up and make the rate they went on board much quicker than on their return'.

New South Wales was such a new colony in the 1820s, just over thirty years old, that it could not be expected to support the level of fashionable sophistication of New York State. Camden Park, for example (see 205), was to be built and furnished in the next decade. A cabinet-maker such as Duncan Phyfe could not have prospered in New South Wales or Tasmania; his rapidly expanding business provided furniture for clients not only in New York but also elsewhere in the States. He competed successfully against foreign imports from England (except during the Napoleonic War period) and the workmanship of emigré French cabinet-makers, with products that were fairly highly priced, of excellent craftsmanship and good design. His fortune at the time of his death was equivalent, in modern terms, of that of a multi-millionaire.

The little Lilies of the Vale,
White ladies delicate & pale;

A naked Greek female slave, carved in white marble, stood surrounded by products of modern technology in the heart of the Great Exhibition of 1851 in London (235). Mounted on a rotating pedestal under a red plush canopy which set her apart from an adjacent railway bridge, the sculpture was not only the most arresting exhibit in the American section, but also one of the most popular in the whole Crystal Palace in the eyes of 'King mob', as a contemporary newspaper dubbed the crowds that surged through the building. The statue, unmistakably Neoclassical in style, is clear evidence that the movement was not moribund. It has continued to inspire artists in a variety of media, and this chapter looks at a small sampling from the period after 1830 to suggest the variety of their responses to Neoclassicism.

The *Greek Slave* by the American sculptor Hiram Powers (1805–73) was one of the most famous mid-nineteenth century examples of Neoclassicism. However, Neoclassicism was no longer the predominant contemporary style: by 1851 numerous alternative 'revival' styles had made it impossible for any one style to predominate. The mid-nineteenth century is characterized across Europe, North America and the colonies by a mixture of styles far more complex than had ever been seen before. Neoclassicism now jostled with revivals inspired by the medieval period, the Renaissance, seventeenth- and eighteenth-century art, as well as art from the Middle and Far East. Revivalism was rampant, except in one category of exhibits in the Crystal Palace, that of industrial machinery, where historical precedents were lacking. The Battle of the Styles, as the mid-nineteenth century came to be labelled, was in full swing.

Comments by the French writer Alfred de Musset (1810–57) in his autobiographical novel *Confessions of a Child of the Century*

234
Walter Crane,
Lilies of the Valley, from his *Flora's Feast*, 1888.
Coloured print;
18×13 cm,
7×5¹⁄₈ in

(*Confessions d'un enfant du siècle*) were as relevant in 1851 as they had been when he first published them in 1836. 'Eclecticism is our taste,' he wrote. 'The apartments of the rich are cabinets of curios … We have something from every century except our own … We take what we find, this for its beauty, that for its convenience, and that for its antiquity.' Perhaps we would not agree, though, with his unduly pessimistic conclusion that as a result of this eclecticism 'we live amid flotsam, as if the end of the world were near.' Amid this 'flotsam' Powers's *Greek Slave* represented a style that was to become an increasingly minority one.

The *Greek Slave* combined classical antiquity with a contemporary love of storytelling, which helped to assuage any prudish element in current taste. When a version of the marble was toured in the United States, viewers' sensibilities were further protected by excluding gentlemen from the exhibition room in the afternoons so that ladies could visit it on their own. The statue was one of the most popular of marbles on both sides of the Atlantic in the mid-nineteenth century. Even before it was exhibited in the Crystal Palace, an earlier version had been seized upon by ceramic manufacturers as an ideal sculpture to reproduce in miniature, using a new kind of porcelain which looked like white marble when it came out of the kiln, 'Parian' ware. One American publisher even produced an anthology of ecstatic critical pieces on the sculpture in prose and in verse.

Powers took the pose for his *Greek Slave* from a well-known Venus in the Vatican collection. He added a few details to suggest the story that she was a Christian who had been forced to present herself naked at a slave market after she had been captured, presumably by the Turks in the Greek War of Independence. She is therefore conscious of her nakedness, and ashamed, unlike her prototype goddess. A cross among her discarded clothing gives the clue to her religious beliefs, but some contemporary viewers argued further that she was an allegory of the Christian faith. Also among the clothing is a locket, suggesting to some that she was an allegory of innocent love. Others even saw in the *Greek Slave*,

since she is shown chained and was a work by an American sculptor, an allegory of democratic idealism. Far-fetched as some of these interpretations might be, they were responses to a kind of visual teasing typical of some mid-nineteenth-century art. It had been grafted on to a Neoclassical style which in its heyday would not have played with the viewer in this way. These multiple interpretations of the statue's meaning undoubtedly added to its popularity, since it could be enjoyed for many reasons by a wide variety of the public. As one contemporary put it: 'The grey-headed man, the youth, the matron, and the maid alike, yield themselves to the magic of its power.' Satirists too relished her popularity. The weekly magazine *Punch* published a mock advertisement for clothing that it deemed appropriate for nude statuary, in which Powers's work was provided with Turkish trousers, and, somewhat less appropriately, the *Apollo Belvedere* with a pair of check pants.

While increasingly the butt of satirical humour, Neoclassicism survived unscathed, if diminished. Even at the height of the artistic turmoil associated with Art Nouveau at the turn of the nineteenth and twentieth centuries, when pure revivalisms were anathema to the avant-garde, Neoclassicism was still regarded as a viable form of artistic expression by some of the leading artists and designers. Walter Crane (1845–1915), for example, so prolific in the fields of ceramics, wallpapers and book illustration, in which he explored an eclectic variety of source material, could also produce a purely Neoclassical image (234). His *Flora's Feast* is an enchanting series of anthropomorphic flowers, some of which stylistically descend directly from the work of Flaxman and his contemporaries, especially in this page devoted to lilies of the valley, which resemble classical bacchantes swathed in draperies of white and pale green.

In the field of architecture, Neoclassicism attracted much hostility in the decades around 1900. Walking around Chicago at the turn of the century, the American architect Louis H Sullivan (1856–1924), who played a significant role in the development of the skyscraper,

stopped in front of a building that he took to be a Roman temple. He used the opportunity in his *Kindergarten Chats*, a series of imaginary dialogues between a master and pupil first published between 1901 and 1902, to denounce what he saw as errors in the current state of architecture. Sullivan fantasized that some ancient Romans had recently emigrated to North America, still clad in their traditional togas and sandals, and had settled in the countryside around Chicago. They had prospered in the great new city, and as a result had erected a temple to their guardian deity. The imaginary professor rambles on, to be interrupted eventually by his puzzled student. 'Let me lead you away. You are ill,' he says. 'This is no Roman temple – it's a bank.' The façade of the Chicago National Bank did indeed have the appearance of a Roman temple, complete with fluted columns and Corinthian capitals. Sullivan's hostile reactions to such a Neoclassical building are central to any debate on revivalism versus modernism.

The imaginary conversation continued with the remarks: 'Stay! Young man! If I dream, these money-people dream! How did they get into the temple? Was their architect a dreamer too?' He may have been, but he was also an astute promoter of the ancient style, telling the bankers that 'Roman temples are rather the go now for banks.' The master is disillusioned about the bank. 'What a woeful come-down from my dream. What a singular debacle of a vision, old in story, rich in wonder, of a people proud in conquest, wise in laws – what a deep descent to this frenetic pigeon-house you call a bank.' For Sullivan a Roman temple-bank was not a fulfilment of present-day requirements. By implication the design of a bank should be a new one conceived in and for 1900, as Sullivan's own designs were; a Roman temple-bank is a 'misappropriation', an 'abuse of confidence', comparable to that of a financial crook. The architect has perpetuated a fraud, yet instead of being imprisoned he is exonerated by 'taste' and 'scholarship'. The critic must fight against such travesties, argues Sullivan, otherwise architecture will no longer be a fine art, but will have become a 'bargain counter, and the people merely shoppers', buying products which are 'crumpled and soiled'. Roman temples were part of Roman life,

235
Hiram Powers,
Greek Slave,
1844.
Marble;
h.166·4 cm,
65 ½ in.
Raby Castle

not American life. Just over a century earlier the architects of America's first capitols thought otherwise. The contemporary relevance of a classical architectural vocabulary was to resurface constantly in the course of twentieth-century debates about revivalism.

For Sullivan, Roman temples were not part of American life; no more were Greek ones part of Japanese, but the marked preference of the banking community worldwide for the architecture of the ancient classical world influenced the design of the Doric edifice in Kobe which was the local branch of the Yokohama Shohkin Bank (236). Neoclassicism had been one of several European styles imported after Japan opened its doors in 1868, having been almost entirely shut off from the rest of the world for two and a half centuries. The bank illustrated here, subsequently converted into the Kobe City Museum, was a branch of the only Japanese bank at the time engaged in international trade, and it was appropriate that a foreign style of architecture should be

236
Shohtaro
Sakurai,
Yokohama
Shohkin Bank,
Kobe, Japan
(now Kobe City
Museum), 1935

adopted. The architect, Shohtaro Sakurai (1870–1953), had trained in London, and was the first Japanese to become an Associate of the Royal Institute of British Architects. His combination of the latest modern building technology using ferroconcrete, combined with an outer cladding of granite for his Greek classical order, was fully in keeping with Western practice in such public buildings at the time.

Banks, art galleries, war memorials, and many other public buildings and monuments, as well as private houses, provide examples of the survival of Neoclassicism into the twentieth century. It has also been adopted as the official style of architecture of modern totalitarian regimes, most notably in Germany under Hitler.

When the National Socialists, or Nazis, came to power in 1933 their control of all aspects of the country's life included its art. Works of which the Nazis disapproved were removed from museums and art galleries, classified as 'degenerate', displayed for mockery in a special exhibition, and in many cases destroyed. National Socialism was determined to enforce its own interpretation of Germany's historical achievement in the arts, which the Nazis saw as a vital contribution to a national identity from which 'alien' elements had been expunged. The National Socialists understood the effective propaganda role that the visual arts can play. They needed to look no further back than the French Revolutionary and Napoleonic periods; but they pursued their self-promotion with a thoroughness far exceeding such historical precedents. Art became identified with a state which would lay the foundations for 'a new and genuine German art', to use Hitler's words in his opening speech for the House of German Art in Munich, the first public building inaugurated in the Third Reich.

As a model for the exterior design of this new museum, the architects, Paul Ludwig Troost (1878–1934) together with Hitler himself, turned to the only major precedent on German soil, the vast Altes Museum in Berlin by Schinkel (see 194). This imposing Neoclassical structure, designed for the public display of art of all periods and nationalities in the royal collections, had been built

for a fundamentally different function. The 1930s museum adopted the exterior pomp of Schinkel's museum and its overpowering scale, and gave it a new role. But the irony of the new design is that, whereas the contents of the proposed exhibitions would be deprived of any 'alien' elements, the building itself was entirely foreign in origin, deriving as it did from ancient Greece. The Neoclassical style, however, identified the National Socialists with a long-accepted great civilization, unconnected – in their eyes – with the style of modern architecture which they hated so much. The radical contemporary architecture of the International Style, to which Germany had made such a significant contribution, particularly in the 1920s, had been developed in Germany by individuals whose politics and religious beliefs the National Socialists despised. Concrete, steel and glass, materials that were characteristic of that style of architecture, became tainted in Nazi eyes, and were replaced by a more traditional use of stone and marble.

Hitler's grandiose ideas of power were translated into megalomaniac building schemes from 1934 onwards by Albert Speer (1905–81), one of his favourite architects, who became the most famous designer of the Third Reich, and during the war Hitler's right-hand man as Minister of Armaments and War Production. Speer greatly admired Schinkel and considered himself his successor, especially in the even greater mark that he hoped to leave on the face of Berlin. Speer's increasingly ambitious architectural projects were hampered by shortage of funds when money had to be diverted to the war effort; they would have culminated in a new centre to Berlin, based on an enlarged version of the axis running through Paris down the Champs Elysées to the Arc de Triomphe. Berlin was to have its own triumphal arch, together with a broad avenue for the marching of troops and a great domed hall. The designs reflect the influence of the grand visions of Boullée and Ledoux. These projects were scheduled for completion in 1950, but the course of the war changed that.

237
Albert Speer,
Zeppelinfeld,
Nuremberg,
1934

From the start, Hitler and Speer looked to the monuments of the classical past, both as statements of power and as reminders to

future generations of former greatness. According to Speer's memoirs, Hitler once asked, 'What had remained of the emperors of Rome? What would still bear witness to them today, if their buildings had not survived?' The Nazis exploited all political means in the hope of creating a new Germany, including the political role of architecture. Naturally, as Speer goes on to recount, 'a new national consciousness could not be awakened by architecture alone. But when after a long spell of inertia a sense of national grandeur was born anew, the monuments of mens' ancestors were the most impressive exhortations.' Mussolini, with his ambitious Fascist building schemes in Italy which were contemporary with the German 1930s programme, lived among the remnants of ancient Roman heroism and imperialism. With this advantage, according to Hitler, Mussolini could 'fire his nation with the ideas of a modern empire', while in Germany, 'our architectural works should also speak to the conscience of a future Germany centuries from now.' When visiting archaeological sites in Italy in 1939,

238 Overleaf Norman Neuerburg and others, J Paul Getty Museum, Malibu, California, 1970–5

Speer's reactions were somewhat different from those of the eighteenth-century Grand Tourist. Here he found justification for the scale of his own buildings, observing 'with some satisfaction' that even the ancient world provided evidence of megalomania. The Greeks who had settled in Sicily were 'obviously departing from the principle of moderation so praised in the motherland'.

Speer's realization of Hitler's aims began with the building of a stadium for Nazi rallies in Nuremberg, held in the Zeppelinfeld (237). For the grandstand Speer designed a gigantic flight of steps, with a long colonnade (or peristyle) flanking the stand and framing large areas for spectators. Subsequently Speer realized he had been influenced by a vast ancient Greek altar, the most famous archaeological remain in the Berlin museum collections (the Great Altar of Pergamon). Speer labelled his work at Nuremberg as 'Neoclassical', and continued to work in this style into the 1940s. Nuremberg was also intended to be the site of more buildings to cope with Nazi rallies, including a stadium capable of seating 400,000 spectators. 'Why always the biggest?' asked Hitler in a speech. 'I do this to restore to each individual German his self-respect. In a hundred areas I want to say to the individual: We are not inferior; on the contrary, we are the complete equals of every other nation.' In the event, most of the buildings erected during the Nazi period were destroyed in World War II, and many more were not even built.

The close identification of Neoclassicism with the Nazi era, and with Mussolini in Italy, Stalin in Russia and Ceausescu in Romania, has given Neoclassicism a regrettably tragic role in the twentieth century. Fortunately the style has proved itself adaptable, as in previous generations, suitable not only within totalitarian states but also within democracies.

California in the early 1970s was the setting for a classical re-creation in the spirit of the Pantheon at Stourhead and the Parthenon at Regensburg. But on this occasion it was a villa from Herculaneum, born again as the J Paul Getty Museum (238). Only the plan of the original house, the Villa of the Papyri,

survived amidst the ruins, and this was accurately copied as the ground plan of the museum. For the museum's structure above ground level, walls, colonnades and gardens were reconstructed from archaeological evidence provided by other buildings. Every detail, from coffered ceilings to wall decoration, has a historical precedent, so thoroughly has this scholarly exercise been carried out. The result is an appropriate setting for the ancient Greek and Roman antiquities which form an important part of the Getty collections. The bright sunshine and the close proximity of the sea enhance the illusion that one might actually be in the Bay of Naples. As the benefactor himself said of his project, 'it will simply be what I felt a good museum should be, and it will have the character of a building that I would like to visit myself ... I realize our new building will be an unusual one and that architecture of this nature is not being done in our day and age.' Once completed, the 'unusual' building was to generate a great deal of discussion. It was to be loved, and it was to be hated.

Critics of the Getty Museum, while succumbing to the 'delicious' setting and the 'gorgeous' appearance of the architecture, complained that 'one can't forgive the grindingly remorseless accuracy of the detailing, ... done with such bureaucratic precision and lack of wit.' The aesthetic arguments have been partially confused by attitudes to Getty himself, whose immense wealth made his great collection possible (the article just quoted is entitled 'Lair of the Looter'). But if one can look at the building in its own right, it is possible to assess it as a major example of Neoclassical architecture in the twentieth century. The villa in its new role as a museum functions perfectly, providing spacious settings for the works of art. The architecture has been beautifully crafted in its detailing, re-creating the pleasurable experience of an ancient villa far removed from 'arrogant heavy modernism', as one admirer put it. The design of the Getty is naturally anathema to anti-revivalists, but at a popular level its architecture has met with undoubted approval, and among critics and fellow architects there are many who

A Tower of the Winds
B Choragic Monument of Thrasyllas } Athens
C Portico of Augustus

Maitland Ro

Library

D Medici Chapel, Florence
E Osberton House, Notts
F Fitzwilliam Museum, Cambridge

Francis Terry. fecit

239
Francis Terry,
Quinlan Terry's
Maitland
Robinson
Library,
Downing
College,
Cambridge,
1990–2. Pen
and ink drawing:
43·5×61·5 cm,
17 1⁄8×24 1⁄4 in.
Downing
College,
Cambridge

admire a design which they claim 'underscores the visual abundance made possible by the classical. It is a cornucopia of all arts awaiting anyone who is willing to accept the lessons of the past.'

A recent champion of the classical tradition, the British architect Quinlan Terry (b.1937), has argued that 'people are not happy with the new buildings they see around them.' For him, the explanation lies in the fact that 'it all seems to belie some deep-rooted and subconscious distrust of all things unnatural which have been thrust upon us by this brave new world of technological achievement.' While new classicists like Terry do not totally reject modern technology, they do reject large glass surfaces, concrete, and 'plastic and steel tubing clipped together', preferring the durability of traditional materials. For Terry, the argument between modernists and classicists (or more broadly any traditionalist) is not just about styles, but more fundamentally about the environment, reflecting the increasing awareness in the 1980s and 1990s of man's depletion of the world's natural resources. Terry has posed the problem succinctly in two rhetorical questions: 'Are we to satisfy the short-lived lusts of a throwaway society with their glossy space-age structures, which suck out the earth's resources and leave behind a scrap-heap of unrecyclable rubbish? Or do we return to sanity and build slowly and traditionally like our forefathers – preserving our God-given resources for the generations that are to come?' The debate between advocates of a technological architecture as opposed to a more traditional kind has at times been acrimonious, as when a proposed high technology extension to London's National Gallery (the style of which is Neoclassical) was dubbed a 'carbuncle' by the Prince of Wales, eventually being rejected for a modern design in stone which playfully incorporates Neoclassical detailing derived from the original building.

At Downing College, Cambridge, where the original buildings are distinguished examples of Neoclassicism from the early

nineteenth century, Quinlan Terry was an obvious choice of architect for new additions to the site. A new library, completed in 1992 (239), is a perfect complement to the existing Greek Revivalism. Terry borrowed the main components of his design from Athens, using two different porticoes and, for the octagonal cupola, the Tower of the Winds, which he combined into a beautifully proportioned building. Its function as a library is symbolized in the frieze representing different academic subjects, completing a building which exemplifies the trend towards a 'recovery of reverence', to use the title of a recent paper by the architectural historian David Watkin.

Under this title Watkin argued that the twentieth century has been 'marked by a drastic loss of the sense of piety. We need in the twenty-first century to recover the lost reverence for the wisdom and achievements of our ancestors.' He then proposed, somewhat provocatively, that he would like in the next century to come upon 'a classical airport terminal in which my fellow travellers and I can be calmed by the representation of order and continuity while we await our flights in symmetrically designed halls, cool and high-ceilinged, where the seats will be klismos chairs, and the signs will be written in Trajan lettering.' Possibly far-fetched, but nevertheless a reminder that it is most conspicuously in architecture that Neoclassicism has retained its momentum in the twentieth century.

Architecture may take the dominant role in twentieth-century Neoclassical art, but painters and sculptors have made their marks too. Greek myth – and one could add Greek art – was like a famous jug in Greek legend which could never be emptied. 'And the milk that draws me there', continued the French writer André Gide in the course of using this analogy, 'is certainly not the same as that drunk by earlier writers.' Gide's short essay, 'Considerations on Greek Mythology', was written in 1919, at a time of a resurging classical influence. World War I with all its unprecedented destruction had ended only the year before, and during the ensuing peace thoughts turned to the Greek and

Roman legacy that had been the foundation of European culture, but had been challenged by European avant-garde movements in the decade before the war. Now, in 1919, some of these same avant-garde writers and artists returned afresh to the classical past. Pablo Picasso (1881–1973), among others, contributed to this 'return to order' as it was called at the time.

Since his days as a student in Spain when he had to draw from plaster casts of classical statuary, Picasso had shown little interest in the classical past. He had found his subject matter in contemporary life, portraits and still lifes. Now, just after the war, there was to be a change of direction in his art. It began with a series of portrait drawings influenced by Ingres (1918), and was followed by a series illustrating scenes from classical mythology.

The period 1920–25 is usually described as Picasso's 'Classical' or 'Neoclassical' period, when his style and subject matter were sometimes derived from the art and literature of ancient Greece and Rome. As so often in his career, Picasso drew and painted concurrently in more than one style. Along with Neoclassical works went a continuing exploration of Cubism. He saw no contradiction in this disparity, claiming that he did not believe artists evolved towards some imagined, single goal. Certainly for Picasso there was no such goal. 'Variation does not mean evolution,' he said. 'If an artist varies his mode of expression this only means that he has changed his manner of thinking ... When I have found something to express, I have done it without thinking of the past or of the future ... If subjects I have wanted to express have suggested different ways of expression I have never hesitated to adopt them.'

Picasso 'changed his manner of thinking' at the time Greek mythology entered his consciousness, which he said could only happen in the Mediterranean, where he felt more closely in touch with the ancient world. It was there, at Juan-les-Pins in the summer of 1920, that Picasso produced a series of drawings based on the story of the attempted rape of Herakles's

wife. Recently won in combat, Deianira had been entrusted to the centaur Nessus, who had offered to carry her safely across a river but instead tried to rape her. He was to be foiled by a poisoned arrow shot by Herakles. This tale of lust and treachery was frequently illustrated in ancient art. Picasso's response to this passionate tale (240) shows the influence on his style of Greek vase-painting and Roman relief sculpture, together with other classical works he had seen in Naples and Pompeii in 1917 in the company of Jean Cocteau (they were visiting Italy to collaborate on a new work for Diaghilev's Russian Ballet – the impresario was currently in Rome on a tour). Picasso's fascination with classical subject matter lasted into the 1930s, and included his famous series of etchings to Ovid's *Metamorphoses*, as well as a set for Aristophanes's *Lysistrata*, in which Picasso brilliantly captured the sexual antics of the Greek comedy. The play was translated by an American writer, Gilbert Seldes, and it was for his publication that Picasso produced the prints, and to whom Picasso dedicated one of his 'Dejanira' drawings. Picasso's classical narrative drawings were never worked up at the time into large-scale oils. Part of the reason for this lies in his general avoidance of narrative subjects in his oils, with the major exception of his reaction to the Spanish Civil War, in *Guernica*. As an avant-garde artist, Picasso had an intense dislike of academic, storytelling paintings which had played such a prominent part in European art, and which the avant-garde – with only rare exceptions – had rejected.

By the 1930s Picasso's classical imagery was no longer Neoclassical in style in the way that it had been in the early 1920s. His subject matter was Greek, but the style of his line drawings was not. In fact Picasso became more outspoken in expressing what he disliked about Greek art, which he blamed for a fixed concept of beauty perpetuated by teaching in academies. In 1935 he asserted that 'academic training in beauty is a sham'. He found 'the beauties of the Parthenon, Venuses, Nymphs, Narcissuses, are so many lies. Art is not the application of a canon of beauty

240
Pablo Picasso,
*Nessus and
Deianira*,
1920.
Pencil;
21 × 26 cm,
8¼ × 10¼ in.
Museum of
Modern Art,
New York

but what the instinct and brain can conceive beyond any canon.'
To which he added a typical Picassoesque touch: 'When we love
a woman we don't start measuring her limbs.'

Picasso's involvement with the classical tradition was brief
and ambivalent. A younger generation, especially in the 1980s
onwards, has shown a greater commitment. Picasso's generation
of the 1920s and 1930s could not resolve the apparent contradic-
tion of an avant-garde classicism. To later artists, that contradic-
tion seems to no longer apply. After a period dominated by
abstract art from the 1950s onwards, a wide range of non-abstract
styles reasserted themselves. Some artists who had once been
abstract changed direction, while the younger generation
included a diverse group of painters and sculptors in Europe and
the USA who can be loosely categorized as classical. They are,
however, so varied in style that one critic, Charles Jencks, has
even subdivided them into five different trends. Two individual
artists will be discussed here in order to illustrate some aspects
of Neoclassicism today.

Carlo Maria Mariani (b.1931) works in a style closely associated
with the Neoclassicism of the late eighteenth and early
nineteenth centuries; David, Mengs and Winckelmann are
among his acknowledged sources of inspiration. Posing for
a photographer in Rome, he leaned against the base of an
isolated column gazing towards an ancient pyramid: the camera
reinvents the Grand Tour portrait. In an interview Mariani once
said that he looked to the past as if he were an eighteenth-
century artist living in the present day, 'incapable of forgetting
silence, calm, proportion, serenity'. His choice of words is
reminiscent of those used by Winckelmann. His paintings are
of a 'Paradise Regained', as he entitled one of his exhibitions.
His self-confessed indebtedness to the Neoclassical period,
'confronting great art head on, audaciously and openly', implies
a total absorption in the past. His portraits of fellow artists give
them mock-heroic roles derived from eighteenth-century portrai-
ture, sometimes complete with Roman toga and classical ruins.

41
Carlo Maria
Mariani,
Apollo and
Cupid, 1983.
Pen and water-
colour on paper;
102·9 × 114·3 cm,
40½ × 45in.
Private collection

Despite Mariani's assertion that 'content does not really interest me', he often chooses subjects from classical mythology which presuppose the viewer's familiarity with them, and he also borrows heavily from the art of the past. He has copied the whole of David's *Death of Marat* (see 141), adding a standing figure of Charlotte Corday in the background, and adopted elements of the composition of Mengs's *Parnassus* and Tischbein's portrait of *Goethe in the Campagna* (see 82 and 31). Mariani's reworkings are as Neoclassical in style as their proto-types, but devoid of their original purpose and meaning. He is using art to comment on art.

When not reworking historical precedents, Mariani's large canvases and watercolours often depict handsome young male nudes, whose perfectly formed bodies suggest hours spent in gymnasium work-outs in preparation for a photographic session (241). They are painterly, Neoclassical records of the body beautiful, either acting out a classical myth or a less specific event, for example *It is Forbidden to Doubt the Gods*

or *The Hand Submits to the Intellect*. Asked if he drew these figures from life, Mariani responded 'No no, the real does not interest me. They are suggested to me by fantasy or by certain classical iconography, especially Greek statuary. That is my source.'

David's Marat has fascinated another artist of the post-war generation, Ian Hamilton Finlay (b.1925). But his fundamental concerns are not only with Neoclassical art and the classical tradition, but also the Revolutionary ideals of Marat and his contemporaries. Finlay is a prolific British artist, poet and gardener, who has produced sculptures, garden installations, prints and artist-designed books. He was one of the leading international writers in the 1960s of 'Concrete' or 'Visual' poetry, in which poems were reduced to a minimum number of words, with their typographic arrangement on the page presenting a visual expression of the poem's content. This fusion of literature and art was then taken by Finlay out into the landscape. There the literary or philosophical content of his sculptures and other objects set into the garden layout was often indicated by inscriptions, usually as minimal as his 'Concrete' poetry had been. Sculptures sited as far apart as a university campus in California, a public park near London and an olive grove on an estate in Tuscany all bear witness to Finlay's combination of word and image.

242
Ian Hamilton
Finlay (with
Alexander
Stoddart),
*Apollon
Terroriste*,
1988.
Resin and
gold leaf;
h.78·7 cm,
31in.
in situ in Finlay's
garden at
Dunsyre,
Scotland

The most extensive garden that Finlay has designed is his own, Stonypath, or Little Sparta, at Dunsyre in Scotland. It can be entered either by passing through a gate dedicated to Rousseau or under an archway inscribed on the front 'A Cottage. A Field. A Plough.' On the reverse side it reads 'There is Happiness.' By either route the visitor's elegiac mood, inspired by Rousseau's love of nature, is established at the outset of a unique, arcadian twentieth-century walk, comparable to those laid out 200 years before in landscaped grounds of Stourhead and Ermenonville. Stonypath too is filled with classical images and references, as well as paying homage to the painter who influenced such

gardens, namely Claude. His name is boldly incised on the para-
pet of a bridge, as one of several tributes to him at Dunsyre.
Claude has been the most influential artistic source for Finlay's
garden designs in general, with several layouts specifically based
on Claude paintings. Also at Dunsyre, the Isle of Poplars at
Ermenonville reappears in a scaled-down and altered version,
while Laugier's primitive hut is re-created beside a small lake.
This picturesque idyll also contains discordant references to war
and revolution, ranging from aircraft carriers, submarines and
hand grenades, to inscriptions relating to the French Revolution.
A large gilded head lies in woodland grass. Partially based on
that of the *Apollo Belvedere*, it has been inscribed across the
forehead in French with the words 'Apollon Terroriste' (242).
Elsewhere in the garden another Apollo, complete but small-
scale, stands holding a machine-gun, a deadly modern version of
the god's original bow and arrow.

243
Ian Hamilton
Finlay (with
Gary Hincks),
*After John
Flaxman.
The Classics!*
1981.
Print;
5·4×9·3cm,
2^1⁄$_8$×3^5⁄$_8$in

Finlay's version of Neoclassicism can be as didactic as that
of the art of the period he admires so much. Idealism and tyranny
or death, locked inseparably in combat at certain periods of
European history, is a major theme in Finlay's work, for which
he derives inspiration from the time of the French Revolution
and that of the Nazi regime. The treatment can be understated,
as when he takes David's *Death of Marat* and translates it into
a carved stone panel, or redraws the painting as a black-and-
white print, merely adding a tricolour rosette lying on the
wooden box beside the bath. His reworking of the *Apollo* is
more explicit, using a long-accepted image of ideal beauty for
the body of a modern perpetrator of terrorism. Even in Arcadia
there is death, an idea rendered most famously in two seven-
teenth-century paintings by Poussin, one of which Finlay has
adapted as a marble relief panel, substituting a tank for the
tomb which the shepherds find in a wood. Finlay has also
adapted some of Flaxman's illustrations to Homer, including
one of Apollo and Diana discharging their arrows, as they fly
over a harbour, aiming at the ships below. On his own print (243)
Finlay removed the original text and substituted: 'Classical U-boat

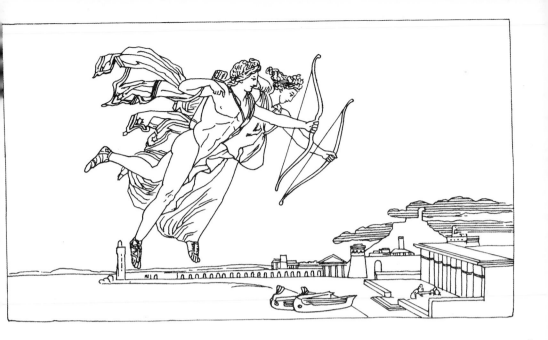

pens in wartime. Note Type 11C U-boats anchored outside the pens. A section of Albert Speer's Atlantic Wall can be seen in the background (centre). An Allied air raid is in progress.' This playful misuse of a Neoclassical image from the 1790s identifies the style of that period with the destructive forces that were unleashed at the time, a union of classicism and modern political aspirations turned into tyranny which Finlay also sees in the Third Reich.

Finlay has often expressed his ideas in the form of maxims; his definitions of Neoclassicism include several referring to the bellicose associations of the style, for example 'The Neoclassical colonnade conceals the door to the armoury.' As far as he was concerned other aspects of Neoclassicism remain as pertinent now as they had originally been. Restraint, which was so crucial to Winckelmann, is neatly reworded as: 'Neoclassicism emulates the classical while at the same time withholding itself.' The importance of morality emerges as: 'Classicism aims at beauty, Neoclassicism at virtue.' Like many of his maxims, this last one is provocative, helping to keep alive the notion of Neoclassicism at the end of the twentieth century.

An abundance of evidence in the late twentieth century shows that Neoclassicism in some form or other is still alive, with new works being created in a style recalling the Neoclassical heyday between 1750 and 1830. It may no longer be the all-embracing style it once was, but paintings, sculptures and buildings, together with many other arts such as ceramics, continue to show an inventive response to Neoclassicism that goes beyond the examples – also numerous – of its straightforward revival or continuous survival.

Glossary

Age of Reason See **Enlightenment**

Baroque A major style in European art in the seventeenth century, lasting in some countries into the early decades of the eighteenth. A highly charged style in both its exaggerated forms and emotional content, the style merged into the much-modified **Rococo**. Its greatest manifestations were in Rome.

Basalt ware A form of black stoneware manufactured in imitation of the hard stone used in antiquity, particularly by the Egyptians (when black, however, was only one of several colours available).

Classical For the Neoclassical period Classical art meant Greek (after 450 BC), Roman, Egyptian and Etruscan art. Virtually nothing was known at first hand about earlier Greek art, and much Greek art was in any case known only through Roman copies.

Corinthian The third of the three main classical orders of architecture, with bell-shaped capitals ornamented with leaves of acanthus, laurel or olive.

Decorum In the context of history paintings it means accurate settings and costumes, and the omission of inappropriate details deemed unworthy of the noble content of the picture.

Doric The earliest of the three classical orders of architecture, massive in style, with simple capitals, with the shafts of Greek columns fluted without a base. The Roman version had a base, and the columns could be either fluted or unfluted.

Egyptian Revival Although there had been several short-lived revivals before the Neoclassical period, the term is usually applied to the strong influence of Egyptian architecture and artefacts sparked off by Napoleon's Nile campaign. This revival lasted c.1800–25.

Enlightenment A philosophical movement originating in the late seventeenth century, and developing throughout Europe during the course of the eighteenth. The outstanding contributors were British, French and German. The Enlightenment questioned authority and traditional values, including religion, and stressed all forms of freedom. It was dominated by reason and empiricism – the only means, it was believed, of attaining knowledge of the universe, and also for improving the state of human progress. The alternative name for the period was the **Age of Reason**.

Etruscan The early part of the Neoclassical period confused ancient Greek vases made on the Italian mainland ('Etruscan') with the actual Etruscan civilization which had been established there from the eighth century BC. The 'Etruscan' style was therefore partly based on Greek vase decorations and not on genuine Etruscan artefacts, about which the Neoclassicists had an inadequate knowledge.

Greek Revival Part of the Neoclassical movement was given this more specific title to distinguish it from the earlier phase of the style that had been predominantly Roman. The Greek element became increasingly pronounced from the 1780s onwards.

History Painting In academic theory this was regarded as the highest and noblest form to which artists should aspire. The subject matter was morally edifying, drawn from history in the widest sense – actual, mythological or literary. By the Neoclassical period, subjects could be classical, religious, medieval or contemporary.

Ideal, Idealization Used in the context of paintings and sculptures that are not direct representations of nature but rather a blend of the 'best' parts of it. The resulting work of art is devoid of nature's imperfections, and is therefore considered to be an improvement on it.

Ionic The second of the three main classical orders of architecture, in which the capitals have volutes and the columns have bases.

Jasperware A form of stoneware, which in its natural state is white. It can be coloured by mixing pigments into the clay, or by applying colouring to the surface. The relief decoration is left uncoloured.

Picturesque (Landscape) Garden A style of garden design which succeeded the taste for formality in the early eighteenth century, and lasted until about 1820. It was developed primarily in Britain, but there are also many examples across the continent. The style was partially influenced by seventeenth-century landscape painting (eg Claude), but above all by a desire to recreate the informality and asymmetry of nature itself.

Rococo A lighter, more delicate and prettier style than its **Baroque** precursor. The Rococo style originated in France about 1700 and spread throughout Europe, most notably to Germany and Austria.

Brief Biographies

Robert Adam (1728–92) British architect and designer, and one of the leading figures of Neoclassicism in Britain. Together with his brothers he built up a large practice, which embraced in both England and Scotland country houses, public buildings, urban developments and the decorative arts. The publication, jointly with his brother James, of *The Works in Architecture* (from 1773 onwards) spread the Adams' influence far and wide. Aspiring for recognition as a scholar, Robert Adam had earlier published his pioneer study of *The Ruins of the Palace of Diocletian at Spalatro* (1764).

John Bacon (1740–99) British sculptor, who also designed for Derby and **Wedgwood** ceramics and **Coade**'s artificial stone. The bulk of his œuvre consisted of monuments, for which he built up a considerable reputation. His first major commission was the Chatham monument for Westminster Abbey (1779). His son John continued the practice and completed some of his father's commissions.

James Barry (1741–1806) Irish painter who spent most of his life in London from 1764. His major commission was the large series of paintings on *The Progress of Human Culture* for the Society of Arts' building by **Adam** in London (1777–83). He was appointed Professor of Painting at the Royal Academy in 1782, but was expelled in 1799 because he failed to carry out his duties, and had bitterly attacked fellow academicians. He devoted himself almost entirely to **history paintings**, only occasionally painting portraits.

Pompeo Batoni (1708–87) Italian painter. His main speciality of portraiture was much favoured by Grand Tourists in Rome, especially those from Britain. He was particularly successful in giving his portraits a setting of classical statuary and ruins. This aspect of his work has overshadowed his church commissions and many mythological paintings. He was curator of the papal collections.

Etienne-Louis Boullée (1728–99) French architect and theorist, one of the leading exponents of the Neoclassical style. His early commissions were mainly private houses, with an innovatory use of classical forms. These gave way increasingly to visionary designs of such grandeur they could not have been realized, either in terms of finance or engineering. The proposed monument to Newton is the most famous of these designs. In 1793 he completed his important theoretical treatise, *Architecture: Essay on the Art.*

Matthew Boulton (1728–1809) British manufacturer in the industrial town of Birmingham, mainly of products in metal, such as ormolu and silver-plate. His products included candlesticks, clock cases, door furniture and jewellery. In partnership with James Watt he helped with the development of the famous steam-engine. Other projects included reproduction oil paintings, which could be incorporated into decorative schemes.

Antonio Canova (1757–1822) Italian sculptor, and to a lesser extent painter, who was one of the most important of all Neoclassical artists. For most of his life from 1781 onwards he worked in Rome, and his large output included church monuments, classical figures and groups, as well as portrait statues and busts. His clients included Napoleon, Catherine the Great and the Pope. After the defeat of Napoleon in 1815, Canova was appointed the Pope's representative to recover the looted works of art taken to Paris. He was created Marchese d'Ischia by the Pope.

William Chambers (1726–96) British architect. Although an important contributor to British Neoclassicism, he was not as influential as his rival **Robert Adam**. Active in the formation of the new Royal Academy in London, of which he was treasurer, he succeeded in excluding Adam. Somerset House in London, begun in 1776 when he was government architect, was one of his outstanding buildings. His *Treatise on Civil Architecture* (1759), an important work on classicism, was widely read. Unlike **Adam**, Chambers enjoyed royal favour. He was the Prince of Wales's architectural tutor, then Architect to the King, and eventually Surveyor General. He was knighted in 1770 .

Charles-Louis Clérisseau (1721–1820) French architect, painter and archaeologist. As a friend in Rome of **Piranesi**, **Winckelmann** and **Robert Adam**, he was in a key position to help spread the Neoclassical style. He accompanied Adam to Split (formerly Spalatro) and drew the plates for his book (unacknowledged in the text). He published a pioneer volume on Roman antiquities in France. His most ambitious project, a new country house for Catherine the Great, was too vast for her taste and was rejected. He collaborated with **Thomas Jefferson** on the design of the Virginia State Capitol (1785–90).

Eleanor Coade (1733–1821) Manufacturer of artificial stone. She set up in business in Lambeth, London, in 1769 and employed the sculptor **John Bacon** senior as her manager

and principal designer. Her products, which included church monuments, garden sculptures, and architectural ornaments, were widely used. Her business was continued by William Croggan until 1833, when he went bankrupt.

Jacques-Louis David (1748–1825) French painter and one of the most important figures in the development of Neoclassicism. He firmly established his reputation with his *Oath of the Horatii* (1784), the best known of the many historical and mythological works he painted throughout his career. He was active during the French Revolution, becoming a Deputy, voting for the King's execution, and organizing many festivals. Napoleon appointed him his official painter, which led to commissions recording contemporary events, particularly his coronation. David was also a fine portraitist. After Napoleon's defeat, David had to leave France, and settled in Brussels.

Dominique-Vivant Denon (1747–1826) Baron, French painter, printmaker and writer. He is best known for his publication, with extensive illustrations, of the archaeological finds in Egypt, where he led the team of scholars accompanying Napoleon's campaign. Napoleon also appointed him director of the newly refurbished Louvre museum in Paris.

Denis Diderot (1713–84) French philosopher and critic. He was the main editor of the monumental *Encyclopedia* (1751–72), which covered all aspects of human knowledge and represents one of the greatest works of the **Age of Reason**. He also wrote reviews of the biennial Salon exhibitions in Paris, from 1759 to 1781. Circulated at the time only in manuscript, they represent the birth of modern art criticism.

John Flaxman (1755–1826) British sculptor, designer and illustrator, and a major exponent of Neoclassicism. His international reputation was based on his illustrations to Homer, Aeschylus, Hesiod and Dante. His early work included many designs for **Wedgwood** as well as sculptures, but the latter supplanted the decorative arts after his return from Italy in 1794, with the exception of some fine metalwork designs in silver and silver-gilt, including pieces for the royal collection. In 1810 he was appointed the Royal Academy's first Professor of Sculpture.

Pierre-François-Léonard Fontaine (1762–1853) French architect and designer. Together with **Charles Percier**, he was the major contributor to the development of French Neoclassicism in the Napoleonic period. Percier and Fontaine were Napoleon's favourite architects, carrying out work at Malmaison, the Tuileries palace and elsewhere, and designing the Arc de Triomphe du Carrousel. Their influence was widespread, greatly helped by their books, especially their *Recueil de décorations* (1801 and 1812).

Henry Fuseli (1741–1825) Swiss painter and writer active in London. He trained as a Zwinglian priest and was ordained in 1761. He settled in London in 1765, where he translated **Winckelmann** and other writers. Sir Joshua Reynolds encouraged him to take up painting, and he spent the years 1770 to 1778 in Italy with this end in view. He produced a prolific series of historical and literary subjects, including book illustrations. He was appointed Professor of Painting at the Royal Academy in 1799. His writings included the first history of Italian art in English, published posthumously.

Ange-Jacques Gabriel (1698–1782) French architect, much patronized by Louis XV, who was himself passionately interested in architecture. Appointed premier architect by the King, Gabriel went on to become director of the Royal Academy of Architecture. His Place de la Concorde in Paris (originally named Place Louis XV) exemplifies his elegant version of Neoclassicism, as do his designs for the Petit Trianon and the opera house at Versailles. He also worked on many of the other royal properties, and designed the École Militaire in Paris.

François-Pascale-Simon Gérard (1770–1837) French painter. His training included a period working under **David**, who left an indelible mark on the younger artist's style. Gérard built up a high contemporary reputation as the most sought-after portraitist in Paris, employing many assistants. A bitter rivalry developed between him and David. Louis XVIII made Gérard a baron.

Felice Giani (1758–1823) Italian painter involved in many decorative schemes, especially at the turn of the century. His classical history and mythological scenes ornamented ceilings in Rome (including the Palazzo Quirinale, now the presidential palace) and in Faenza, an important provincial centre of Neoclassicism.

Johann Wolfgang von Goethe (1749–1832) German writer, scientist and amateur artist, and one of the greatest literary figures of the period. Best known for such works as his novel *The Sorrows of Young Werther* and his poetic drama *Faust*, many of his writings dealt with art and art-related topics, including an essay on **Winckelmann** and a book on colour theory.

Gavin Hamilton (1723–98) British painter, archaeologist and dealer. He spent most of his working life in Rome, settling there in 1766. Although he occasionally painted portraits, his contemporary reputation rested on his classical history paintings. The most important of these were based on Homer, and are among the earliest examples of Neoclassical painting in Europe. He was a leading figure in Neoclassical circles in Rome, a friend of **Winckelmann** and **Mengs**.

Sir William Hamilton (1730–1803) British diplomat, archaeologist, collector and scientist, based in Naples where he was the British envoy. An enthusiastic collector of classical antiquities, especially Greek vases, he published his first collection (1766–7), and subsequently sold it to the recently established British Museum. His second collection was published in 1791–5. Greek vases were enormously influential in forming Neoclassical taste. Hamilton also published observations on volcanoes, most

notably Mount Vesuvius. He was the hub of British social life in the Bay of Naples, and his second wife, Emma, was famous for her 'attitudes' in which she recreated classical and theatrical poses. She was also notorious as a result of her affair with Nelson.

Thomas Hope (1769–1831) British collector, patron, traveller and writer. He was influential in spreading Neoclassical taste through the book he published on his own London house, *Household Furniture and Interior Decoration* (1807). He also published an important book on ancient costume, and a Romantic novel *Anastasius*, which when first published anonymously was attributed to Byron.

Jean-Antoine Houdon (1741–1828) French sculptor, and the most outstanding sculptural portraitist of the period. His marble busts are particularly fine, and include many of the famous people of the day. After Independence, the Americans turned to him to commemorate George Washington, and Houdon visited the States especially to draw him.

Jean-Baptiste Huet (1745–1811) French painter, engraver and designer of wallpapers and textiles. He became **Christophe-Philippe Oberkampf**'s main designer for his printed cottons from 1783 onwards. His early designs were often pastoral and pretty with some concessions to Neoclassicism, but his later designs were uncompromisingly in the austerer Neoclassical manner.

Jean-Auguste-Dominique Ingres (1780–1867) French painter, and the leading Neoclassicist in the generation following **David**, in whose studio he studied. His early reputation was based on his superb ability in portraits. To these he added an extensive range of history paintings, drawn from classical and Renaissance subject matter. These works often received hostile reviews until 1824; in that year Charles X presented him with the Cross of the Legion of Honour, and in 1829 he was appointed a professor at the École des Beaux-Arts in Paris, and president of it in 1833.

Thomas Jefferson (1743–1826) American statesman, third President of the United States, and architect. In the latter role he was self-taught, becoming the most important native-born architect in America in his day. He designed his own house, Monticello, devoting many years to the project from 1768 onwards. He was largely responsible for the design of the Virginia State Capitol. Towards the end of his life he realized his scheme for the campus of the University of Virginia. He also took an active role in the planning of Washington, the new federal capital.

Angelica Kauffmann (1741–1807) Swiss painter. She settled in London in 1766, where she established a good reputation as a portrait painter and was a founder member of the Royal Academy. She turned increasingly to history painting, producing an often charming version of Neoclassicism which lent itself to incorporation in decorative schemes. Through the inter-

mediary of engravings, many of her paintings were adapted for decorating ceramics and other objects. After she married her second husband, the decorative artist Antonio Zucchi in 1781, they settled in Rome.

Leo von Klenze (1784–1864) German architect and painter. He was the most important Neoclassicist in Bavaria, contemporary with Schinkel in Prussia. Klenze set his mark on Munich, developing it into a modern city, under the patronage of Ludwig, Crown Prince and subsequently King of Bavaria, from 1816 until his death. His major buildings include the galleries in Munich for ancient sculpture and for painting (the Glyptothek and Pinakothek), as well as the imposing entrance gate to the city, the Propylaeum. On the outskirts of Regensburg he designed the Walhalla, or Hall of Fame.

Benjamin Henry Latrobe (1764–1820) British-born architect, engineer and painter active in America. After emigrating in 1796, he soon established himself as the leading Neoclassicist in the new United States, and is often described as the founder of the architectural profession there. His major designs include the Roman Catholic Cathedral in Baltimore, the Waterworks in Philadelphia, and work on the Capitol in Washington.

Marc-Antoine Laugier (1713–69) French architectural theorist. A Jesuit abbé, with a good reputation as a preacher, he had at an early age been struck by the artistic principles governing ancient Roman architecture. These were to be developed in his most important work, *Essai sur l'architecture* (1753). He left the Order of Jesus and devoted himself to writing.

Claude-Nicolas Ledoux (1736–1806) French architect, and one of the most famous Neoclassicists of his generation. He was a prolific architect, but unfortunately much of his work was destroyed in the nineteenth century. His most famous work to survive is the royal salt-mine near Besançon, at Arc-et-Senans, which he had hoped to incorporate into an ideal city (Chaux). Clients for his highly individual houses ranged from a wealthy banker's widow to one of the King's mistresses, Madame du Barry. He also designed the toll-houses around Paris, much hated at the Revolution as symbols of tyranny. Imprisoned during the Reign of Terror, he managed to survive, and in 1804, near the end of his life, started to publish his architectural works.

Anton Raphael Mengs (1728–79) German painter and theorist. Mengs settled in Rome in 1752 and was to spend most of his life there, except for two periods in Spain as court painter. He was much influenced by the ideas of **Winckelmann**. Mengs's work embraces frescoes in Italy and Spain, including a famous commission from Cardinal Albani, as well as oil paintings of classical subjects and a fine range of portraits.

John Nash (1752–1835) British architect working in the Neoclassical style but strongly

influenced by the 'picturesque' movement. His most ambitious and successful fusion of the two was in the terraces surrounding Regents Park, London. The character of the centre of London still bears his imprint, from the park down Regent Street to the Mall, and on to Buckingham Palace. He was the Prince Regent's favourite, and official, architect.

Christophe-Philippe Oberkampf (1738–1815) French textile manufacturer of printed furnishings and dress fabrics. Established at Jouy, between Paris and Versailles, from 1758 onwards, he eventually earned the title of *manufacture royale*, and in 1787 he was ennobled. He managed to survive the Revolution by making liberal patriotic donations and incorporating Revolutionary motifs into his textiles. His factory boomed under Napoleon. He always used the latest textile technology imported from England, and was by far the most successful industrialist in France in his day.

Charles Percier (1764–1838) French architect and designer, whose main Neoclassical works were executed jointly with **Pierre-François-Léonard Fontaine**.

Duncan Phyfe (1768–1854) The most famous American cabinet-maker of his day. He emigrated from Scotland in 1783 or 1784, and within ten years successfully established himself as an independent craftsman in New York. He built up a large business selling mostly Neoclassical pieces, reflecting the shift in taste within the style from the early to the late. He died leaving a considerable fortune.

Giovanni Battista Piranesi (1720–78) An Italian of great versatility, best known for his topographical prints, but also an architect, designer, theorist, archaeologist and dealer. His only realized building was the reconstruction of the Priory Church of the Order of Malta in Rome. His enormous output of prints included the 135 plates of the *Vedute di Roma* and the 250 of the *Antichità Romane*. In the realm of fantasy his set of prison interiors, the *Carceri*, have long been popular.

Johann Gottfried Schadow (1764–1850) German sculptor, printmaker and theorist. His main sculptural works were tombs and especially portraits, of which the finest series were the busts he contributed to the Walhalla. His most publicly sited work was the four-horse chariot (quadriga) mounted on top of the Brandenburg Gate in Berlin (1793). In 1816 he was appointed head of the Academy in Berlin.

Karl Friedrich Schinkel (1781–1841) The greatest German architect of the nineteenth century, and also a painter as well as a designer for the stage and the decorative arts. As the government's official architect, he was able to establish Neoclassicism as the dominant style throughout Prussia, and develop Berlin into an imposing, modern city. There he was responsible, among other works, for the main theatre and concert hall (Schauspielhaus), the museum for the display of the royal collection (Altes Museum), and a variety of residences for members of the royal family, not only in Berlin but also elsewhere in Prussia. Neoclassicism, especially in the form of the Greek Revival, dominated his style, but he did occasionally employ the Gothic Revival style. He died through overwork.

John Soane (1753–1837) British architect, and one of the most innovative Neoclassicists of his generation. His major work was the extensive building programme for the Bank of England in London, from 1788 to 1833, much of which has since been rebuilt. A range of domestic work throughout England survives, including his own house of Pitzhanger, Ealing, London (1802), and his later house in Lincoln's Inn Fields in the city itself, which he turned into a museum. Another notable work was the Art Gallery and Museum at Dulwich College, London (1811–14). In 1806 he was appointed Professor of Architecture at the Royal Academy, and was knighted in 1831.

Jacques-Germain Soufflot (1713–80) French architect. His career was dominated from 1755 to 1780 by the design for the new church of Sainte-Geneviève in Paris, dedicated to the city's patron saint. Left unfinished at his death, it was completed by others. During the Revolution it became the Panthéon. Apart from a series of commissions for private houses, his other most notable work was a theatre for Lyon (1753–6).

James Stuart (1713–88) British architect, designer and writer. He was known in his day as 'Athenian' Stuart because together with Nicholas Revett he started to publish the important and influential volumes of *The Antiquities of Athens*, based on their studies in Greece which had been financed by the Society of Dilettanti. Stuart's buildings included some of the earliest Neoclassical works in Europe, the Doric Temple at Hagley Park, Worcestershire (1758), and the interiors of Spencer House, London (1759–65).

Bertel Thorvaldsen (1768–1844) Danish sculptor, who spent most of his working life in Rome. He settled there in 1797, returning home in 1838. He was a major and popular Neoclassicist. So successful was his practice that he maintained an unusually large number of assistants to cope with the demand. His work embraced tombs and monuments (including ones to Schiller and Byron), portraits, classical groups and reliefs, and for his native Copenhagen a series of Christ and the Apostles for the Church of Our Lady. The Thorvaldsen Museum in Copenhagen was built 1839–48 to house a display of his sculptures and his art collection, as well as his tomb.

Joseph Mallord William Turner (1775–1851) British painter and printmaker, and one of the greatest artists of the nineteenth century in Europe. He travelled throughout Britain and parts of the Continent extensively, but not as far as Greece. His subject matter was equally extensive, ranging from imaginary historical landscapes to the modern Industrial Revolution

scene. He responded to Neoclassicism as is evident from some of his works, but he belongs more fully to Romanticism. His knowledge of classical antiquity was important to him, as was the scientific precision he brought to bear in his lectures as Professor of Perspective at the Royal Academy from 1808.

Joseph-Marie Vien (1716–1809) French painter, one of the pioneers of the Neoclassical style. Key early works in the new style include his *Seller of Cupids* (1763). He continued to paint mainly classical subjects throughout his career, occasionally bordering on the erotic. He played an important role in the artistic establishment, being appointed Director of the French Academy in Rome (1776) and First Painter to the King (1789). Napoleon made him a senator and then a count. He was further honoured by being buried in the Panthéon.

Louise-Elizabeth Vigée-Lebrun (1755–1842) French painter who specialized in portraits. She was much patronized by Marie-Antoinette, and for this reason had to escape from France in 1789. Throughout most of the Revolutionary and Napoleonic period, up to 1809, she travelled extensively throughout Europe, going as far as St Petersburg. She was famous for her wit, charm and beauty. These attributes combined with her skill as a portraitist made her most welcome at innumerable courts.

Josiah Wedgwood (1730–95) British potter with an international reputation in his own lifetime. To his partner Thomas Bentley's skills in matters of taste he added his own as a scientist, and between them they built up a flourishing industrial concern that catered for both decorative and utilitarian markets. The firm promoted Neoclassicism in earnest, especially from the mid-1770s, sometimes employing sculptors and painters to produce designs. As a pioneer industrialist, Wedgwood was a sponsor of the newly developing canal system. He was a Fellow of the Royal Society. His liberal views led him to support the American Revolution and the campaign for the abolition of the slave trade.

Benjamin West (1738–1820) American painter active in Britain. He left North America in 1760, and after three years in Italy settled in London in 1763 for the rest of his life. He established himself as a portraitist, but although he continued to work in this genre throughout his career, it was as a history painter that he was best known and on which his contemporary reputation rested. He was much patronized by George III, who appointed West as his historical painter in 1772. He was among the founder members of the new Royal Academy, of which he became president in 1792, after the death of Reynolds. West was not knighted as some biographical entries erroneously state.

Johann Joachim Winckelmann (1717–68) German art historian and theorist. He settled in Rome in 1755, remaining there for the rest of his life. He was employed by the collector Cardinal Albani as his librarian, and in this influential milieu soon established himself as a classical scholar with a considerable reputation.

His writings, widely read, included his essay *Reflections on the Imitation of the Painting and Sculpture of the Greeks* (1755), and the more substantial *History of Ancient Art* (1764), the first chronological analysis to discuss and evaluate changes in style. Some commentators claim that he established the academic discipline of the history of art.

Key Dates

Numbers in square brackets refer to illustrations

Neoclassicism	A Context of Events
1750 Soufflot's second visit to Italy. Chambers in Italy (to 1755)	
	1751 Publication of the *Encyclopédie* edited by Diderot and d'Alembert (completed 1872) [140] Linnaeus publishes *Philosophia Botanica*
1752 Establishment of the Accademia Ercolanese, which will publish the findings at Herculaneum, where excavations had begun in 1738. Comte de Caylus begins publication of his *Recueil d'antiquités Egyptiennes, Etrusques, Grecques, Romaines* (to 1767)	**1752** Franklin invents the lightning-rod
1753 Robert Wood publishes, *Ruins of Palmyra* [29]. Laugier's *Essai sur l'architecture* (second edition in 1755) [43]	**1753** British Museum founded (opens to the public 1759)
1754 Robert Adam on his Grand Tour (to 1758)	**1754** Outbreak of war between Britain and France in Canada
1755 Winckelmann publishes *Reflections on the Painting and Sculpture of the Greeks*, and settles in Rome	**1755** Lisbon earthquake. Samuel Johnson publishes *Dictionary of the English Language*
1756 Piranesi publishes *Antichità romane* [36]	**1756** Seven Years' War breaks out (to 1763). 'Black Hole' of Calcutta. Gessner publishes his *Idylls*
1757 Robert Wood publishes *The Ruins of Balbec*. Comte de Caylus publishes *Tableaux tirés de l'Iliad, de l'Odyssée d'Homère et de l'Eneide de Virgile*. Accademia Ercolanese starts to publish *Antichità di Ercolano* (to 1792), beginning with wall-paintings [21, 84, 189]	**1757** Hume publishes *Natural History of Religion*. Bodmer publishes his edition of the *Nibelungenlied*. Edmund Burke publishes *Origins of our Ideas of the Sublime and the Beautiful*
1758 Le Roy publishes *Les Ruines des plus beaux monuments de la Grèce*. Etienne-Maurice Falconet models his *Cupid* (*L'Amour menaçant*) for Sèvres [129]. Doric Temple, Hagley Park, designed by Stuart	**1758** Helvetius publishes *De l'Esprit* (to be publicly burned in Paris 1759)
1759 Chambers publishes his *Treatise on Civil Architecture*	**1759** General Wolfe killed at the Battle of Quebec. Diderot writes his first *Salon* for private circulation. Voltaire publishes *Candide*
1760 Gavin Hamilton starts painting *Achilles bewailing the Death of Patroclus* (to 1763) [77]. Mengs starts his *Parnassus* ceiling in the Villa Albani (completed 1761) [82] and his painting of *Augustus and Cleopatra* (completed 1761) [81]. Vien publishes his engravings *Suite de vases* [137]. West goes to Italy (to 1763). Oberkampf's factory at Jouy starts production	**1760** James Macpherson publishes *Fragments of Ancient Poetry*. George III succeeds to British throne (to 1820)

Neoclassicism	A Context of Events
1761 Piranesi publishes *Della magnificenza ed' architettura de' Romani*. Gabriel's Petit Trianon, Versailles (completed 1768) [44–5] Robert Adam starts work at Syon House (completed 1769) [58–9] Mengs leaves Rome for Madrid (returns 1769)	**1761** Rousseau publishes *La Nouvelle Héloïse*
1762 Stuart and Revett publish the first volume of *The Antiquities of Athens* (four more volumes up to 1830). Mengs publishes his *Thoughts on Beauty*. Winckelmann publishes *Observations on the Architecture of the Ancients*	**1762** Catherine the Great succeeds to the Russian throne (to 1796). Duke of Bridgewater starts construction of the first canal in Britain: Manchester to Worsley. Rousseau publishes *Emile* and *Du Contrat social*. Macpherson publishes *Fingal*
1763 Vien paints *The Seller of Cupids* [83], and starts *St Denis Preaching the Faith in France* (completed 1767) [95]. Pompeii, serious excavations under way (had begun in 1748)	
1764 Winckelmann publishes his *History of Ancient Art*. Robert Adam publishes *The Ruins of Spalatro*. Houdon in Italy (to 1769). Sainte-Geneviève, Paris, foundation stone laid (designed by Soufflot from 1757, completed 1790) [41–2]. Stuart starts work at Shugborough (completed 1770)	**1764** Beccaria publishes *Of Crimes and Punishments*. J C Bach gives recitals in London, together with Carl Friedrich Abel (to 1781)
1765 Robert Adam starts work at Kedleston about 1765 (completed 1770) [61]. Piranesi remodels Santa Maria del Priorato, Rome [68]. Fragonard paints *Coresus and Callirhoë* [104]	**1765** Britain imposes Stamp Act on American colonies; first signs of revolt. Horace Walpole publishes *The Castle of Otranto*. Turgot publishes *Reflexions sur la formation et la distribution des richesses*. Boucher appointed court painter at Versailles.
1766 Sir William Hamilton's first collection of antiquities published by d'Hancarville (completed 1767). Barry in Italy (to 1771). Gavin Hamilton settles in Rome. Angelica Kauffmann settles in London. Completion of the classical temples in the gardens at Stourhead by Flitcroft (begun 1744)	**1766** Bougainville's first French voyage round the world (to 1769). Lessing publishes his *Laocoön*
1767 Winckelmann publishes *Monumenti antichi inediti* (completed 1768). Robert Adam works at Newby Hall (completed 1785) [37]. James Craig's New Town Plan for Edinburgh. Gluck's opera *Alceste*	**1767** Explusion of Jesuits from France and Spain. Joseph Priestley publishes *History of Electricity*. Herder publishes *Fragments of the New German Literature*. D'Holbach publishes *Le Christianisme dévoilé*. Gluck's opera *Alceste*
1768 Thomas Major publishes *The Ruins of Paestum*. Robert Adam works at Saltram House (to 1769, and 1780) [63], and starts on the Adelphi scheme in London (completed 1772). West paints *Agrippina Landing at Brundisium* [79]. Jefferson starts works on Monticello	**1768** Cook's first voyage (to 1771) Foundation of Royal Academy, London, with Reynolds as president
1769 Society of Dilettanti publishes the first volume of *Chandler's Antiquities of Ionia* (the second in 1797). Wedgwood opens his pottery factory at Etruria. Erdmannsdorff starts work at Schloss Wörlitz (completed 1773). Piranesi publishes *Diverse maniere d'adornare i cammini*. Museo Pio-Clementino, Rome, opened. Greuze paints *Septimius Severus Reproaching Caracalla* [102]	**1769** Madame du Barry becomes mistress of Louis XV (to 1774)

Neoclassicism	A Context of Events
1770 Goya in Italy (to 1771). West paints *Death of General Wolfe* [100]. Versailles opera house by Gabriel opened [46]. Eleanor Coade establishes the artificial stone factory in Lambeth, London. Fuseli in Italy (to 1778)	**1770** Dauphin of France marries Marie-Antoinette, daughter of Empress Maria Theresa of Austria. Edmund Burke publishes *Thoughts on the Causes of the Present Discontents*
1771 Dundas House, Edinburgh, by Chambers (completed 1774) [65]. Goya paints *Sacrifice to Priapus* [105]. Houdon's bust of Diderot in terracotta (marble 1773) [139]	**1771** Bougainville publishes *Voyage autour du monde*. Arkwright's first water-powered spinning mill in England. *Encyclopaedia Britannica* first published. Klopstock publishes his *Odes*
1772 British Museum buys Sir William Hamilton's first vase collection. Alexander Runciman paints the *Ossian* ceiling at Penicuik [176]. Cameron publishes his *Baths of the Romans*	**1772** Cook's second voyage (to 1775)
1773 Gavin Hamilton publishes his volume *Schola italica picturae*. Robert and James start publishing their *Works in Architecture* (completed 1822) [138]	**1773** Coalbrookdale cast-iron bridge constructed. Boston 'Tea Party'. Monboddo publishes *Origin and Progress of Language* (completed 1792)
1774 Work on the garden of the Désert de Retz begins (completed 1789)	**1774** Death of Louis XV of France, and accession of Louis XVI. Goethe publishes *The Sorrows of Werther*. Gluck's opera *Iphigenia in Aulis*. John Wesley publishes *Thoughts on Slavery*. Lavoisier publishes *Opuscules physiques et chimiques*. Priestley discovers oxygen. Ann Lee emigrates to New York with her 'Shakers'
1775 Robert Adam at Osterley (*c.*1775–6) [62]. Wedgwood perfects his jasperware invention, and Flaxman starts to design for him [119]. Construction of Ledoux's salt-works at Arc-et-Senans begins (completed 1779) [50–1, 53].	**1775** American War of Independence breaks out (to 1783). Goethe settles in Weimar. Watt builds his first steam-engine. Sarah Siddons's début at Drury Lane Theatre, London. Herder publishes *Philosophy of History and Culture*. Beaumarchais's *Barber of Seville* performed in Paris after a two-year prohibition (written 1772). Lavater publishes his *Physiognomy*
1776 Museo Vaticano, Rotonda, by Simonetti (completed 1780) [6]. Vien appointed director of French Academy, Rome. David's first visit to Italy (to 1780)	**1776** American Declaration of Independence. Cook's third voyage (to 1780). Edward Gibbon publishes *The Decline and Fall of the Roman Empire* (completed 1788) Adam Smith publishes *The Wealth of Nations*
1777 Barry starts series of paintings on *Human Culture* [99] for the Society of Arts, London (completed 1784)	**1777** John Howard publishes *The State of the Prisons of England and Wales*. Gluck's opera *Armide*
1778 Piranesi's engravings of Paestum published. Ledoux starts the Hôtel de Thélusson, Paris (completed 1781). Flaxman's Wedgwood design *The Apotheosis of Homer* as a plaque (as a vase 1786 [121]). Rousseau's tomb at Ermenonville completes Girardin's landscaping begun 1764 [107]	**1778** France and the American colonists sign alliance and treaty. Britain declares war on France. Mesmer practises 'mesmerism' in Paris. Sheridan's play *School for Scandal*

Neoclassicism	A Context of Events
1779 Hirschfeld publishes *Theory of Garden Art* (completed 1785). Sèvres dinner service for Catherine the Great [127]. Cameron starts working at Tsarskoye Selo [71]. Soane in Italy (to 1780)	**1779** Samuel Crompton invents the spinning mule. First steam-mills in action in England. Lessing's play *Nathan the Wise*. David Hume publishes *Dialogues of Natural Religion*
1780 Fuseli paints *The Oath of the Rütli* [93]. Jacob More paints *Mount Vesuvius in Eruption: The Last Days of Pompeii* [20]	**1780** Paisiello's opera *Barber of Seville*. Wieland's heroic poem *Oberon*
1781 Canova settles in Rome. David paints *St Roch Interceding with the Virgin* [97]. Angelica Kauffmann settles in Rome. St Non publishes *Voyage pittoresque ou description des royaumes de Naples et de Sicile* (completed 1786)	**1781** Herschel discovers the planet Uranus. Kant publishes *Critique of Pure Reason*. Rousseau publishes his *Confessions*. Mozart's opera *Idomeneo*
1782 G B and E Q Visconti publish their *Museo Pio-Clementino descritto* (completed 1807). Choiseul-Gouffier publishes his *Voyage pittoresque de la Grèce* (completed 1822). West's first work on windows for St George's Chapel (resumed 1796) [98]	**1782** Herder publishes T*he Spirit of Hebrew Poetry* (completed 1783). Mozart's opera *Il Seraglio* Laclos publishes *Les Liaisons dangereuses*
1783 Ledoux starts to design toll-houses and guard-posts (*barrières*) for the Paris city wall. David paints *Andromache Bewailing the Death of Hector* [89]. Oberkampf is awarded the royal licence and employs Huet	**1783** Treaty of Versailles between France and Britain, both recognizing American Independence. Montgolfier brothers make first manned balloon ascent. Start of the British campaign for the abolition of the slave trade, with Quakers petitioning Parliament
1784 David starts *Oath of the Horatii* [86, 88]. Boullée's project for Newton monument [55–6]	**1784** Kant publishes *What is Enlightenment?* Beaumarchais's play *The Marriage of Figaro*. Herder publishes *Ideas towards a Philosophy of History* (completed 1791)
1785 Schadow in Italy (to 1797) Blake's painting of *Oberon, Titania and Puck with Fairies Dancing* [106]	**1785** Affair of the Queen's Necklace: Marie-Antoinette's reputation undermined. First Channel crossing by balloon
1786 Percier in Rome (to 1792) and also Fontaine (to 1790). Richard Payne Knight publishes *An Account of the Remains of the Worship of Priapus*. West starts his medieval history paintings for the Audience Chamber, Windsor Castle (completed 1789)	**1786** Anglo-French Commercial Treaty. Coal gas first used to make light. Botanic Gardens, Calcutta, established. Goethe visits Italy (to 1788) Mozart's opera *The Marriage of Figaro*. Herschel publishes his *Catalogue of Nebulae*. William Beckford publishes his story *Vathek*. Robert Burns publishes *Poems Chiefly in the Scottish Dialect*
1787 Canova starts on *Cupid and Psyche* [182]. David paints *The Death of Socrates* [90]. Valenciennes paints *The Ancient City of Agrigentum: Ideal Landscape* [115]. Flaxman in Italy (to 1794)	**1787** Mozart's opera *Don Giovanni*. Goethe's play *Iphigenia in Tauris*. Schiller's play *Don Carlos*. John Wesley publishes his *Sermons*. First ascent of Mont Blanc by Horace Saussure
1788 Barthélémy publishes *Les Voyages du jeune Anacharsis en Grèce*. Houdon's statue of George Washington for State Capitol, Richmond (modelled 1785) [73]. Sèvres factory makes Rambouillet dairy service for Marie Antoinette [130]	**1788** Britain starts to colonize Australia, first settlement in New South Wales. First steam-boat built. Goethe's play *Egmont*. Mozart's last three Symphonies, nos 39-41. Haydn's 'Oxford' Symphony. Linnean Society founded in London

Neoclassicism	A Context of Events
1789 David paints *The Lictors Returning to Brutus the Bodies of his Sons* [91–2]	**1789** Sack of the Bastille and start of the French Revolution. George Washington inaugurated as the first President of the United States of America. Mozart's opera *Così fan tutte*. Buffon concludes his *Histoire naturelle* (started 1749). Bernardin de Saint Pierre's novel *Paul et Virginie*. Lavoisier publishes his *Traité élémentaire de chimie*. Gilbert White publishes *The Natural History of Selborne*. William Blake publishes *Songs of Innocence*
	1790 French religious houses suppressed. Edmund Burke's *Reflections on the Revolution in France*. Robert Burns's poem *Tam O'Shanter*
1791 Sainte Geneviève, Paris, renamed the Panthéon. Sir William Hamilton's second collection published (completed 1795) [172]. Charlotte Square, Edinburgh, designed by Robert Adam (constructed 1792 onwards) [66]. Thomas Sheraton publishes his *Drawing-Book* (completed 1794)	**1791** Thomas Paine publishes *The Rights of Man*. Mozart's opera *The Magic Flute*. Haydn's twelve 'London' Symphonies (to 1795). Jeremy Bentham's new prison, the 'panopticon'
1792 White House, Washington, begun (James Hoban, Benjamin Latrobe and others) [76]. Soane's Bank Stock Office, Bank of England (completed 1794) [180]	**1792** France declares war on Austria and Prussia. France declared a Republic. Reign of Terror in France (to 1793). Rouget de Lisle composes *La Marseillaise* (chant de guerre). Mary Wollstonecraft publishes *Vindication of the Rights of Women*
1793 Flaxman's illustrations to the *Iliad* and *Odyssey* published [169–70], and his *Dante* illustrations first issued privately [174]. David's *Death of Marat* [141]. Bacon's Cornwallis monument [202]	**1793** Execution of Louis XVI and Marie-Antoinette. Marat assassinated by Charlotte Corday. End of the Terror and fall of Robespierre
1794 Rehberg's illustrations of Emma Hamilton's 'attitudes' [188]	
1795 Flaxman's illustrations to *Aeschylus* published [171]	**1795** Goethe publishes *Wilhelm Meister*
1796 Flaxman's monument to Sir William Jones [203]. Latrobe emigrates to USA	**1796** Napoleon Bonaparte's successful military campaign in Italy as commander of the French army. Jenner makes the first vaccine against smallpox
1797 Thorvaldsen settles in Rome (to 1838). First French industrial exhibition	
1798 Government House, Calcutta, begun (completed 1803) [201]	**1798** Haydn's oratorio *The Creation*. Wordsworth and Coleridge publish *Lyrical Ballads*
1799 Flaxman's proposal for a colossal Britannia on Greenwich Hill [163]. Bank of Pennsylvania, Philadelphia, by Latrobe (completed 1801) [207]	**1799** Napoleon invades Syria and Egypt, defeating the Turks at Aboukir. Consulate established with Napoleon as First Consul, effectively the ruler of France, for ten years
1800 David's portrait of *Madame Récamier*	**1800** Napoleon moves into the Tuileries palace in Paris. Napoleon's army crosses the St Bernard Pass into Italy, and occupies Milan. Establishment of the Cisalpine Republic. Beethoven's First Symphony

Neoclassicism	A Context of Events
1801 Percier and Fontaine publish *Recueil de décorations* (second edition 1812) [216]. Gérard paints *Ossian Evoking the Spirits on the Edge of the Lora* [177]	**1801** French evacuate Egypt. Thomas Jefferson becomes President of the United States (to 1809). Jacquard exhibits his revolutionary new loom in Paris. Chateaubriand's novel *Atala*
1802 Denon publishes *Voyages dans la Basse et la Haute Egypte* [191]	**1802** Peace of Amiens between France and Britain. Many people travel on the Continent for the first time, and see the Napoleonic artistic plunder in the Louvre. Plebiscite votes Napoleon Consul for life
1803 Canova's *Napoleon as Mars* (completed 1806) [150]. Schinkel's first visit to Italy (completed 1804)	**1803** Renewal of war between France and Britain. France sells Louisiana to the United States
1804 Ingres paints *Napoleon I on the Imperial Throne* (completed 1806) [148]. Ledoux publishes his *L'Architecture*. Henry Auguste makes the silver-gilt Coronation Service for Napoleon [155]. Canova starts *Paolina Borghese as Venus Victrix* (completed 1808) [187]. Panoramic wallpapers introduced by Zuber and Dufour [217]	**1804** Napoleon proclaimed Emperor, and King of Italy. France's First Empire (to 1814). Beethoven's 'Eroica' Symphony (no.3)
1805 David paints *the Coronation of the Emperor and Empress* [154]. Baltimore Cathedral by Latrobe (completed 1818) [208]. Gérard paints *Portrait of Madame Récamier* [185]. British Museum buys part of Charles Townley's classical collection (more in 1814)	**1805** Battle of Trafalgar, Nelson killed. Battle of Austerlitz, Napoleon defeats Prussia and Russia. Sir Walter Scott's novel, *Lay of the Last Minstrel*
1806 Canova starts tomb to Alfieri (completed 1810) [165], and works on a proposal for a tomb to Nelson. Ingres goes to Italy (to 1824), taking up Prix de Rome won in 1801. Sèvres *Table des Grands Capitaines* (completed 1812) [156]	**1806** Battle of Jena, Napoleon again defeats Prussia and Russia
1807 Flaxman's monument to Nelson (completed 1818) [160]. Elgin starts to display the Parthenon Marbles at his London house. Thomas Hope publishes *Household Furniture and Interior Decoration* [231]. William Gell publishes *The Geography and Antiquities of Ithaca*. William Wilkins publishes *The Antiquities of Magna Graecia*, and starts Downing College, Cambridge (completed 1820). Schadow starts a series of busts (completed 1815) intended for the Walhalla (installed 1842) [168]	**1807** Madame de Stael's novel *Corinne*. Foscolo's poems *I Sepolcri*
1808 Vigée-Lebrun paints *Portrait of Madame de Staël as Corinne* [186]	**1808** France invades Spain, start of Peninsular War (to 1814). Goethe's play *Faust*, part 1. Beethoven's Fifth Symphony
1809 Thomas Hope publishes *Costume of the Ancients*. Latrobe works on the Capitol, Washington [206]	**1809** Napoleon divorces Josephine. Ackermann starts his periodical *The Repository of Arts, Literature, Commerce* (to 1828)

	Neoclassicism	A Context of Events
		1810 Napoleon marries Marie-Louise, daughter of Emperor Francis I of Austria. Sir Walter Scott's poem *The Lady of the Lake*. Goya starts engraving *The Disasters of War*
1811	Ingres paints *Jupiter and Thetis* [179]	**1811** King of Rome, Napoleon's heir, born. Prince of Wales appointed Regent as George III stricken with porphyria. Byron writes the poem *The Curse of Minerva* (published 1815). Jane Austen's novel *Sense and Sensibility*
1812	Ludwig of Bavaria buys the Aegina Marbles. Nash starts to remodel central London	**1812** French army's disastrous Russian campaign. Tide subsequently starts to turn against French military domination of Europe. United States declares war on Britain. Byron's poem *Childe Harold's Pilgrimage*, Cantos 1 and 2
1813	Canova works on the first version of the *Three Graces* (completed 1814). Ingres paints *The Dream of Ossian*	**1813** Battle of Leipzig, Napoleon defeated. Jane Austen's novel *Pride and Prejudice*. Frederick Accum's *Practical Treatise on Gas-Light*. Schubert's First Symphony
1814	British Museum acquires the Phigaleian Marbles	**1814** French forces defeated, Napoleon abdicates, exiled on Isle of Elba. Congress of Vienna (to 1815). Beethoven's opera *Fidelio*. Sir Walter Scott's novel *Waverley*. George Stephenson builds steam locomotive. First street lighting in London by gas
1815	Schinkel's scenery for *The Magic Flute* [190]	**1815** Napoleon escapes from Elba, rallies forces in France, his 'Hundred Days'. Battle of Waterloo, final defeat of Napoleon. Exiled to St Helena. Louis XVIII King of France again (briefly in 1814)
1816	British government purchases the Elgin Marbles. Klenze starts the Glyptothek, Munich (completed 1830) [193]. Turner's pair of canvases of *The Temple of Jupiter Panellenius* [116]. Henrietta Villa, Point Piper, Sydney (completed 1820) [204]	**1816** Rossini's opera *The Barber of Seville*. Coleridge's poem *Kubla Khan* published (written 1797)
1817	Flaxman publishes illustrations to *Hesiod*. Schinkel's New Guard House, Berlin (completed 1818) [192]. Jefferson's University of Virginia (completed 1826). Vatican classical sculpture galleries extended, Braccio Novo (completed 1821)	**1817** Rossini's opera *La Gazza Ladra*. Byron's poem *Manfred*
		1818 First steamship, *Savannah*, crosses Atlantic, in 26 days. Prado Museum, Madrid, founded. Byron's poem *Don Juan* (completed 1823) Keats's poem *Endymion*. Mary Wollstonecraft Shelley's novel *Frankenstein*
1819	Thomas Hope's novel *Anastasius*. Schinkel's Schauspielhaus, Berlin (completed 1821)	**1819** Menai Suspension Bridge by Thomas Telford (completed 1821). 'Peterloo' Massacre, Manchester. Géricault's painting *The Raft of the Medusa*. Turner's first visit to Italy. Victor Hugo's *Odes*. Schopenhauer's *World as Will and Idea*

Neoclassicism	A Context of Events
1820 *Venus de Milo* discovered and acquired by the French	**1820** George III dies, and is succeeded by the Prince Regent as George IV. Keats's poem *The Eve of St Agnes*. Shelley's poem *Prometheus Unbound*. Lamartine's *Méditations poétiques*
1821 Start of publication of *Examples for Manufacturers and Craftsmen* by Schinkel and others. Klenze's design for the Walhalla approved by Ludwig of Bavaria [166–7]	**1821** Beginning of the Greek War of Independence. Weber's opera *Der Freischütz*. Thomas de Quincey's *Confessions of an English Opium Eater*. Heine's *Poems*
	1822 Massacre at Chios (Greek War of Independence). Beethoven's *Missa Solemnis*. Schubert's 'Unfinished' Symphony, no.8. Alfred de Vigny's *Poèmes*. Pushkin's *Eugene Onegin* (completed 1832)
1823 Start of new building for British Museum by Smirke (completed 1847) [195]. Schinkel's Altes Museum, Berlin (completed 1826) [194]. Klenze visits Italy	
1824 Schinkel's second visit to Italy [199]	**1824** Death of Byron in Greece at Missolonghi. Delacroix's painting *The Massacre of Chios*. Charles X succeeds as King of France. National Gallery, London, established with donation of the Angerstein Collection. Beethoven's 'Choral' Symphony, no.9. Leopardi's *Canzoni e Versi*
	1825 Ludwig I becomes King of Bavaria (to 1848). Stockton–Darlington Railway opened, the first steam locomotive railway. Pushkin's *Boris Godunov*. Manzoni's novel *I Promessi Sposi* (completed 1827)
1826 Nash's Cumberland Terrace, Regents Park (completed 1827) [196–7]	**1826** Invention of photography: Niépce fixes camera's image. Mendelssohn's incidental music for *A Midsummer Night's Dream*. Fenimore Cooper's novel *The Last of the Mohicans*. Weber's opera *Oberon*
1827 Ingres paints *Apotheosis of Homer* [178]	**1827** John Clare's poems *Shepherd's Calendar*. Heine's *Das Buch der Lieder*. Schubert's *Die Winterreise*
	1829 Balzac starts his novels of *La Comédie humaine* (completed 1848). Rossini's opera *William Tell*. Victor Hugo's *Les Orientales*
1831 Camden Park, New South Wales, by John Verge (completed 1835) [205]	**1830** Thonet begins experimenting with bentwood furniture. Sewing machine invented by Thimonier. Greek independence formally recognized. Uprising in Paris, Charles X abdicates. George IV dies and is succeeded by William IV. Stendhal's novel *Le Rouge et le Noir*. Charles Lyell's *Principles of Geology* (completed 1833). Tennyson's *Poems Chiefly Lyrical*. Berlioz's *Symphonie Fantastique*. Audubon's *Birds of America*

GREENLAND

ALASKA

CANADA

Missouri

Chicago ● ● Philadelphia
Baltimore ● ●● New York
● Washington
Richmond

UNITED STATES OF
AMERICA

Malibu ●

Mississippi

MEXICO

Atlantic Ocean

Amazon

BRAZIL

PERU

Pacific Ocean

ARGENTINA

L

0 1000 2000 3000 miles

0 1000 2000 3000 kilometres

INLAND

St Petersburg
Tsarskoye Selo

RUSSIA

MONGOLIA

Athens

IRAN

Yellow River

CHINA

Ganges

Yangtze

Nile

SAUDI ARABIA

INDIA Calcutta

JAPAN

Kobe

Pacific Ocean

MALAYSIA

INDONESIA

PAPUA
NEW
GUINEA

Indian Ocean

AUSTRALIA

Sydney

AFRICA

NEW
ZEALAND

ANTARCTICA

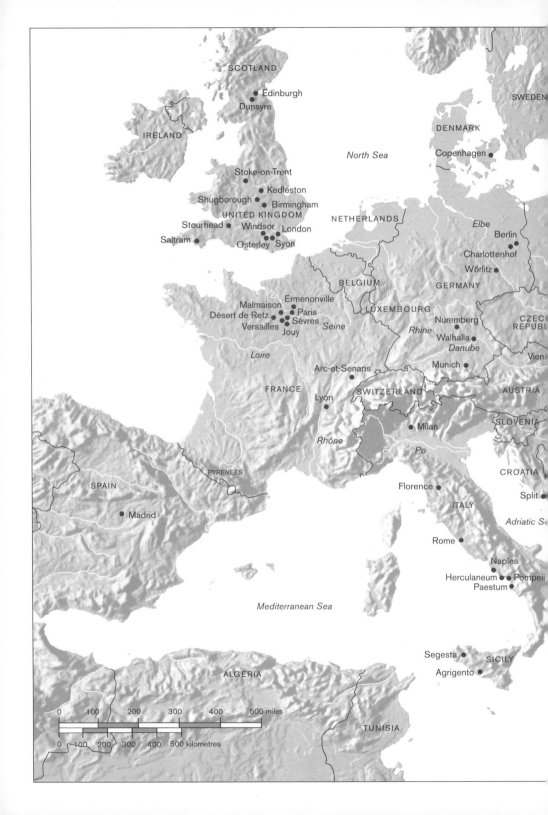

SCOTLAND

• Edinburgh
Dunsyre •

IRELAND

SWEDEN

DENMARK
Copenhagen •

North Sea

• Stoke-on-Trent
• Kedleston
Shugborough • • Birmingham
UNITED KINGDOM
Stourhead • Windsor
• London
Saltram • Osterley • Syon

NETHERLANDS

Elbe
Berlin •
Charlottenhof •
Wörlitz •

BELGIUM

GERMANY

LUXEMBOURG

Ermenonville •
Malmaison • • Paris
Désert de Retz • • Sèvres
Versailles • Jouy
Seine

Rhine

Nuremberg •

Walhalla •
Danube

CZECI
REPUBLI

Vien

Loire

FRANCE

Arc-et-Senans •

Lyon •

SWITZERLAND

Munich •

AUSTRIA

SLOVENIA

Rhône

Po

• Milan

PYRENEES

SPAIN

• Madrid

Florence •

CROATIA

Split •

ITALY

Adriatic S

Rome •

Naples •
Herculaneum • • Pompeii
Paestum •

Mediterranean Sea

Segesta •
SICILY
Agrigento •

ALGERIA

0 100 200 300 400 500 miles

0 100 200 300 400 500 kilometres

TUNISIA

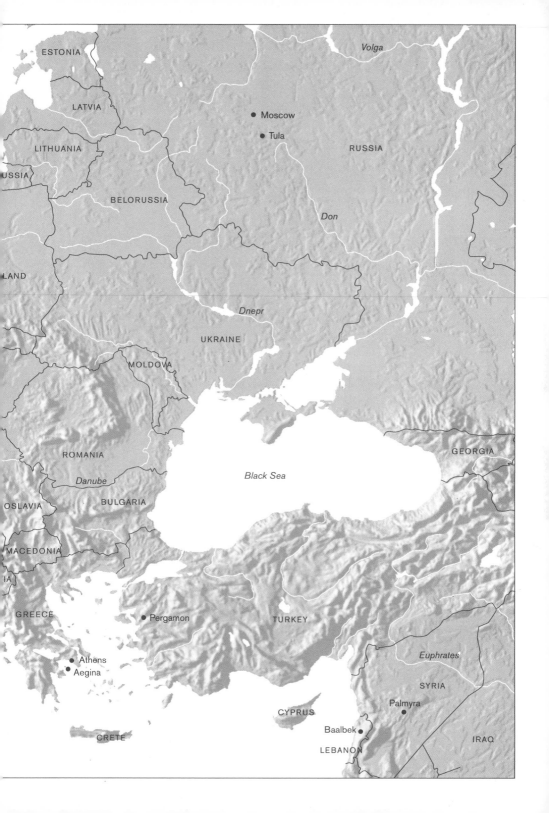

ESTONIA

Volga

LATVIA

● Moscow

LITHUANIA

● Tula

RUSSIA

USSIA

BELORUSSIA

Don

LAND

Dnepr

UKRAINE

MOLDOVA

ROMANIA

GEORGIA

Danube

Black Sea

OSLAVIA

BULGARIA

MACEDONIA

IA

GREECE

● Pergamon

TURKEY

Euphrates

● Athens

SYRIA

● Aegina

● Palmyra

CYPRUS

Baalbek ●

CRETE

IRAQ

LEBANON

General Works

Listed under this heading are general cultural histories as well as more specifically art historical studies, with the two categories often overlapping. For the whole of Neoclassicism the reader could well start with Rosenblum, Honour and the 1972 Council of Europe exhibition catalogue, plus, for background, Hampson on The Enlightenment. Thornton is excellent for an overview of domestic living.

Albert Boime, *Art in the Age of Revolution 1750–1800* (Chicago and London, 1987)

Allan Braham, *The Architecture of the French Enlightenment* (London, 1980)

Josette Brédif, *Classic Printed Textiles from France 1760–1843: Toiles de Jouy* (London, 1989)

W H Bruford, *Culture and Society in Classical Weimar, 1775–1806* (Cambridge, 1962)

Anthony Burgess and Francis Haskell, *The Age of the Grand Tour* (London, 1967)

E M Butler, *The Tyranny of Greece over Germany* (Cambridge, 1935)

Council of Europe, *The Age of Neoclassicism* (exh. cat., Royal Academy and Victoria and Albert Museum, London, 1972)

—, *La Révolution française et l'Europe 1789–1799* (exh. cat., Grand Palais, Paris, 1989)

J Mordaunt Crook, *The Greek Revival: Neoclassical Attitudes in British Architecture, 1760–1870* (London, 1972)

Thomas E Crow, *Painters and Public Life in Eighteenth-Century Paris* (New Haven and London, 1985)

Svend Eriksen, *Early Neoclassicism in France* (London, 1974)

Svend Eriksen and Geoffrey de Bellaigue, *Sèvres Porcelain: Sèvres and Vincennes 1740–1800* (London, 1987)

Robert Fermor-Hesketh, *Architecture of the British Empire* (London, 1986)

Walter Friedlander, *David to Delacroix* (Cambridge, MA, 1952)

Peter Gay, *The Enlightenment*, 2 vols (New York and London, 1966–70)

Talbot F Hamilton, *Greek Revival Architecture in America* (New York, 1944)

Norman Hampson, *The Enlightenment* (Harmondsworth, 1968)

Francis Haskell and Nicholas Penny, *Taste and the Antique: The Lure of Classical Sculpture 1500–1900* (New Haven and London, 1981)

Henry Hawley, *Neoclassicism: Style and Motif* (exh. cat., Cleveland Museum of Art, Ohio, 1964)

Hugh Honour, *Neo-classicism* (Harmondsworth, 1968)

David Irwin, *English Neoclassical Art: Studies in Inspiration and Taste* (London, 1966)

Kalnein Wend, *Architecture in France in the 18th Century* (New Haven and London, 1995)

Michael Levey, *Painting and Sculpture in France in the 18th Century, 1700–1789* (New Haven and London, 1993)

Andrew McClellan, *Inventing the Louvre* (Cambridge, 1994)

Carroll L V Meeks, *Italian Architecture, 1750–1914* (New Haven, 1966)

Robin Middleton and David Watkin, *Neoclassical and Nineteenth Century Architecture* (New York, 1980)

Charles F Montgomery, *American Furniture, the Federal Period* (New York, 1966)

Pierre Rosenberg et al., *De David à Delacroix*, trans. as *French Painting 1774–1830: the Age of Revolution* (exh. cat., Grand Palais, Paris; Detroit Institute of Arts; and Metropolitan Museum of Art, New York, 1974–5)

Robert Rosenblum, *Transformations in Late Eighteenth-Century Art* (Princeton, 1967)

Terence Spencer, *Fair Greece Sad Relic* (London, 1954)

Damie Stillman, *English Neoclassical Architecture* (London, 1988)

John Summerson, *Architecture in Britain 1530–1830* (Harmondsworth, 1953)

Peter Thornton, *Authentic Decor: The Domestic Interior 1620–1920* (London, 1984)

Ellis K Waterhouse, *Painting in Britain 1530 to 1790* (Harmondsworth, 1953)

David Watkin and Tilman Mellinghoff, *German Architecture and the Classical Ideal 1740–1840* (London, 1987)

Margaret Whinney, *Sculpture in Britain 1530–1830* (Harmondsworth, 1964)

Dora Wiebenson, *Sources of Greek Revival Architecture* (London, 1969)

Andrew Wilton (ed.), *Grand Tour* (exh. cat., Tate Gallery, London, 1996)

A J Youngson, *The Making of Classical Edinburgh* (Edinburgh, 1966)

Monographs and Contemporary Writings

Items marked with an asterisk * are either original texts, complete anthologies of contemporary writings or at least contain substantial passages. The best introductory anthology is Eitner. For a vivid account of an artist abroad try Fleming. The liveliest of memoirs is Goethe's.

William Howard Adams (ed.), *The Eye of Thomas Jefferson* (exh. cat., National Gallery of Art, Washington, DC, 1976)

Anita Brookner, *Jacques-Louis David* (London, 1980)

—, 'Diderot', in *The Genius of the Future* (London, 1971), pp. 7–29

—, *Greuze. The Rise and Fall of an Eighteenth-Century Phenomenom* (London, 1972)

Anthony M Clark, *Pompeo Batoni: Complete Catalogue* (Oxford, 1985)

Denis Diderot, *Diderot on Art*, trans. and ed. John Goddman (London, 1995)*

David Lloyd Dowd, *Pageant-Master of the Republic: Jacques-Louis David* (New York, 1948)

Lorenz Eitner, *Neoclassicism and Romanticism 1750–1850*, 2 vols (Englewood Cliffs, NJ, 1970)*

Helmut von Erffa and Allen Staley, *The Paintings of Benjamin West* (New Haven and London, 1986)

John Fleming, *Robert Adam and his Circle* (London, 1962)

Brian Fothergill, *Sir William Hamilton: Envoy Extraordinary* (London, 1969)

Johann Wolfgang von Goethe, *Italian Journey*, trans. by W H Auden and Elizabeth Mayer (London, 1962) *

Nicholas Goodison, *Ormolu: The Work of Matthew Boulton* (London, 1974)

John Harris, *Sir William Chambers* (London, 1970)

Robert L Herbert, *David, Voltaire, Brutus and the French Revolution* (London, 1972)

Wolfgang Herrmann, *Laugier and Eighteenth Century French Theory* (London, 1962)*

Thomas Hope, *Household Furniture and Interior Decoration* (London 1807, repr. London 1970) *

Gérard Hubert et al., *Napoléon* (exh. cat., Grand Palais, Paris, 1969)

David Irwin, *John Flaxman: Sculptor, Illustrator, Designer* (London and New York, 1979)

David Irwin (ed.), *Winckelmann: Writings on Art* (London, 1972) *

Alison Kelly, *Mrs Coade's Stone* (Upton-upon-Severn, 1990)

David King, *Complete Works of Robert and James Adam* (Oxford, 1991)

Fred Licht and David Finn, *Canova* (New York, 1983)

Thomas J McCormick, *Charles-Louis Clérisseau and the Genesis of Neoclassicism* (Cambridge, MA, and London, 1990)

H B Nisbet (ed.), *German Aesthetic and Literary Criticism* (Cambridge, 1985) *

Thomas Pelzel, *Anton Raphael Mengs and Neoclassicism* (New York, 1979)

Charles Percier and Pierre F L Fontaine, *Recueil de décorations intérieurs* (Paris, 1812, repr. Farnborough 1971) *

Giovanni Battista Piranesi, *The Polemical Works*, ed. John Wilton-Ely (Farnborough, 1972) *

Alex Potts, *Flesh and the Ideal: Winckelmann and the Origins of Art History* (New Haven and London, 1994)

Helen Rosenau, *Boullée and Visionary Architecture* (London and New York, 1976) *

Robert Rosenblum, *Jean-Auguste-Dominique Ingres* (London, 1967)

Wendy Wassyng Roworth, *Angelica Kauffmann: A Continental Artist in Georgian England* (London, 1992)

Antoine Schnapper et al., *Jacques-Louis David* (exh. cat., Grand Palais, Paris, 1989)

Michael Snodin (ed.), *Karl Friedrich Schinkel: A Universal Man* (exh. cat., Victoria and Albert Museum, London, 1991)

Dorothy Stroud, *Sir John Soane, Architect* (London, 1984)

John Summerson, *The Life and Work of John Nash* (London, 1980)

Anthony Vidler, *Charles-Nicholas Ledoux:*

Architecture and Social Reform at the End of the Ancien Regime (Cambridge, MA, and London, 1990)

Elizabeth-Louise Vigée-Lebrun, *Memoirs*, trans. by Sian Evans (London, 1989) *

David Watkin, *Thomas Hope and the Neoclassical Idea* (London, 1968)

Timothy Webb (ed.), *English Romantic Hellenism 1700–1824* (Manchester, 1982) *

John Wilton-Ely, *The Mind and Art of Giovanni Battista Piranesi* (London, 1978) *

Hilary Young (ed.), *The Genius of Wedgwood* (exh. cat., Victoria and Albert Museum, London, 1995)

Index

Numbers in **bold** refer to illustrations

Photographic Credits

Aberdeen University Library: 13, 21, 28, 29, 142, 172, 189, 191, 227; AKG, London: 31, 32, 166; Archivi Départementales du Nord, Lille: 145; Archivi Alinari, Florence: 3, 11, 14, 82; Argyll Estates, Inverary Castle: 30; Arxiu Mas, Barcelona: 105; Ashmolean Museum, Oxford: 78; The Lord Barnard: photo Courtauld Institute of Art: 235; Basilica of the Assumption Historic Trust, Baltimore: 208; Bibliothèque Municipale de Besançon/Charles Choffet: 46; Bibliothèque Nationale de France, Paris: 55, 56, 142, 146, 229; Bildarchiv der Staatlichen Schlösser und Gärten Wörlitz Oranienbaum/Peter Kühn, Dessau 1980: 72; Bildarchiv Preussischer Kulturbesitz, Berlin: 190, 194, 199, 218; Birmingham City Archives: 124; Birmingham Museums and Art Gallery: 109, 126; Blair Castle, Pitlochry: 19; Clive Boursnell/Country Life: 242; Bridgeman Art Library, London: 57, 80, 83, 106, 186, 222, 241; Bridgeman Art Library/Giraudon: 86, 98, 134, 144; British Museum, London: 22, 23, 24, 25, 36, 38, 110, 121, 184, 188; Centre Nationale des Arts Plastiques, Paris: 213; City of Nottingham Museums: 120; Collection of Sir John Clerk of Penicuik: 176; © Cleveland Museum of Art 1996, gift of the John Huntington Art and Polytechnic Trust (1919.1018): 101; Corbis UK: photo Paul Almasy 192, photo Robert Holmes 238, photo Adam Woolfitt 44, 45, 76; Courtauld Institute of Art, London: 151, 168; Crown Copyright: Royal Commission on the Ancient and Historical Monuments of Scotland: 164; photo © 1992 The Detroit Institute of Arts, Founders Society Purchase with funds from Mr and Mrs Edgar B Whitcomb: 4; Edifice, London: 65; English Heritage Photographic Library, London: 209, 210; Erith and Terry Architects/Francis Terry, Colchester: 239; Faringdon Collection Trust, Buscot Park: 231; Richard L Feigen: 116; Dr Ian Hamilton Finlay: 243; Fitzwilliam Museum, Cambridge: 70, 183; Glyptothek, Munich/Blow Up: 243; Hamburger Kunsthalle/Elke Walford: 177; © Fogg Art Museum, Harvard University Art Museums. Grenville L Winthrop Bequest: 173; The Hermitage, St Petersburg: 71; Angelo Hornak, London: 195; Hulton Getty Picture Collection, London: 237; Image Library, State Library of New South Wales: 204; India Office Library, London: 200, 201, 202; Institute Claude-Nicholas Ledoux/photo D Chandon: 50, 51, 53; Interior Archive, London: photo Christopher Simon Sykes 58, photo Fritz von der Schulenburg 215, 229; Professor David Irwin: 114, 169, photo Mike Craig 34; A F Kersting, London: 42, 59, 66, 160, 203; KPM–Archiv im Schlosse Charlottenburg (Land Berlin), Berlin: 198; Kunstbibliothek, Berlin: 137; © 1996 copyright by Kunsthaus Zurich. All rights reserved. Deposited by the Canton of Zurich: 93; Leeds Museums and Galleries, Lotherton Hall: 226; Library of Virginia, Richmond: 123; MAK–Österreichisches Museum für angewandte Kunst:

133, 223, 224; Mary Evans Picture Library, London: 140, 153, 197; Maryland Historical Society, Baltimore: 74; Massachusetts Historical Society, Boston: 75; Metropolitan Museum of Art, New York: acquired through the Lillie P Bliss Bequest 240, Catherine Lorillard Wolfe Collection, Wolfe Fund (1931) 90; Harris Brisbane Dick Fund (1948) 12; gift of Mr and Mrs Charles Wrightsman (1970) 129; Mountain High Maps © 1995 Digital Wisdom Inc: pp.432–5; Musée des Beaux-Arts, Lille: 88; Musée des Beaux-Arts de Belgique, Brussels: 141; Musée de la Chartreuse, Douai: 15; Musée de Valence: 9; Museo de Arte de Ponce, the Luis A Ferré Foundation, Inc: 98; National Galleries of Scotland: 17, 20, 77; National Gallery of Canada, Ottawa, transfer from the Canadian War Memorials, 1921 (Gift of the 2nd Duke of Westminster, Eaton Hall, Cheshire, 1918): 100; National Graphic Center, Virginia: 206; National Library of Scotland, Edinburgh: 123, 138; National Trust of Australia, New South Wales: 205; National Trust Photographic Library, London: photo Bill Batten 62, photo John Bethell 63, photo John Hammond 5, 60, photo Horst Kolo 81, photo Mike Williams 61; Newby Hall, Ripon: 37; Norsk Folkemuseum, Oslo: 221; Yasumasa Oka: 236; Philadelphia Museum of Art, gift of Mr and Mrs Wharton Sinkler: 103; Photothèque des Musées de la Ville de Paris: 41, 48, 49, 143, 147, 159, 185, 211; Dr Cecilia Powell: 167; Powerhouse Museum, Sydney: 233; Porzellanmanufaktur Furstenberg: 108; RMN, Paris: 40, 89, 92, 95, 96, 102, 115, 127, 130, 139, 148, 154, 155, 157, 159, 178, 179, 182, 214; The Royal Collection © Her Majesty Queen Elizabeth II: 1, 2, 85, 94, 131, 156; RSA, London: 99; Scala, Florence: 6, 87, 152, 165, 175, 187; Stiftung Weimarer Klassik Museen: 32; courtesy of the Trustees of Sir John Soane's Museum, London: 180, 181; Tate Gallery, London: 162; Thorvaldsens Museum, Copenhagen: 7, 33; Union Centrale des Arts Decoratifs, Paris: 135; by courtesy of the Board of Trustees of the Victoria & Albert Museum, London: 125, 127, 132, 136, 150, 219; by courtesy of the Trustees of the Wedgwood Museum, Barlaston, Staffordshire: 117, 118, 199; reproduced by permission of the Trustees of the Wallace Collection, London: 47; The Whitworth Art Gallery, University of Manchester: 8; by courtesy of the Winterthur Library, Printed Book and Periodical Collection: 207; by courtesy of the Winterthur Museum: 232; Yale Center for British Art, Paul Mellon Collection: 122, 161, 228; Yale University Art Gallery: gift of Louis Rabinowitz 79

Phaidon Press Limited
Regent's Wharf
All Saints Street
London N1 9PA

First published 1997
Reprinted 2000
© 1997 Phaidon Press Limited

ISBN 0 7148 3369 X

A CIP catalogue record for this book is
available from the British Library.

Typeset in Akzidenz Grotesk

Printed in Singapore

Cover illustration Sèvres, *Table des Grands
Capitaines*, 1806–12 (see p.273)